Performance: a critical introduction

Performance: A Critical Introduction is the first textbook to provide an overview of the modern concept of performance, how it has developed in various fields, and the ways in which its multiple applications overlap and interact.

Marvin Carlson has provided a much-needed, highly accessible survey of the contested interpretations of performance art as a theatrical activity, as well as its diverse meanings within the fields of anthropology, ethnography, linguistics, and cultural studies. Tracing the evolution of performance art and theory since the 1960s, Carlson goes on to examine the relationships between performance, postmodernism, and the politics of identity.

For any student of performance studies, visual and performing arts, or theatre history, *Performance: A Critical Introduction* offers a range of vital insights into the diverse meanings and uses of performance.

Marvin Carlson is the Sydney E. Cohn Distinguished Professor of Theatre and Comparative Literature at the City University of New York.

Petrovaper co

The state of Annual Resident and a site of the second of t

Performance: a critical introduction

Marvin Carlson

First published 1996 by Routledge 11 New Fetter Lane, London EC4P 4EE

Simultaneously published in the USA and Canada by Routledge 29 West 35th Street, New York, NY 10001

Routledge is an International Thomson Publishing company

© 1996 Marvin Carlson

Typeset in Palatino by Keystroke, Jacaranda Lodge, Wolverhampton Printed and bound in Great Britain by Clays Ltd, St. Ives PLC

All rights reserved. No part of this book may be printed or reproduced or utilized in any form or by any electronic, mechanical, or other means, now known or hereafter invented, including photocopying and recording, or in any information storage or retrieval system, without permission in writing from the publishers.

British Library Cataloguing in Publication Data A catalogue record for this book is available from the British Library

Library of Congress Cataloguing in Publication Data A catalogue record for this book has been requested

ISBN 0-415-13702-0 (hbk) ISBN 0-415-13703-9 (pbk)

To Michael Quinn

erior serroudite

Contents

	Acknowledgements	viii
	Introduction: what is performance?	1
Part	I Performance and the social sciences	
1	The performance of culture: anthropological and ethnographic approaches	13
2	Performance in society: sociological and psychological approaches	34
3	The performance of language: linguistic approaches	56
Part	II The art of performance	
4	Performance in its historical context	79
5	Performance art	100
Part	III Performance and contemporary theory	
6	Performance and the postmodern	123
7	Performance and identity	144
8	Resistant performance	165
	Conclusion: what is performance? Notes Selected bibliography	187 200 222
	Name index Subject index	237243

Acknowledgements

The colleagues, friends, and artists who have provided information, suggestions, and inspiration for this book are far too numerous to list here, but my gratitude to them is nevertheless beyond measure. I must, however, single out for special thanks Jill Dolan, Tia DeNora, and Joseph Roach, who provided thoughtful, extended, and invaluable commentary as this complex project was evolving. Particular thanks also must go to my editor at Routledge, Talia Rodgers, who encouraged me to undertake this study in the first place and who has been absolutely unflagging in her support and encouragement. Without her enthusiasm and support this book would never have come into existence.

Introduction What is performance?

The term "performance" has become extremely popular in recent years in a wide range of activities in the arts, in literature, and in the social sciences. As its popularity and usage has grown, so has a complex body of writing about performance, attempting to analyze and understand just what sort of human activity it is. For the person with an interest in studying performance, this body of analysis and commentary may at first seem more of an obstacle than an aid. So much has been written by experts from such a wide range of disciplines, and such a complex web of specialized critical vocabulary has been developed in the course of this analysis, that a newcomer seeking a way into the discussion may feel confused and overwhelmed.

In their very useful 1990 survey article "Research in Interpretation and Performance Studies: Trends, Issues, Priorities," Mary Strine, Beverly Long, and Mary Hopkins begin with the extremely useful observation that performance is "an essentially contested concept." This phrase is taken from W. B. Gallie's Philosophy and the Historical Understanding (1964), in which Gallie suggested that certain concepts, such as art and democracy, had disagreement about their essence built into the concepts themselves. In Gallie's terms: "Recognition of a given concept as essentially contested implies recognition of rival uses of it (such as oneself repudiates) as not only logically possible and humanly 'likely,' but as of permanent potential critical value to one's own use or interpretation of the concept in question." Strine, Long, and Hopkins argue that performance has become just such a concept, developed in an atmosphere of "sophisticated disagreement" by participants who "do not expect to defeat or silence opposing positions, but rather through continuing dialogue to

attain a sharper articulation of all positions and therefore a fuller understanding of the conceptual richness of performance."² In his study of the "post-structured stage," Erik MacDonald suggests that "performance art has opened hitherto unnoticed spaces" within theatre's representational networks. It "problematizes its own categorization," and thus inevitably inserts theoretical speculation into the theatrical dynamic.3

The present study, recognizing this essential contestedness of performance, will seek to provide an introduction to the continuing dialogue through which it has recently been articulated, providing a variety of mappings of the concept, some overlapping, others quite divergent. Recent manifestations of performance, in both theory and practice, are so many and so varied that a complete survey of them is hardly possible, but this book attempts to offer enough of an overview and historical background to single out the major approaches and sample significant manifestations in this complex field, to address the issues raised by the contested concepts of performance and what sorts of theatrical and theoretical strategies have been developed to deal with these issues.

My own background is in theatre studies, and my emphasis will be on how ideas and theories about performance have broadened and enriched those areas of human activity that lie closest to what has traditionally been thought of as theatrical, even though I will not be devoting a great deal of attention to traditional theatre as such, but rather to that variety of activities currently being presented for audiences under the general title of "performance" or "performance art." Nevertheless, in these opening remarks it might be useful to step back at least briefly from this emphasis and consider the more general use of the term "performance" in our culture, in order to gain some ideas of the general semantic overtones it may bear as it circulates through an enormous variety of specialized usages. I should perhaps also note that although I will include examples of performance art from other nations, my emphasis will remain on the United States, partly, of course, because that is the center of my own experience with this activity, but, more relevantly, because, despite its international diffusion, performance art is both historically and theoretically a primarily American phenomenon, and a proper understanding of it must, I believe, be centered on how it has developed both practically and conceptually in the United States.

"Performing" and "performance" are terms so often encountered in such varied contexts that little if any common semantic ground seems to exist among them. Both the New York Times and the Village Voice now include a special category of "performance" separate from theatre, dance, or films-including events that are also often called "performance art" or even "performance theatre." For many, this latter term seems tautological, since in simpler days all theatre was considered to be involved with performance, theatre being in fact one of the so-called "performing arts." This usage is still much with us, as indeed is the practice of calling any specific theatre event (or for that matter specific dance or musical event) a "performance." If we mentally step back a moment from this common practice and ask what makes performing arts performative, I imagine the answer would somehow suggest that these arts require the physical presence of trained or skilled human beings whose demonstration of their skills is the performance.

I recently came across a striking illustration of how important the idea of the public display of technical skill is to this traditional concept of "performance." At a number of locations in the United States and abroad, people in period costume act out improvised or scripted events at historical sites for tourists, visiting schoolchildren, or other interested spectators—a kind of activity often called "living history." One site of such activity is Fort Ross in Northern California, where a husband and wife, dressed in costumes of the 1830s, greet visitors in the roles of the last Russian commander of the fort and his wife. The wife, Diane Spencer Pritchard, in her role as "Elena Rotcheva," decided at one time to play period music on the piano to give visitors an impression of contemporary cultural life. But later she abandoned this, feeling, in her words, that it "removed the role from living-history and placed it in the category of performance."4 Despite taking on a fictive personality, dressing in period clothes, and "living" in the 1830s, Ms. Pritchard did not consider herself "performing" until she displayed the particular artistic skills needed to give a musical recital. Normally human agency is necessary for "performance" of this sort (even in the theatre we do not speak of how well the scenery or the costumes performed), but the public demonstration of particular skills can be offered by nonhuman "performers," so that, for example, we commonly speak of "performing" dogs, elephants, horses, or bears.5

Despite the currency of this usage, most of her audience probably considers Ms. Pritchard to be performing as soon as she greets them in the costume and character of a long-dead Russian pioneer. Pretending to be someone other than oneself is a common example of a particular kind of human behavior that Richard Schechner labels "restored behavior," a title under which he groups actions consciously separated from the person doing them—theatre and other role playing, trances, shamanism, rituals.6 Schechner's useful concept of "restored behavior" points to a quality of performance not involved with the display of skills, but rather with a certain distance between "self" and behavior, analogous to that between an actor and the role the actor plays on stage. Even if an action on stage is identical to one in real life, on stage it is considered "performed" and off stage merely "done." Hamlet, in his well-known response to the Queen concerning his reactions to his father's death, distinguishes between those inner feelings that resist performance and the "actions that a man might play" with a consciousness of their signifying potential.

Hamlet's response also indicates how a consciousness of "performance" can move from the stage, from ritual, or from other special and clearly defined cultural situations into everyday life. Everyone at some time or another is conscious of "playing a role" socially, and recent sociological theorists, who will be discussed in some detail in Chapter 2, have paid a good deal of

attention to this sort of social performance.

The recognition that our lives are structured according to repeated and socially sanctioned modes of behavior raises the possibility that all human activity could potentially be considered as "performance," or at least all activity carried out with a consciousness of itself. The difference between doing and performing, according to this way of thinking, would seem to lie not in the frame of theatre versus real life but in an attitude—we may do actions unthinkingly, but when we think about them, this introduces a consciousness that gives them the quality of performance. This phenomenon has been perhaps most searchingly analyzed in the various writings of Herbert Blau, to which we also will return later.

So we have two rather different concepts of performance, one involving the display of skills, the other also involving display, but less of particular skills than of a recognized and culturally

coded pattern of behavior. A third cluster of usages takes us in rather a different direction. When we speak of someone's sexual performance or linguistic performance or when we ask how well a child is performing in school, the emphasis is not so much on display of skill (although that may be involved) or on the carrying out of a particular pattern of behavior, but rather on the general success of the activity in light of some standard of achievement that may not itself be precisely articulated. Perhaps even more significantly, the task of judging the success of the performance (or even judging whether it is a performance) is in these cases not the responsibility of the performer but of the observer. Ultimately, Hamlet himself is the best judge of whether he is "performing" his melancholy actions or truly "living" them, but linguistic, scholastic, even sexual performance is really framed and judged by its observers. This is why performance in this sense (as opposed to performance in the normal theatrical sense) can be and is applied frequently to non-human activity—TV ads speak interminably of the performance of various brands of automobiles, and scientists of the performance of chemicals or metals under certain conditions. I observed an amusing conflation of the theatrical and mechanical uses of this term in an advertisement by the MTA (Metropolitan Transportation Authority) on the New York subway in October 1994, when the subway was celebrating 90 years of service. This was billed as "New York City's longest running performance."

If we consider performance as an essentially contested concept, this will help us to understand the futility of seeking some overarching semantic field to cover such seemingly disparate usages as the performance of an actor, of a schoolchild, of an automobile. Nevertheless, I would like to credit one highly suggestive attempt at such an articulation. This occurs in the entry on performance by the ethnolinguist Richard Bauman in the International Encyclopedia of Communications.7 According to Bauman, all performance involves a consciousness of doubleness, through which the actual execution of an action is placed in mental comparison with a potential, an ideal, or a remembered original model of that action. Normally this comparison is made by an observer of the action —the theatre public, the school's teacher, the scientist—but the double consciousness, not the external observation, is what is most central. An athlete, for example, may be aware of his own performance, placing it against a mental standard. Performance is

always performance *for* someone, some audience that recognizes and validates it as performance even when, as is occasionally the case, that audience is the self.

When we consider the various kinds of activity that are referred to on the modern cultural scene as "performance" or "performance art," these are much better understood in relation to this over-arching semantic field than to the more traditional orientation suggested by the piano-playing Ms. Pritchard, who felt that so long as she was not displaying a virtuosic skill she could not be "performing." Some modern "performance" is centrally concerned with such skills (as in the acts of some of the clowns and jugglers included among the so-called "new vaude-villians"), but much more central to this phenomenon is the sense of an action carried out *for* someone, an action involved in the peculiar doubling that comes with consciousness and with the elusive "other" that performance is not but which it constantly struggles in vain to embody.

Although traditional theatre has regarded this "other" as a character in a dramatic action, embodied (through performance) by an actor, modern performance art has, in general, not been centrally concerned with this dynamic. Its practitioners, almost by definition, do not base their work upon characters previously created by other artists, but upon their own bodies, their own autobiographies, their own specific experiences in a culture or in the world, made performative by their consciousness of them and the process of displaying them for audiences. Since the emphasis is upon the performance, and on how the body or self is articulated through performance, the individual body remains at the center of such presentations. Typical performance art is solo art, and the typical performance artist uses little of the elaborate scenic surroundings of the traditional stage, but at most a few props, a bit of furniture, and whatever costume (sometimes even nudity) is most suitable to the performance situation.

It is not surprising that such performance has become a highly visible—one might almost say emblematic—art form in the contemporary world, a world that is highly self-conscious, reflexive, obsessed with simulations and theatricalizations in every aspect of its social awareness. With performance as a kind of critical wedge, the metaphor of theatricality has moved out of the arts into almost every aspect of modern attempts to understand our condition and activities, into almost every branch of the human

sciences—sociology, anthropology, ethnography, psychology, linguistics. And as performativity and theatricality have been developed in these fields, both as metaphors and as analytic tools, theorists and practitioners of performance art have in turn become aware of these developments and found in them new sources of stimulation, inspiration, and insight for their own creative work and the theoretical understanding of it.

Performance art, a complex and constantly shifting field in its own right, becomes much more so when one tries to take into account, as any thoughtful consideration of it must, the dense web of interconnections that exists between it and ideas of performance developed in other fields and between it and the many intellectual, cultural, and social concerns that are raised by almost any contemporary performance project. Among them are what it means to be postmodern, the quest for a contemporary subjectivity and identity, the relation of art to structures of power, the varying challenges of gender, race, and ethnicity, to name only some of the most visible of these.

This book attempts, in an admittedly brief way, to provide an introduction to this complex field of activity and thought. In Part I, three opening chapters seek to provide a general intellectual background and context for the modern idea of performance by tracing the interrelated development of this concept in the various modern human sciences-first in anthropology and ethnography, then in sociology and psychology, and finally in linguistics. As performance studies has developed as a particular field of scholarly work, especially in the United States, it has been very closely associated with the various social sciences, and a complex and interesting cross-fertilization has been the result. The study of traditional "artistic" performance, such as theatre and dance, has taken on new dimensions and begun to explore newly observed relationships between these and other cultural and social activities, while the various social sciences have found theatre and performance metaphors of great use in exploring particular kinds of human activities within their own fields of study. While the actual practice of modern performance art is most closely related to concerns in sociology and psychology, its theory and certain of its strategies relate importantly to anthropological and ethnographic interests. Linguistic theories of performance have to date proven of greater interest to theorists of traditional theatre than to those of performance art, but the

implications, for example, of Derrida's critique of Searle (to be considered in Chapter 3 on the performance of language) offer intriguing possibilities for the analysis of performance art as well, especially, of course, in those examples of performance involved with linguistic strategies.

Part II of this study consists of two chapters devoted to the background and recent history of what has come to be called "performance art" (or sometimes simply "performance"), with special emphasis upon its development in the contemporary United States. The first of these chapters looks backward to suggest some of the historical antecedents of this major contemporary cultural expression, and the second traces the historical development of modern performance from its appearance at the end of the 1960s to its most recent manifestations. While these two chapters contain some theoretical material, they are primarily historical and descriptive, attempting to give some idea of just what sort of work has been associated with the idea of performance in the United States and elsewhere, and how it both relates to and differs from more traditional theatrical forms.

An impressive body of theoretical writing has grown up around performance art, and Part III of the book examines in different chapters three of the major orientations of the literature. The first of these theoretical chapters deals with the relationships between "performance" and "postmodernism," terms often rather casually linked in critical discourse, but in fact related to each other in very complex and occasionally quite contradictory ways. Postmodern dance, an especially illuminating area for the study of the relationship of performance and postmodernism, is given particular attention in this chapter. The next chapter explores the relationship between performance and identity, a relationship that is in many ways central to how modern performance has developed and been theorized, particularly in the United States. These two chapters have certain dialectic implications, since the frequent associations of the postmodern (the focus of Chapter 6) with a loss of origins, a free play of signification, and an instability of truth claims seem to suggest that to the extent that performance is a significantly postmodern form it is very illsuited to the grounding of subjectivity or identity, either for purposes of defining or exploring the self or for providing a position for political or social commentary or action (the focus of Chapter 7). The final chapter explores this seeming contradiction

in a more detailed manner, looking at the theory and practice of performance that seek within the general assumptions of a postmodern orientation to find strategies of meaningful social, political, and cultural positioning, arguably the most critical challenge confronting performance today, and certainly the site where the most lively and interesting discussion of performance is now taking place.

Performance and the social sciences

Start O

entatina esmannon ella eccueracione repos

sit

Haty Haty History

> olid 1000 1001

> > eti eti

The performance of culture Anthropological and ethnographic approaches

The term "performance," as it is encountered, for example, in departments or programs of "performance studies" in the United States today, is heavily indebted to terminology and theoretical strategies developed during the 1960s and 1970s in the social sciences, and particularly in anthropology and sociology. Especially important in making connections across the boundaries of traditional theatre studies, anthropology, and sociology have been the writings of Richard Schechner, coming from a theatre background, the anthropologists Victor Turner and Dwight Conquergood, and the sociologist Erving Goffman. For persons involved in theatre studies, a major statement of these converging interests appeared in the fall of 1973, in a special issue of The Drama Review devoted to "Theatre and the Social Sciences." In the introduction to that issue, guest editor Richard Schechner listed seven "areas where performance theory and the social sciences coincide." These were:

- 1. Performance in everyday life, including gatherings of every kind.
- 2. The structure of sports, ritual, play, and public political behaviors.
- 3. Analysis of various modes of communication (other than the written word); semiotics.
- 4. Connections between human and animal behavior patterns with an emphasis on play and ritualized behavior.
- 5. Aspects of psychotherapy that emphasize person-to-person interaction, acting out, and body awareness.
- 6. Ethnography and prehistory—both of exotic and familiar cultures.

 Constitution of unified theories of performance, which are, in fact, theories of behavior.¹

Schechner's listing is somewhat reminiscent of a similar attempt to suggest future areas of research between theatre and the social sciences published in 1956 by Georges Gurvitch to summarize the proceedings of a French conference on the subject. Anticipating the subsequent research of scholars such as Goffman and Turner, Gurvitch called attention to the theatrical or performance elements in all social ceremonies, even in "a simple reception or a gathering of friends."²

Both Schechner and Gurvitch's lists outline a rather broader field than the main line of research has in fact followed, but each may be considered as a whole remarkably prescient about a significant part of modern performance study. Indeed, an understanding of contemporary usage of the term "performance" can probably most usefully begin with an overview of the most influential and relevant writings on the subject in anthropology and sociology. Accordingly, we shall consider, in this chapter, the issues and concerns surrounding performance in recent anthropological writing, and in the following chapter, turn to sociology. The hope in outlining developments in both fields is by no means to provide a general introduction to recent anthropological or sociological theory, but rather to introduce the specific aspects of that theory that have contributed to current thinking about performance, both in the abstract and in practice.

The field of anthropology has been a particularly rich source for the discussion of performance in recent years. Indeed it has become so attractive a subject in that field that some anthropologists have expressed concern about its ubiquity. Dell Hymes, for example, has complained that: "If some grammarians have confused matters by lumping what does not interest them under 'performance,' cultural anthropologists and folklorists have not done much to clarify the situation. We have tended to lump what does interest us under 'performance.'"³

Hymes makes an attempt to confine the sprawling field of what is lumped under "performance" by contrasting it with two activity categories often confused with it: behavior and conduct. The first refers simply to "anything and everything that happens," the second to behavior "under the aegis of social norms, cultural rules, shared principles of interpretability." Clearly conduct is a

certain subset of behavior, and performance Hymes defines as a further subset within conduct, in which one or more persons "assume a responsibility to an audience and to tradition as they understand it." Yet, in keeping with the essentially contested nature of performance, even this rather specific articulation raises as many problems as it solves, particularly in what is meant by "assuming responsibility." The audience certainly plays a key role in most attempts to define performance, especially in those attempts to separate performance from other behavior, but just how the performer is "responsible" to them has itself been the subject of much debate.

Even more problematic is the idea of responsibility to tradition. There is widespread agreement among performance theorists that all performance is based upon some pre-existing model, script, or pattern of action. Richard Schechner in a useful and widely quoted phrase calls performance "restored behavior." John MacAloon has similarly asserted that "there is no performance without preformance." 5 On the other hand, much of the recent anthropological analysis of performance has emphasized how performance can work within a society precisely to undermine tradition, to provide a site for the exploration of fresh and alternative structures and patterns of behavior. Whether performance within a culture serves most importantly to reinforce the assumptions of that culture or to provide a possible site of alternative assumptions is an ongoing debate that provides a particularly clear example of the contested quality of performance analysis.

Precisely what performance accomplishes and how it accomplishes this clearly can be approached in a variety of ways, although there has been general agreement that within every culture there can be discovered a certain kind of activity, set apart from other activities by space, time, attitude, or all three, that can be spoken of and analyzed as "performance." Folklore studies has been one of the areas of anthropology and cultural studies that has contributed most significantly to modern concepts of performance study, and one of the first anthropological theorists to utilize "performance" as a central critical term, William H. Jansen, employed it to deal with a major concern of the 1950s in folklore studies, that is, classification. Jansen suggested a classification model with performance and participation as two ends of a spectrum, based primarily upon the degree of involvement of the "audience" of the event.

The term "cultural performance," now widely found in anthropological and ethnographic writing, was coined by Milton Singer in an introduction to a collection of essays on Indian culture that he edited in 1959. There Singer suggested that the culture content of a tradition was transmitted by specific cultural media as well as by human carriers and that a study of the operations of such media on particular occasions could provide anthropology with "a particularization of the structure of tradition complementary to the social organization."7 South Asians, and perhaps all peoples, Singer argued, thought of their culture as encapsulated in discrete events, "cultural performances," which could be exhibited to themselves and others and provided the "most concrete observable units of the cultural structure." Among these "performances," Singer listed traditional theatre and dance, but also concerts, recitations, religious festivals, weddings, and so on. All such performances possessed certain features: "a definitely limited time span, a beginning and an end, an organized program of activity, a set of performers, an audience, and a place and occasion of performance."8 If one were to substitute "a script" for Singer's "organized program of activity," then these distinctive features of cultural performance could as easily be describing the traditional concept of theatre, and Singer's approach and his influence has unquestionably contributed significantly to the convergence of anthropological and theatrical theory in the area of performance from the early 1970s onward. His "features" of performance, especially their emphasis on performance as "set apart" in time, place, and occasion, find countless echoes in subsequent research, and his view of performance as a discrete concretization of cultural assumptions significantly contributed to what might be categorized as the conservative interpretation of performance's role in culture.

During the next decade, the relationship between culture and performance became a matter of increasing concern in both folklore studies and general anthropology. Between his two surveys of the former field in 1963 and 1972, Richard M. Dorson noted the rise of a new orientation, which he called a "contextual approach" to folklore research. The emphasis of such an approach shifts from the text to its function as a performative and communicative act in a particular cultural situation and has looked to the field of sociolinguistics for much of its theory and methodology. Dell Hymes has characterized this blending of communication models

and cultural placement as a new "ethnography of communication,"10 and Dan Ben-Amos and Kenneth S. Goldstein, in their introduction to a 1975 collection of essays on folklore, suggest that the new emphasis falls not upon "the entire network of culturally defined communicative events, but upon those situations in which the relationship of performance obtains between speakers and listeners."11

In their analysis of the component elements of this relationship, contextual folklorists began to converge with performance analysts in other fields. A common source for a number of these was the writings of Kenneth Burke, especially for those contextualists who began to consider the rhetorical function of folkloric performance. Roger Abrahams, for example, in advancing a "rhetorical theory of folklore," claimed that "performance is a way of persuading through the production of pleasure" and specifically recommended Burke as a source of analytic strategies. 12 Burke has perhaps been even more influential among performatively oriented sociologists than anthropologists, but his interest in language and thought as "situated modes of action" and his pragmatic assertion that "every text is a strategy for encompassing a situation"13 were clearly extremely useful concepts for these contextual theorists. Burke's central utilization in his rhetorical analysis of a whole set of theatrical metaphors further emphasized for anthropological theory that aspect of the performative situation, but his model of action was even more influential in sociological theory, and it will be considered in more detail later, when we turn to that tradition.

A shift in attention from the folkloric text to the performative context involved, as in Burke, a shift from traditional content to the more "rhetorical" study of means and techniques. In a 1986 study of oral narrative, Richard Bauman attempted to define the "essence" of performance in terms that clearly echoed the earlier formulations of Hymes, but equally clearly incorporated this new orientation. The definition began with a paraphrase of Hymes: "the assumption of responsibility to an audience for a display of communicative skill," but significantly continued "highlighting the way in which communication is carried out, above and beyond its referential content" (emphasis mine).14 In an earlier study of verbal performance, Bauman suggested that performance was "marked as subject to evaluation for the way it is done, for the relative skill and effectiveness of the performer's display," and

also "marked as available for the enhancement of experience, through the present enjoyment of the intrinsic qualities of the act of expression itself." ¹⁵

Despite their apparent emphasis upon the "how" of performance, Hymes and Bauman remain firmly "contextual," giving much more attention to the total performance situation than to the specific activities of the performer. Yet another "essentially contested" aspect of performance involves the question of to what extent performance itself results from something the performer does and to what extent it results from a particular context in which it is done. When Bauman speaks of performance as being "marked" in order to be interpreted in a particular way, he is assuming, as most anthropological theorists have done, that it is this "marking" that permits a culture to experience performance as performance. The operations of this "marking" have been a particular concern of Gregory Bateson, whose writings, especially the 1954 essay "A Theory of Play and Fantasy," have provided several extremely important concepts and terms to performance theory.16 Bateson is concerned with how living organisms distinguish between "seriousness" and "play." In order for play to exist (and Bateson cites examples of it among animals and birds as well as humans) the "playing" organisms must be "capable of some degree of metacommunication," to signal to each other that their mutual interactions are not to be taken "seriously." 17 For the metacommunicative message "this is play" to operate, some mental operation must establish what is and is not included in "this." In Bateson's words, "every metacommunicative message is or defines a psychological frame" within which is contained the total subject of that message. 18 These closely related concerns of metacommunication and psychological framing have been of great importance in later thinking about performance, even though the conflation of "performance" and "play" raises problems of its own, to which we will later return. Anthropological and folklore theorists, as well as psychological and sociological theorists (in particular, Erving Goffman), have built upon these ideas to develop a view of performance that owes more to context and to the dynamics of reception than to the specific activities of the performer.

A very different orientation is found in the work of the performance theorist who has most closely associated himself with an anthropological approach, Eugenio Barba. In his various writings,

but most extensively in what Barba terms his "Dictionary of Theatre Anthropology" in *The Secret Art of the Performer*, co-edited with Nicola Savarese (1991), Barba focuses upon the "sociocultural and physiological behavior" of the performer across various cultures. ¹⁹ The distinction made by such theorists as Hymes and Bauman between an enjoyment of the content of verbal performance and an enjoyment of "the relative skill and effectiveness of the act of expression," and its own "intrinsic qualities" as an act (see note 14 above), is essentially a restatement in performance terms of the traditional artistic division of form and content. Semiotician Jean Alter has suggested a similar understanding of performance as involving two "functions," which he calls referential (content) and performant (virtuosic display). ²⁰

Barba suggests a different paradigm, dividing potential bodily activity into three types: 1) daily techniques, which are concerned primarily with communication of content; 2) virtuosic techniques, such as those displayed by acrobats, which seek "amazement and transformation of the body"; and 3) extra-daily techniques, which seek not to transform but to "in-form" the body, to place it in a position where it is "alive and present" without representing anything.21 Barba places the foundations of performance not in the situation of its enactment (its cultural "frame" or marking), but in a basic level of organization in the performer's body, at the "pre-expressive" level, the operations of which cause the spectator to recognize behavior as performance. The spectator (about whom Barba says relatively little) responds to performance not due to operations of some cultural "frame," but because of a pre-cultural set of universal "physiological responses" to such stimuli as balance and directed tensions. 22 Barba postulates that the pre-expressive level underlies all performance, Eastern and Western, providing a transcultural "physiology" independent of traditional culture and involving such matters as balance, opposition, and energy. The transcultural study of this physiology, seeking the general physical principles of pre-expressivity, Barba proposes as the mission of theatre anthropology.²³

Probably the most important contributor to the recent convergence of anthropology and theatre was Victor Turner, beginning in the late 1950s with his *Schism and Continuity*. In this study of the Ndembu people, Turner first set forward the concept of "social drama" as a tool for social anthropologists. Turner's "social drama," like Singer's "cultural performance," developed a

model from the specific cultural form of theatre to apply to the analysis of a far larger body of cultural manifestations, though Singer's model drew more directly upon the performance situation of theatre, Turner upon traditional structures of dramatic action. Thus Turner's concept is defined not by its frame or marking, nor by its particular physical dynamics (the focus of Barba), but by its organizational structure.

As Turner explains at some length in his From Ritual to Theatre, his concept of social drama was based upon the early twentiethcentury work of Arnold van Gennep, especially upon his 1908 classic, Rites de Passage. 25 Van Gennep was interested in developing a model to analyze the organization of ritual ordering the transition of individuals or whole societies from one social situation to another. He concentrated on ceremonies by which individuals passed from one role within their society to another, and the phrase "rites of passage" has become commonly associated with this process, especially with the puberty rites marking the change from child to adult. Turner points out, however, that van Gennep originally spoke of rites of passage as including any ceremony marking individual or social change—from peace to war, from plague to health, even regularly repeated calendrical or seasonal changes—and it is this more general type of transition that Turner seeks to analyze. Turner's intellectual debt to van Gennep has had major implications for subsequent performance theory. Despite their very different orientations, Singer, Hymes, Bauman, and Barba all generally view performance as an activity somehow "set apart" from that of everyday life, an orientation also of the "play" theorists we will consider presently. Turner, looking to van Gennep's rites of passage, emphasizes not so much the "set-apartness" of performance, but its "in-betweenness," its function as transition between two states of more settled or more conventional cultural activity. This image of performance as a border, a margin, a site of negotiation, has become extremely important in subsequent thinking about such activity: Indeed, in the opening address to the First Annual Conference on Performance Studies, held in New York in spring 1994, Dwight Conquergood cited performance's location on the borders and margins as that which most clearly distinguished it from traditional disciplines and fields of study, concerned with establishing a center for their activity.26

Van Gennep suggested that rites of passage normally involved

three steps, with particular types of rite involved in each: 1) rites of separation from an established social role or order; 2) threshold or liminal rites performed in the transitional space between roles or orders; and 3) rites of reincorporation into an established order.27 Van Gennep's terms are rites de séparation, marge or limen, and agrégation, translated by Turner as "separation, transition, and incorporation." But Turner also makes important and original use of M. B. Vizedon and G. L. Caffee's translations of van Gennep's terms: "preliminal, liminal, and postliminal."

The use of drama as a metaphor for non-theatrical cultural manifestations continued to mark Turner's work as he studied a wider variety of such activity. In his 1974 Dramas, Fields, and Metaphors, he explained how in his early attempts to analyze social activities among the Ndembu of Northwestern Zambia he combined the process-based structure of van Gennep with a metaphorical model derived from the cultural form of the stage drama,²⁸ and subsequently expanded this analytic strategy from the village level of the Ndembu to complex sequences of events on the national level, such as the conflict between Henry II of England and Thomas à Becket or the Hidalgo Insurrection in early nineteenth-century Mexico. In each of these "social dramas," Turner traced the same pattern: First a breach in an established and accepted norm (corresponding to van Gennep's separation), then a mounting crisis as factions are formed, followed by a process of redress, as formal and informal mechanisms of crisis resolution are employed (these two phases corresponding to van Gennep's transition), and finally a reintegration, very likely involving an adjustment of the original cultural situation (corresponding to van Gennep's reincorporation) or, alternatively, a recognition of the permanence of the schism.

No theatre theorist has been more instrumental in developing modern performance theory nor in exploring the relationships between practical and theoretical work in theatre research and in social science research than Richard Schechner, and the interrelationship between Schechner and Turner was a particularly fruitful one. When Schechner in 1966 first called for approaches to theatre theory more informed by work in the social sciences, he suggested as possible sources cultural historians such as Johan Huizinga or theorists of social psychology such as Erving Goffman or Eric Berne. Later, however, he turned more toward anthropological work, and his investigations began to converge with those of Turner.²⁹ The two collaborated on a workshop exploring the relationship between "social and aesthetic drama," an experiment that, Turner reports, "persuaded me that cooperation between anthropological and theatrical people was not only possible but also could become a major teaching tool for both sets of partners," and that central to this cooperation were the concepts of "performance" and "drama."30

Schechner was especially interested in Turner's model of the "social drama" and drew upon it in a variety of ways as he was seeking to develop a theory and poetics of performance during the 1970s. He argued that Turner's four-phase plan was not only universally found in human social organization, but also represented a form discoverable in all theatre. At the same time, Schechner sought to explore both the similarities and the differences between the performance and cultural placement of "social drama" and that of "aesthetic drama." In his essay "Selective Inattention" (1976), Schechner proposed a chart of this relationship, which he and Turner both utilized in later writings. This chart represents aesthetic drama and social drama as the two parts of a figure 8 lying on its side, with social energy flowing around the figure. The theatre person uses the consequential actions of social life as raw material for the production of aesthetic drama, while the social activist uses techniques derived from the theatre to support the activities of social drama, which in turn refuel the theatre.31

This diagram, and other insights from Schechner's work, are used extensively in Turner's 1982 book From Ritual to Theatre, in which Turner, while expressing great admiration for his work, diverges from Schechner in several ways. He does not agree that traditional drama normally echoes the four-stage pattern of his social drama, but it tends rather to concentrate on the third phase, the ritualized action of redress. Turner also suggests that the figure-8 diagram is "somewhat equilibrist in its implications for my taste" since it suggests cyclical rather than linear movement. Nevertheless, he continued to cite Schechner's model in later essays as an important attempt to demonstrate the relationship between social drama and "expressive cultural genres" such as traditional theatre.32

Turner also continued to develop his own complex elaboration of van Gennep's concept of the "liminal" and eventually opposed to it a related concept of his own, the "liminoid," both of which terms have been widely used in subsequent writings about performance. In his 1969 book, The Ritual Process, Turner called liminal activities "anti-structure," opposing the "structure" of normal cultural operations, a concept also indebted to van Gennep. Such situations provide a space removed from daily activity for members of a culture to "think about how they think in propositions that are not in cultural codes but about them."33 Although at this time Turner did not stress the subversive potential of the anti-structural, this aspect was subsequently emphasized by Brian Sutton-Smith in his studies of child and adult games. Sutton-Smith suggested that the "disorderly" quality of liminal activities sometimes merely involved "letting off steam" from an "overdose of order" (the conservative view) but could also be undertaken "because we have something to learn through being disorderly." What we have to learn is precisely the possibility of alternate orders. As Sutton-Smith argues:

The normative structure represents the working equilibrium, the "antistructure" represents the latent system of potential alternatives from which novelty will arise when contingencies in the normative system require it. We might more correctly call this second system the protocultural system because it is the precursor of innovative normative forms. It is the source of new culture.34

Turner dealt much more extensively with the social functions of this performative process in the essay "Liminal to Liminoid, in Play, Flow, and Ritual,"35 an essay which also showed Turner moving more toward the innovative possibilities of performance stressed by Sutton-Smith. Turner indeed here remarked that "what interests me about Sutton-Smith's formulations is that he sees liminal and liminoid situations as the settings in which new models, symbols, paradigms, etc. arise—as the seedbeds of cultural creativity in fact."36 Turner continued to accept the position of theorists such as Singer that performance remained a culturally conservative activity in tribal and agrarian societies. Although such performance, which Turner styled liminal, might seem to mark sites where conventional structure is challenged, this structure is ultimately reaffirmed. Liminal performance may invert the established order, but never subverts it. On the contrary, it normally suggests that a frightening chaos is the alternative to the established order. In complex modern industrial

societies, this sort of general cultural affirmation is no longer possible, and here we find instead what Turner called "liminoid" activities, much more limited and individualistic, devoted to play, sport, leisure, or art, all outside the "regular" cultural activity of work or business. Liminoid, like liminal, activities mark sites where conventional structure is no longer honored, but being more playful, more open to chance, they are also much more likely to be subversive, consciously or by accident introducing or exploring different structures that may develop into real alternatives to the status quo. This emphasis on the potential of liminoid activity to provide a site for social and cultural resistance and the exploration of alternative possibilities has naturally been of particular interest to theorists and practitioners of performance seeking a strategy of social engagement not offered by the more culture-bound structures of the conventional theatre.

Turner's association of cultural self-reflexivity with cultural conservatism in traditional liminal situations and with the operations of cultural change in more recent liminoid activities continues to be much debated, as does indeed the whole question of the relationship between performance and cultural critique. Clifford Geertz has suggested a distinction between "deep play" and "shallow play" in performance, a distinction recalling Turner's liminal and liminoid, but seemingly reversing Turner's speculation about which sort of activity is radical and which conservative. According to Geertz, only those performances involving the participants in "deep play" are likely to raise real concerns about the fundamental ideas and codes of the culture.37 Bruce Kapferer, on the other hand, seems closer to Turner, arguing that in "deep play," both performers and audience may be so involved in the activity (perhaps at the level of "flow") that reflection does not occur, and that paradoxically, it may be in the more "distanced" experience of "shallow play" that cultural self-reflexion is most likely to occur.38 Clearly, the question of the relationship between performance and its culture is another aspect that demonstrates the essentially contested essence of the term "performance," with some theorists viewing it as reinforcing cultural givens, others seeing it as at least potentially subversive of these givens, and still others seeing it working under some circumstances in one way and in some the other, as in MacAloon's definition of cultural performance as "occasion in which as a culture or society we reflect upon and define ourselves, dramatize

our collective myths and history, present ourselves with alternatives, and eventually change in some ways while remaining the same in others."³⁹ Even those who agree with MacAloon disagree on what stimulates some customs to change while others remain the same. Naturally these debates are of central concern to theorists and practitioners of socially and politically oriented performance, and we shall return to these concerns in that context.

In addition to the rite and ritual studies of van Gennep, Turner, as well as most other cultural anthropologists who have dealt with performance, has been much influenced by earlier research on human play. The two most widely known and most influential studies in this field are Homo Ludens by the Dutch cultural historian Johan Huizinga and the closely related study, Man, Play, and Games, by Roger Caillois. The aim of both theorists was to analyze the function of play within human culture. Huizinga concentrated on culturally constructed and articulated forms of playful activity, such as performances, exhibitions, pageants, tournaments, and contests, while Caillois cast a broader net, including even the "playful" activities of children and animals. Caillois indeed proposes a continuum of playful activity extending from such spontaneous manifestations as an infant laughing at his rattle or a cat with a ball of yarn, to which he gave the term "paidia," on through increasingly institutionalized and rule-bound play structures that Caillois called "ludus." 40

This difference aside, the six essential "qualities" of play activity according to Caillois (that it is not obligatory, that it is circumscribed in time and space, undetermined, materially unproductive, rule-bound, and concerned with an alternate reality)⁴¹ are basically identical with Huizinga's "characteristics" of play. The first quality of play according to Huizinga is that it is a voluntary activity, freely selected and capable of being suspended at any time. It is thus closely tied to "free time," or leisure. This connection is particularly important to Turner, who argues that the concept of leisure itself is one that arises with modern industrial society, which clearly divides human activity into periods of work and non-work. The activities of the nonworking, leisure periods, play activities, are precisely those that Turner characterizes as liminoid. The association of liminoid with such circumscribed periods also recalls Huizinga's second characteristic, according to which play is set apart from ordinary

life, occurring in a "temporary sphere of activity with a disposition all of its own." 42 Clearly this involves the process that theorists speak of as "framing."

Both Huizinga and Caillois see battles or contests as one central preoccupation of play. Caillois uses for this a term with a long history in theatre theory, "agon," a concept which is also central to Turner's model of the "social drama." Another Caillois category, "mimicry," is perhaps even more central to traditional theatre, but both "conflict" and "mimesis," particularly the latter, have played a much less central and more problematic role in modern performance theory. Probably this is in part due in fact to their close association with the theatre tradition, from which modern performance has often tried to distance itself. Caillois' further two categories, though seemingly less familiar, in fact relate much more closely to common concerns of modern performance. The first of these is "alea," or chance, a concern that entered the tradition of modern performance partly from the theatre experiments of dada and surrealism earlier in the century, partly from developments related to happenings and chance theatre in the 1960s, and partly from the writings and work of a key figure in modern performance, John Cage. All of these developments will be discussed more fully in the context of performance art itself, but here we might only note that Caillois himself sees "alea" as in a sense the opposite of "agon." In the latter, the emphasis is upon clever planning, logic, ingenuity, and control, all elements that Caillois sees in some measure opposed to the freedom and spontaneity of the play instinct. Performance theorists and practitioners have similarly looked to chance as a means of breaking free of the normally highly codified structures and expectations of the conventional theatrical experience.

Caillois' final category, "ilinx," or "vertigo," performs a similar subversive function. Caillois describes this as "an attempt to destroy momentarily the stability of perception and inflict a kind of voluptuous panic upon an otherwise lucid mind." The emphasis here is upon subversion, the destruction of "stability," the turning of "lucidity" to "panic," brought about by a foregrounding of physical sensation, an awareness of the body set free from the normal structures of control and meaning. In a sense, vertigo is to the body what chance is to the mind, a casting loose into free play, there of elements, here of sensations. Huizinga speaks, in distinctly more positive terms, of a similar freeing from

normal structures and constraints, which he describes as a sense of "enchantment" or "captivation" that is felt in play. 44 Turner also speaks of this sense of "enchantment," though he favors the more familiar term "flow," 45 derived from such psychological theorists as John MacAloon and Mihaly Csikszentmihalyi. During "flow," which these psychological theorists associate not only with play but also with creative and religious experience, reflexivity is swallowed up in a merging of action and awareness, a focus upon the pleasure of the present moment, and a loss of a sense of ego or of movement toward some goal.

Caillois does not specifically oppose vertigo to mimicry as he does chance to conflict, but it is striking that one of the major fault lines in modern theory runs down a divide that can be considered in precisely these terms, that is in the division Bert States makes between semiotics, based upon a model of mimesis, and phenomenology, based on one of physical sensation, or the model proposed by Jean Alter opposing semiosis to performance on essentially the same grounds (both the Alter and States models will be discussed in more detail later). To the extent that modern performance has defined itself in opposition to traditional theatre, it has largely followed these theoretical divisions, championing the operations of chance and the physical awareness of the performative situation against the control and the mimetic distance of conventional theatre.

Huizinga, in considering the cultural functions of play, sees them as primarily conservative, providing through the deepening of communal experience and the ludic display of communal values and beliefs an ultimate strengthening of cultural assumptions. Indeed the development or reinforcement of a community spirit or consciousness, "communitas," Huizinga considers one of the basic features of play, and he suggests that its effects often continue on beyond the actual play experience. Thus cultural play, like Singer's cultural performance, provides a solidifying of the community, and the "actualization by representation" of the hidden values, assumptions, and beliefs of the culture.46 This becomes particularly apparent as Huizinga explores the close relationships between play and ritual. Nevertheless, building upon the emphasis both he and Caillois give to the absolute freedom necessary for the functioning of play, there is clearly room for a much more subversive function, congruent with that suggested by Sutton-Smith and later Turner, particularly when Huizinga notes that in "more advanced civilizations" the great cultural play periods of "savage societies" leave their traces in "saturnalia and carnival customs" characterized by disruptive and disorderly behavior. 47 The theorist most associated with the concept of carnival and carnivalization in modern literary and performance theory is Mikhail Bakhtin, whose comments on this subject, particularly in his study of Rabelais,48 bear a remarkable resemblance to Turner's discussion of liminal phenomena within a culture. During carnival, notes Bakhtin, "the laws, prohibitions, and restrictions that determine the structure and order of ordinary, that is noncarnival, life are suspended," making carnival "the place for working out, in a concretely sensuous, half-real and half-play-acted form, a new mode of interrelationship between individuals, counterposed to the all-powerful sociohierarchical relationships of noncarnival life" (emphasis in original).49 This vision of carnival as an open testing ground for new social and cultural structures clearly marks it as an example of what Turner would classify as a liminal or liminoid activity. Bakhtin lists the categories of carnival as: free and familiar contact among people, the free expression of latent sides of human nature in eccentric conduct (recall the emphasis on freedom in Huizinga), profanations, and carnivalistic misalliances, allowing the combining and uniting of the most disparate and ill-assorted things. He stresses that these categories are not involved with abstract thought, but with the sensuous playing out in the form of life itself, that is, by cultural performance. This leads in turn to a consideration of specific carnivalistic acts, the most important of which is the mock crowning and decrowning of the carnival king, a ritual deeply imbricated with the pathos and emphasis on change, the concerns with death and renewal that lie at the base of the carnivalistic experience itself.

Like Turner, Bakhtin distinguishes between the carnivalization available to earlier cultures and its more mediated, truncated, and scattered modern descendents, a shift that Bakhtin feels begins as early as the seventeenth century. Theatre and spectacle are of course one of the offshoots of this once mighty cultural force, and Bakhtin notes that "It is characteristic that the subculture of the theatre has even retained something of carnivalistic license, the carnivalistic sense of the world, the fascination of carnival."50 The high point of carnival's interpenetration of the literary tradition, Bakhtin feels, occurs during the Renaissance, and his

concept of the carnivalization in Renaissance literature has been very influential among recent studies of Elizabethan drama.⁵¹ But the concept of carnival as a site for the playful exploration and possible challenging of traditional cultural assumptions and roles has also attracted the interest of performance artists and theorists concerned with precisely these matters.⁵²

An important critique of both Huizinga and Caillois was presented in 1968 by Jacques Ehrmann. In the theories of both of these authors, as well as in those of the linguist Emile Benveniste, Ehrmann finds an assumed cleavage between play and seriousness, with play linked to dreams, imagination, gratuitousness, and such "free" phenomena, while seriousness is linked to such concepts as consciousness, utility, and reality. In addition to creating what is in any case a highly suspect division, this strategy also simultaneously privileges the second term as the ground of the first, a neutral and objective referent needing no discussion.⁵³ In Huizinga's terms, "Play always represents something."54 Ehrmann's argument suggests the common strategy of Derrida, who has similarly exposed the strategy of creating a false "grounding" of a binary by making one of its terms the axiomatic base of the other. Derrida's critique also has important implications for performance theory, to which we will return in exploring the relation between performance and postmodern thought. At this point, I wish only to emphasize that Ehrmann, like Derrida, resists the model that derives play from a fixed, stable reality that precedes and grounds it. In this more modern view, play, reality, and culture are all involved in a continually shifting pattern of concepts and practices that condition each other, and rather than attempt to separate or privilege any of these terms, the critic or theorist of human activity should have as a goal the explanation of "how this nature-culture manifests itself in different historical and cultural contexts."55

A closely related concern and analytic strategy has been offered by Marshall Sahlins, who suggests that anthropologists tend to think of cultures as being modeled by both "prescriptive" and "performative" structures—the former the relatively stable institutional forms of a society, the latter operations that evolve in response to contingent circumstances. Clearly there is a parallel here to the "play" and "reality" of Ehrmann, especially when play is associated with the cultural changes or adjustments opened by Turner and van Gennep's liminality. However, like Ehrmann, Sahlins cautions against so clear a dichotomy, and even more important, against the priority normally given in the social sciences to the prescriptive over the performative, clearly parallel to the priority Ehrmann finds given to the stable "reality" from which play derives. Certainly a cultural act can and often does arise from a social form, but all societies also continually improvise social form by means of acts, and the mixture of these strategies and the levels upon which they operate vary greatly from society to society.⁵⁶ The cautions of Ehrmann and Sahlins are extremely important in broadening the scope and the significance of liminal and performative activity. Indeed in considerations of the social functioning of performance, even Sahlins' flexible definition needs to be qualified, since it reinscribes the fixed/fluid dichotomy on another level, with "performative" acts associated. as always, with the fluid part of this familiar binary, dissolving (at least temporarily) the "prescriptive" already existing structures of the culture.

Turner's own explorations have been carried on by Colin Turnbull and others in directions that overlap in striking ways with performance theory of the 1990s, as Turner's did with performance theories of the 1970s and early 1980s. In a 1990 essay, Turnbull specifically speculates on how his own theories seemed to be evolving in parallel directions with Turner's last work (he died in 1983). These new directions involved a shifting understanding of the nature of cultural performance, and particularly of the performative nature of anthropological work itself. While the young Turner had applied a theatrical model to certain phenomena in a culture being analyzed, Turnbull saw its potential relevance to the process of analysis itself.⁵⁷

The anthropological process and performance, suggests Turnbull, have many points of correspondence, since the field-worker is fulfilling the "role" of anthropologist expected by his society and also "performing" to achieve specific goals. (These concerns echo those of Goffman and will surface again in the next chapter.) The fieldworker is also a spectator in a cultural performance, and in a more subtle sense within the specific context of a study this spectator is forced to modify normal behavior, giving it special significance for others. The next step in Turner's project, argues Turnbull, must involve dealing with the recognition that liminal phenomena cannot simply be objectively studied, but must also be understood by participation, informed

by the sort of rigorous preparation and training that leads back to the disciplines of theatre. In short, the fieldworker can no longer rely upon the traditional methods of "objective" reporting of performance, not because objectivity is impossible (though it is at best extremely difficult), but because performance cannot really be understood in this way. Entering the liminal or performative situation requires, among other things, discipline and concentration, a clearly defined goal, or perhaps the negation of all goals and a surrender of the inner self to become something else. The first two of these demands, says Turnbull, present no problem to most anthropologists, but the third, calling into question traditional academic objectives, inner beliefs, and the

sense of identity, presents a far greater challenge.58

The shift in emphasis Turnbull suggests in fact represents a major shift in modern anthropology, from the model of the neutral objective reporter of cultural customs to that of a native from one culture observing natives from another, creating a complex interplay of influence and adjustment. Dwight Conquergood in 1985 suggested that five types of attitudes toward the ethnography of performance could now be charted out, four of them morally problematic. The suspect stances were that of the custodian, the enthusiast, the skeptic, and the curator. The custodian collects examples of performance, interested only in acquisition or exploitation. The skeptic, like many traditional ethnographers, stands aloof from and superior to the performance being studied. The enthusiast goes to the opposite extreme, seeking an easy identity in quick generalizations. The curator takes a tourist's stance, seeking exoticism or spectacle. Against all four of these, Conquergood champions the fifth stance, a "dialogical" performance, which aims "to bring together different voices, world views, value systems, and beliefs so that they can have a conversation with one another." The result sought is an open-ended performance, resisting conclusions and seeking to keep interrogation open.59

The role of the "reporter" is a less central concern when we move to performance study outside the traditional area of anthropology (although it has stimulated some important theoretical speculation, which will be examined in a later chapter). In more general terms, however, performance, critical and theoretical, underwent a parallel and doubtless related development during the 1980s, moving from an almost exclusive preoccupation with the performer and the performative act to a consideration also of who is watching the performance, who is reporting on it, and what the social, political, and cognitive implications of these other transactions are upon the process. Moreover, a closely related concern has proven one of the most stimulating areas of theoretical speculation in both ethnography and theatre studies in the late 1980s and early 1990s. The move from a model of a fieldworker as a neutral observer to that of a fieldworker as a participant in performance, both in initial experience and in subsequent relaying of that experience to others, means moving into the complex field of intercultural performance. In the modern world of easy transportation and communication, not only anthropologists, but all sorts of cultural performances or parts of cultural performances, can and do circulate with relative ease about the globe, weaving complex patterns of contact with other cultures or other cultural performances.

A number of European theatre theorists, most notably Patrice Pavis in France and Erika Fischer-Lichte in Germany, have provided important studies of interculturalism within the context of theatre studies. But although this work is very much informed by anthropological models (Pavis, for example, bases his cultural analysis largely upon the work of French anthropologist Camille Camillieri), it has not been, at least so far, involved in the sort of direct, ongoing, mutual exploration and influence that has characterized, for example, the work of Schechner and Turner in the 1970s. Nevertheless, an important element in recent anthropological studies shares with recent theatre studies of this sort a common interest in how cultural performance is affected by the increasing intercultural borrowings of the modern or postmodern world; and so quotations from current anthropological theories often show up in studies of a more traditionally theatrical nature. The Predicament of Culture (1988), by ethnographic historian James Clifford, is an important example of such theory, with its argument that modern-world societies have become "too systemically interconnected to permit any easy isolation of separate or independently functioning systems" and that everywhere individuals and groups "improvise local performance from (re)collected pasts, drawing on foreign media, symbols, and languages." Clifford and others have spoken of this new interculturalism as "creolized," 60 in reference to the mixed and layered culture of regions such as the Caribbean.61

The function of performance within a culture, the establishment and use of particularly designated performative contexts, the relation of performer to audience and of the reporter of performance to performance, and the generation and operations of performance drawing upon or influenced by several different cultures —all of these cultural concerns have contributed importantly to contemporary thought about what performance is and how it operates. The emphasis of culture theories, however, remains focused primarily upon performance as an ethnographic or anthropological phenomenon. Equally important to modern performance theory has been consideration of performance from a social or psychological perspective, and to such theories we shall now turn.

Performance in society Sociological and psychological approaches

The recognition that all social behavior is to a certain extent "performed" and that different social relationships can be seen as "roles" is of course hardly a recent idea, and in certain periods of theatre history, such as the Renaissance and the Baroque, this "theatrical" quality of regular social life appeared as a motif or a central subject in countless plays. It was not really until the twentieth century, however, that an exploration of the actual personal and social implications of this way of viewing human activity appeared, directed not toward the creation of an artistic product, but toward the analysis and understanding of social behavior.

Researchers in both psychology and sociology became interested in the application of the theatrical concept of role playing to study in their own fields during the 1940s and 1950s, and although there is a good deal of overlap in their analytic vocabulary, the two fields developed quite separate strategies, according to their own concerns. More recent performance theory has been much more directly influenced by the sociological model, particularly as represented in the work of Erving Goffman, whose writings in this area have exerted an influence at least equal to, and perhaps even greater than, Turner's in the anthropological study of performance. Psychological theories of performance have been less directly influential, but Schechner and others have regularly referred to them, and they have in fact often involved performance events more directly comparable to conventional "theatrical" performance than have the sociological theories. The leading name among these psychological theorists is J. L. Moreno, who in 1946 presented the concept of psychodrama in a book with that title. A variety of other competing role-playing approaches

to psychotherapy followed, the most important being the behavior rehearsal of J. Wolpe and A. A. Lazarus. Eric Berne's transactional analysis was also often cited in The Drama Review in the mid-1960s as the relationships between social-science theory and the new idea of performance analysis were evolving. We will consider the contributions of these sociological and psychoanalytic theorists to performance theory presently, but first let us glance backward to two earlier theorists whose writings significantly anticipate some of the central features of these mid-century writers.

Both of these theorists, interestingly, are quite impossible to place in terms of conventional professions or academic areas, and there is little doubt that the scope and variety of their backgrounds led to their interest in so ubiquitous a human phenomenon as performance. The first, Nikolas Evreinoff, is perhaps now best remembered as an experimental Russian playwright from the brilliant period at the turn of the century, and perhaps also for his organization of mass spectacles celebrating events of the Revolution. In addition to his varied theatre career, however, he was a successful musician and composer, novelist, historian, psychologist, biologist, archeologist, and philosopher, and his various books and articles, while nominally concerning theatre, draw upon all these interests. Between 1912 and 1924 he published a series of books and monographs, sections of which were woven together into the English collection The Theatre in Life, published in 1927.

The Theatre in Life begins with a discussion of the wide-spread phenomenon of play, an activity humanity shares with the animal kingdom, then proceeds to a concern with the specifically theatrical. Evreinoff rejects the general assumption of anthropological and theatrical theorists that theatre arose from ritual bases or evolved from an early interest in the aesthetic, expressed at first in images and dances. Instead he argues that the theatrical is itself a basic instinct, more fundamental than the aesthetic or even the organization of ritual. "The art of the theatre is preaesthetic, and not aesthetic," he argues, "for the simple reason that transformation, which is after all the essence of all theatrical art, is more primitive and more easily attainable than formation, which is the essence of aesthetic arts."² (This distinction is strikingly similar to that made by Eugenio Barba between expressivity and pre-expressivity.) Later Evreinoff observed that this ability to imagine something "different" from everyday reality and to "play" with this imagination was also a pre-condition for religion, which required the ability to conceive of and personify "gods." "Man became first an actor, a player; and then came religion."³

In the opening chapters of The Theatre in Life, Evreinoff's approach and examples are basically anthropological, but by the sixth chapter, "The Never Ending Show," he has moved to a much more distinctly sociological analysis. "We are constantly 'playing a part' when we are in society," Evreinoff avers, citing fashion, make-up and costume, the everyday operations of life, and the social "roles" of such representative figures as politicians, bankers, businessmen, priests, and doctors. The life of each city. of each country, of each nation Evreinoff sees as articulated by the invisible "stage manager" of that culture, dictating scenery, costume, and characters of public situations throughout the world. Each epoch has "its own wardrobe and scenery, its own 'mask.'"4 Many of the concerns and metaphors of later role and performance theory in sociological literature are already clearly in place in Evreinoff's rather fanciful analysis, including not only the particular dynamic of the social self as defined internally and externally by culturally conditioned roles, but also the reinforcement of those roles by the costumes, properties, and physical settings provided by the "stage management" of society. These same concerns can be found in the more influential writings of both Kenneth Burke and Erving Goffman.

Kenneth Burke, like Evreinoff, is difficult to categorize, though he has been referred to as a literary critic, a philosopher, a semanticist, and a social psychologist. Certainly his system of thought has had profound influence in all of those fields, and such leading performance theorists as Goffman, Turner, and Schechner have all followed his strategy of using the approach of "dramatism" to analyze a variety of social interactions and cultural behavior. The titles of Burke's two major statements on "dramatism," A Grammar of Motives (1945) and A Rhetoric of Motives (1950), indicate his central concern, which is the establishment of analytic terms and strategies for the discussion of human motivation and the devices by which people, consciously or unconsciously, try to influence the opinions or actions of each other.

Any complete statement about motives, argues Burke, must answer five questions, which lead to the "five key terms of dramatism": "what was done (Act), when or where it was done (Scene), who did it (Agent), how he did it (Agency), and why

(Purpose)."5 The situation of human action within a "staged" context is what ties Burke most closely to subsequent performance theorists, and his particular interest in literary analysis has provided particular stimulation for critics who have sought to extend performance analysis into that area. Burke's central interest in motivation has proven for performance theory less important than his general approach, since those interested in the "theatrical" side of performance have tended to look more toward communication or the effect produced by performance than the motivation of the artist. Theorists of social performance, on the other hand, have tended to place much more emphasis on the social constraints governing an act than upon its specific motivation.

Erving Goffman shares with these theorists a use of the metaphor of theatrical performance to discuss the importance and the operations of role playing in social situations, though his influence on performance theory outside the social sciences has been much greater. Barbara Kirshenblatt-Gimblett, for example, has pointed out the usefulness of some of Goffman's earliest analytic approaches to everyday behavior for the potential analysis of the

more distinctly performative situation of storytelling.6

The essay to which Kirshenblatt-Gimblett primarily refers, Goffman's 1955 "On Facework," is striking in the similarity of the structure it imposes on "interpersonal ritual behavior" to Turner's "social drama." Both describe an event structure in which the orderly flow of normal interaction, social or cultural, is disrupted by an incident, some breach of social or cultural norms. This precipitates a crisis and sets in motion what Turner calls a "redressive stage" and Goffman a "corrective interchange." The normal phases of this crisis and redressive action are labelled by Goffman as challenge, offering, acceptance, and thanks, and through their operations the equilibrium is reestablished (though Goffman, like Turner, recognizes that the equilibrium may not mean a return to the old order; it may be an accommodation to a permanently changed new one).

The Presentation of Self in Everyday Life (1959) is Goffman's bestknown work, and is centrally concerned with performances, that indeed being the title of its opening chapter. "Performance" Goffman defines as "all the activity of an individual which occurs during a period marked by his continuous presence before a particular set of observers and which has some influence on the observers."8 This definition, though it raises a few problems, could serve very well for much of the artistic activity that has appeared in recent years under the title of "performance." It is important, however, to note that even this seemingly very general and calculatedly neutral definition reflects certain assumptions and biases. Perhaps most significant is how the definition determines what makes performance performance and not simply behavior. Goffman in this formulation does not emphasize, as, for example, Burke does, the conscious production of a certain type of behavior, as might be expected for a theory of "presentation" or of "role playing." Both of these terms suggest the initiative of a subject, but Goffman stresses the fact that certain behavior has an audience and, moreover, has an effect on that audience. Indeed in terms of this definition, the individual might quite possibly be engaged in performance without being aware of it.

Goffman's definition nevertheless addresses what seems to be an essential quality of performance, that it is based upon a relationship between a performer and an audience. All theorists of performance recognize this in some measure, but as we have seen, theorists of cultural performance tend, not surprisingly, to place more emphasis upon the audience, or upon the community in which performance occurs. Theorists of social performance, if they are sociologists, naturally also tend in this direction, while ethical philosophers and psychologists equally naturally tend to emphasize the activities and operations of the performer. Although Goffman draws strongly upon both concerns, his overall emphasis, as this definition suggests, is rather more toward the audience—how social performance is recognized by

society and how it functions within society.

This is even more clearly the case in another highly influential work by Goffman, Frame Analysis (1974), which explores in considerable detail the concept and implications of "framing," of central importance in performance theory. "Framing," like the concept of metacommunication already discussed in connection with the anthropological theories of Turner, comes from the influential 1954 essay by Gregory Bateson, "A Theory of Play and Fantasy." Central to Bateson's discussion of play (and to the closely related fields of histrionics, fantasy, and art) is the psychological notion of the "frame," which is the major enabling device allowing the fictive world of "play" to operate. Within the "play frame," all messages and signals are recognized as "in a

certain sense not true," while "that which is denoted by these signals is nonexistent."9 For Goffman the "frame" is an organizing principle for setting apart social events, especially those events that, like play or performance, take on a different relationship to normal life and normal responsibilities than the same or similar events would have as "untransformed reality" outside the confines of the frame. 10

Goffman spends one chapter in Frame Analysis specifically on the peculiar and complex "keying" involved in the theatrical frame, closely related to his concept of performance. "Performance" Goffman further defines as a framing arrangement that places a circumscribed sequence of activity before persons in an "audience" role, whose duty it is to observe at length the activities of the "performers" without directly participating in those activities. ¹¹ Goffman particularly distinguishes his usage from that of certain linguists who have called behavior "performance" when there is an assumption that this behavior is subject to evaluation. The concept of performance in linguistic theory, however, involves much more than this and will be treated in detail in the next chapter.

A concept very similar to "framing" that has become quite popular in semiotic analysis of performance is "ostentation," introduced to this field by Umberto Eco in his 1977 article, "Semiotics of Theatrical Performance," one of the first articles in English to consider theatre from a semiotic perspective. The primary concern of semiotics is the operations of human communication, and it is from this perspective that semiotic theorists have considered both theatre and the construction or performance of social roles. Despite its title, much of Eco's article in fact deals not with theatre but with social performance, as may be seen in its central example. Eco selects for his analysis an imaginary figure from the writings of the pioneer semiotician Charles Peirce: a drunkard exposed in a public place by the Salvation Army in order to serve as a sign communicating a message about the negative effects of drink. Like Peirce, Eco finds this example fascinating because it involves communication in an intriguingly indirect way. Normally signs are intentionally produced by human beings in order to communicate a message, and in this sense the various actions produced in social-role playing can be seen as signs of that social role or position. What then of the drunkard, whose red nose, slurred speech, and so on, are certainly recognizable as signs of his condition and whose appearance under the auspices of the Salvation Army permits him to stand as a sign for the evil effects of drink, but who is involved in all of this communication without necessarily being aware of it?

To approach this problem, Eco refers to another semiotician, Charles Morris, who allows consideration of the drunkard himself to be put aside by locating the central dynamic of the sign not in the intention of the sign producer but in the interpretation of its receiver. According to Morris' formulation, something is a sign "only because it is interpreted as a sign of something by some interpreter."12 The drunkard thus becomes a sign not because he has decided to do so, but because some person or group of persons, whom we may designate as his audience, recognize him as such. This still leaves us with the question of how they do this. Goffman's response would be that some conceptual frame has been established signalling to this audience that material within it is being presented for their observation and interpretation. Eco acknowledges that one may speak of this process in terms of frame analysis, but he suggests "ostentation" as an alternate, and, in this situation, rather more accurate term. Although it was Eco who brought this term into the modern theoretical vocabulary, it is by no means original with him. Eco himself notes its use in the writings of medieval logicians, in Wittgenstein, and among theatre theorists, in the Eastern European Ivo Osolsobe, When something is ostended, it is picked up among existing items and displayed, as the Salvation Army has placed Peirce's drunkard in a public space. Although obviously related to framing, ostentation in fact characterizes a different operation: The former emphasizes special qualities that surround a phenomenon, the latter something about the phenomenon itself.

Different ways in which a physical phenomenon, be it an object or an action, is perceived, have also been the subject of analysis by phenomenological theorists, some of whom have a particular interest in theatre and performance. Bert States, dealing with the theatre's special relationship to the world of physical objects, discusses a process clearly related to Eco's ostentation, which occurs when a living creature such as a dog or an inanimate object such as a piece of furniture is placed in an "intentional space" such as a stage. In the words of Shakespeare's Cleopatra, the object is thus "uplifted to the view," triggering a perceptual change during which, according to States, the consciousness slips

"into another gear" allowing the viewer to regard the object so displayed as "a signifying, exemplary image." 13

The theories we have just been examining all place a major and in some cases an almost exclusive emphasis upon the audience and upon reception. This does not necessarily present a serious problem for semiotics, insofar as it follows the general direction suggested by Morris, nor for phenomenology, insofar as it focuses upon how the world is experienced. Performance analysis, however, must use reception study as only a part, if a necessary part, of its approach. Eco's drunken man suggests the problem: There is no question that he, his appearance, and even his behavior is a sign, but there is a very real question about whether he is involved in performance. Like the dog or item of furniture mentioned by States, the drunken man is essentially an object semiotized by ostentation or by placement within a theatrical frame. Even the frame is not of his own making, but is established by an external agent, the Salvation Army. Such a model does not really represent what we normally think of as theatre, where actors, even though they submit themselves to an external production apparatus to provide their "framing," are very much aware of the operations of their activity. Still less does the model represent modern performance, where performers often control much of the production apparatus that establishes their frame. Important as the audience function is, therefore, we must also necessarily consider the conscious contributions to the performance process of the performer.

In fact, most theories of social performance also consider this a necessary concern. When Goffman, for example, proceeds to the specific analysis of social performance, he in fact turns his attention from the function of the "audience" to the activity of playing the social role, focusing upon the various ways that members of society, with greater or lesser degrees of success and with greater or lesser degrees of consciousness, pursue "the work of successfully staging a character." 14 The "interaction constraints" that transform "activities into performances" are essentially constraints not upon the audience but upon the role-playing individual: the selection of an appropriate "front" (setting, costume, gestures, voice, appearance, etc.) and the commitment to coherence and selective arrangement of material presented, both of these required by the direction of activity toward communication rather than toward work-tasks. 15 As he

discusses the activities and choices involved in setting up this successful communication, Goffman is close to the definition of performance that sociolinguist Dell Hymes has derived from Goffman's theories: "cultural behavior for which a person assumes responsibility to an audience." 16 This reformulation does not deny the social aim of performance—"for" an audience that Goffman stressed earlier, but nevertheless it places the responsibility of performance, and its agency, squarely back upon the performer.

Among the many theorists of social performance who have focused their attention more upon the activity of the performer than upon that of the audience or upon the reception process generally, the question of just what is meant by "assuming responsibility" often has been a central theoretical issue. Three general positions (with some inevitable overlap) may be distinguished among the theorists who have focused upon the implications of performance and role playing in the construction of the social self. Each of these is involved with the relationship of the self being performed to the self performing. First Goffman, in his consideration of social performance primarily in its communicative function, may be taken as representing what can be characterized as a position of neutrality. The "responsibility" taken by the performer is one of ease and clarity of communication, and the question of whether the "self" being represented is the "true" self or not is a relatively minor concern.

Other theorists, however, have viewed social performance as much more value-inflected. A second position sees this negatively, the third positively. The negative arguments often recall Plato's ancient suspicion of mimesis, suggesting that the playing of social roles tends to deny or subvert the activities of a "true" self. Nietzsche offers a metaphor of performance as a kind of alien force that takes possession of the self:

If someone wants to seem to be something, stubbornly and for a long time, he eventually finds it hard to be anything else. The profession of almost every man, even the artist, begins with hypocrisy, as he imitates from the outside, copies what is effective. The man who always wears the mask of a friendly countenance eventually has to gain power over benevolent moods without which the expression of friendliness cannot be forced—and eventually then these moods gain power of him and he is benevolent.17

Around the turn of the century, when the philosophy of Bergson and others had generated a wide-spread view of life as fluid and mutable, social roles were condemned by many writers and philosophers because of their rigidity. Thus Santayana:

Every one who is sure of his mind, or proud of his office, or anxious about his duty assumes a tragic mask. He deputes it to be himself and transfers to it almost all his vanity. While still alive and subject, like all existing things, to the undermining flux of his own substance, he has crystallized his soul into an idea, and more in pride than in sorrow he has offered up his life on the altar of the Muses. . . . Our animal habits are transmuted by conscience into loyalties and duties, and we become "persons" or masks. 18

More recent philosophers concerned with role playing and social performance have focused less on flexibility and spontaneity and more on the taking of responsibility, especially in an ethical sense. Probably the best-known example of this is Sartre, whose chapter on "Bad Faith" in Being and Nothingness (1943) is concerned primarily with the analysis of this phenomenon. In a striking passage (quoted in full by Goffman) Sartre analyzes the behavior of a waiter in a café, all of whose activity has a touch of the artificial, the imposed. He is, Sartre suggests, in fact "playing at being a waiter in a café." It is a kind of game, but a game with very serious implications, since it is through this "playing" that the waiter "realizes" his condition. Such performance is imposed, says Sartre, upon all tradesmen: "Their condition is wholly one of ceremony. The public demands of them that they realize it as a ceremony; there is the dance of the grocer, of the tailor, of the auctioneer, by which they endeavour to persuade their clientele that they are nothing but a grocer, an auctioneer, a tailor. A grocer who dreams is offensive to the buyer because he is not wholly a grocer." This characteristic of performance, that it is produced for an audience, Sartre sees as its greatest danger to the psyche. When we commit ourselves to become a "representation" for others or for ourselves, we exist "only in representation," a condition of what Sartre calls "nothingness" or "bad faith." The social position substitutes attitudes and actions for being, substitutes the simple, predictable role desired by society for the complex consciousness that fulfills the needs of the self. 19

A similarly negative view has been developed much more recently by phenomenologist Bruce Wilshire, who has attacked not the performance of a social role but even thinking of the social role in such a theatricalized metaphor, which he characterizes as false, alienating, and demoralizing. Wilshire argues that the use of this metaphor by such theorists as Goffman, who is a particular target for Wilshire's displeasure, blurs the distinction between "on stage" and "off stage" activity, with an attendant erosion of ethical responsibility. Wilshire does not deny the existence of social roles, but he argues that certain physical predispositions are "built into" the body before any social mimesis occurs and thus condition that mimesis, and, more importantly, that creative or spontaneous acts, belonging to the realm of moral and ethical action, fall outside the realm of the "repeatable" or "enactable" patterns of social roles. Since Wilshire's "I" can become aware of "my" roles (even though this may be of the "meta-role" of evaluation of roles), "I" cannot be ever reduced to or entirely circumscribed by these roles.20

Wilshire's identification of ethical responsibility with the identity of the self and his conviction that the "aestheticizing" effect of performance or role playing is inimical to such responsibility leads him to a spirited defense of the boundaries between "on stage" and "off stage" behavior, boundaries that many other modern theorists, and especially theorists of performance, find much more permeable. In his more recent article "The Concept of the Paratheatrical" (1990), Wilshire insists with still greater force that even when activities are performance in one sense or another, "I as a person cannot be reduced to them." Whether performing or "performing"—"I am the being who possesses potential for more than aesthetically evaluable acts." The difference again is that Wilshire insists that performance remains on the side of the aesthetic, and that to preserve an ethical and existential reality, indeed sanity itself, "in the end we must bound and limit the activities which count as paratheatrical."21

Other theorists have given performance a much more positive and creative function, suggesting that performance, far from standing in the way of the development of the self, provides in fact the means by which, wholly or in large part, the self is actually constituted. Thus we find in Robert Park, a leading early twentieth-century sociologist of race relations, a recognition of the stability of such physical traits as racial markers, but an insistence

nevertheless that social performance in fact really defines races as well as individuals:

It is probably no mere historical accident that the word person, in its first meaning, is a mask. It is rather a recognition of the fact that everyone is always and everywhere, more or less consciously, playing a rôle. We are parents and children, masters and servants, teachers and students, clients and professional men, Gentiles and Jews. It is in these rôles that we know each other; it is in these rôles that we know ourselves. Our very faces are living masks, which . . . tend more and more to conform to the type we are seeking to impersonate. . . . In a sense, and in so far as this mask represents the conception we have formed of ourselves—the rôle we are striving to live up to—this mask is our truer self, the self we would like to be. In the end, our conception of our rôle becomes second nature and an integral part of our personality.22

Perhaps the most uplifting vision of social performance as self-creation is provided by William James, who divides the self into material, social, and spiritual constituents. His social self is very close to that of Goffman, especially in its emphasis upon the observers; a person "has as many social selves as there are individuals who recognize him and carry an image of him in their mind." Thus practically speaking, one "has as many social selves as there are distinct groups of persons about whose opinion he cares."23 James, unlike some theorists who regard the self as created by social performance, postulates a "self of all the other selves," which selects, adjusts, and can disown the rest. Nevertheless, he suggests that even this "self of selves" may ultimately seek its highest expression and fulfillment in an "ideal social self," recognized by the "highest possible judging companion, if such companion there be. This self is the true, the intimate, the ultimate, the permanent Me which I seek."24

The potential positive effects of the performance in the construction and adaptation of social roles has been of particular concern to certain psychotherapists, who have made extensive use of theatrical models and even specifically theatrical techniques in their work. J. L. Moreno, the father of psychodrama, applies the dramatic model to human actions and motivations not simply for purposes of analysis, but for therapy. He draws upon a large collection of theatrical examples as background for his theory, but suggests that the true precedent of psychodrama can be found in shamanistic rites or reenactments undertaken for the purpose of catharsis and healing. The emphasis is not upon imitation itself but "the opportunity of recapitulation of unsolved problems within a freer, broader and more flexible social setting."25 Like many more recent theorists of social roles and social performance, Moreno argues that roles do not emerge from the self but that the self emerges from roles. A child is born into the world with a drive for spontaneity that allows it to maintain itself as a functioning organism, but it at once encounters auxiliary egos and objects that form its "first environment, the matrix of identity." The first such role assimilated is the mother role, itself a clustering of roles, and as the child develops, more roles are integrated as a "self" is built. The social roles, such as doctor and policeman, are added still later, in general on a more objective and conceptual level, which makes them generally more available for conscious enactment.26

Most of the specific examples discussed by Moreno are of individual persons enacting, in an improvisatory way, role aspects of their selves that seem to require therapeutic attention. From time to time, however, Moreno also suggests a more communal activity, where an "audience" of involved spectators would share with the participants the insights gained by the enactment. The specifically therapeutic orientation of psychodrama may seem to set it apart from the emphasis upon simple play or aesthetic pleasure of theorists such as Evreinoff or of the anthropological play theorists. This may be why Moreno and psychodrama, despite their very close ties to traditional theatre (with constant references to theatre practice in general, as well as to such specific artists and phenomenona as Stanislavsky, the Living Newspaper, and the Commedia dell'arte), are cited from time to time by performance theorists but have not really been extensively utilized in the way that Goffman, Turner, and other sociological and anthropological theorists have been. Nevertheless, it should be noted that there are rather closer functional and structural similarities between Moreno's psychodrama and Turner's social drama than between the models of Turner and Goffman, who have been particularly popular with American performance theorists. Moreno's "recapitulation of unsolved problems within a freer, broader and more flexible social setting" as a strategy for the working out of personal crises might with equal ease be used to describe Turner's suggestion of the social operations in the "broader and more flexible" context of liminal or liminoid activity. The framing of psychodrama and of social drama is also typically more distinct and tightly controlled than that of Goffman's role playing. The emphasis on replication of social activity also has close ties with Richard Schechner's concept of performance as "restored behavior," which will be considered presently.

The strategies and theories of the behavior therapists have attracted even less attention from theatre and performance theorists than has the work of Moreno, which is surprising since they also have drawn very specifically upon the theatrical model. This influence is stated with particular clarity in the article "Role Theory," contributed by behavior therapists T. Sarbin and V. Allen to the 1968 Handbook of Social Psychology. Here they recapitulate in some detail the conventional theatre process, in which the goal of the actor is to achieve a successful enactment of a role by means of practice. In this the actor may be aided by a coach whose function it is "to provide social reinforcement to the learner. Praise and criticism provide incentives for the learner, and at the same time furnish feedback which can be used to improve performance." In fact, behavior therapists have suggested, one need only substitute "client" for "actor" in this description and "therapist" for "coach" to obtain an accurate model of the clinical operations of behavior rehearsal.²⁷ In the early days of behavior therapy, its role playing techniques were called "behaviorodrama" or "behavioristic psychodrama," but confusion with Moreno's approach caused its practitioners to seek another name. The term "replication therapy" had some vogue (and arouses intriguing associations with Schechner's concept of "restored behavior"), but gradually "behavior rehearsal" came to be the preferred term.²⁸ Although both behavior rehearsal and psychodrama share a strong interest in the theatrical model and utilize performance of scripted behavior from the past for clinical purposes, their theoretical grounding and approaches are in fact quite distinct. Moreno focuses upon the theatrical concept of catharsis and sees role playing as a method of freeing the client's spontaneity, allowing a break-through into a new social/psychological configuration. Behavior rehearsal focuses more on the theatre's rehearsal and learning process, with less emphasis upon new insight than upon gaining better social/psychological skills,

under the guidance of a therapist who serves a function similar to the acting coach or director.

Although Eric Berne feels that the most rewarding moments of human experience are to be attained in what he calls "intimacy" or "spontaneity," he also suggests that for most people such moments are rarely if ever achieved, and so "the bulk of the time in serious social life is taken up with playing games,"29 a distinctly performative activity that involves the assuming of a role and the following of certain predictable actions with a concealed motivation. Berne's model becomes even more specifically theatrical when he moves up from the rather simple social interactions he calls "games" to larger, more complex sets of transactions, which he calls "scripts." Instead of dealing, as do games, with a simple reaction or situation, scripts are "an attempt to repeat in derivative form a whole transference drama," which indeed may even be split up into acts "exactly like the theatrical scripts which are intuitive artistic derivatives of the primal dramas of childhood." Berne specifically characterizes the script as a "performance" that is "by nature recurrent," even though the performance may be the work of a lifetime.30

Berne's model reflects one of the major orientations in modern sociology, owing much to a highly influential figure in establishing the field, Talcott Parsons. Although Parsons did not utilize as much specifically theatrical terminology as did Berne, his system for the analysis of human action, first extensively developed in his 1937 The Structure of Social Action, contains almost identical elements: an "actor," an "end" sought by the actor, a "current situation," which the actor seeks to transform by action, and a "mode of orientation," basically comparable to Berne's "script," drawn from a repertoire of normative patterns of activity provided by the society and repeated either directly, or, as Berne suggests, "in derivative form" by individual social "actors."31 Although this model, and variations of it, have been to date the most influential sociological concepts for performance theorists, other competing models offer provocative alternatives and relate, arguably more directly, to more recent work in performance itself.

During the 1960s a competing orientation to the study of human action arose that came to be called "social constructionism," from P. L. Berger and T. Luckman's study, The Social Construction of Reality (1967). Although this new direction was prefigured by Karl Mannheim's study of the "sociology of knowledge," Ideology and Utopia (1936),32 the theorist generally credited with establishing it as a major direction was Alfred Schutz. Schutz argued that instead of following institutionalized, externally given, and essentially stable "scripts," the "actors" of the social world navigate this world by using a patchwork of "recipe knowledge," in which "clear and distinct experiences are intermingled with vague conjectures; suppositions and prejudices cross well-proven evidences; motives, means and ends, as well as causes and effects, are strung together without clear understanding of their real connections. There are everywhere gaps, intermissions, discontinuities." Schutz suggests that there is apparently "a kind of organization by habits, rules and principles," but the origins and operations of these have been scarcely studied and may be impossible to determine.33

"Social constructionism" thus hypothesizes that patterns of social performance are not "given in the world" or "pre-scripted" by the culture, but are constantly constructed, negotiated, reformed, fashioned, and organized out of scraps of "recipe knowledge," a pragmatic piecing-together of pre-existing scraps of material recalling the process French theorists have called "bricolage." An important extension of Schutz's work has been developed by Harold Garfinkel, to which Garfinkel has given the name "ethnomethodology"—a study of these pragmatic methods by which "common-sense actors" constitute their social world.34 The potential implications of this constructive orientation for performance are considerable, since it suggests how performance, while operating within the highly coded systems of a culture, may yet generate constantly new configurations of action.

A similar view of pragmatic human activity is advanced in Michel de Certeau's The Practice of Everyday Life, which, drawing upon sociological studies such as those of Goffman and ethnomethodological work such as that of Garfinkel, distinguishes between "strategies" (much like Schutz's "recipe knowledge"), the institutionalized frameworks, scripts, or patterns of action that serve as general guides to behavior, and "tactics," the specific instances of behavior improvised by individuals according to the perceived demands of the moment and unknowable in advance.35 Even though de Certeau's tactics never directly oppose cultural strategies, their operations in improvising upon these strategies and combining elements of them in new ways provides

a continual performative ground for change, since new strategies come into being through tactical improvisation. This is the behavioral equivalent of the operations of Bakhtin's utterance, but even more oriented toward working for an expression "outside" an established "proper" system. This active operation from an "outside" position makes this concept of great importance for theorists interested in performance as resistant to social and cultural "givens." Alan Read, for example, whose Theatre and Everyday Life provides a fascinating application of the insights of de Certeau and other social constructionists to the phenomenon of theatre, asserts unequivocally that theatre "is worthwhile because it is antagonistic to official views of reality."36

Of the many social theorists associated with social constructionism, only Erving Goffman has so far exerted widespread influence among performance theorists, partly because of Goffman's greater general visibility outside the field of sociology and partly because of the specifically performative metaphors he has often employed. On the whole, however, Goffman stresses the improvisatory, ad hoc nature of social performance much less than most social constructionists, and this makes his ideas much less useful than others might be in the currently active area of socially or culturally resistant or transformative performance.

One concept of Goffman's that does point in this direction is that of "keying," which does consider at least one sort of transformative performance. For purposes of analysis, Goffman needs to be able to isolate sequences or happenings from the ongoing stream of human behavior, and these sequences he calls "strips of experience." A "strip of experience," he is careful to point out, is not necessarily a natural division for those involved or even an analytical device for inquirers, but is simply a "raw batch of occurrences (of whatever status in reality) that one wants to draw attention to as a starting point in analysis."37 Whenever such a sequence of activity is given coherence by some cultural frame, then it is subject to replication and transformation within the social world through two basic processes: fabrication and keying. In the case of fabrication, one or more individuals manage a strip of activity so that others will have a false idea of what is going on. Keying, much more directly connected with what is normally thought of as performance, involves a strip of activity already meaningful on some terms that is transformed by recontextualization into something with a different meaning. Among the basic

"keys" in our society, Goffman mentions such "playful" redoings as make-believe or contests, ceremonial redoings, and technical redoings (such as theatrical rehearsals). He might also have mentioned, though he does not, the more "serious" keys represented by the "scripts" of Eric Berne or the reenacted behavior

of psychodrama or behavior therapy.

Goffman's concepts of "keying" and the "strip of experience," while conceived for sociological analysis, have proven extremely useful also to ethnographic theorists with a performance orientation. Both Richard Bauman and Dell Hymes have explored the concept of "keying," though from somewhat different directions. Bauman, rather closer to Goffman, uses "keying" to refer to the metacommunication (in Bateson's sense) that establishes a performative "frame," seeking, in Bauman's terms, "to determine the culture-specific constellations of communicative means that serve to key performance in particular communities."38 Hymes uses the term to suggest degrees of "authenticity"—distinguishing rote or perfunctory performances from those that successfully fulfill "the standards intrinsic to the tradition in which the performance occurs."39

Goffman's "strip of experience" is a major inspiration for Richard Schechner's closely related "strip of behavior," a central concept in his Between Theater and Anthropology (1985). Goffman, however, emphasized the function of the "strip" in the process of social analysis, while Schechner is concerned with the strip as a mechanism for performance. The process of strip transformation that interests Schechner is closely related to what Goffman calls "keying," but Schechner creates his own term for this phenomenon, "restored behavior," a term that has proven very useful for subsequent performance theorists. With this shift in terminology comes also a shift in focus. "Keying" emphasizes the transformations themselves, while "restored behavior" emphasizes the process of repetition and the continued awareness of some "original" behavior, however distant or corrupted by myth or memory, which serves as a kind of grounding for the restoration. Schechner compares a culture's use of restored behavior to a film director's use of a strip of film. The source of this strip may be apparently honored, but in practice the strip, removed from its conditions of origin, now becomes raw material available to make "a new process, a performance." 40 Human cultures offer a rich variety of restored behaviors-organized sequences of events that exist separately from the performers who "do" these events, thus creating a reality that exists on a different plane from "everyday" existence. Schechner lists shamanism, exorcism, trance, ritual, aesthetic dance and theatre, initiation rites, social dramas, psychoanalysis, psychodrama, and transactional analysis as among the performances that utilize restored behavior.

One might note that in all such cases the operations of restored behavior are marked for both participants and spectators by various framing devices. From the point of view of the performer, restored behavior involves behaving as if one is someone else or even oneself in other states of feeling or being. The difference between such operations and Goffman's "presentations of self in everyday life" Schechner calls a difference in degree, not in kind, 41 though it seems important to note that for the operations of restoration to function, there must even in everyday life be at least some consciousness of performing a social "role." This double consciousness, on the part of both the performer and the audience, provides the subject for some of Schechner's most thoughtful analysis in Between Theater and Anthropology. He speaks of a visitor to one of America's restored villages, such as the Plimouth Plantation, as operating with an awareness of "being in" the seventeenth and twentieth centuries at the same time. Two actually exclusive frames are allowed to coexist by an effort of the imagination, analogous to Coleridge's famous "willing suspension of disbelief." In applying this paradoxical awareness to the performer, Schechner cites the research of the British psychoanalyst D. W. Winnicott on how babies learn to distinguish between self and other. Between the baby's growing awareness of self and of an exterior reality there exists a realm of "transitional phenomena," 42 a realm that Schechner likens to Bateson's "play frame" and to the liminal transitional domains of Turner and van Gennep.

What these parallels seem to suggest is that it is extremely difficult, and ultimately perhaps not particularly useful, to try as Wilshire does to draw a clear distinction between the "real" world of "responsible" human action, and the "imaginary" realm of play or performance. On the contrary, an important tradition of modern anthropological and psychoanalytic theory suggests that the realm of play not only overlaps "reality" in important ways, but in fact often serves as the crucible in which the material that we utilize in the "real" world of "responsible" action is found,

developed, and cast into significant new forms. Indeed social constructionism and ethnomethodology introduce into the most common of everyday activities the kind of openness, improvisation, and experimentation that more conventional social theory has normally associated with states of "play."

Since the raw material of both traditional theatre and social performance is found in the everyday world of object and actions, its use in these activities inevitably carries with it associations from that world. In a 1994 essay, "Invisible Presences: Performance Intertextuality," I have used the term "ghosting" to describe the external associations that the continually recycled material of theatre brings in from the external world, as well as from previous performance. 43 For semiotic theorists interested in the representative function of this material in traditional theatre, such associations may seem largely disruptive or distracting. Thus Michael Quinn in "Celebrity and the Semiotics of Acting" (1990) discusses how associations from an actor's life and career outside the theatre may confuse the mimetic process by creating a link between actor and audience "quite apart from the dramatic character."44 In performance art, unlike traditional theatre, the performer's personal contribution is very often foregrounded, and a certain measure of celebrity is often built into the reception assumptions. Both theatre and performance, however, continually play with the boundary between the actual and the imaginary. Objects and actions in performance are neither totally "real" nor totally "illusory," but share aspects of each. As Bert States has observed, the perceptual change involved in the process of framing or ostentation never involves a simple change from viewing an object as a part of everyday reality to regarding it as a signifying image. Framing or ostentation adds this function but it does not completely remove the perceptual awareness of the object as an object in the real world. A major contribution of phenomenological theorists such as States to theatre and performance theory is surely this attention to the fact that theatre to a large extent utilizes everyday objects, situations, and people as raw material-what States calls "the real in its most real forms"-to construct fictions that by employing this material have an unusual claim upon actuality. Not only the operation, but also indeed the peculiar power of theatre, States argues, derives from the "binocular vision" or double relationship to the object of performance that its audiences must carry out. It is not, as

a simple theory of make-believe or illusion would suggest, that the audience is involved in "joining its being" to the illusory, but rather in joining to "a certain kind of actual," which holds in continual tension the mimetic and the "real." Richard Schechner has memorably expressed this "binocular" situation in terms of a double negativity. Within the play frame a performer is not herself (because of the operations of illusion), but she is also not not herself (because of the operations of reality). Performer and audience alike operate in a world of double consciousness. This "not me . . . not not me" quality of performance has been found a useful formulation by a number of subsequent performance theorists.

Although States calls this peculiar in-between quality of material in the theatrical frame "a certain kind of actual," the "certain kind of actual" encountered in theatre and perhaps even more noticeably in performance art involves not only the material utilized, but even more importantly, the social, cultural, and psychological effects of this activity. In many cases, and especially when performance is viewed from a social science viewpoint, the entire performative situation becomes "a certain kind of actual," with real and lasting effects upon the community or individuals within it, as can be seen in the social dramas of Turner or the psychodramas of Moreno. Indeed Schechner suggested in 1970 the use of the term "actual" 47 to characterize those cultural performances in both tribal and industrialized societies that make this claim. According to Schechner, an "actual" happens "here and now," makes any reference to past events present, involves consequential, irrevocable acts in a concrete space, and results in its participants experiencing some change in status, and therefore recognizing that they have something important at stake in the event. 48 Having "something important at stake," like the "taking responsibility" of Morris and others mentioned earlier, emphasizes both the seriousness and the importance of agency in this process.

The operations of agency and of social or cultural negotiations will be involved to some extent in any performance. Even in the case of Eco's drunken man, when the performer may be quite unaware of the implications of his display, the agency of the production apparatus takes over these responsibilities. In conventional theatre, such an apparatus is still an important part of the situation, though agency is dispersed throughout the

organization, and so is shared at least to some extent by the individual performers. When we turn to other sorts of cultural and social performance, even more responsibility can become available to these performers. In recent performance art the personal agency of the performer is often of central concern. The performance artist may work as an individual who combines several traditional theatre positions—actor, director, designer, playwright. The performer is not, like Eco's drunken man, "uplifted to the view" by another authenticating agency; it is as a result of the performer's own decision that the presentation to an audience takes place.

Closely related to this dynamic of self-presentation is the normally very close relationship between the "self" of the performance artist and the "self" being presented. Indeed, as we shall discuss later, some theorists have considered this absence of traditional character impersonation as one of the most distinctive characteristics of this approach. This is surely the reason for the very close ties between a significant amount of recent performance work and social, political, and cultural commentary. A later chapter will return to a more extended consideration of the practice and theory of recent performance art, but we should probably note here that it provides one of the clearest examples of the difficulty of establishing the clear division that some theorists have attempted to make between activities in everyday life for which ethical responsibility is taken and performance in a "theatrical" context that is more distanced from such implications.

The performance of language Linguistic approaches

Performance first emerged as an important term in linguistic theory in the writings of Noam Chomsky, who in his Aspects of the Theory of Syntax (1965) distinguished between "competence," the ideal general grammatical knowledge of a language possessed by a speaker of it, and "performance," the specific application of this knowledge in a speech situation. In fact this division strongly echoes the division made at the beginning of modern linguistic study by Ferdinand de Saussure between la langue, the basic organizing principles of a language, and la parole, specific speech acts. Chomsky's formulation had the advantage of stressing ability and action, but it still preserved the emphasis of traditional linguistics upon la langue or upon competence, the structuralist study of abstract principles, generalized from a variety of individual examples.

This grounding in some sort of transcendental system or set of givens has continued to dominate much of the speculation on human action, language, and thought, even in the writings of some theorists who have specifically sought to emancipate themselves from the assumptions of traditional positivism. Jürgen Habermas, for example, developed a theory of communicative competence and performance that drew heavily upon Chomsky, though he sought to apply Chomsky's more narrowly linguistic concerns to such broader matters as truth, justice, and freedom. Like Chomsky, Habermas posits a tacit knowledge of these "universal" values, which speakers recognize even though their communicative performances may be distorted by the ideologies of a particular social context.¹

As early as the 1960s, however, many scholars interested in linguistic study began to regard performance not simply as a restricted, circumscribed, even corrupted derivative of competence, but as a positive and enabling activity in its own right. Traditional linguistic theory remained a strong inspiration for them, but so did the sort of parallel research and writings elsewhere in the humanities and social sciences discussed in the previous chapters—the writings of Kenneth Burke and Erving Goffman, for example, or anthropological or folklore studies. New terms stressing this interdisciplinary attitude became increasingly popular—"ethnography of communication," for example, and especially "sociolinguistics."²

Dell Hymes, one of the leading developers of modern sociolinguistics, very much reflects these relationships and concerns, urging a more "functional" linguistics to supplement more traditional "structural" linguistics. The former would draw upon sociological and anthropological analysis and methods to look at performance and the contextualization of the speech event rather than the grammatical or linguistic rules that might inform it. Concern shifts from the structure of la langue to the event in which specific speech takes place, and the speech community and situation is looked to as the matrix and repository of codes and meanings rather than as some general homogeneous cultural community.³ In a 1982 article on "Linguistic Indeterminacy and Social Context," John Dore and R. P. McDermott propose that "Talk is not simply a set of propositions transmitted from encoder to decoder, in which context is occasionally useful as an added interpretive grid through which to pass strange utterances. Rather, people use talk reflexively to build the very contexts in terms of which they understand what they are doing and talking about with each other."4 We have seen in the previous chapters how well this approach in general and the writings of Hymes in particular have fitted into the developing interest in approaching a wide variety of social and anthropological concerns through an emphasis on performance.

Bakhtin, whose writings on carnival have entered performance theory along with analogous concerns in modern anthropology, has also importantly contributed to linguistic performance theory through his contextually oriented work on the "utterance," a central concept in his writing. According to Bakhtin, the utterance is a strip of language that is "always individual and contextual in nature," an "inseparable link" in an ongoing chain of discourse, never reappearing in precisely the same context, even if, as often occurs, a specific pattern of words is repeated.

All words, Bakhtin proposes, exist in three aspects: "as a neutral word of a language, belonging to nobody; as an other's word, which belongs to another person and is filled with echoes of the other's utterance; and, finally, as my word, for, since I am dealing with it in a particular situation, with a particular speech plan, it is already imbued with my expression." Like Derrida (whom we shall consider later in considering his disagreement with Searle) Bakhtin sees all speech involved with citation of previous speech, but he also stresses that no citation is ever entirely faithful, because of the ever-varying context. We continually "assimilate, re-work, and re-accentuate" the already existing words of others, even though they still carry with them something of "their own expression, their own evaluative tone."5 This double orientation of speech, always involved with reproduction but also with flux, looks to the same phenomenon as the concept of "restored behavior," a creative tension between repetition and innovation that is deeply involved in modern views of performance, linguistic and non-linguistic. We shall see, when we turn to the strategies of resistant performance, that this tension is of major significance.

For Bakhtin, utterances, in a naturally more elaborate manner than particular words, involve a complex layering of previous usages and current context, resulting in a plurality of "voices":

Any utterance, when it is studied in greater depth under the concrete conditions of speech communication, reveals to us many half-concealed or completely concealed words of others with varying degrees of foreignness. Therefore, the utterance appears to be furrowed with distant and barely audible echoes of changes of speech subjects and dialogic overtones, greatly weakened utterance boundaries that are completely permeable to the author's expression.6

Bakhtin speaks of three categories of words within narrative: direct (denotative), object-oriented (direct discourse of characters, also univocal), and ambivalent, when the writer appropriates another's words for a new usage, but does not or cannot remove from them the marks of appropriation. This third process Bakhtin sees as the goal of narrative writing, a situation in which a variety of "voices" can be heard within a single "speech," giving rise to a variety of "meanings" as well as calling attention both to the open-endedness of the speech and to its performance within a context. Bakhtin uses the term "monologism" to refer to structures or texts that emphasize a singular message, unaffected by context, and "dialogism" to refer to more open texts and to an awareness of the way they are articulated within a specific milieu.

Julia Kristeva's first published work in France, "Le Mot, le dialogue, et le roman,"7 dealt centrally with Bakhtin, and Kristeva has been extremely important in calling the attention of subsequent performance theorists to his work. Kristeva links together Bakhtin's concepts of carnival and dialogism under the operations of performance and dramatic action. She speaks of carnival as a mise en scène in which "language escapes linearity (law) to live as drama in three dimensions. At a deeper level, this also signifies the contrary: drama becomes located in language. A major principle thus emerges: all poetic discourse is dramatization, dramatic permutation (in a mathematical sense) of words." In the scene of carnival, discourse attains a "potential infinity," where "prohibitions (representation, 'monologism') and their transgression (dream, body, 'dialogism') coexist."8 The "doubleness" of this operation should be emphasized. Carnival is not simply a parodic reversal, but a true transgression. It is not the other side of the law; it contains the law within itself, as Bakhtin's polyphonic utterance includes what would be excluded by the representation of a monologistic "meaning." Even on "the omnified stage of carnival," Kristeva notes, language "remains incapable of detaching itself from representation" even as it repudiates its role in representation by parodying and relativizing itself.⁹ This process is strikingly similar to the operations of restored (or keyed) behavior in anthropological theory, where an established form and a contextualized variation are experienced as somehow coexisting within the same action.

Another aspect of modern linguistic theory, less directly related to social contextualization of the speech event, has also been very influential in the wide range of writings about performance in modern society. This is the concept of speech-act theory, developed primarily by John Austin and John R. Searle. One might say that these theorists have provided a methodology for considering language as performance, as Turner for example has provided a methodology for considering culture as performance or Goffman for considering social behavior as performance.

The foundations of speech-act theory were laid in the William James lecture series delivered by Austin at Harvard in 1955 and published as *How To Do Things with Words*. In these lectures,

Austin called attention to a particular type of utterance, which he named a "performative." In speaking a "performative," someone does not simply make a statement (the traditional focus of linguistic analysis, which Austin labels the "constative"), but one performs an action, as, for example, when one christens a ship or takes marriage vows. 10 Since the primary purpose of the performative was to do something rather than simply to assert something, Austin suggested that its success had to be judged not on the basis of truth or falsity, as was the case with an assertion, but on whether the intended act was in fact successfully achieved or not. To these alternatives Austin gave the names "felicitous" or "infelicitous."

Originally, Austin considered performative statements to be characterized by certain verbs ("performative verbs") spoken in the first person and the present tense, such as "I promise," or "I swear." Subsequently, however, he suggested that other expressions without this characteristic functioned in the same manner. "Go away," for example, operated the same as "I order you to go away," involving not truth or falsity but the success or failure of the command as an act. Such performatives Austin called "implicit." This, however, created a new problem, for almost any utterance can be seen as an implicit performative; constatives could be "performatively" recast to begin with "I assert" or "I declare." Far from seeing this as a weakening of his theory, Austin suggested that we take such activities as stating, describing, and reporting "a bit off their pedestal" and recognize "that they are speech acts no less than all these other speech acts that we have been mentioning and talking about as performative."11

The general term that Austin began to apply to his concerns was "illocution." In an attempt to separate out the various general ways in which "to say something was to do something," he distinguished three types of verbal "actions," and, since these are operating on different levels, all three are typically involved in a single utterance; they are the "locutionary," the "illocutionary," and the "perlocutionary." Locutionary acts involve making an utterance with a certain sense and reference, roughly equivalent to "meaning" in the traditional sense. Illocutionary acts are utterances with a certain conventional "force" (as opposed to "meaning"); they call into being, order, and promise, but also inform, affirm, assert, remark, and so on. The focus here is on the force such utterances seek to apply to their discursive situation. In perlocutionary acts, analysis focuses not upon what the utterance is doing, but what it seeks to bring about in a hearer: convincing,

persuading, deterring, even surprising or misleading. 12

Austin's student, John R. Searle, continued to develop the theory of speech acts, most notably in a 1969 book with that title. While the Austin lectures focused on the particular, rather restricted type of utterance that he designated as the "performative," Searle stresses the performance aspect of all language: "The unit of linguistic communication is not, as has generally been supposed, the symbol, word or sentence, or even the token of the symbol, word or sentence, but rather the production or issuance of the symbol or word or sentence in the performance of a speech act."13 Again, as with anthropological or social performance, we find Searle's performative approach to language looking to the particular context of the act, the intentionality of the producer of the act, and the presumed or actual effect of the act upon those who witness it. "A theory of language," says Searle, "is part of a theory of action," but action undertaken as "a rule-governed form of behavior."14 Austin's strategy of setting off certain utterances as doings rather than sayings, Searle feels, makes too sharp a distinction, since all language is also doing. Even the simple process of uttering words and sentences performs what Searle calls an "utterance act." This utterance act is made up of reference to objects and concepts, such reference constituting the performance of a "propositional act." Whenever a particular intention is involved in the utterance (as it almost invariably is), even if this intention is a simple assertion or stating, the performance of that intention Searle calls an "illocutionary act," while the effect on any hearer, following Austin, is designated as the "perlocutionary act."15

The effect of this sort of analysis is to shift the apparent focus of Austin from a few rather specialized speech situations to a recognition of the performative nature of language in general, and to shift from the traditional linguistic concerns with the structure and formal elements of language to concerns with the intentions of the speaker, the effects on the audience, and the analysis of the specific social context of each utterance. This orientation is now generally characterized by linguists as "pragmatics," although this term was not used by either Austin or Searle. It was coined by semiotician Charles Morris, who defined it as "the science of the relation of signs to interpreters," 16 a definition subsequently

expanded by another scholar in this field, R. C. Stalnaker, to "the study of linguistic acts and the contexts in which they are performed."17

A differently focused but equally important correction to Austin was provided by Kristeva. While Searle attacked Austin's neutral and descriptive "locutionary" on the grounds that illocution and perlocution were always involved, Kristeva attacked it on the related grounds that description itself was based upon symbolic convention, and thus involved already in illocution and perlocution, and the performative "scene" of shifting and negotiated meanings.18

The approach of Austin and Searle seems to find within language itself a division that performance theorists have often sought to place between language and physical action (or in some cases between theatre and performance itself). On the one hand we have the semiotic, the linguistic, the symbolic, whose elements stand in for absent realities and whose utilization is governed by more or less fixed abstract structures. On the other hand we have the realm of physical presence, whose elements offer an accessible reality which, however, can only be understood within a specific, never precisely repeated context. (As we have seen, Bakhtin, and subsequently Kristeva, make a similar distinction within a model that suggests how these two opposing operations coexist within performance.) Communication is still involved, but the emphasis is not on the traditional communication of an abstract and unitary thought content, but of an original movement, an effect, a force.

The emphasis placed upon the changing social context of the utterance in speech-act theory and the tendency to apply performative analysis to a very wide range of linguistic phenomena aroused strong reaction among linguistic theorists who preferred a more formal or structural approach. Particularly influential was Emile Benveniste, who in the essay "Analytical Philosophy and Language" supported Austin's constative/performative division, but faulted Austin for not making the distinction between them absolutely clear. To correct this imprecision, Benveniste insisted that any performative "must conform to a specific model, that of the verb in the present and in the first person," and, moreover, must be uttered by "someone in authority" who has the power to effect the act uttered. Anyone, says Benveniste, can shout "I decree a general mobilization" in a public square, but this is

not an act, and thus not a performative statement, "because the requisite authority is lacking. Such an utterance is no more than words."19

A quite different attempt to limit and control (if not marginalize) Austin's performative is represented by the work of Jerrold Katz, a psycholinguist who looks less to the structuralist approach represented by Benveniste than to its major rival in modern linguistic theory, the transformational grammar of Chomsky. Like Benveniste, Katz tries to give Austin's divison a rigidity and specificity Austin avoided, and again like Benveniste, he does this by focusing not upon the slippery area of language use (what Chomsky called "performance") but upon the more stable and abstract system that theoretically provided the foundations for this use (Chomsky's "competence"). In the preface to his Propositional Structure and Illocutionary Force (1977), Katz states frankly that in order to develop his own theory, "the performance slant that Austin gave speech act theory had to be eliminated, and the basic ideas of the theory had to be removed from the theory of acts and relocated in the theory of grammatical competence." In place of speech act theory, Katz proposes two new related theories—one of competence, one of performance—both notably based on abstract operational principles rather than on speakers or speaking situations. The "competence" theory concerns "what the ideal speaker-hearer knows about the illocutionary information embodied in the grammatical structure of sentences" (emphases mine), while the "performance" theory concerns the "principles that determine how the information about illocutionary force embodied in the structure of a sentence and the information about a speech context assign an utterance meaning to the use of a sentence" (emphases mine).20 Although Katz undertakes to "save Austin from Austin,"21 by removing the blurriness, ambiguities, and uncontrolled spread of performative concerns in Austin's work, he ends, as does Benveniste, in developing a brilliant and highly influential theory that in fact turns radically away from Austin's orientation on language as a human activity toward a concern with language in the abstract, as structure or grammar.

What is at stake here is a conflict that in various forms is very widely manifested in modern thought, and in which "performance" and "language" are both deeply involved. A particularly articulate exploration of the struggle may be found in Shoshana Felman's The Literary Speech Act: Don Juan with Austin, or Seduction

in Two Languages (1983), who uses Austin and Benveniste, along with Jacques Lacan and Molière's Don Juan, to pursue a project in literary, linguistic, and philosophic texts based on the tropes of promising and of truth. In each of these three domains, Felman sees a struggle between a force of playfulness, of transgression of established boundaries, and a force that seeks to police and defend those boundaries. Don Juan, says Felman, "does nothing but promise the constative,"22 a promise, like Austin's performatives, enacted for its own sake, outside the reality of truth or falsehood. Don Juan's opponents in the play, like Austin's, attempt to establish and protect the truth value of the constative, and reject the disruptive seductions of play or performance. It is the performative element of Austin's thought, Felman concludes, that most disturbs his critics, and ties him most closely to thinkers such as Nietzsche, Lacan, or Kierkegaard. This can be seen not only in the humor of the approach (a quality most puzzling to "serious" theorists), but also in what Felman calls its "radical negativity." Ultimately act and knowledge, the constative and performative, while they constantly interfere with each other, can never be made totally congruent. Radical negativity, recognizing this, commits the "scandal" of rejecting the demands of history and normalizing theory for a negative/positive alternative, for truth or falsity, to seek a position outside of the alternative, which nevertheless and paradoxically is the ground of history.²³ Naturally such an approach makes impossible any orderly analysis of language, history, or any human activity, and it is for this reason, as Monique Schneider observed in an extended review of Felman's book, Katz and Benveniste insist that "the performative must remain one linguistic category among others. The linguistic domain must be protected against the scandal of a general invasion by the performative of the territory of language as a whole."24 We have already seen how a similar fear of a "general invasion by the performative" has been manifested by defenders of other territories of social and cultural interaction, and John Lechte, in his study of Kristeva, remarks on the similarity of orientation in Kristeva and Felman, both interested in the tension between the communicative aspect of language, and its scandalous, disruptive aspect.25

Felman's study is not only a thought-provoking analysis of a major debate in contemporary cultural study, it is also a provocative approach to a major classic drama, which she sees

as performing this same debate in theatrical terms. Her work thus provides an important example of how speech-act theory can be utilized in dramatic criticism. Felman is a distinguished but by no means an isolated example of such utilization; speechact theory has become an important analytic tool for a number of modern theorists in the study of both literary texts and theatrical performance. This development is a bit surprising, since Austin himself specifically excluded literary language from the processes of illocution or perlocution. Language in poetry he ranks among the "aetiolations, parasitic uses, etc., various 'not serious' and 'not fully normal' uses," where "the normal conditions of reference may be suspended, or no attempt made at a standard perlocutionary act, no attempt to make you do anything, as Walt Whitman does not seriously incite the eagle of liberty to soar." Citations, or oratio obliqua, are similarly excluded from the domain of illocution, Austin continues, because "here I am not reporting my own speech," and thus do not take responsibility for it.26 Despite Felman's in many ways accurate placement of Austin among the playful destabilizers of traditional dichotomies, on this point at least he remains quite conventional—accepting the traditional structural strategy of driving a wedge between "literary" and "actual" language, with the former characterized in such diminutive ways as "parasitic," "not serious," "not fully normal," and so on.

Students of contemporary theoretical speculation will recognize this privileging of spoken language over its "parasitic" derivative-written language-as a typical manifestation of the "metaphysics of presence" that Jacques Derrida has called into question in so much of his criticism. It is therefore not surprising that, despite certain common assumptions, Derrida has challenged Austin on this matter, initiating a heated and well-known debate between proponents of speech-act theory and of deconstruction that has tended to overshadow more positive relationships between speech-act analysis and current literary and performance theory. Even in its broad outlines, this debate goes far beyond our particular concern, which is the contribution of this approach to modern ways of thinking about performance; but one central concern in Derrida's first essay on the question, "Signature Event Context," that of citation, relates so clearly to parallel concerns in the study of cultural performance in general that it deserves some special attention.²⁷

As a result of its interest in the "presence" and the specific context of linguistic performance, there is little suggestion within Austin's theory of the performance concepts of restored or repeated behavior, although Searle's characterization of language as "rule-governed" behavior might be considered as opening this possibility. Speech acts are very closely tied to their creators and their context, and seem to be considered as essentially untainted by the sort of mimetic aura that Wilshire and others find ethically troubling in other theories of social performance. Derrida, however, has pointed out that this apparently clear and comfortable division between non-mimetic speech and mimetic writing is an illusion. Although Austin specifically excludes from his system citation (which, like literature, he considers to be a "non-serious" use of language), Derrida, like Bakhtin earlier, argues on the contrary that it is only by virtue of citation, or what he calls "iterability," that performative utterances can succeed. A performative could not open a meeting, launch a ship, or seal a marriage if it were "not identifiable as conforming with an iterable model" —if it were not identifiable in some way as a "citation." 28 It is important to note, however, that for Derrida, citation is never exact because, like Bakhtin's utterance, it is always being adapted to new contexts. Any citation, indeed any sign, "can break with every given context, engendering an infinity of new contexts in a manner which is absolutely illimitable."29 This argument moves the concept of linguistic performance back into the realm of repeated (or restored) and contextualized activity that is so basic to performance theory.

Somewhat surprisingly, when speech-act theory began to be utilized in the early 1970s by scholars of literature, it was with a full acknowledgement that Austin himself had exempted literature from his theory. Richard Ohmann was an important leader in this approach, undertaking to view literature as a "quasispeech-act." In "Speech Acts and the Definition of Literature" (1971), Ohmann admitted that literary works were "discourse abstracted, or detached from, the circumstances and conditions which make illocutionary acts possible." Nevertheless, he proposed an "illocutionary" approach to literature based on a reader's activity and knowledge of speech acts. 30 The "quasispeech-acts" of literature do not do anything in the world, but since they are mimetic of actual speech acts, the reader is invited to provide their illocutionary force imaginatively, and thus

construct the fictive world in which they occur. This productive animation of a world through the mimetic process is what corresponds in literature to illocutionary force. The social self of the reader, as conditioned by such matters as gender, class, and race, is given particular attention in Ohmann's "Literature as Act,"31 bringing his speech-act interest very close to reader-response theory and to such reader-response concerns as Stanley Fish's "community of readers."

Other pioneers in the application of speech-act theory to literature denied the clear distinction between literature and ordinary language found in Austin (and even more distinctly in Searle) and Ohmann. Fish notes a consistent opposition in Searle between such entities as "serious discourse vs. fictional discourse" and "the natural vs. the conventional." In each such case, argues Fish:

the left-hand term stands for something that is available outside of language, something with which systems of discourse of whatever kind must touch base—Reality, the Real World, Objective Fact. What I am suggesting is that these left-hand terms are merely disguised forms of the terms on the right, that their content is not natural but made, that what we know is not the world but stories about the world, that no use of language matches reality but that all uses of language are interpretations of reality.32

Essentially, this same argument is developed in much greater detail by Mary Louise Pratt, whose Toward a Speech-Act Theory of Literary Discourse (1977) identified the distinction in Austin and Ohmann between literature and ordinary language as a fallacy invented by the Russian formalists and maintained by subsequent structuralist theorists. She argued both that so-called ordinary language contains the same sort of features presumably characteristic of "poetic" discourse and that literature, like other language, "cannot be understood apart from the context in which it occurs and the people who participate in it."33 An important source for Pratt was the work of the American sociolinguist William Labov on the oral narrative of personal experience, a type of ordinary discourse that is consciously and aesthetically constructed. Labov analyzes the normal structure of such narratives and characterizes their content as "tellable," an important term for Pratt. Unlike the paradigmatic assertions of information given, for example, in response to a question, "tellable" assertions are normally elaborated "stories" that "represent states of affairs that are held to be unusual, contrary to expectations, or otherwise problematic," and their speaker is

not only reporting but also verbally displaying a state of affairs, inviting his addressee(s) to join him in contemplating it, evaluating it, and responding to it. His point is to produce in his hearers not only belief but also an imaginative and affective involvement in the state of affairs he is representing and an evaluative stance toward it.34

The relationship between this common situation in everyday speech and written literary narratives is clear, as is Pratt's idea of how both illocution and perlocution operate in "tellable" assertions. The emphasis upon "display" recalls Umberto Eco's interest in "ostentation" as a strategy for signalling an "aesthetic" response.

Pratt's other major source is the work of H. P. Grice, another speech-act philosopher, who presented some highly influential correctives to Austin in his William James lectures of 1967, "Logic and Conversation." Pratt derives from Grice two helpful analytic concepts: the cooperative principle and conversational implicature, which assume a tacit contract between speaker and hearer in a literary speech situation. They "have commitments to one another as they do everywhere else," and far from being "autonomous, self-contained, self-motivating, context-free objects which exist independently from the 'pragmatic' concerns of 'everyday' discourse, literary works take place in a context, and like any other utterance they cannot be described apart from that context."35

There is no question that Pratt's approach provides for literature an illocutionary dimension much closer to what Austin has in mind for regular discourse than that which Ohmann provides, and a number of subsequent literary analysts have followed Pratt in considering the "performative" qualities of various works of fiction as elaborate "speech acts" of their authors. This, however, requires the designation of the original author as the authoritative "speaker" of the text and the assumption that the text guarantees a continuing, more or less stable context of communication between that speaker and an audience—assumptions very much at variance with the postmodern concept of the "author" as a shifting "function" in the text. Kristeva, for example, develops

this concept from Bakhtin, who observed that the "author" not only contains a variety of voices, but also operates as a position, presenting itself as a speaking subject addressing an imagined reader. Similarly, the actual reading process involves the projection back of a speaking "author," so that each new reading involves a new "performance" by a new set of "voices." Kristeva evokes both performance and carnival in describing this process: "The scene of the carnival introduces the split speech act: the actor and the crowd are each in turn simultaneously subject and addressee of the discourse. The carnival is also the bridge between the two split occurrences as well as the place where each of the terms is acknowledged: the author (actor + spectator)."37

Sandy Petrey proposes a way around the problem of the author's "intention" in Speech Acts and Literary Theory (1990), suggesting that what words do, inside and outside literature, "depends not on speakers but on (conventional) context," 38 and that speech-act theory should be involved not with intentions but with effects. This is a point stressed by Austin in his first lecture, which rejected as mistaken the view that "words are uttered as (merely) the outward and visible sign, for convenience or other record or for information, of an inward and spiritual act."39 The intention assumed by the speech act must be distinguished from the normally quite inaccessible actual intention of the speaker. This concern is developed in some detail by Teun A. van Dijk in Text and Context (1977), which argues that "We understand what somebody does only if we are able to interpret a doing as a certain action. This implies that we reconstruct an assumed intention, purpose and possible further reasons of the agent." An action cannot really be defined or analyzed unless the analysis takes into account "the various mental structures underlying the actual doing and its consequences."40 Van Dijk's underlying mental structures—intentions and purposes—correspond essentially to Austin's illocutionary and perlocutionary forces, but the presence of the key qualifier "assumed" in van Dijk's formulation is an essential qualification, recalling (as do Bakhtin and Kristeva) that, from an audience point of view, the intentions of an author/ speaker are necessarily a construct. Van Dijk also suggests that immediate purposes be distinguished from long-term global purposes, that the immediate effect of a single speech act can normally best be understood as a single operation in a whole series of actions directed toward a general goal.41

Ross Chambers has specifically applied Austin's theories to analysis of theatre, but he begins by rejecting Austin's concept of the "parasitic" nature of fictive discourse. Also, like Kristeva, he emphasizes that the role of the "speaker" in such discourse cannot operate within the standard illocutionary model, which assumes a speaker in contact with a specific, known hearer:

Very quickly cut loose from its ties with its "author," an artistic discourse keeps addressing constantly new hearers who must interpret it in continually varying contexts. The "performative" underlying aesthetic discourse would be then something like: "I offer myself for your interpretation" or "I invite you to interpret me"—always supposing that such an act could be attributed to the message itself (become its own sender) and that the receiver designated here as "you" could be conceived as a perfectly indeterminate "to whom it may concern." 42

Umberto Eco extends this strategy in an extremely important direction for theatre and performance theory, claiming a similar illocutionary operation for the activation of an interpretive relationship not only between a reader and a literary text, but also between an audience member and a performance. Within the fictive world of the play, says Eco, actors make speech-act "pseudo-statements" to each other (understood by the audience through the operations of Ohmann's mimetic activation). But, Eco continues, the production also involves a necessary speech act presented by the performer corresponding to Chambers' aesthetic performative, which establishes that fictional world: "I am now going to act." The establishment of the theatrical frame can be thus conceived as a speech act: "through the decision of the performer ... we enter the possible world of performance."

Chambers makes a useful distinction, based on standard linguistic theory, at the beginning of his analysis, observing that,

like any discourse, the theatrical text can be thought of as "énoncé" and as "énonciation." In the first case, it is considered, one might say, "grammatically," in its components and how they work together. In the second, it appears in the context of a communication situation, as an act destined to produce an effect on one or several spectators.⁴⁴

Chambers then proceeds to comment on both of these levels. On the level of the *énoncé*, illocution within the narrative world of the play, he notes: It is easy to determine that the basic subject of dramatic narration is the illocutionary relationship, a communicative exchange between a sender and a receiver of a speech in a given context. . . . It is quite correct to think that the particular vocation of theatre is to explore the consequences of this intuition that "to say is to do," and "to do is to say." 45

On the level of énonciation, illocution between play and audience, he suggests a variety of social functions proposed for the drama, citing theatrical theorists such as Brecht and anthropological theorists such as Caillois.

Chambers' attempt to apply speech-act theory to both levels of theatre as a discourse is rather unusual. Generally speaking, those theorists who have applied speech-act analysis to theatre have worked primarily or exclusively on the level of the énoncé, the operations of illocution within the fictive world of the play, a level that is more clearly compatible both with traditional literary analysis and with the use of speech-act analysis in ordinary speaking situations. Indeed, Joseph A. Porter, who applied Austin's theories to Shakespeare's history plays in his 1979 The Drama of Speech Acts, argued that speech-act theory could not in fact be applied to the drama as a whole, because there was "no single speaker who is the doer of the action," but that it was ideal for analysis of the workings of the fictive world portrayed since this world is based on speech acts. Porter even proposed that one might rephrase Aristotle in Austin's terms: "speech action is the soul of verbal drama."46 Ohmann similarly argues that "in a play, the action rides on a train of illocutions," and that "movement of the characters and changes in their relations to one another within the social world of the play appear most clearly in their illocutionary acts."47

A particularly extensive example of the application of speechact analysis to drama is Keir Elam's The Semiotics of Theatre and Drama (1980), the first book-length application of semiotic theory to theatre studies in English. Indeed, so central was speech-act theory to Elam's approach that many readers assumed, until other works in the field began to appear, that semiotics and speechact theory were essentially identical. Nevertheless, despite its comprehensive analysis of various aspects of discourse, Elam's book really only directed its analysis to the fictive world of the play. In a typical passage, Elam asserted that:

Dramatic discourse is a network of complementary and conflicting illocutions and perlocutions: in a word, linguistic interaction, not so much descriptive as performative. Whatever its stylistic, poetic and general "aesthetic" function, the dialogue is in the first place a mode of praxis which sets in opposition the different personal, social and ethical forces of the dramatic world.48

A pioneering work in reader-response theory, Stanley Fish's Is There a Text in This Class?, appeared the same year as Elam's pioneering work in semiotics, and the presence in Fish's book of a chapter entitled "How to Do Things with Austin and Searle" suggests that here may be found an application of speech-act theory to the drama/audience relationship rather than to the fictive world of the play. Somewhat surprisingly, Fish focuses his analysis on the speech acts within Shakespeare's Coriolanus, which Fish avers might almost have been written to illustrate this theory. Fish's literary analysis is very impressive, and he continually suggests that the operations of speech acts in Shakespeare's play can also be found in our own world, but the speech-act operations of the play itself are not really considered. A number of passages are highly suggestive, however, of ways such consideration might be developed. Fish, for example, calls attention to Coriolanus' error in thinking he can find a world where he can escape social obligations: "There are only other speech-act communities, and every one of them exacts as the price of membership acceptance of its values and meanings."49 The emphasis on the importance of interpretive communities and how they control the meaning of speech acts has potential great importance for the study of the relationship between a performance and its audience, even though it is not developed

Herbert Clark and Thomas Carlson's "Hearers and Speech Acts" (1982) similarly, and perhaps even more surprisingly, fails to extend its interesting analysis of a Shakespearean play, here Othello, outward to the operations of theatre itself. They suggest that in addition to the traditional "illocutionary" act directed at the addressee, there is in all conversations involving more than two people a second illocutionary act directed at all "hearers" in the conversation and serving to inform them jointly of the assertion being made. Although they take as their basic

example Othello's speech "Come, Desdemona," with Iago and Roderigo as other "hearers," they do not explore the fact that in the theatre there is an even more important set of secondary "hearers," the actual audience, who also are being "informed jointly of the assertion, promise, or apology being directed at the addressees."50 If such a statement is illocutionary because "Othello not only intends to give an order to Desdemona but intends the other hearers to understand that he is giving this order," this same illocutionary argument clearly extends to the audience as well, although the "intention" shifts to another level, that of the speaking actor, not the speaking character.

Another literary critic much interested in speech-act analysis is Elias Rivers, who argued in his 1983 Ouixotic Scriptures that "the theatre of Golden Age Spain, like that of Elizabethan England, provided a sociolinguistic laboratory within which to test old and new ideas about the authority of speech acts."51 Rivers pursued this approach in a 1984 National Endowment for the Humanities seminar, which resulted in a collection of essays published in 1986 applying speech-act theory to a range of classical and modern plays. 52 Since that time speech-act theory has become a standard tool of literary analysis, still applied primarily to Shakespeare and Spanish Renaissance plays, but also to a variety of other traditions, including the drama of Germany, France, and Ireland,53 though most such work follows Fish and Clark and Carlson in keeping this analysis within the fictive world of the play.

Application of speech-act analysis to theatre in a more general manner has been most notably carried out in a number of articles by Eli Rozik.54 Drawing upon the vocabulary not only of speechact theory, but of semiotics, Rozik has suggested that theatrical speech acts should be considered as verbal indexes of actions, an index being a sign that according to Charles Peirce signifies "by virtue of contiguity, particularly, a part-whole relationship."55 Given this "part-whole" relationship, speech acts should not be analyzed as if they were self-contained units (which speech-act theory, despite its interest in context, has tended to do), but rather in terms of the complex actions of which they are a part.

This shift in focus from speech to act characterizes Rozik's approach and moves him away from linguistic theorists such as Austin and Searle and literary theorists such as Fish and Rivers toward action theorists such as van Dijk, Geoffrey Leech, and Stephen Levinson.⁵⁶ When speech acts are considered in terms of their force, Rozik argues, they become better understood, despite their use of language, as part of a different set of human phenomena. Functionally speaking, "they are not a part of language, but a part of action." By way of illustration, Rozik cites several possible speech acts along with non-verbal gestures, all of which express the same action "force," such as making a threat or asking pardon.⁵⁷ As we move from the illocutionary interpretation of such acts, verbal and non-verbal, to the mental construction of the character they gradually illuminate and the fictive world of which that character is a part, a process is assumed that is the theatrical equivalent of the mimetic process outlined by Ohmann for the reader of fiction, similarly constructing a fictive world by the interpretation of illocutionary forces. Rozik again looks, however, not to literary or speech-act theorists but to pragmatic or action theorists to suggest this broader reception concern. Van Dijk, for example, seems to Rozik to move speech-act theory very close to a strategy for the analysis of the total dramatic action, where individual speech acts are calculatedly organized by playwright, director, and actor to serve as easily decoded indexes of actions, and where in conventional dramatic structure "every speech act in a play, whatever its location, indicates not only immediate purposes but also global ones."58 Van Dijk's idea of global purpose seems to come very close to Stanislavky's concept of the super-objective.

Rozik, like other theorists applying speech-act or action theory to drama or fiction, devotes most of his attention to what is happening within the fictive world, though he does provide a number of stimulating suggestions about the double operations of theatrical speech acts on their two receivers, the characters in the play and the audience. He gives a particular emphasis, for example, to what he calls "ironic conventions," a variety of theatrical devices such as the soliloguy, the aside, and functional characters such as the chorus, all of which "depart from the basic iconic nature of the theatrical text" but by that very departure "play a crucial role in the communication between author and audience, different from that played by the interaction among characters."59 Elsewhere he provides brief but stimulating speculations about the dynamics of the invitation to interpretation mentioned by Eco and Chambers. These observations suggest how a perlocutionary analysis of a theatre speech act's effect on its audience might be pursued.

Speech-act theory has joined with the new performative interest in the social sciences in general to effect a major change, one might almost say a revolution, in the areas of literary studies most associated with performance. To date, it has had much less effect upon performance theory that is less tied to traditional dramatic literature. This emphasis appears to be changing, however, as may be seen, for example, in the shifting interests of the interdisciplinary journal Literature in Performance, established in 1980 by the Speech Communication Association of America. Its original editorial policy was stated in fairly conventional and traditional terms, to study "literature through performance" and to serve those "involved in the teaching of oral interpretation." 60 Soon, however, the journal began to show a growing interest in a variety of performance, with articles from religion, folklore, anthropology, psychology, sociology, and cultural history along with the more predictable pieces on the teaching and practice of theatre and oral interpretation. By 1989, the concerns of the journal and the field had sufficiently shifted to call for a new title, Text and Performance Quarterly. In the opening editorial to this new version of the journal, James W. Chesebro suggested that the new title implied not only a shift in orientation from literature to a far more diverse set of communication forms, but also an interest in a variety of theoretical questions surrounding the term "text" in contemporary thought. Central to this new orientation, according to Chesebro, is a recognition that both text and performance are conditioned by their media, making an interest in the operations of media essential to both text and performance. 61 Subsequent issues have in fact continued to emphasize rather traditional performative analysis of drama, novels, and poetry, but this important and eclectic journal has also offered a wide variety of articles drawing upon Austin and Searle, Fish, Bakhtin, Goffman, and Turner, and is concerned with performances by no means wholly literary in origin. Here as elsewhere the concept of "performance" seems to be serving as an impetus to dissolve traditional disciplinary and methodological boundaries in order to explore more general concerns.

The art of performance

constitution of the fire of

Performance in its historical context

When modern performance, or performance art, began to be recognized during the 1970s as an artistic mode in its own right, it naturally began to stimulate an array of secondary material. First came reviews and studies of individual performances, then more general studies of the new approach and attempts to place it within contemporary culture and a historical tradition, even though the protean nature of performance, a characteristic of such work from the very beginning, made the task of chroniclers, commentators, and source-seekers a difficult one. RoseLee Goldberg, who wrote the first history of "performance" in 19791 and issued a revised and expanded history of "performance art" in 1988,2 observed that this phenomenon "defies precise or easy definition beyond the simple declaration that it is live art by artists." Goldberg argues that the mutability of such art results from its iconoclastic focus: "The history of performance art in the twentieth century is the history of a permissive, open-ended medium with endless variables, executed by artists impatient with the limitations of more established art forms."3

In the course of her books, Goldberg traces this history of revolt and experimentation, beginning with futurism, then proceeding to experimental theatre of the Russian Revolution, dada and surrealism, the Bauhaus, Cage and Cunningham, happenings, Ann Halprin and the new dance, Yves Klein, Piero Manzoni, and Joseph Beuys, to body art and modern performance. Except for the more recent manifestations, this history is essentially the history of twentieth-century avant-garde theatre, and historians and theorists of performance art have generally followed Goldberg in viewing it within that tradition. So the authors of *Performance: Texts and Contexts* (1993) remark that performance

art "belongs in the traditions of the avant-garde" and trace its heritage from futurism through dada, surrealism, happenings, and the poem-paintings of Norman Bluhm and Frank O'Hara.⁴ This heritage clearly influences the authors' proposed "definition" of performance art. Though they admit that such works "vary widely," they rather boldly assert that "all share a number of common characteristics" (emphasis mine). These are:

(1) an antiestablishment, provocative, unconventional, often assaultive interventionist or performance stance; (2) opposition to culture's commodification of art; (3) a multimedia texture, drawing for its materials not only upon the live bodies of the performers but upon media images, television monitors, projected images, visual images, film, poetry, autobiographical material, narrative, dance, architecture, and music; (4) an interest in the principles of collage, assemblage, and simultaneity; (5) an interest in using "found" as well as "made" materials; (6) heavy reliance upon unusual juxtapositions of incongruous, seemingly unrelated images; (7) an interest in the theories of play that we discussed earlier [Huizinga and Caillois], including parody, joke, breaking of rules, and whimsical or strident disruption of surfaces; and (8) open-endedness or undecidability of form.⁵

Although this is in fact a very useful categorization of a number of frequent characteristics of modern performance art, obviously not all performance art shares all of these characteristics. Moreover, in Goldberg as well as in others who have followed her model, these characteristics are so heavily weighted toward an avant-garde orientation that they are very likely to distort a reader's idea not only of what has been included in modern performance art, but also how that art is related to performance history. When, for example, Stern and Henderson in *Performance* discuss Whoopi Goldberg, one of four "performance artists" analyzed in some detail in this book, only passing mention is made of Whoopi Goldberg's similarity to Ruth Draper, the great monologue artist of the 1930s and 1940s,6 and the monologue tradition in which Draper worked is not considered at all, even though the futurist, dadaist "background" of modern performance art is carefully traced, following the model established by RoseLee Goldberg.

It could surely be argued, however, that the now standard

"experimental" genealogy leading from the futurists through dada and surrealism, to the happenings, and then to modern performance art is much less relevant to the work of a performer such as Whoopi Goldberg than the great twentieth-century monologue tradition in the United States, including such great women artists as Beatrice Herford, Marjorie Moffett, and especially Ruth Draper. It is unquestionably correct to trace a relationship between much modern performance art and the avant-garde tradition in twentieth-century art and theatre, since much performance art has been created and continues to operate within that context. But to concentrate largely or exclusively upon the avant-garde aspect of modern performance art, as most writers on the subject have done, can limit understanding both of the social functioning of such art today and of how it relates to other performative activity of the past. Therefore, before looking at the relationship of modern performance to the avant-garde tradition, let us consider, at least briefly, some of its relationships to other and much older performance activities.

Despite her emphasis upon the close relationship between the avant-garde and performance art in the twentieth century, RoseLee Goldberg in her very brief remarks on performance in earlier periods does cite a few examples that might at first seem quite unrelated to performance as she subsequently chronicles it: medieval passion plays, a 1598 mock naval battle, royal entries, and elaborate court spectacles designed by da Vinci in 1490 and Bernini in 1638. Performance in these examples is clearly not based on a concern about "the limitations of existing artistic forms," nor does it involve, as much modern performance does, the physical presence of the artist. What it does provide, argues Goldberg, is "a presence for the artist in society," a presence that can be variously "esoteric, shamanistic, instructive, provocative or entertaining."

What seems to be involved in each of these cases is a manifestation of the artist's "presence" through a striking display of technical accomplishment and virtuosity, a theatrical and social phenomenon discussed insightfully by Jean Alter in his A Sociosemiotic Theory of Theatre (1990). Here Alter suggests that the art of theatre is always based on the "dual appeal" of two coexisting functions. The traditional communicating of a story, carried out with "signs that aim at imparting information," Alter calls theatre's "referential function." To this he adds a

"performant function," clearly closely related to Goldberg's idea of performance in earlier periods, which is shared by other such public events as sports or the circus, and which seeks to please or amaze an audience by a display of exceptional achievement. Such performances are most often associated with acting, but they are achievable by any of the arts of the theatre—lighting, design, directing, costuming. According to Alter, these performances are not primarily concerned with communicating by "signs"; they stress instead the direct physical experience of the event. Hence the importance of physical presence: the technical skill and achievement of the performer, the visual display of dazzling costumes, or scenic effects are dependent for a certain part of their power upon the fact that they are actually generated in our presence.

As Alter notes, theatre inevitably involves both performant and referential functions, as most writers on the subject have in one way or another acknowledged. Nevertheless, most such writers in the West, from Aristotle onward, have devoted comparatively little attention to the performant function, and a number of very influential writers, among them Goethe, Charles Lamb, and most of the symbolists, have considered the performant a troubling distraction, if not an aesthetic flaw. Plays have been traditionally regarded as stable written objects, their various manifestations in different productions a more or less accidental part of their history, not really essential to their understanding, and when plays have been placed in a broader context of human activity, that context has been until quite recently only a literary one. From Aristotle to Hegel, theorists spoke of the three forms of poetry epic, lyric, and dramatic—a division continued into more modern times as prose, poetry, and drama. Not until the rise of the modern interest in performance was there much thought that a play might be presented in a different contextualization, not as a cousin of such literary forms as the poem or the novel, but of such performance forms as the circus, the sideshow, the parade, or even the wrestling match or the political convention. Thus, another way to look at performance would be to separate it from the broader social and anthropological usages discussed in previous chapters, and consider it only within the much more limited confines of an artistic or entertainment activity consciously produced for an audience, and thus seek its historical context in earlier artistic and entertainment activities. Such an investigation will be more useful

and productive if we acknowledge this new contextualization, moving outside the traditional "referential" orientation of theatre studies to the more "performative" activities that often surround this tradition but have tended to be marginalized or ignored

completely.

There has always been, surrounding and doubtless long predating the more formally structured social activity that has been called "theatre," a vast array of other sorts of entertainment activity that could be designated as "performance." The classic period had its musicians, its mimes, its jugglers, even its ropedancers, mentioned by Terence in the prologue to Hecyra. In the middle ages there were the troubadours, the scalds and bards, the minstrels, the montebanks, and that miscellaneous group of entertainers that in England were designated as the "gleemen," "a term which included dancers, posturers,9 jugglers, tumblers, and exhibitors of trained performing monkeys and quadrupeds."10

The range and variety of such activity was much greater than is often assumed today. The word "jester" today, for example, very likely calls up the mental image of a court clown in motley, perhaps a bit unstable mentally, but possessed of a certain wit or at least verbal dexterity and daring. And yet there were in fact many types of jestours (or gesters), some who literally recited the medieval gestes, tales of famous persons and heroic deeds, but others who told popular tales, comic tales, anecdotes, verses and ballads, moral speeches—every sort of verbal material, some learned, some patched together from a variety of sources, and

some original with the teller.11

Many a modern performance artist, monologuist, or stand-up comedian would likely, in terms of technique and approach, fit very easily into this versatile company. The natural gathering places for such performers were the great medieval and Renaissance fairs, but like the strolling players of the period (and often in league with them) they traveled about the countryside, performing in marketplaces, in great houses, in taverns, wherever an audience could be assembled. Elizabeth grouped jugglers and minstrels along with itinerant thieves, beggars, and gypsies in her Vagrancy Act, designed to discourage such activity, 12 but in fact, contrary to the impression left by literary studies of the period, even the most "respectable" theatre was deeply involved with such performance. As M. C. Bradbrook observes:

The theatre of the Elizabethans, in its social atmosphere, was less like the modern theatre than it was like a funfair. . . . Merriment, jigs and toys followed the performance: songs, dumb shows, fights, clowns' acts were interlaced. When Leicester's Men visited the court of Denmark in 1586 they were described as singers and dancers; Robert Browne of Worcester's Men, who toured the continent for thirty years with other English actors, jumped and performed activities. ¹³

In 1647 popular entertainments were outlawed in England along with the theatres, but such official discouragements were never very long or very widely effective. Traveling performers, like traveling actors, could normally find audiences for their offerings somewhere or other, and even in London under the ban the ever-curious John Evelyn in August of 1657 witnessed a variety of popular entertainments including a "famous ropedancer, called The Turk." ¹⁴

Rope-dancing (performance on a tight-rope) was one of the most popular types of performance in England and on the continent during the next century, so much so that when fair-ground entertainers began to establish permanent theatres in Paris in the late eighteenth century and the authorities wished to draw a clear legal line between them and "legitimate" theatre, one of the common distinctions was that tumbling and rope-dancing were to be found in the minor houses. Not infrequently, in deference to such distinctions, actors wishing to present a more conventional play would enter the stage with a somersault or walk in on a rope before continuing with a more conventional presentation.

The late seventeenth century saw also the establishment in London and Paris of what were then called "music-booths," the ancestors of the later music halls, cabarets, vaudevilles, and café-concerts, which offered a variety of performance in a series of "acts"—vocal and instrumental music alternating with ropedancing and tumbling. The fair nevertheless remained the favored center of such entertainment, as John Gay's ballad singer (himself one such performer) notes in "The Shepherd's Week":

The mountebank now treads the stage, and sells His pills, his balsams, and his ague-spells; Now o'er and o'er the nimble tumbler springs And on the rope the venturous maiden swings;

Jack Pudding, in his party-coloured jacket, Tosses the glove, and jokes at every packet. 15

Although the greatest of the London fairs, Bartholomew Fair, existed until the middle of the nineteenth century, many of the types of performance that it sheltered and encouraged, as well as new entertainments in a similar vein, were found much more frequently from the late eighteenth century onward in the new center for such entertainment, the circus, developed in London and Paris by Phillip Astley, but soon gaining enormous popularity in Europe, and then around the world. Circus historian John Clarke dates the origin of the circus to 1780 when Astley offered in London a variety of horse acts, his own speciality, along with tumbling, rope-vaulting, a human pyramid, and even a clown. 16

The marketplace, the fairground, the circus—gathering places for a large general public—have been traditionally the favored site of performance, but the solitary performer or small group of performers displaying their skills before a small gathering, even a single family in a medieval great hall, offered a more intimate performance model that has continued up until the present. Private court entertainments, aristocratic salons and soirées, and private parties today offer a continuing tradition of such activity, some of which might be called avant-garde, but much of which is quite traditional. A well-known example from the late eighteenth century is the "attitudes" of Lady Emma Hamilton, poses and movements suggesting to entranced observers a great variety of emotions as well as evocations of classical art.17

Lady Hamilton's attitudes inspired several popular women performers of the next generation, such as Ida Brun in Denmark and Henriette Hendel-Schütz in Germany, as well as the enormously popular tableaux vivants that swept Europe during the next century. Her tarantella and her shawl dance drew new attention to these forms, not only in the theatre, but in private society, where such dances became a favored choice as "a party entertainment for the ladies of the bourgeoisie."18 It will be remembered that a century later, Ibsen's Nora offers a performance of the tarantella at her fateful Christmas Party. These lively dances, with their emphasis upon emotional expressiveness and freedom from traditional dance movement, anticipate in important ways modern experimental dance, with its own close relationship to performance art. Indeed, one of Lady Hamilton's

biographers notes that "The modern-day spectacle which resembles the Attitudes is, of course, Isadora Duncan's Greek dance." Duncan herself, as we shall see, contributed importantly to the development of modern experimental performance.

The circus, vaudeville and variety shows, and the music hall flourished in the course of the nineteenth century, providing a fertile ground for performance activities presented in review form. Peter Jelavich's summary of the offerings in the German vaudevilles (known as *Variétés* or *Singspielhallen*) suggests the range: "juggling, wrestling, tightrope-walking, trapeze-artistry, clowning, pantomime, folk songs and folk dances, skits, restrained striptease, and costume ballet." ²⁰

The American theatrical tradition, developed during this period, was strongly oriented in this performative direction, so much so that Richard Kostelanetz has suggested that the almost universal attempt by theatre scholars to develop a European-style history of literary theatre for the United States has been misguided. Rather, Kostelanetz proposes, "what theatrical genius we have had in America gravitates not to formal theater or literary drama, but to informal theater, where the performer is the dominant figure," and that just as America created its own indigenous "opera" in musical comedies and vaudevilles, so it developed "its own kind of theater—not of literature, but of performance."21 One important strand of this, engagingly traced in a book by John Gentile,22 was the one-person show, ranging from the platform readings of authors such as Dickens and Twain, through the lectures and performances organized by the Lyceum and Chautauqua circuits, on to the early twentieth-century solo monologuists such as Ruth Draper and Cornelia Otis Skinner, to modern impersonations of earlier performers such as Willym Williams as Dickens and Hal Holbrook as Twain and a variety of other historical impersonations, and individual readings of such classics as selections from Shakespeare or the Bible. This tradition is continued in contemporary performance in the autobiographical work of Spalding Gray and Quentin Crisp and the character creations of Whoopi Goldberg, Lily Tomlin, and Eric Bogosian.

Near the end of the nineteenth century, a new form in the music hall tradition, the cabaret, drew upon the public love of such physical and visual theatricality to develop another center for performance activity that would in turn inspire major innovators

in the modern drama such as Wedekind and Brecht, as well as a wide range of avant-garde performance activity. Laurence Senelick, a leading contemporary chronicler of cabaret material, places in the variety-oriented European cabaret the roots of the avant-garde tradition that RoseLee Goldberg and others trace from the futurists onward into modern performance. One must look to the cabaret, argues Senelick, for the beginnings of "many of the most exciting innovations in twentieth-century performance art":

Emerging from bohemian haunts, the cabaret was the earliest podium for the expressionists, the DADAists, the futurists; it was a congenial forum for experiments in shadowgraphy, puppetry, free-form skits, jazz rhythms, literary parody, "naturalistic" songs, "bruitistic" litanies, agitprop, dancepantomime, and political satire.23

Because of this extremely eclectic range, and probably because it sought from the outset to utilize popular forms in new ways, the cabaret enjoyed a far longer career and attracted a far larger and more diverse public than the various rather specialized and esoteric artistic avant-gardes that in part emerged from it. In both the eclecticism and the spread of appeal from its original bohemian creators to a much more general public, the cabaret more closely prefigures the dynamic of modern performance than any of the more specialized avant-garde movements. Nevertheless, individually and collectively, these movements have unquestionably provided influences and models for such performance and certainly for individual performers. Therefore let us briefly examine this likely more familiar terrain, stressing those aspects of it most closely related to recent performance art.

The brilliant innovative Russian theatre at the beginning of this century provided models of performance unparalleled in their richness and diversity. In the utopian early years of the Revolution, before the stifling uniformity of socialist realism was imposed by Stalin, this innovation was not, in the frequent pattern of Western European experimentation, considered to be primarily by artists for artists, but a spirited search for new approaches to art that could speak to a new and much more broadly based public. With this goal in mind, leading theatre innovators emphasized physicality and spectacle (what Alter calls the "performative" side of theatre) and also sought inspiration in such previously scorned popular forms as the fairground and the circus. Cabaret-type theatres enjoyed a tremendous popularity in Russia beginning in 1908, headed by the famous Bat, the subterranean resort frequented by Moscow Art Theatre performers after their own productions were over, and Nikolas Evreinoff's Crooked Mirror, specializing in parody and the grotesque. Vsevolod Meyerhold, in his famous 1912 essay "The Fairground Booth," approvingly quotes Ernst von Wolzogen, founder of Germany's first literary cabaret, in arguing that the spirit of cabaret, variety, and fairground performance can provide a conciseness and profundity, clarity and vigor denied to the traditional drama, "where the play takes up a whole evening with its ponderous bombastic exposition of depressing events." ²⁴

Other innovators sought even more literally and specifically to merge theatre with varieties of popular performance. Meverhold's student Sergei Radlov rejected the actor's bond to "someone else's words" and invited clowns, acrobats, and jugglers into his "Popular Comedy" theatre in 1920 to develop improvisatory work, 25 inspiring in turn the circus- and variety-oriented "Factory of the Eccentric Actor" (FEKS) in Petrograd in 1922-3 and Sergei Eisenstein's influential concept, the montage of attractions, applied by him to the revival of an Ostrovsky play in 1923. Nikolai Foregger experimented with music hall routines, elaborate and spectacular scenic effects, and called for a closer alliance between the theatre and the circus, claiming that in the golden ages of Elizabethan England and Renaissance Spain, the theatre and the circus had operated as inseparable "Siamese Twins." The arts of the future, said Foregger, are the cinema and the music hall, the obvious appeal of the latter being the living body as an expressive instrument 26

The appearance of Isadora Duncan in St. Petersburg in 1904 had a profound effect on both dance and theatre in Russia, focusing attention on the individual performer and upon the natural movement of the body. Evreinoff credited Duncan with revealing to him the simplicity and inevitability of "real, honest art," ²⁷ and Alexander Tairov looked to Duncan, as well as to masters of the traditional ballet such as Mikhail Fokine and Anna Pavlova, as models for restoring a lost sense of the corporeal to theatre. ²⁸

The subjective approach championed by Duncan was soon challenged by the more objective eurythmics of Emile Jaques-Dalcroze and the biomechanics developed by Meyerhold, but all three contributed to a powerful new interest in the expressive

qualities of the body and to the convergence of dance and theatre, both central to the development of modern performance. In a 1914 class in stage movement, Meverhold remarked that "the new actor's view of the stage" was "as an area for the presentation of unprecedented events"-very much the view of a modern performance artist—and among possible models and inspirations for such work he cited Jaques-Dalcroze, Isadora Duncan, Loie Fuller (another American pioneer of the modern dance), the circus, the variety theatre, and Chinese and Japanese theatres.²⁹

In terms of the number of people involved, both as performers and as public, Russia's Revolutionary spectacles far surpassed the modest evenings of the Western European futurists, dadaists, and surrealists. Nevertheless, these latter exerted then, and still exert, an influence on the popular imagination and on subsequent artistic experiments far out of proportion to their numbers. They were highly visible, taking place in traditional centers of artistic activity and supported by a strong and well-established publicity organization. The launching of futurism in 1909 was a typical example, with a manifesto by Filippo Marinetti in the widely circulated Parisian paper, Le Figaro. Futurism is in fact rather better known for its manifestos than for its actual artistic achievements, but both contributed importantly to the performance tradition of this century. The interest of the futurists in movement and change drew them away from the static work of art and provided an important impetus for the general shift in modern artistic interest from product to process, turning even painters and sculptors into performance artists. Far from seeking to stimulate positively a mass audience, the futurists were often frankly and proudly confrontational, arousing public outrage that anticipated the scandals of later performance art. One of Marinetti's manifestos spoke proudly of "The Pleasure of Being Booed," a likely consequence of challenging the anticipations of complacent audiences by demanding from artists "an absolute innovative originality" and by renouncing conventional "historical reconstruction" and "psychological photography" in favor of "a synthesis of life in its most typical and significant lines."30 The "Variety Theater" manifesto of 1913 praised that form of entertainment over traditional theatre because of its healthy "dynamism of form and color," including jugglers, ballerinas, gymnasts, and clowns, because, in short, it rejected conventional psychology in favor of what Marinetti called fisicofollia, or "body-madness."31

Despite a strong interest in the physical body in such manifestos as these, futurist productions very often emphasized the mechanical, surrounding (and even hiding) the actor's body in the trappings of modern technology, for which futurism had an inexhaustible passion. Turning bodies into machines or replacing bodies by machines certainly can be found in modern performance, but the tendency of futurism to move toward theatres of puppets, machinery, even colored clouds of gas, on the whole ran counter to later more determinedly body-oriented performance. Most futurist performances also followed a variety format, with a sequence (or a simultaneous presentation) of bits of short performance material-skits; acrobatics; mechnical, lighting, and sound effects; rapid display of movements or objects. This dazzling and quickly moving variety was essential to the futurist aesthetic of speed, surprise, and novelty, but it resulted in a presentation format that on the whole looked backward to the performances of the cabaret, the vaudeville, the circus, and the variety stage rather than forward to the performance art of more recent times, which has been largely devoted to the display of individual acts, even if these are of very short duration.

Dada had an even more direct connection to cabaret culture than futurism, developing out of performances in the Cabaret Voltaire in Geneva, Switzerland. Musical performances and poetry readings formed the basis of activities here, from which Tristan Tzara and others developed the approach they christened dada. Futurism's influence was strong in the antiestablishment and antitraditional attitudes, in the bizarre activities, and even in the style of Tzara's manifestos. His report on the first dada evening might as readily have come from Marinetti, as the following excerpt suggests:

the people protest shout smash windowpanes kill each each demolish fight here come the police interruption. Boxing resumed: Cubist dance, costumes by Janco, each man his own big drum on his head, noise, Negro music/trbatgea bonoooooo oo ooooo ... 32

The final section of this excerpt recalls one of the most important interests of the futurists, as well as of the dadaists—bruitism or "noise music," an exploration of the expressive qualities of non-musical sound. As dadaist Richard Huelsenbeck explained: "Music of whatever nature is harmonious, artistic, an activity of

reason—but bruitism is life itself."33 This interest in non-musical sound of course prepares the way for the pivotal experiments of John Cage, himself a major influence on subsequent experimental theatre and performance.

As a pioneer in experimental performance, Cage is perhaps even more widely known for his utilization of chance techniques in composition, and here too his innovations were to some extent anticipated by the dadaists. Both dada and surrealism were interested in spontaneous creative activity. Some of this involved pure chance, such as Hans Arp creating collages by allowing scraps of paper to fall randomly on the floor, Tzara creating poems by pulling words from a hat, or more theatrically, dada performance's attempt to stimulate and incorporate audience reaction. There was also, however, an interest in tapping and expressing the unconscious, what André Breton called "pure psychic automatism" in his "Manifesto of Surrealism" of 1924. Breton described this as an attempt "to express either verbally, in writing, or in some other fashion what really goes on in the mind. Dictation by the mind, unhampered by conscious control and having no aesthetic or moral goals."34

Francis Picabia's ballet Rélâche in 1924 featured interaction with the audience, various "performances" interspersed with the main action such as a chain-smoking fireman pouring water from one bucket to another and a stagehand chugging across the stage in a small automobile trailing balloons, a tableau vivant of Cranach's Adam and Eve, film clips, and blinding lights in the eyes of the audience. 35 In his review of the production, Fernand Léger praised the work for surmounting the boundaries of ballet and music hall: "author, dancer, acrobat, screen, stage, all the means of 'presenting a performance' are integrated and organized to achieve a total effect."36

Perhaps the most important contribution of the surrealist movement to subsequent experimental theatre and performance was the theoretical writings of Antonin Artaud, which exerted an enormous influence in the 1960s and 1970s. In his visionary The Theater and Its Double, Artaud advanced his own powerful version of the argument found throughout the early twentiethcentury avant-garde that the traditional theatre had lost contact with the deeper and more significant realms of human life by its emphasis on plot, language, and intellectual and psychological concerns. The subjugation of the theatre to the written text must be ended, to be replaced by a spectacle of direct "physical and objective" action:

Cries, groans, apparitions, surprises, theatricalities of all kinds, magic beauty of costumes taken from certain ritual models; resplendent lighting, incantational beauty of voices, the charms of harmony, rare notes of music, colors of objects, physical rhythm of movements whose crescendo and decrescendo will accord exactly with the pulsation of movements familiar to everyone, concrete appearances of new and surprising objects, masks, effigies yards high, sudden changes of light, the physical action of light which arouses sensations of heat and cold, etc.³⁷

In addition to the continuing and by no means insignificant influence of its cabaret, Germany during the 1920s contributed importantly to the development of both the theory and practice of modern performance through the work of the influential art school, the Bauhaus, the first such school to undertake a serious study of performance as an art form. Oskar Schlemmer was the leader of this enterprise, and his writings and abstract dance compositions (most notably the Triadic Ballet of 1922) attracted European-wide attention to the compositional possibilities of the human body in space. Lazlo Moholy-Nagy, another major Bauhaus figure, stressed the importance but not the centrality of the performing figure as one contributing element to a work of "total theatre." Instead of his traditional role as the "interpreter of a literarily conceived individual or type, in the new THEATRE OF TOTALITY he will use the spiritual and physical means at his disposal PRODUCTIVELY and from his own INITIATIVE submit to the over-all action process."38

The observations by Moholy-Nagy on Bauhaus performance and by Léger on the surrealist *Rélâche* make similar points, and both suggest not only the importance of the various avant-gardes of the 1920s for later performance work, but also certain ways in which this later work had quite different emphases. Moholy-Nagy notes one of the key contributions of this experimental tradition, the rejection of the traditional concept of the performer as an interpreter of an already-existing literary text in favor of the performer as creator of an act or an action. Closely related to this is the shift, already seen in futurism, from product to process, from the created object to the act of creation. Of almost equally great

importance was the breaking down of traditional boundaries between the plastic and performing arts, between the high arts of theatre, ballet, music, and painting, and popular forms such as circus, vaudeville, and variety, indeed even between art and life itself, as in the concept of bruitism. On the other hand, as both of these observations suggest, much of the avant-garde tradition we have been tracing placed little emphasis on the individual performer, a central concern of more recent performance. The futurists and dadaists favored loose, revue formats, often overlaid with simultaneous actions. The surrealists and the Bauhaus artists also regarded the individual performer essentially as one element in a larger picture—the abstract performance as a whole. A very similar orientation can be found in the Merzbühne theories of dadaist Kurt Schwitters, who is often cited as one of the forerunners of modern happenings and performances. Schwitters followed in his own career the trajectory later suggested by Kaprow from painting, through collages and assemblages, to the sort of activity involved in happenings, mixing objects and human actions in a free-wheeling phantasmagoria uniting sound and lighting effects with sewing machines, shoes, bicycle tires, dentists' drills, and people walking on their hands and wearing hats on their feet.39

The individual performer was much more favored in the major contribution of the United States to the varied performance experimentation in the early twentieth century in the area of dance. The influence of Isadora Duncan and Loie Fuller on Russian experimental theatre of the Revolutionary period has already been mentioned, but their impact, along with that of Ruth St. Denis, was equally great in Germany and France, where all three American dancers appeared before World War I, pioneering revolutionary individual approaches to the art form. Of the three, only St. Denis, with her partner Ted Shawn, produced a major line of successors, headed by Martha Graham, Doris Humphrey, and Charles Weidman, who during the 1930s essentially defined "modern dance." In these dancers the rather romantic and personal style of the Duncan generation was replaced by a more consciously theatrical approach, but also one rather more concerned with abstract allegorical or mythic subjects. The next generation, headed by such dancers as Erick Hawkins, Katherine Litz, Midi Garth, and Jack Moore, was diverse in its experimentation, from the cool abstractions of Hawkins to the sprightly dada

Closely linked with Cunningham is his frequent collaborator, John Cage, whose revolutionary ideas on music and aesthetics have profoundly influenced modern experimentation in all the arts. Indeed, Natalie Crohn Schmitt argues in her 1990 Actors and Onlookers that in the contemporary theatre the traditional aesthetics and world-view represented by Aristotle have been replaced by that of Cage, itself a reflection of the altered view of nature under the influence of modern scientific theory. Central to this shift is a recognition that "events do not possess discrete facts and discrete perceivers; rather the two are joined in an observation,"40 a recognition placing new emphasis upon the phenomenal experience of performer, performance event, and audience and a fresh interest in their complex interrelationship. Cage's 1937 manifesto, "The Future of Music," opens with a call for the utilization of everyday material in performance that distinctly recalls the bruitism of the futurists:

Wherever we are, what we hear is mostly noise. When we ignore it, it disturbs us. When we listen to it, we find it fascinating. The sound of a truck at 50 m.p.h. Static between the stations. Rain. We want to capture and control these sounds, to use them, not as sound effects, but as musical instruments.⁴¹

Later, Cage qualified even the "capture and control" aspects of this concern, turning control over to various chance operations and capture over to the creation of specific frames around material not subject to the decisions of the artist. Perhaps his most famous work, 4'33" (1952), clearly illustrates this latter strategy, placing a pianist who does not play before an audience for four minutes and thirty-three seconds, during which time whatever the audience hears is "music."

An important parallel in dance to Cage's experiments in movement was taking place concurrently on the West Coast of the United States in the San Francisco Dancers' Workshop Company, formed in 1955 by Ann Halprin. Halprin carried on the interest of early experimenters such as Fuller and Duncan in the

performance of everyday activities. Her utilization of walking, eating, bathing, and touching in dance compositions has clear affinities to Cage's use of natural and artificial noises in musical ones, and her interest in "task-oriented movement," which was "unrestricted by music or interpretive ideas," 42 helped prepare the way for happenings and other performance activities of the 1960s. Halprin also shared Cage's interest in improvisation and free association as a way of breaking free of conventional artistic organizational strategies.

Cage and Cunningham met in 1938, and they began to collaborate regularly in the mid-1940s. In 1948 they taught and performed at Black Mountain College, a center in North Carolina for experimental artists from all fields that had been established in 1933 and had particularly close ties with the Bauhaus movement. Back at Black Mountain in 1952, Cage and Cunningham, along with Robert Rauschenberg and others, produced an untitled event that has been often cited as the model for the wave of happenings and related performance events that swept the art world in the late 1950s and early 1960s. In many respects, this event recapitulated many of the motifs and practices of earlier avantgardes. Performances, each timed to the second, took place in and around an arena audience. Cage read a dadaist lecture, films were projected on the ceiling, Cunningham danced in the aisles, followed by an unplanned excited dog who was enthusiastically incorporated into the performance. David Tudor, Cage's earlier silent pianist, poured water from one bucket into another, perhaps quoting one of the actions in Rélâche.

This event was taken as an experimental model by Cage in the course on experimental music he began to teach at New York's New School for Social Research in 1956. Pioneers of the avantgarde art of the 1960s, painters, musicians, poets, and film makers, found inspiration in these classes, which helped to create an art scene much oriented toward performance. Jim Dine appeared at his Reuben Gallery opening in New York in costume, Red Grooms painted for an audience in Provincetown, Rhode Island, in 1958, and a 1959 article in Art News proclaimed that "what counts is no longer the painting but the process of creation" and that the latter should be the object of the audience's attention. 43

A key event in the history of modern performance was the presentation in 1959 of Allan Kaprow's 18 Happenings in 6 Parts at the Reuben Gallery. This first public demonstration established

the "happening" for public and press as a major new avant-garde activity, so much so that a wide range of performance work during the following years was characterized as "happenings," even when many creators of such events specifically denied the term. Audiences at Kaprow's happenings were seated in three different rooms where they witnessed six fragmented events, performed simultaneously in all three spaces. The events included slides, playing of musical instruments, posed scenes, the reading of fragmentary notes from placards, and artists painting on canvas walls. During the following months Kaprow and others created a large number of such works, some entirely technological (such as Claes Oldenburg's Snapshots from the City (1960), a collaged city landscape with built-in street and immobile figures on a stage against a textured wall, flickering lights, and found objects on the floor), others involving the actions of a single artist, much more in the style of what would later be thought of as performance art (such as Jim Dine's The Smiling Workman (1960), in which Dine, dressed in a red smock with hands and face painted red, drank from jars of paint while painting "I love what I'm . . . " on a large canvas, before pouring the remaining paint over his head and leaping through the canvas).44 A similar and much more notorious converging of painting and the body was offered in Paris this same year, when Yves Klein's Anthropometries of the Blue Period presented nude models covered with blue paint pressing against a canvas like living brushes. In Milan the following year, Piero Manzoni went further still, converting living bodies into "authentic works of art " by signing them as if they were paintings.

Kaprow chose the title "happening" in preference to something like "theatre piece" or "performance" because he wanted this activity to be regarded as a spontaneous event, something that "just happens to happen." Nevertheless, 18 Happenings, like many such events, was scripted, rehearsed, and carefully controlled. Its real departure from traditional art was not really in its spontaneity, but in the sort of material it used and its manner of presentation. In his definition of a happening, Michael Kirby notes that it is a "purposefully composed form of theatre," but one in which "diverse alogical elements, including non-matrixed performing, are organized in a compartmental structure." Non-matrixed" contrasts such activity to traditional theatre, where actors perform in a "matrix" provided by a fictional character and

surroundings. An act in a happening, like Halprin's "taskoriented" movement, is done without this imaginary setting. In Alter's terms, it seeks the purely performative, removed from the referential. The "compartmental structure" relates to this concept; each individual act within a happening exists for itself, is compartmentalized, and does not contribute to any overall meaning.

Theatre scholars and historians naturally tend to place happenings and later performance art in the tradition of the theatrical avant-garde, looking back, as we have just been doing, to futurism, dada, and surrealism. It is important to remember, however, that these last three movements were really movements in other arts, organized by non-theatre artists, that expanded into performance. The same is true of the happenings, and indeed Kaprow traces their historical evolution not back through these performance avant-gardes but through modern painting. The Cubist collages, he suggests, attacked classical harmonies by introducing "irrational" or non-harmonic juxtapositions, and "tacitly opened up a path to infinity" by introducing foreign matter into the painting. "Simplifying the history of the ensuing evolution into a flashback, this is what happened; the pieces of paper curled up off the canvas, were removed from the surface to exist on their own, became more solid as they grew into other materials and, reaching out further into the room, filled it entirely."47 Thus canvas evolves through collage to assemblage and environments. As environments become more complex, and as the activities of participants in them (both spectators and performers) become more regulated and structured, environments become happenings.

In fact, Kaprow deplored the "theatrical" aura that began to surround the happenings as soon as an audience appeared, an aura that suggested either a "crude" avant-garde or else the popular performance world of "night club acts, side shows, cock fights and bunkhouse skits," instead of "art or even purposive activity."48 To combat this, Kaprow suggested a number of guidelines, among them keeping the line between art and life fluid and perhaps indistinct, seeking themes entirely outside the theatre or other arts, using several different locales and discontinuous time to avoid a sense of a theatrical "occasion," performing happenings only once, and eliminating entirely the traditional, passive audience.49

Recognizing Kaprow's desire to restrict the burgeoning

application of the term "happening" to all sorts of experimental performance, Richard Kostelanetz proposed a more embracing label, the "Theater of Mixed Means," in a 1968 book with that title. Performances of this type, said Kostelanetz in a subsequent summary, "differ from conventional drama in de-emphasizing verbal language, if not avoiding words completely, in order to stress such presentational means as sound and light, objects and scenery, and/or the movement of people and props, often in addition to the newer technologies of films, recorded tape, amplification systems, radio, and closed-circuit television."50

Kostelanetz divides such activity into four genres: pure happenings, staged happenings, kinetic environments, and staged performances. "Pure happenings" are very loosely structured, encourage improvisation, tend to envelop audiences, and are rarely if ever done in traditional theatrical spaces. Included in this category are the private "events," a genre particularly favored by the post-dada movement Fluxus, which gained the most attention in Germany and the United States. Fluxus was a loosely associated group of publishers and performers, many of whom studied with John Cage. They produced one of the first collections of performance art, conceptual art, event structures, and similar material simply called An Anthology in 1963.51 Probably the best-known performance artist associated with Fluxus was the German Joseph Beuys, a sculptor who turned to symbolically charged and often physically rigorous action events performed by himself.

Kostelanetz's "staged happenings" are more controlled events, occurring within a fixed space, often a theatrical stage, for example the Cage/Cunningham Variations V (1965), with a stage filled with vertical poles that generated an electronic sound as dancers approached them. The development of the "new dance" during the 1960s, drawing upon such sources as Halprin, Cage and Cunningham, Kaprow and Fluxus, produced some of the most memorable work of this sort. Central to such activity were the concerts of the Judson Dance Group, where such emerging artists as Yvonne Rainer, Simone Forti, Meredith Monk, and Carolee Schneemann experimented with chance composition, non-dance movement, and multi-media spectacles. "Kinetic environments," according to Kostelanetz, created "a constant, intrinsically interminable, enclosed field of multisensory activity through which spectators may proceed at their own pace." Finally, "staged performances" resembled traditional theatre, but with less emphasis on speech and more on mixed media. 52 Examples of this would include much recent avant-garde theatre: the Living Theatre, Robert Wilson, Richard Foreman, the Wooster Group, and modern dance-theatre—Meredith Monk, Pina Bausch, Maguy Marin. Timothy Wiles, seeking a descriptive term to characterize this latter non-traditional activity, has suggested "performance theatre," recognizing, like Kostelanetz, that this sort of theatre event "finds its meaning and being in performance, not in literary encapsulation."53

Thus, in the course of the 1960s, various strands from the visual arts (especially painting and sculpture), from experimental music and dance, from the traditions of avant-garde theatre, as well as from the evolving world of the media and modern technology, combined to offer an extremely varied mixture of artistic activity, much of it centered in New York, which stressed physical presence, events, and actions, constantly tested the boundaries of art and life, and rejected the unity and coherence of much traditional art as well as the narrativity, psychologism, and referentiality of traditional theatre. Although some such activities were spoken of as "performances," that was not commonly used as a term to describe them; indeed some experimenters, such as Kaprow, specifically rejected the term as too closely associated with traditional theatre. The terms "performance" and "performance art" only began to be widely utilized after 1970 to describe much of the experimental work of that new decade, which, although it expressed new concerns and took new directions, drew much of its inspiration and methods from the complex experimental mix of the 1960s.

Performance art

Performance and performance art emerged during the 1970s and 1980s as major cultural activities in the United States as well as in Western Europe and Japan. So complex and varied have been such activities, and so popular have they proven with the public and the media, that, like postmodernism (a product of the same historical culture), their very ubiquity and popularity have made them very difficult to define. What will be attempted in this chapter, therefore, will be a discussion of the general parameters of this diffuse field and of some of the most prominent of its features and practitioners. Perhaps it would be best to begin in the early 1970s, when the terms "performance" and "performance art" were just coming into vogue in the American artistic community, and to see what concerns in the art world encouraged such activities and what interests and felt needs among theatre theorists encouraged critical speculation upon these activities.

As performance art developed during the 1970s and 1980s, becoming always more varied in its manifestations and moving, if not into the mainstream of contemporary culture, at least into the general public consciousness, its relationship to many of the traditional entertainers in popular culture, such as the clown, the manipulator of physical objects, the monologuist and the stand-up comedian became clearer. In the early 1970s, however, performance art was, like the earliest cabaret performances, futurist evenings, or dada exhibitions, created by and for a very limited artistic community. What it had most in common with these and other experimental movements in both theatre and dance of the early twentieth century was an interest in developing the expressive qualities of the body, especially in opposition to logical and discursive thought and speech, and in seeking the celebration of form and process over content and product.

The primarily European avant-garde of the early twentieth century provided a background and lineage for early performance art, and in certain cases this avant-garde even provided direct inspiration through individual European artists who brought such experimental concerns to the United States during the 1930s and 1940s. The major foundations for the performance work in New York and California in the 1970s, however, came primarily not out of experimental theatre work, but out of new approaches to the visual arts (such as environments, happenings, live and conceptual art), and to dance (by such innovators as Ann Halprin, Simone Forti, and Yvonne Rainer).

When performance appeared as an artistic phenomenon around 1970, it had a close but ambiguous relationship to the then popular experimental form, "conceptual art." The term derives from a 1913 definition by Marcel Duchamp of the artist as one who selects material or experience for aesthetic consideration rather than forming something from the traditional raw materials of art, an approach that led first to his exhibition of already existing objects, the "ready-mades," and eventually to a consideration of real-life activities as art. Even those concept -artists who worked on something close to traditional painted surfaces, such as Jasper Johns with his collages or David Hockney with his photomontages, nevertheless called attention in their works to the process of creation and perception. Works such as the tableaux of Edward Kienholz, the mixed media abstractions of Judy Pfaff, or the disturbing assemblages of icons of racial stereotyping discovered and presented by Bettye Saar move off their surfaces to claim significant physical and psychic space in the external world. Earth and site artists such as Robert Smithson or Christo have extended concept art to large natural and human environments to make social and political statements or to alter conventional perceptions of the sites targeted by their work. Finally, certain artists such as Kaprow in the United States, Gilbert and George in England, and Joseph Beuys in Germany followed Duchamp in extending this interest in process, in perception, and in the revelation of already existing material to the activities of the human body as a part of the found or constructed environment. By the early 1970s such work had begun to be regarded not simply as a type of concept art, but as an approach of its own, to which the terms "body art" and "performance art" were given.

In its first manifestations, performance art was largely and often very specifically concerned with the operations of the body. The California magazine *Avalanche* in its opening issue (1970) offered a survey of recent "Body Works": "Variously called actions, events, performances, pieces, things, the works present physical activities, ordinary bodily functions and other usual and unusual manifestions of physicality. The artist's body becomes both the subject and the object of the work." In such work, according to an article the next year in *Arts Magazine*, the "verb and subject became one," and "the equipment for *feeling* is automatically the same equipment as for *doing*."

Bruce Naumann was one of the first of the body artists, taking his cue, several chroniclers of the movement have suggested, from Marcel Duchamp's act of having a star shaved on the back of his head in 1921.³ Naumann began in the mid-1960s making videotapes of parts of his body and audiotapes of its sounds, making casts of parts of his body, and manipulating his body or moving it through a series of repeated gestures. Later he created performance environments requiring the participants to follow a

carefully controlled set of actions.

Almost any sort of physical activity was explored by the body artists of the 1970s. Some, taking their cue from Kaprow, simply offered examples of "real-time activity"—walking, sleeping, eating and drinking, cooking-presented straightforwardly or with a distinctly playful edge, as in Tom Marioni's first major event, a beer party at the Oakland Museum in 1969 with the dadaflavored title The Act of Drinking Beer with Friends is the Highest Form of Art. The following year Marioni founded the Museum of Conceptual Art in San Francisco, an important center for such experimentation. The San Francisco Bay Area became for a time the center of "life art," involved with framing, intensifying, or ostending everyday activities. Bonnie Sherk performed such actions as Sitting Still (1970) and having a Public Lunch (1971) in unlikely places and placed a performative frame around certain of her activities as a short order cook at Andy's Donuts, as in Cleaning the Griddle (1973). Howard Fried, trained as a sculptor, placed framing devices around a wrestling match, a baseball game, and a golf lesson. Linda Montano and Marioni spent three days in 1973 handcuffed together in order "to achieve a heightened awareness of habitual behavior patterns."4

An important part of early 1970s performance, however, and

certainly the part that attracted the most attention from the media and the general public, were those pieces that went beyond everyday activity to push the body to extremes or even to subject it to considerable risk or pain. The artists most associated with work of this sort were Chris Burden and Vito Acconci. Chris Burden's first major performance piece, Five-Day Locker Piece (1971), confined him to a small locker ($2 \times 2 \times 3$ feet) in a campus art gallery, recalling a similar box confinement Beuys did with Fluxus in 1965. For his Shoot (1971), a friend shot him in the arm with a rifle, fascinating the national media. During the next several years he toyed with electrocution, hanging, fire, and a variety of sharp objects piercing his flesh. Two themes run through his many interviews about his pieces. One is that he was trying to use extreme body situations to induce certain mental states. "The violent part wasn't really that important," he said in 1978, "it was just a crux to make all the mental stuff happen."5

The other theme is that such acts partook of reality instead of the "more mushy" illusory world of theatre. "It seems that bad art is theatre," Burden posited in 1973. "Getting shot is for real ... there's no element of pretense or make-believe in it." After 1975 Burden turned away from works dealing with his own body, but a concern with violence and structures of power continues to inform his later work, as in Samson (1985) at the Seattle Art Gallery, where the entry turnstile was attached by rigging to two massive timbers so that if enough patrons passed through, the

front of the building would collapse.

Acconci's body works, which were given in New York while Burden was working primarily in California, were strongly influenced by the idea of "power-fields," described in The Principles of Topological Psychology by Kurt Lewin. Each of Acconci's works was thus involved with "setting up a field in which the audience was, so that they became a part of what I was doing ... they became part of the physical space in which I moved."8 Like Burden, Acconci performed a number of dangerous pieces that violently rejected the traditional illusion of theatre, but most were less spectacular, and in a number he was not physically visible at all, as in the notorious Seedbed (1971), in which he reportedly masturbated under a ramp over which his gallery audience walked.

As artists and critics struggled to define the emerging new genre of performance (and to draw boundaries through which individual artists, predictably, were always slipping), theatre was probably the most common "other" against which the new art could be defined. In Washington in 1975 Kaprow headed a panel on "Performance and the Arts," which included Acconci, Yvonne Rainer, and Joan Jonas, whose performance works incorporated elements from Native American Zuni and Hopi ceremonies of her native Pacific Coast. Attempting to define "performance," this panel noted that the space utilized in performance "is more often like a work space than a formal theatrical setting," and that performance artists initially avoid "the dramatic structure and psychological dynamics of traditional theater or dance" to focus upon "bodily presence and movement activities."

This orientation certainly was widespread in the performance work of the early 1970s, especially due to the influence of Kaprow and the happenings and the visual art background of most of the leading practitioners. The influence of the theatre was not, however, so easily denied. The very presence of an audience watching an action, however neutral or non-matrixed, and presented in whatever unconventional space, inevitably called up associations with theatre. Moreover, even as performance emerged as a distinct genre in the early 1970s, many of its practitioners utilized distinctly theatrical approaches. Despite the great range of experimental practice during this period, it is possible to group these more "theatrical" performances into two general types, which remained fairly distinct throughout the 1970s, until they joined together in what was widely regarded as the emergence of performance art into mainstream cultural consciousness, Laurie Anderson's United States in 1980 (see discussion later this chapter, pp. 115-16). On the one hand, there was performance as it was, for the most part, developed in California and New York-the work of a single artist, often using material from everyday life and rarely playing a conventional "character," emphasizing the activities of the body in space and time, sometimes by the framing of natural behavior, sometimes by the display of virtuosic physical skills or extremely taxing physical demands, and turning gradually toward autobiographical explorations. On the other hand, there was a tradition, not often designated as "performance" until after 1980 but subsequently generally included in such work, of more elaborate spectacles not based on the body or the psyche of the individual artist but devoted to the display of non-literary aural and visual images, often involving spectacle, technology,

and mixed media. Both approaches were often usually undertaken outside traditional theatre spaces, but one-person performance tended to favor "artistic" venues such as galleries, while the larger spectacles sought a wide range of performance spaces, both indoors and out. An important part of this latter activity came to be known as "site-specific" or "environmental."

During the late 1960s and early 1970s these image-oriented spectacles came to be recognized as representing an important area of avant-garde experimentation, and although they were given various labels, "performance" was not among them. 10 In 1968 Richard Kostelanetz gave the label "the theater of mixed means" to new works that rejected the verbal and narratological emphases of traditional theatre "in order to stress such presentational means as sound and light, objects and scenery, and/ or the movement of people and props, often in addition to the newer technologies of films, recorded tape, amplification systems, radio, and closed-circuit television."11 In 1977 Bonnie Marranca coined the term "Theatre of Images" to describe this same approach -works that rejected traditional plot, character, setting, and especially language, to emphasize process, perception, the manipulation of time and space, and the tableau to create "a new stage language, a visual grammar 'written' in sophisticated perceptual codes."12

Both Kostelanetz and Marranca traced the tradition of this new visual and aural theatre back to a mixed heritage of artistic and theatrical avant-gardes—the new dance, the cinema, Cagean aesthetics, popular culture, experimental painting, the happenings, the artistic "isms" of the early twentieth century. To this eclectic list one could add early performance art itself, since several of the most influential practitioners of such spectacle, such as Laurie Anderson and Robert Wilson, began as performance artists working with very simple means.

Contemporaneously with the development of happenings and of early performance art in the United States, a number of groups in Europe were experimenting with performance work emphasizing visual images rather than the body, much of it presented out of doors and often with a particular interest in odd, Rube Goldbergtype mechanical contraptions. British performance artists took the lead in such work in the mid-1960s, under the combined influence of the American happenings, a renewed interest in dada and other avant-garde theatre experiments, and the anarchic British comedy tradition. The People Show, founded by Jeff Nuttall in 1965 and characterized by alternative theatre historian Sandy Craig not only as Britain's "oldest and still [1980] most influential performance art group" but also as the "post-Dadaists of British theatre," introduced to its audiences a new kind of open and free-wheeling experience, offering collages of atmospheres, moods, and striking images clustered around some central theme. Despite its title and its formation in the revolutionary year 1968, The Welfare State, at least in its early years, was not overtly political, but operated in a spirit much closer to the carnivalesque People Show. The 1972 "Welfare State Manifesto" stated among its goals to:

make images, invent rituals, devise ceremonies, objectify the unpredictable, establish and enhance atmospheres for particular places, times, situations and people. In current terminology we fuse art, theatre and life style, but we aim to make such categories and role definition in itself obsolete.¹⁴

Rather more formalistic was The Theatre of Mistakes, founded in 1974 by Anthony Howell, a former member of the Royal Ballet, who under the infuence of Artaud, Noh drama, and recent experiments in painting and sculpture set up a workshop of "performance art" in order to explore the neglected "art of action, the art of what people do." ¹⁵

In the United States, and generally speaking on the European continent, the first modern performance artists tended to emphasize their artistic backgrounds and to reject any connection with popular performance, but many British performance artists from the beginning consciously incorporated into their experiments material from street mime, clown acts, and traditional vaudeville and burlesque—certain artists even specialized in such material, albeit with a theoretical or avant-garde consciousness that gave it a new context and orientation. The British willingness to mix popular entertainment with artistic experimentation could be seen in the popularity of such groups as the "world's first pose band," founded in London in 1972, which revived the nineteenth-century popular tradition of the *tableau vivant* to present extremely funny evenings of tableaux, most of them mocking the pretensions of the current art world and society.

During this same period the British gave a warm welcome to a related experimental performance group from Paris, Jérôme

Savary's Grand Magique Circus. Savary was an important international pioneer in the mixing of variety entertainment with physical spectacle, and in utilizing the sorts of unconventional locations that would come to be associated with "site-specific" theatre. In a 1970 interview in The Drama Review, Savary noted: "I am a firm believer in magic, in the creation of atmosphere. To liven things up we use real fires, smoke of all types and colors, fireworks, animals in the theatre. Sometimes we use a little tree or a chair, but derisively." The current avant-garde Savary condemned as too intellectual (and indeed the intellectual French avant-garde has never had much respect for Savary). He sought instead a broad general public, reared on television and the movies and open to "visual forms of entertainment." 16

After Savary's troupe visited Britain in the early 1970s, suggesting the avant-garde possibilities of such entertainment, circus skills, live music, and variety turns were developed by a number of younger British performance collectives, such as Incubus and Kaboodle, and by such feminist groups as Beryl and the Perils and Cunning Stunts. Such groups became known collectively as "Performance Art Vaudevillians." A similar interest developed somewhat later in the United States, where the quite eclectic group of mostly solo performers sometimes referred to as the "New Vaudevillians" became during the 1980s some of the most publicized experimental performers in the country (see pp. 112-13).

Large-scale outdoor spectacle, often utilizing fireworks, elaborate costuming and properties, and produced in an almost infinite variety of natural and constructed environments, became a specialty during the 1970s of the British company Welfare State, and during the following decade was a major sort of experimental performance in both Europe and the United States. Warner von Wely, who worked with Welfare State for three years, drew upon this inspiration to found Dogtroep, the leading outdoor theatre company in the Netherlands, which has presented at home, across Europe, and in the United States innovative performance involving elaborate visual images, bizarre mechanical constructions, and fireworks. The aim, says von Wely, is to "create ambiguous, hermetic images which you can hang meaning on, but which don't have any meaning themselves . . . the dramaturgical structure is a pretext to show the images." ¹⁷ Another image-oriented company that has performed in a wide variety of non-theatrical spaces in England also descended from Welfare State. This was the International Outlaw University (IOU), established in 1976.

The 1980s also saw the development of certain artists and groups in the United States specializing in site-specific multimedia spectacles with huge casts and crews. In California Lin Hixon put together enormous environments like movie sets, with motorcades and musical-comedy-style choruses. Her 1984 Hey John, Did You Take the Camino Far? occupied the loading dock of an industrial building in downtown Los Angeles, but its song and dance numbers and the movements of its teenager gangs and their cars spilled out into the adjacent public streets with no clear division between the performance and the city beyond. In 1985 Anne Hamburger founded En Garde Arts in New York, which has produced an impressive range of site-specific events at locations all over the city. Among the most ambitious was the 1990 Father was a Peculiar Man by Reza Abdoh, a series of visual and aural meditations on Dostoevsky's The Brothers Karamazov and on American popular culture of the 1950s and 1960s, performed by sixty actors and musicians throughout a four-block area of streets and warehouses in New York's meatpacking district.

In a special section devoted to performance art in *Artweek* in 1990, Jacki Apple suggested how the orientation of performance had shifted over its first decade:

In the '70's performance art was primarily a time-based visual art form in which text was at the service of image; by the early '80's performance art had shifted to movement-based work, with the performance artist as choreographer. Interdisciplinary collaboration and "spectacle," influenced by TV and other popular entertainment modes, as in the new work of Lin Hixon, set the tone for the new decade.¹⁸

Many of these new "spectacles," as we have seen, continued the anti-theatre orientation of early performance by seeking out non-theatrical spaces for their development, but despite the visibility and popularity of elaborate site-specific performances, especially in Europe, the technical demands of such work encouraged some of the best-known image and mixed-media performers to present most of their work in more conventional theatre spaces. This has been true of all three of the artists discussed in Marranca's book as the leading practitioners of the "Theatre of Images"—Richard

Foreman, Lee Breuer, and Robert Wilson. Foreman's Ontological-Hysteric Theatre has, of these three, been most consistently developed in small, experimental performance spaces, but these are packed full of the elaborate visual and aural material that characterizes Foreman's work—posed tableaux, a welter of odd objects, sketches and fragments of words and sentences, all sorts of framing and pointing devices, such as boxes, windows, frames, and strings, recordings, odd sound effects, repeated movements—all contributing to a rich overlay that continually calls attention to the constructedness of Foreman's work and to the process of reception itself. Breuer and the Mabou Mines have worked with more conventional narrative, though presented in a colorful style stressing poses, movement, visual puns, and the incorporation of visual and aural echoes from a wide range of popular culture. Most of Breuer's work, like Foreman's, has been presented in modest experimental venues, but one section of his on-going epic, The Warrior Ant, was offered at the Brooklyn Academy of Music, a center of large-scale performance work. He took full advantage of the facilities available there, with a number of bands and ethnic dancing companies, street parades, and both huge- and small-scale puppets.

The Brooklyn Academy has also been the favored U.S. venue for the best-known of the image-spectacle makers, Robert Wilson, whose first major work, The Life and Times of Sigmund Freud, premiered there in late 1969. Wilson began as a performance artist, dancer, and designer in the 1960s, strongly influenced by the happenings and early performance work of that period. His Sigmund Freud was immediately recognized as a significant new approach in experimental performance, especially by such sympathetic viewers as Richard Foreman, who wrote in the

Village Voice:

Wilson is one of a small number of artists who seem to have applied a very different aesthetic to theatre-one current among advanced painters, musicians, dancers and filmmakers—a non-manipulative aesthetic which would see art create a "field" situation within which the spectator can examine himself (as perceptor) in relation to the "discoveries" the artist has made within his medium. . . . Bodies and persons emerged as the impenetrable (holy) objects they really are, rather than the usual virtuoso tools used to project some play's predetermined energies and meanings. 19

Wilson's visual operas of the 1970s, especially Deafman Glance (1970), the 168-hour KA MOUNTAIN AND GUARDenia TERRACE at the 1972 Shiraz Festival in Iran, A Letter for Queen Victoria (1974), and Einstein on the Beach (1976), established him as one of the leading experimental theatre artists of his generation, a position he still maintains. His manipulation of space and time, his fusion of visual, aural, and performing arts, his utilization of chance and collage techniques in construction, his use of language for sound and evocation rather than discursive meaning, all show his close relationship to earlier experimental work in theatre, music, the visual arts, and dance. Speaking of Einstein on the Beach, Wilson advised: "You don't have to think about the story, because there isn't any. You don't have to listen to words, because the words don't mean anything. You just enjoy the scenery, the architectural arrangements in time and space, the music, the feelings they all evoke. Listen to the pictures."20 Between 1973 and 1980 Wilson created at least one project a year with Christopher Knowles, a brain-damaged teenager whose unconventional approaches to perception, language, and performance provided an important source of inspiration for Wilson and his theatre, reflected especially in the structure and use of language in A Letter for Queen Victoria and The \$ Value of Man (1975).

Theatre-based mixed media and performance spectacle appeared as a highly visible part of the experimental performance scene in many theatre centers outside the United States during this period as well. Wilson himself began premiering the majority of his large-scale works abroad, particularly in Germany, and his work inspired many young European and Japanese artists. (Parts of Wilson's monumental international project, the CIVIL warS (1984), were developed in the United States, the Netherlands, Germany, Italy, and Japan.) Wilson-type works became so important a part of the Italian experimental scene as to be considered a new genre, the "Nuova Spettacolarità" (new spectacularity) or "Media Theatre." The visual spectacles of Jan Fabre in Belgium, such as The Power of Theatrical Madness (1986), of the visceral Fura dels Baus in Spain, who terrorized international audiences with their Suz/o/Suz (1990), or of French-Canadian Robert Lepage, in such performances as Needles and Opium (1992), extended this sort of performance imaginatively and internationally.

Certain leading choreographers of the 1970s and 1980s worked in similar directions. Wilson himself worked with leading dancers and choreographers (with Lucinda Childs and Andrew deGroat in Einstein on the Beach, for example). Other contemporary choreographers have developed various combinations of dance, theatre, and performance art. Among these are Martha Clarke in the United States, whose painterly Garden of Earthly Delights and Vienna: Lusthaus (1986) were major dance and performance events of this period, and Maguy Marin in France, who has drawn upon Spanish and surrealist sources as well as the work of Samuel Beckett in such pieces as May B (1981). Modern dance-theatre (Tanztheater) became particularly important in Germany, led by the work of Pina Bausch, whose use of shock and sexual violence, as in her 1984 Bluebeard, contribute to her association with German expressionism. She also has much in common visually with Robert Wilson's cooler and more abstract visual operas in her love of large-scale works, with hypnotic sequences and monumental physical surroundings, such as the flooded stage and its wandering hippopotamus in Arien (1984).

While image-oriented and multi-media performance was developing the elaborate visual spectacles and explorations of space, time, and perception variously represented by Wilson's operas, Foreman's ontologic-hysteric productions, and the sitespecific, dance-theatre and mixed-media displays in Europe and the United States, small-scale individually oriented performance by no means declined in interest or popularity, but it did continue to change in character. Body art, especially the sort of foregrounded physical bodily display represented by Burden or Acconci, gave way to other sorts of display. A number of performance artists in Great Britain took quite literally the concept of turning their bodies into art through costuming and face and body painting. Best known internationally were Gilbert and George, whose first "singing sculpture," Underneath the Arches (1969), presented them in business suits and gold-painted faces, moving mechanically to the lyrics of a recorded song. Gilbert and George are also credited with pioneering the "static freeze" in the 1960s, in which a mime/robotic performer attracts the attention of an audience by holding a position of tension midway through an action. In these and related activities, traditional mime, such popular entertainments as the tableau vivant, magic, juggling, tumbling, and clown routines were enlisted in the service of modern performance.

An important element of American performance art since the

1980s has involved activity of this sort, set apart from the traditions that inspired it by a modern ironic and reflexive consciousness of the performing act. The group of performers has been generally characterized as the "New Vaudevillians," a term rejected by several of them and by Ron Jenkins who prefers simply "modern clowns" or "comic performers" and who has provided one of the best surveys of their work in his 1988 *Acrobats of the Soul.*²¹

Among his "acrobats" Jenkins includes: ventriloquist Paul Zaloom, who manipulates society's detritus—toys, utensils, milk cartons, boxes, and automobile parts-into a socially satiric "theatre of trash"; banjo performer Stephen Wade; the clown acts of leading contemporary circuses—the Big Apple, the Cirque du Soleil, and the Pickle Family Circus; magician clowns Penn and Teller; monologuist Spalding Gray; the Flying Karamazov Brothers, whose specialty is juggling almost any conceivable objects; and two solo clowns, Bill Irwin and Avner the Eccentric. Aside from Gray, who, as a rather straightforward monologuist, seems a bit out of place in this collection of highly physical artists, Bill Irwin is probably the best known of this group, and he is, for many, the central example of the "new vaudeville" or of modern clown performance. Irwin's background includes training in modern dance, in clown performance with both the traditional Ringling Brothers and the contemporary Pickle Family, and in avant-garde theatre with Herbert Blau's KRAKEN ensemble, and this diverse blend informs his multi-layered performances. Irwin's The Regard of Flight (1982) mixed traditional clown routines with continually foiled attempts to establish a new avantgarde approach to theatre and with the running accompaniment of a critic from the audience commenting on the work. In Largely New York (1989) Irwin appeared, according to the program, as a "post-modern hoofer" who attempted in vain to absorb the complexities of a variety of modern dance styles before ending up trapped inside a television set.

While some of the British and U.S. "vaudevillians," especially those closest to the clown tradition, perform in recognizable costumes, the primary concern of their display has not been the presentation of a particular "character" in the theatrical sense, but of physical activity and achievement—mime, physical dexterity, juggling, and so on. Other performance of the late 1970s and early 1980s displayed the body in costume but without the

vaudevillians' emphasis upon physical achievement. Generally speaking, these costumed performances did not seek to establish a coherent narrative character in the traditional sense, but to create a powerful visual image, or to embody some historical or contemporary individual or type upon which the artist wished to comment, often in order to make some social or satirical point. Paul Best created a female alternate persona Octavia, who appeared in makeup and costume in social situations that Best felt would reveal stereotyped gender expectations.²² Other improvised public performances sought to reveal aspects of the artist's own personality or dreams. Eleanor Antin developed a whole series of "personae" built up in a series of performances, the best known being her black ballerina, Eleanora Antinova, and her King of Solona Beach who appeared from time to time in

makeup and costume to chat with his "subjects."23

Antin's roving King and Best's Octavia bear a close relationship to a type of European performance activity the British have called the "walkabout," in which costumed performers improvise interactions with the general public. Some attempt to blend in with their surroundings, often consciously seeking to stimulate amused confusion. The trio La Compagnie Extrêmement Prétentieuse pretends to be obsequious but incompetent waiters in French street cafés. Théâtre Décale is made up of Inspector Clouseau-type detectives who look into people's luggage, inspect displays in shops, stop passing bicyclists, and then walk off with various items. One of the best known and most consciously subversive groups is Natural Theatre, which greeted then prime minister Margaret Thatcher as pram-pushing nannies, appeared as pot-smoking policemen at the Glastonbury Festival, and has parodied protest demonstrations by demonstrating in normal if rather outdated clothes against bicycles. Other groups attract attention by assuming interesting public roles. The German Scharlatan Theater has pretended to be a film crew setting up for a shoot. The actors of Spain's Trapu Zaharra Teatro Trapero appear as seemingly harmless, bewildered mental patients with bandaged heads, who appeal for comfort to passersby until they are picked up and carried off by what appears to be a real ambulance. Other walkabout performers are more eccentric still. Natural Theatre has appeared as egg-headed aliens from space, and the German trio The Crazy Idiots roam city streets in penguin costumes, confronting and even attacking passersby.24 Most walkabout work is performed by one, two, or three performers, but Natural Theatre normally works with more, as does the Amsterdam company Tender, which has become so familiar a part of the local intellectual landscape that Amsterdam citizens will often assume, correctly or not, that any odd occurrence that they note in the streets is a Tender performance.

"Walkabouts" in the United States have tended to be more interested than parallel European performances in the exploration of alternate "selves." Indeed the use of performance to explore alternate "selves" or to reveal fantasies or psychic autobiography had become by the mid-1970s a major approach to performance in the United States. For much of the general public, this still remains the most familiar and accessible manifestation of this movement. The work of Antin suggests two quite different directions such work could take. One direction presents alternate "selves," one per performance or several in sequence, exploring concerns vital to the performer's psyche. An example would be Whoopi Goldberg's dramatic monologues, enjoying a successful Broadway run in 1985, drawing upon her marginalized position as a performing black woman to depict a range of "outsider" personae, yet harkening back also to the mainline entertainment monologue tradition of Ruth Draper and Beatrice Herford. Such popular and important contemporary monologue artists as Eric Bogosian and Anna Deveare Smith can also be viewed as working in this tradition, but both also draw very consciously upon the material and attitudes surrounding modern performance art. Bogosian's background includes performance art work, and he has been characterized as "less a writer or actor than a mixture of stand-up comic and performance artist."25 Bogosian himself has commented on his ambiguous position:

People from theater came and said, "That's not theater".... Performance artists came and said, "That's not performance art." But I don't really care what you call it. That's not important. What's important is effect.²⁶

It is doubtless the depiction of created "characters" that makes many persons interested in performance art unwilling to apply this label to performers like Whoopi Goldberg and Eric Bogosian. Much less of a problem is posed by another direction in contemporary monologue work, which utilizes a distinctly more individualized autobiographical narrative avoiding the alternate

"selves" that have a tendency to crystallize into new "characters" with a distinctly "theatrical" feel. Despite its privileging of language uncharacteristic of early performance art, this sort of work still focuses on the specific persona of the performer, displaying now both body and psyche. A well-known example of this approach is Spalding Gray, who has spun his dreams, memories, and reflections into a fascinating series of oral histories, delivered simply sitting at a table with notes and a glass of water. Solo performance art and monologue have been particularly associated in the late 1980s and early 1990s with feminist and gay performers such as Holly Hughes, Karen Finley, and Tim Miller, and will be considered in more detail in later chapters.

Autobiographical material is also the foundation of the work of Laurie Anderson, whose *United States* is in many respects a pivotal event in modern performance. It brought the concept of performance art for the first time to a wide general public, as was witnessed by such mass circulation periodicals as *Time*, which called it "the biggest, most ambitious and most successful example to date of the avant-garde hybrid known as performance art,"27 and People Weekly, which observed that Anderson was "the only practitioner of that quirky, free-form genre called

'performance art' to have catapulted into pop culture."28

In addition to the public attention United States brought to performance art, however, it was a key work in bringing together the two hitherto quite disparate approaches to performance represented by individual performers stressing the body, and the mixed media "theatre of images." Anderson's own career was distinctly influenced by leading practitioners in both approaches. In the early 1970s she became interested in the body work of Vito Acconci, who in 1974 sponsored an early concept work by Anderson, O-Range. After this she explored autobiographical subject matter presented in mixed media and with the aid of such gadgets as a self-playing violin, suggesting the dadaist devices of such contemporary British performance groups as The People Show. In 1976 she attended Philip Glass and Robert Wilson's Einstein on the Beach, which inspired her to develop her smallscale pieces into large and complex multi-media productions, these leading in turn to United States, a seven-hour "performance portrait of the country," which combined stories, songs, slide projections, film, and, in a kind of tribute to the performance art tradition, a percussion solo played on Anderson's amplified skull. People Weekly, alert to Anderson's populist appeal, characterized it as a "whizzbang techno-vaudeville." The songs and stories grew out of Anderson's dreams and experiences, including even the experience of creating this production, but like the more minimalist work of Spalding Gray (for whom Anderson has also provided soundtracks), these personal musings reverberated through a cultural moment. Anderson is well aware of this and has remarked:

If I were really just expressing myself, I wouldn't think that people would be that interested. I try to pick things that would make people say, "I was just thinking that a couple of days ago; I didn't say it exactly like that but I had that idea."²⁹

This sense of providing a voice and body to common (and generally unarticulated) experience is very important to much modern performance, especially that created by and for marginalized or oppressed communities. Performance artist Barbara Smith, for example, has explained: "I turn to question the audience to see if their experiences might enlighten mine and break the isolation of my experience, to see if performance art puts them into the same dilemma." ³⁰

Despite the enormous variety of performance activities during the 1970s and 1980s, it is possible to trace two over-all and related trends. First, the initial wide-spread opposition of performance to theatre has steadily eroded; and second, the initial emphasis on body and movement, with a general rejection of discursive language, has given way gradually to image-centered performance and a return of language. In her brief survey of modern performance art in *Artweek*, Jacki Apple proposes precisely these phases, arguing that by 1990, word had become "the dominant factor—the performance artist as poet, storyteller, preacher, rapper, with image at the service of text."³¹

This shift is clear almost everywhere one looks in recent performance. Solo performance, though still built upon the physical presence of the performer, relies heavily upon the word, and very often upon the word as revelation of the performer, through the use of autobiographical material. This is true whether one considers the work of a visual minimalist such as Spalding Gray or the elaborate mixed-media productions of Laurie Anderson. Even the physically oriented "new vaudevillians," such as Bill Irwin, Paul Zaloom, Avner the Eccentric, or the Flying

Karamazov Brothers, rely heavily upon language to provide an intellectual and often political or artistically self-reflexive depth to the physical display. Henry Louis Gates, Jr., in a spring 1995 issue of The New Yorker chronicles the recent appearance at two downtown New York performance spaces (the Fez and the Nuyorican Café) of a new "scene" or "movement" in language performance called "rap meets poetry." Gates' description emphasizes the performative nature of this work—work that is "captivating in performance" even though it "just doesn't survive on the page." Gates' description of the performative space of this work is strikingly similar to Victor Turner's liminoid space of performance, a "hybrid space where cultural styles jostle and collide; where culture wars spawn not new resentment but new cultures."32

The so-called "theatre of images," especially in the United States, has also accepted the word as an important part of its activity. This has always been true of Richard Foreman and Lee Breuer, for example, but even Robert Wilson, after a kind of transition in which words were employed rather as chance elements, has since the late 1980s turned increasingly toward the staging of plays from the verbal tradition—Chekhov, Ibsen, Euripides, Büchner, Shakespeare. Wilson has even moved from the huge multi-media spectacles that established his reputation to offer in the summer of 1995 his own solo adaptation of Hamlet for New York's Lincoln Center's Serious Fun Festival.

One of the trends that encouraged a greater use of language in both solo and group performance from the mid-1980s onward, especially in the United States, was that political and social concerns became one of the main themes of performance activity, especially in work involving individuals or groups with little or no voice or active role in the current system. The importance of political and social content, closely tied to the importance of language in more recent performance art, has not only altered the landscape of current performance, but has changed views of its historical development. Performance historians now recognize that during the mid- to late 1960s many types of political demonstrations included consciously performative elements but were not associated with performance art when it developed because of its original emphasis upon non-discursive activity. These political performances of the 1960s and later, often developed by participants with theatrical backgrounds, were more commonly referred to at that time as "guerrilla theatre," a term coined by R. G. Davis to describe popular performances using materials from popular theatre and public spaces to bring political messages to a broader audience.³³

It was Richard Schechner, with his wide-ranging view of performance, who subsequently noted that what would later be called "performance" could equally well include much so-called "guerrilla theatre," as well as other contemporary actions with a similar motive but much less theatrical ambiance carried out by the Provos, by Abbie Hoffman, and later, Jerry Rubin: "dropping dollar bills on the floor of the Stock Exchange; dumping a truck of soot and garbage on the brass of Con Ed [Consolidated Edison]; showing up at HUAC [House Unamerican Activities Committee] meetings dressed as a revolutionary war patriot." 34

More formal companies, such as the United States' Bread and Puppet Theatre, San Francisco Mime Troop, and Teatro Campesino or England's Cartoon Archetypical Slogan Theatre (CAST), also applied many of the strategies of modern performance to political and social concerns, stressing visual display, reviving folk and popular performance elements from vaudeville, clown acts, and puppet shows, and presenting their work out of doors or in unconventional non-theatrical spaces. Early feminist performance groups, such as WITCH, to which we will return in a later chapter, were another part of this activity.

With the end of the Vietnam War, such activities diminished in the United States, but never entirely disappeared. In the 1980s political performance became more common again, but now often involved with new ecological concerns. In England the group Welfare State, for example, took on a much more political orientation, inspired in part by seeking to respond to the concerns of the communities where it performed, and in part by a belief that art should resist the over-production and consumerism of the developed countries. A 1982 statement of "Intentions" began with both artistic and social goals:

- 1. To fuse boundaries between painting, sculpture, theatre, music and events.
- To analyse the relationship between aesthetic input and its social context.
- 3. To explore non-naturalistic and visual performance styles.35

The company's best-known work, repeated several times in the

late 1970s and early 1980s, was *The Burning of the Houses of Parliament*, which punctuated current social concerns with a series of spectacular fire sculptures and featured giant figures representing Margaret Thatcher and Guy Fawkes, a Hell Mouth, and a huge conflagration finale.³⁶

Now that "performance" had entered the cultural vocabulary, such actions as Greenpeace's plugging of chemical effluent pipes or hanging ecological banners on the Statue of Liberty (1984) or on Mount Rushmore (1987) were duly reviewed in the journal High Performance.³⁷ Certainly it is true that the Greenpeace ecological actions, consciously or not, were converging with ongoing performance experimentation much more clearly rooted in the art world. Earth artists like Smithson and Christo had since the 1960s been utilizing environmental themes, as did current performance work such as Joseph Beuys' 7000 Oaks (1982-7), which gathered support to plant trees throughout Kassel, Germany, 38 or Brazilian artist Bené Fonteles, whose "garbage delivery performances" in 1984, 1986, and 1987 piled truckloads of litter on a city's main square to "bring back to the people of Cuiabá the garbage and litter they left behind in the forest, creeks and waterfalls during weekend picnics."39

The materialism, the ecological indifference, and the suspicion of leftist or decadent elements in the arts that were features of the Ronald Reagan-era United States and Thatcher-era England encouraged a distinctly more adversarial, admonitory, and polemic orientation in much performance, typically and highly visibly demonstrated by Laurie Anderson, whose Empty Places (1989) used a visual computer but presented the artist alone on stage, telling tales and singing songs against images of a dark, suffering Reagan-era America, and whose Voices from the Beyond (1991) was a two-hour monologue, with a few songs and a single visual image, dealing with censorship in the arts, the know-nothing patriotism surrounding the Gulf War, and the second-class status of women, illustrated through personal anecdotes. Her Halcion Days: Stories from the Nerve Bible (1992) returned to a more multi-media setting but continued to mix political and personal concerns.

Performance has also moved into political activity directly within disadvantaged communities, inspired in part by the U.S. and European tradition of political performance and in part by specific community-oriented reformers such as Stuart Brisley,

Joan Littlewood and Welfare State in England, Armand Gatti in France, and particularly Augusto Boal in Latin America. Here art merges with daily activity not for perceptual experimentation, as in body art or Cunningham's modern dance, but as a means of exploring social situations and of developing leadership and coping skills in the participants/audience. One example among many is that of John Malpede and the Los Angeles Poverty Dept. (LAPD), a performance collective addressing the needs and concerns of the downtown Los Angeles skid row population and utilizing performance to help that population understand, cope with, and, it is hoped, improve their conditions.⁴⁰

Whether, as some theorists have suggested, social and political concerns have become central to performance in the 1990s, there is no question that the extent of such interest has vastly increased in recent years and continues to grow. Its range also is very great, addressing an enormous variety of ecological, social, economic, and political concerns with an equally wide range of performance strategies. Despite the broad social implications of many of these concerns, solo work has remained a major and for many the most typical type of performance, but solo work has itself become much involved with social concerns and the relation of these to individual identity. Such work will be the focus of Chapter 7, while Chapter 8 will take a more general look at the difficult and complex matter of the strategies and operations of politically and socially relevant performance in the postmodern era.

Performance and contemporary theory

Performance and common and common

Performance and the postmodern

The contemporary terms "performance" and "postmodernism" are products of the same cultural environment, and both have been widely and variously employed to characterize a broad spectrum of activities, especially in the arts. The relationship between them is thus a highly complex one. Critics and reviewers have found "postmodern" a useful tag to apply to much contemporary performance work. Thus Bill Irwin has been tagged a "post-modern choreographer" by the dance critic of the *New York Times*¹ and as a "post-modern clown" by its theatre critic.² Performers themselves have claimed the term, sometimes to give their experiments a fashionable contemporary cachet and perhaps rather more often (given the ironic and self-reflexive nature of much modern performance) to poke a bit of fun at the whole process of genre names and critical fashion. Thus we find New York performance artist Annie Sprinkle offering a 1991 show with the title "Post-Porn Modernism," while a popular San Francisco performance group styles itself Pomo Afro Homos (Post-modern African-American Homosexuals).

Yet there is clearly a much closer relationship between performance and postmodernism than the former's occasional amused appropriation of a currently fashionable critical term as a way of poking fun at such fashion. Nick Kaye, in his thoughtful and stimulating recent study of the relationship of these two terms, suggests that "the condition of 'performance' may be read, in itself, as tending to foster or look towards postmodern contingencies and instabilities," and that performance "may be thought of as a primary postmodern mode." Michel Benamou introduces the major anthology *Performance in Postmodern Culture* (1977), which he co-edited with Charles Caramello, with the similar observation that performance is "the unifying mode of the postmodern."

One of the first attempts to articulate a postmodern aesthetic was Ihab Hassan's The Dismemberment of Orpheus: Towards a Postmodern Literature in 1971. In tracing the development of this aesthetic in literature, Hassan selects as a key figure Marcel Duchamp, who, as we have seen, also occupies a key position in the development of the aesthetic of modern performance. Even more strikingly, in a 1980 essay on "The Question of Postmodernism," Hassan offers a rather surprising binary table opposing features of modernism and postmodernism (surprising in that such binary organization would seem itself a strategy quite opposed to the postmodern project). The first opposition in this table pits two art movements with strong "performative" orientation—'Pataphysics and Dadaism—as representatives of postmodernism, in contrast to romanticism and symbolism, representing modernism. Somewhat further in the list, we find "process/performance/happening" offered as the postmodern opposition to modernism's "art object/finished work." This distinction between the work-in-itself, finished, complete, and unchanging, and the work-in-progress, incomplete, contingent, and fluid, is widely found in systems such as Hassan's that seek to oppose modern to postmodern attitudes, and we will later consider the background and some of the implications of such a distinction. When Hassan summarizes postmodernism "as an artistic and philosophical, erotic and social phenomenon," his list of characteristics closely resembles what one might draw up to characterize "performative" activity. According to Hassan, "postmodernism veers toward open, playful, optative, disjunctive, displaced, or indeterminate forms, a discourse of fragments, an ideology of fracture, a will to unmaking, an invocation of silence—veers toward all these and yet implies their very opposition, their antithetical realities."6

The historical relationship between performance and post-modernism is, however, much more troubled than the current theoretical coziness between them would suggest. When performance emerged as a particular new art activity around 1970, its theoreticians and practitioners were almost entirely associated with the art world, then still dominated by the theoretical interests of minimalism and high modernism. These interests were much concerned with separating out the arts in order to find and develop the "essence" of each. Two statements of the goals of modernist art, both extremely influential and widely

cited, may be taken as central examples of this attitude: Clement Greenberg's "After Abstract Expressionism" (1962) and Michael Fried's "Art and Objecthood" (1968). Greenberg interpreted the history of art as a progressive, empirical search for "the irreducible working essence of art and the separate arts." In this project each separate art rejects the "dispensable, unessential" conventions of its own tradition as well as elements of other arts to seek its own formal essence, which Greenberg saw in pictorial art as "flatness and the delimitation of flatness." Students of theatre history may be reminded of modernist attempts in that field also, such as those of Gordon Craig and Adolphe Appia at the turn of the century and subsequently Artaud, to strip away accumulated conventions and the borrowings from other arts to discover the "essence" of theatre. In early performance theory and practice this modernist or minimalist attitude can be clearly seen-in body art works, for example, that consisted only of simple actions, devoid of narrative, mimesis, or aesthetic shaping.

An essay bridging between Greenberg's "After Abstract Expressionism" and Fried's "Art and Objecthood" was Greenberg's "Recentness of Sculpture," discussed at length by Fried, which introduced the concept of "presence" to the analysis of modern minimalist art. Presence, Fried noted, involved not the obtrusiveness or often even aggressiveness of the work but:

the special complicity that that work extorts from the beholder. Something is said to have presence when it demands that the beholder take it into account, that he take it seriously-and when the fulfillment of that demand consists simply in being aware of it and, so to speak, in acting accordingly.

Such presence, Fried remarks, might in fact be called a kind of "stage" presence, and as such is antithetical to the essential minimalist project, which rejects the situation or the interaction with a viewer to be wholly manifest within itself.9 Similarly, Fried denies any effect of duration in the art experience, presence being available in the perceptual instant and duration of experience being "paradigmatically theatrical." The attention to situation and to the participation of the spectator, introducing in turn irrelevant questions of value, the consciousness of an experience in time, and a rejection of the search of the essence of each art in favor of a blurring of boundaries, all of these Fried characterizes as theatrical tendencies in art, leading to his often-quoted pronouncement: "The success, even the survival, of the arts has come increasingly to depend on their ability to defeat theatre." ¹⁰

Given Fried's rejection of both duration and reception, it is difficult to imagine how performance of any kind could qualify as a modernist or minimalist expression, but a number of theorists and practitioners involved with performance during the 1970s attempted to create something of this sort. Significantly, like Fried, they all saw performance's separation from and rejection of theatre as central to their vision. An important precursor in this project was Antonin Artaud, who offered a particularly influential example of an attempt to restore the art of performance to its essence, which he felt had been corrupted by speech and words, logic and narrative. His interest in a variety of media-light, sound, color, space, gesture—seems far removed from the essentialism of Fried, but there are also strong points of similarity. Artaud too sought an art complete within itself, in which both the passage of time and the split between observer and observed ceased to exist. Early performance, such as body art, conceived under the influence of minimalist theory, shared certain of Artaud's concerns, and came closer than most subsequent performance to addressing them. Such performance sought what might be characterized as a physical rather than a psychic essentialism. Like Artaud, this performance rejected the "theatrical" trappings of discursive language, narration, and character, but in the name of minimalism and anti-theatre it also rejected Artaud's interest in non-verbal spectacle, seeking the "essence" of performance in the operations of the body in space.

Closely associated with the rejection of theatre in both Artaud and early performance artists and theorists was a rejection of the "pretense" of theatre, of its attempted evocation of another, "absent" reality through mimesis. Happenings and similar experiments were based upon pure "presence"; they were, in Michael Kirby's term, "non-matrixed." The traditional semiotic orientation of theatre gave way in the new experimental work to a phenomenological orientation, specifically characterized as "nonsemiotic" by Kirby, who attempted to find structures that would "work against sending a message about something." This idea is strongly felt in Marranca's *Theatre of Images*, which she sees as focused upon "process—the producedness, or seams-showing quality of a work," in an attempt

to make the audience more conscious of events in the theatre than they are accustomed to. It is the idea of being there in the theatre that is the impulse behind Foreman's emphasis on immediacy in the relationship of the audience to the theatrical

The work of Richard Foreman is often cited by phenomenological theorists, and quite appropriately, since Foreman in both his practice and writing rejected traditional theatre's interest in attempting to infuse the audience with some imaginary idea or emotion. He sought instead to call attention to the audience's moment-by-moment existence in the theatre—to seeing what is there, to seeing themselves seeing, and thus to "ground us in what-it-is-to-be-living."13

Thus Fried's rejection of "theatricality," interpreted in the case of performance as a rejection of the narrative, discursive, mimetic quality of traditional theatre, fitted in well with a growing interest in non-narrative, non-discursive, non-mimetic performance, concerned with the immediate experience of an event. Indeed, despite a tendency by the early 1980s to characterize performance art as a postmodern phenomenon, its roots and much of its early development were really more distinctly modernist, as Xerxes Mehta pointed out in a review of current performance art at the end of the 1970s. Far from being a "postmodern" phenomenon, Mehta concluded, this work was "in its insistence on flatness and abstraction, and in its profound indebtedness to every major modern art movement since Cubism, firmly in this century's great tradition of modernist formalism."14

The contradictory pulls of modernism and postmodernism on performance have been articulated most clearly in dance theory, where the two terms have gained almost universal currency, even while their precise meanings have been hotly debated. There has also been a kind of evolution in the associations of the term "postmodernism," that can be seen, for example, in the writings of Sally Banes, the theorist most associated with applying this term to dance. Banes locates the development of "post-modern dance" in the 1960s, centered at the Judson Church in New York, but soon spreading out through galleries, lofts, other churches, and various largely non-proscenium spaces. Among the avant-garde modern dancers who prepared the way for postmodern dance, Banes cites Merce Cunningham, James Waring, and Ann Halprin, all dance experiments.

Despite these innovations, Banes suggests that throughout the 1950s even in the work of Cunningham the traditional modern dance aesthetic still ruled—an aesthetic regarding dance in terms of a particular expressive function, carried out in certain patterns composed of particular styles and materials. The break from this expressive tradition that launched postmodern dance Banes locates at the Judson Dance Theatre between 1962 and 1964, growing out of Robert Dunn's classes in choreography at the Cunningham Studio. Dunn specifically challenged the approach of influential teachers of modern dance, such as Louis Horst and Doris Humphrey, who viewed dance as expressing feelings through the natural languages of bodies and rhythms of life echoed in the essentials of choreographic form. 15 Dunn saw as one of his goals liberating dancers "from Louis and Doris," and the tradition they represented of "appropriate" and even "essential" dance forms and functions. Dunn looked instead to "various sources of contemporary action: dance, music, painting, sculpture, Happenings, literature."16 This eclecticism naturally led to a wide range of experimentation, though one might still argue (as Banes does not) that Judson Dance had not so much broken from modernism as it had broken from the traditional idea of what constituted dance. What was really rejected was the expressionist aesthetic that anchored conventionalized movement to a literary idea or musical form.

Other theorists and commentators on the contemporary dance scene have objected to Banes' line of argument, not because she categorizes the Judson work and related manifestations as post-modern—that categorization is now widely accepted in the dance world—but rather because she argues that this "postmodern" work has its closest parallels to "modernist" work in the other arts. "Often it has been precisely in the arena of post-modern dance that issues of modernism in the other arts have arisen," Banes suggests. "Thus in many respects it is post-modern dance that functions as *modernist* art." In opposition to this, Nick Kaye

in his study of postmodern performance argues that postmodern dance is far too varied and complex a phenomenon to be characterized in this manner, and that, in any case, a performative art such as dance, whether modern or postmodern, could never achieve a really "modernist" form. The "reduction" of dance to a modernist "legitimating essence" of movement is a highly problematic maneuver, and the rejection of duration and situation by modernist theorists such as Fried would exclude from the modernist project not only what Fried calls "theatre" but also dance and indeed any performance.18

Susan Manning, in the course of an extended debate with Banes carried on in the pages of The Drama Review in the late 1980s, argued somewhat similarly that Banes' approach misrepresented both modern and postmodern dance by conflating their aesthetic concerns. If, as Banes states, postmodernism is based on "acknowledgement of the medium's materials, the revealing of dance's essential qualities as an art form, the separation of formal elements, the abstraction of forms, and the elimination of external references as subjects,"19 then it not only corresponds closely to the modernist project in other arts (as Banes herself points out) but, Manning argues, in fact corresponds closely to the project of modern dance itself as it was described by such dance historians as Lincoln Kirstein and John Martin in the 1930s.20

Unquestionably many theorists and performers in the dance world agreed at least in general with the concept of postmodern dance articulated in Terpsichore in Sneakers. As early as 1975, The Drama Review offered a special issue on "Post-modern Dance," in the Introduction to which Michael Kirby defined such dance in the same minimalist terms that were then highly fashionable in the art world and for that matter in the world of performance art, in which Kirby also had a very strong interest. Postmodern dance, suggested Kirby, "ceases to think of movement in terms of music," is not involved with "such things as meaning, characterization, mood or atmosphere," and uses lighting and costume "only in formal and functional ways."21 Clearly this approach informs, for example, a 1981 review of Bill Irwin by Anne Kisselgoff, the dance critic of the New York Times, who comments that "Like a good post-modern choreographer, Mr. Irwin uses repetition, changes in speed and dynamics, and breaks in pattern to achieve his effect. Pure movement is all."²² The power of the essentialist paradigm is clear when one considers how astonishingly inappropriate it is to suggest that "pure movement is all" in this, or indeed in any of Irwin's productions, which are full of ironic content. More to the immediate point, however, is the question of what makes this "good post-modern" work, when such a concept as "pure movement" is so obviously modernist. Clearly the assumptions here are in line with Banes' argument in Terpsichore in Sneakers that postmodernism in dance would be called modernism anywhere else. When this criticism was written, at the beginning of the 1980s, there seems to have developed a general consensus that "postmodern dance," though it referred to a distinct body of experimentation, was something of a misnomer, since this work was really more modernist, essentially the same point that Mehta made at this same time about so-called "postmodern" performance art.

More recently, however, responding to the increasing complexity of dance experimentation and perhaps also to such criticisms as those of Manning and Kaye, Banes has put forward a more complex model of postmodern dance. In the concluding essay of a TDR forum asking "What Has Become of Postmodern Dance?" in 1992, Banes suggested that the modernist "analytic postmodern dance" that was the focus of her 1987 book was really framed by periods of quite different experimentation. Early 1960s experimental dance, she suggests, was created in a spirit of "democratic pluralism," ranging from minimalism to "a welter of multimedia," with minimalism becoming dominant later as this generation "increasingly allied itself with the art world." 23 By the late 1980s and 1990s, however, a second generation of postmodern choreographers, as well as international and media influences, once again encouraged stylistic diversity and work that, Banes argued, had much closer affinities to postmodernism as it had been defined in other artistic fields.

Not surprisingly, when Banes looked for models of usage in other fields her attention turned to architecture, since even though the term "postmodern" was occasionally to be encountered in art criticism as early as the 1930s, it did not gain much currency or much specificity until it was popularized by Charles Jencks, who began in 1975 to apply it to the field of architecture. Central to Jencks' formulation was the concept of "double-coding." Postmodern architecture, according to Jencks, calculatedly appeals to a double audience of experts and the general public by combining elements of modernism and of classicism in a playful, decorative, and self-conscious blend.24

Probably the most fully developed theoretical statement of this approach to postmodernism is Linda Hutcheon's A Poetics of Postmodernism (1988), devoted primarily to literature, although suggesting that analogous work can be found in painting, sculpture, film, video, dance, television, and music. (She does not, unhappily, mention either theatre or performance art.) Hutcheon traces a phenomenon similar to Jencks' double-coding in recent "paradoxical" fiction, which ironically and self-consciously "uses and abuses, installs and then subverts, the very concepts it challenges."25 Umberto Eco suggested a similar double-coding in postmodern literature, which mixed contemporary experiment with an ironic and self-conscious utilization of traditional forms, allowing (as Eco's considerable popular success with The Name of the Rose (1983) demonstrated) an appeal to both popular and specialized audiences. John Barth also stressed the potential appeal of postmodernism both "to a more general public and to devotees of high art" and stressed the "performative" quality of postmodern work-work "that is more and more about itself and its processes, less and less about objective reality and life in the world."26 This approach to postmodernism focused upon the tendency of the modernist project in all of the arts to become increasingly an art for artists and critics-highly abstract and technical—and saw postmodernism, at least in part, as a reaction, restoring art to a broader public without sacrificing its aesthetic richness or complexity.

The "second generation" of postmodern choreographers, Banes now argued, was producing works that could be considered part of the "canon of postmodernism" as defined by Jencks. Such work had clear parallels to postmodern architecture through its "references to classicism and to other dance cultures, its plenitude of theatrical means, and its increased accessibility." In short, Banes now suggests that postmodern dance "began as a postmodernist movement, underwent a modernist interlude, and has now embarked on a second postmodernist project."27 Thus, at least for this new generation (and for much recent work of the older generation), the concepts of postmodernism in dance, as articulated by Banes, and in architecture, as articulated by Jencks, seem to be converging—a convergence already argued as early as 1983 by Roger Copeland, whose essay "Postmodern Dance/ Postmodern Architecture/Postmodernism" suggested that much current work in dance, and in particular that of Twyla Tharp and

Laura Dean, had the same "essential characteristics" as postmodern architecture, these being "a retreat from the doctrines of purity and unity, a learned and eclectic historicism, and perhaps a new determination to heal the century-old rift between the modernist avant-garde and the middle class mainstream."28

The general popularity of "postmodernism" as a critical term has guaranteed its wide appearance in recent writings in the fields of theatre and of performance art, but for good or ill, neither of those fields has produced a specific theorist, like Jencks in architecture or Banes in dance, who has provided a kind of focal point, however disputed, for usage of the term. Thus "postmodernism" has never really been established as defining a particular approach or even a group of artists within the theatre (as, for example, such earlier art terms as "naturalism" or "expressionism" did). Certain works may be characterized by one writer or another as "postmodern," 29 but the term is most frequently encountered as describing certain tendencies or strategies that recall or seem to relate to postmodern work as it has been described and analyzed in other fields, particularly in architecture, dance, and literary studies.

Thus the concept of double-coding, associated by both Banes and Jencks with postmodern expression, has clearly influenced certain critical appraisals of both performance art and recent experimental theatre. It is most likely by analogy with Jencks' model, and not at all because of their use of "pure movement," that the term "postmodernist" has been so often applied to Bill Irwin and to other representatives of the so-called "new vaudevillians." Similarly, one could argue that the simultaneous installation and subversion of already familiar codes and material that Hutcheon characterizes as postmodern practice has become virtually a trademark of the Wooster Group, with its reworkings of material from T. S. Eliot, Eugene O'Neill, Thornton Wilder, Arthur Miller, Gustave Flaubert, Anton Chekhov, and others.

Parody, pastiche, and ironic citation are certainly involved in the work of these and many other performers who have been characterized as postmodern, but the operations of double-coding surely provide only a partial perspective. It is clear that even performers like the Wooster Group who are much involved with cultural citation cannot be primarily characterized as experimenting with double-coding, and, even more seriously, many so-called "postmodern" performers cannot be said to be involved with double-coding at all.

The inadequacy of an attempt to associate postmodernism narrowly or exclusively with Jencks' approach is specifically challenged by the art theorist Hal Foster in his 1984 essay "(Post)-Modern Polemics," which suggested that in current U.S. cultural politics there were "at least two positions on postmodernism": one that he considered "aligned with neoconservative politics," the other "related to poststructuralist theory." 30 Although Foster does not mention Jencks by name (at least not in this particular essay), it is clearly his approach to postmodernism that Foster characterizes as "neoconservative," a program designed "to recoup the ruptures of modernism and restore continuity with historical forms."31 Thus, at least rhetorically, neoconservative postmodernism seeks to move beyond the abstract sterility of modernism by balancing against this abstraction a return to representation, to the images and meanings of earlier periods. Poststructuralist postmodernism, on the other hand, is based on a critique of representation: "it questions the truth content of visual representation, whether realist, symbolic or abstract, and explores the regimes of meaning and order that these different codes support."32 Having made this distinction, however, Foster proceeds to problematize it, suggesting that the neoconservative's apparent return to history and to style is, in fact, a celebration of pastiche, which erodes both style and history in a "hysterical, historical representation in which history is fragmented and the subject dispersed in its own representations."33 In short, the two positions with which Foster began collapse epistemologically into one, in which the subject is decentered, representation is denied, and the sense of history and of the referent rejected.

In this formulation, Foster seems clearly influenced by cultural critic Fredric Jameson, whom he approvingly quotes in defining the "modernist paradigm" as involving a "valorization of myth and symbol, temporality, organic form and the concrete universal, the identity of the subject and the continuity of linguistic expression" and in opposition to the postmodernist paradigm, which stresses "discontinuity, allegory, the mechanical, the gap between the signifier and signified, the lapse in meaning, the syncope in the experience of the subject." The alleged playful pluralism of postmodern art Jameson condemned as being often little more than a fondness for pastiche and a "flat" multiplication of style, in contrast to the "deep" expression of modernism. In postmodern expression, the traditional unified work of art expressing a unified

personality gives way to a "schizophrenic" art, reflecting a shattered and fragmented culture. Neither Foster nor Jameson is ultimately concerned with a mere description of the phenomenon of postmodernism, however. Both are deeply interested in whether and where a strategy for political expression can be found within this new mode of thinking. Neither Jencks' double-coded "pastiche" postmodernism, which Foster specifically characterizes as allied to neoconservatism, nor a poststructuralist dispersal of the subject, meaning, and discursive language would seem to provide any grounding for an engaged, critical art. This problem has been a central one in postmodernism, and we will return to it in the final

chapter of this study.

We have traced, through Jencks' concept of double-coding and related theoretical expressions, something of the background of what Foster characterizes as "neoconservative" postmodernism. Let us now turn to his second current, which has recently become the more important one in writings on theatre and performance. This is postmodern expression as it is related to poststructuralism. The phenomenological approach to performance, with its emphasis (despite Fried's warnings) upon presence, became much more problematic with the arrival of poststructuralist theory, since this brought into question both the sense of plenitude and the freedom from external values and assumptions claimed by the phenomenological approach. The challenge posed to the aesthetics of presence by poststructuralism challenged also performance's modernist and essentialist claim of distinction from the other arts in general and theatre in particular, a claim based upon the presence of the performing body. Yet as this modernist view of performance was fading, it was gradually replaced by a postmodernist view of performance, one that did not give up the vocabulary of "presence" and "absence," or of "theatre" and "performance," but that treated these terms and their relationships in a radically different way.

Henry Sayre has suggested that performance, under the influence of poststructuralism, has moved from an "immanentist aesthetics of presence," which seeks to transcend history and escape temporality, to an "aesthetics of absence," which accepts contingency and the impingement of the quotidian upon art.35 According to Sayre, the modern vocabulary of absence derives primarily from the writings of one of the central figures of poststructuralism, Jacques Derrida, who in an important sense "is to the literary establishment what performance and conceptual art are to the museum: he exposes the weaknesses of the System, points out its strategic ellipses, and undermines its authority—to borrow his word, he *deconstructs* it."³⁶ To simply replace an aesthetics of presence with one of absence, however, would merely reverse the traditional structure, not reject it, and Derrida constantly warns against the temptation of merely reinscribing a binary system by reversing its terms. Derrida's project is rather to suggest a constant field of interplay between these terms, of presence impregnated with absence, a field perpetually in process, always in-between as it is in-between absence and presence. Such art "rejects form, which is immobility, and opts,

instead, for discontinuity and slippage."37

Much of Derrida's writing addresses the concerns mentioned by Sayre, but two 1968 essays are of central importance to the related concerns of theatre, performance, presence, and absence, "The Theater of Cruelty and the Closure of Representation" and "La Parole Soufflée," both exploring questions raised by Antonin Artaud's modernist Theatre of Cruelty project. Derrida rejects the possibility of Artaud's visionary theatre in an argument that could be extended to reject Fried's attempt to purge art of the "theatrical" as well as to much of the phenomenological privileging of presence in happenings and early performance art and theory. All through this tradition runs the themes of language, discursive thought, and indeed traditional symbolic systems in general as structures of repetition deriving their power and authority ultimately from some originary essence or event, but removed from the power of that origin. Modern art, performance, or the Theatre of Cruelty have sought by various strategies to bring about an occurrence uncontaminated by this derivative, secondary quality. Derrida, however, argues that escape from repetition (and thus theatre) is impossible, that consciousness itself is always already involved in repetition.³⁸ This removal of a center, a fixed locus of original meaning, brings all discourse, all action, and all performance into a continuing play of signification, where signs differ from one another but a final, authenticating meaning of any sign is always deferred. (Combining differing and deferring, Derrida creates one of his best-known neologisms, speaking of the play of "différance.")

After Derrida, theorists and performers acquainted with his or with related poststructuralist thought could no longer

comfortably embrace the goal of pure presence so attractive to modernism. Very much in the spirit of Derrida, Herbert Blau in "Universals of Performance" (1983) specifically rejects the attempt of the modernists to create an experience of unmediated presence by removing "theatre" from "performance." In fact, asserts Blau, theatre, which involves both mediation and repetition, "haunts all performance," forcing the recognition that there is something in the nature of both theatre and performance that "implies no first time, no origin, but only recurrence and reproduction."39

The poststructuralist rejection of the "pure" presence of modernism (and of early performance art) did not, however, inspire a postmodern rejection in toto of either presence or performance, but rather a reinterpretation of both concepts. Two key essays in this reinterpretation appeared together in a special issue of Modern Drama in 1982 devoted to the theory of drama and performance. These were Josette Féral's "Performance and Theatricality: The Subject Demystified" and Chantal Pontbriand's "The Eye Finds No Fixed Point on Which to Rest...." Pontbriand devotes much of her essay to the concept of presence, but distinguishes between "classical presence" and "postmodern presence." Both utilize performance, but the former is deeply involved in mediation and repetition. Its goal is to bring forth in present time previously established truths, to restore and reactualize the presence of such material.⁴⁰ Pontbriand does not place "modern presence" in a special category, since its assumptions parallel those of "classical presence"—performance is used to actualize in the present hidden and universal truths that in fact lie outside of time and space. Despite the more phenomenological cast of the "modern" attitude, however, it shares with the "classical" this assumption of a primary, authenticating truth elsewhere, and thus it is necessarily involved with representing rather than presenting. While the minimalist work still sought to embody, to codify some sort of meaning, postmodern performance offers an "inchoative breaking-up," a "continual movement, displacement, or repositioning."41 Nick Kaye has utilized very similar terms, suggesting that the postmodern "might be best conceived of as something that happens," and that this happening involves "breaking free of specific forms and figures. The reason that performance is particularly suited to postmodern experience is that it shares with postmodernism a refusal to be placed, vacillating between presence and absence, between displacement and reinstatement."42

In this vacillation, this refusal to be placed, we can again see

operating Derrida's "play of différance."

Féral utilized Fried's rejection of theatre as a starting point in her discussion of the differences between theatre and performance, but she took this discussion in quite a different direction, away from the context of modernist and minimalist art theory, and much more toward the work of the French postmodernists and poststructuralists, drawing concepts and lines of argument not only from Derrida, but also from such poststructuralist psychoanalytic theorists as Jacques Lacan and Julia Kristeva. She is thus much less concerned with such matters as presence and duration (at least as Fried approaches them) than with representation, the Lacanian imaginary, and the construction of the subject. She begins not with the minimalist goal of reducing arts to their "essences" (a goal incompatible in any case with postmodern relativism and dissolving of boundaries), but with the poststructuralist strategy of problematizing structuralist assumptions and seeking the seams and margins where structures are negotiated. Theatricality she sees as devoted to representation, narrativity, closure, and the construction of subjects in physical and psychological space, the realm of codified structures and of what Kristeva calls "the symbolic."

Féral directly opposes performance to activity of this kind; it undoes or deconstructs the competencies, codes, and structures of the theatrical. Although it begins with the materials of theatre -codes, bodies seen as subjects, actions and objects involved in meaning and in representation—it breaks down these meanings and representational relationships to allow a free flow of experience and desire. Narrativity is denied, except for ironic quoting with a certain remove, so as to reveal a narrative's inner workings or its margins. There is "nothing to grasp, project, introject, except for flows, networks, and system. Everything appears and disappears like a galaxy of 'transitional objects' representing only the failures of representation." Performance "attempts not to tell (like theatre), but rather to provoke synaesthetic relationships between subjects."43

In such writings the attention given by critics such as Fried to the art object shifts to an attention to the art experience—a shift implied in the very concept of performance, but, like the concept of presence, approached in a quite different way by poststructuralist and postmodernist theorists. Jean-François Lyotard's highly influential book The Postmodern Condition (1984) was purportedly concerned with contemporary science and the problem of knowledge, but as Fredric Jameson observed in his Foreword to the English edition, Lyotard's speculations also had profound implications "in the directions of aesthetics and economics."44 In aesthetics, Lyotard's focus upon the event and upon "performativity" as a working principle of knowledge both profoundly affected postmodern thought about performance. The postmodern condition, argues Lyotard, arises from a contemporary erosion of belief in those forms, which he calls "metanarratives," that formerly provided legitimacy for a wide variety of cultural norms, procedures, and beliefs. The "modern" period he characterizes as dedicated to knowledge that legitimated itself "with reference to a metadiscourse ... making an explicit appeal to some grand narrative, such as the dialectics of the Spirit, the hermeneutics of meaning, the emancipation of the rational or working subject, or the creation of Wealth." "Simplifying to the extreme," Lyotard defined postmodernism "as incredulity toward metanarratives." 45 Having lost the support of the metanarratives that tied scientific discovery to absolute freedom and knowledge, modern science has split into a host of specialties, each following its own procedures, or language-game, incapable of harmonization with the rest through any appeal to an over-all truth or authority. The language-games that support what we call "knowledge" are composed, says Lyotard, of two aspects: discourse and figure (roughly analogous to la parole and la langue of classical linguistics). "Discourse" is the general process and structure through which a narrative gives meaning, while "figure" is the specific event of narration. The modern emphasizes discourse as controlling and limiting the contingency of figure, subjecting it to some assumed universality. The postmodern asserts the power of figure to claim its own disruptive space, no more and no less "universal" than others. Says Lyotard: "no single instance of narrative can exert a claim to dominate narratives by standing beyond it."46 This orientation, like that of Bakhtin's performative "utterance" or de Certeau's "tactics," shifts attention from general intellectual or cultural structures to individual events, and from the determination of a general truth or general operating strategy to an interest in "performativity"—activity that allows the operation of improvisatory experimentation based on the perceived needs and felt desires of the unique situation. The test of reality within this new orientation is not what can be demonstrated to be generally "true," but more simply what can be demonstrated. Through Lyotard "performativity" and the privileging of the event becomes tied to "postmodernism" and like postmodernism begins to be applied to a broad range of contemporary cultural phenomena. An excellent summary of these relationships is provided by David George in his 1989 article "On Ambiguity: Towards a post-Modern Performance Theory." George argues that the postmodern emphasis on such terms as "play," "game," "contradiction," "process," and "performance" suggests that

we may be entering an age in which there are only media (semiosis, assumptions, paradigms, models) and no ontology, only experiences (and no Self except the one like an actor's career made up of the parts we enact and rewrite), a world in which difference is primordial (no Ur-whole), and time endless.

In such an age, George concludes, "performance is the ideal medium and model."47

Among the effects of this new orientation is a shift outward from the performance's early focus upon the performing body to the more general performance situation, including of course the audience—the audience that Fried attempted to exclude precisely because it introduced into the art experience a sense of contingency, time, and situation. When theorists speak of the performative quality of art as being its most postmodern aspect, they are frequently concerned precisely with the contingency the work must undergo when it becomes involved in the process of reception. Joel Weinsheimer, commenting upon the work of reception theorist Hans Georg Gadamer, stresses the importance and the implications of performance in undermining the idea of an essential play text:

Performance is not something ancillary, accidental, or superfluous that can be distinguished from the play proper. The play proper exists first and only when it is played. Performance brings the play into existence, and the playing of the play is the play itself. . . . It comes to be in representation and in all the contingency and particularity of the occasions of its appearance.48

For Gadamer, however, theatre was a particularly clear but by no means unique example of this phenomenon. All arts, not only the so-called "performing" arts, "perform" in this way, existing only in the moments of their reception in different contexts and thus change as they move through time and space. Only by denying the dynamics of reception and the performativity of all art can Fried and the minimalists seek to establish unchanging "essential" works. Even the earliest experiments with performance art moved in this direction, and by the end of its first decade, the change in orientation was generally accepted and acknowledged. This can be clearly seen in the responses of a group of performance artists surveyed at the beginning of 1980 by Artforum, which asked "What shifts in emphasis, esthetic or otherwise, have impermanence and specificity of project and performance art brought about?" Vito Acconci observed that by choosing to use the gallery "as the place where the 'art' actually occurred" he shifted attention from 'art-doing" to "art-experiencing." This involved, as most of the artists noted, a new attitude toward the audience and to their active collaboration. As Eve Sonneman observed, the audience was given "a multiplicity of choices" and encouraged "to build its own syntax of esthetic pleasure or intellectual work."49

The building of this syntax, however, necessarily remains a provisional, partial, and ongoing process, the event, as Féral and Pontbriand argued, a continuing flow of energies and negotiations. Postmodernism, notes Barbara Freedman in her psychoanalytic study of Shakespearian comedy, utilizes the metaphor of theatre for the same reason that modern psychoanalysis has used it (and for the same reason that Fried rejected it), because it denies "the possibility of an objective observer, a static object, or a stable process of viewing." Both postmodernism and psychoanalysis "employ theatrical devices to subvert the observer's stable position, and so result in a continuous play of partial viewpoints—none of them stable, secure, or complete."50

Jon Erickson has pointed out how a sensitivity to the audience's role problematizes many traditional assumptions of how political theatre works. Too often theorists of such theatre "assume that the audience is simply a projection of themselves, and that, since they desire a certain theatrical strategy to work (usually to illustrate an already assumed theory), it does indeed work for everyone." In fact, suggests Erickson, for audiences who do not share the agenda of a particular theorist or performer, a work of presumed subversion or resistance may not be experienced in that way at all. "In fact, the more sophisticated these strategies become in their use of irony, for instance, the more likely the opposite meaning will be assumed and reinforced, not undermined."51 We will return to this concern in our discussion of feminist performance and masquerade.

The emphasis upon the unique event, the power of the observer, and the test of performativity at the expense of general truth all might seem to remove postmodern performance from a meaningful engagement with any political, social, or cultural concerns. With no metanarratives, no authenticating knowledge, and thus no apparent base for action or even meaningful social observation, does postmodernism provide for performance only a play of energies and relative positionings? Certainly this is a charge that some politically oriented theorists have made against it. From the late 1980s onward, however, a number of theorists have specifically addressed the question of locating a serious critical function in at least certain aspects of postmodern performance.

Randy Martin's Performance as Political Act (1990) argues that the performing body is by its nature involved in resistance to what he calls the "symbolic," the attempt of authority in art or in politics to enforce a unified and monolithic structure opposed to the "overflowing" quality of the moving, acting, and desiring body. On both the personal and the public levels the symbolic attempts to limit the meanings of action and the body, to channel the flows of desire, but such limitation is inevitably in conflict with the symbolic-defying carnivalesque potential of the performing body. The tension, emotionality, flows of desire, and kinetic circulation of performance can, says Martin, "instigate a tension in the social body" that disrupts the smooth structure of authority, and individual performances create "interventions, ruptures in the conditions of reproduction of dominance." In performance subject and object are realigned to replace the "solitary authority" of the symbolic with the "polyphonous circulation of human feeling."52

Philip Auslander, in a series of essays and in his 1994 book Presence and Resistance, has drawn together the writings of a range of postmodern theorists with an analysis of such contemporary artists as Laurie Anderson and the Wooster Group and contemporary stand-up comedy to develop such a function. Auslander notes in both Jameson and Foster a suggestion that it might be possible within the terms of postmodernism to discover the potential for resistant and critical operations; indeed Foster styles his more liberal postmodernism that of "resistance." However, Auslander continues, postmodernist art's resistance is not to any specific political practices (the type of resistance represented by much of the political performance of the 1960s), but rather resistance to representation in general, a more abstract and difficult strategy. In this regard, Auslander quotes Lyotard:

To hang the meaning of the work of art upon its subsequent political effect is once again not to take it seriously, to take it for an instrument, useful for something else, to take it as a *representation* of something to come; this is to remain within the order of representation, within a theological or teleological perspective. This is to place the work of art, even when one is dealing with non- or anti-representational works, within a (social, political) space of representation. This leaves politics as representation uncriticized.⁵³

The final sentence points the way toward a politically engaged postmodern performance. Instead of providing resistant political "messages" or representations, as did the political performances of the 1960s, postmodern performance provides resistance precisely not by offering "messages," positive or negative, that fit comfortably into popular representations of political thought, but by challenging the processes of representation itself, even though it must carry out this project by means of representation. It is of necessity, says Auslander, "an elusive and fragile discourse that is always forced to walk a tightrope between complicity and critique." ⁵⁴

Similarly, Alan Read has suggested that theatre is not ultimately committed to representation—"the reflection of an 'existing' proposition as though it were fact"—but rather to the presentation of "exemplary and radical" alternatives and possibilities. Postmodernism has called attention to this ethically engaged, performative side of theatre because of a common interest in "the destabilisation of norms, the dissolution of certainties." Read aligns the operations of performance with those of ethics, always involved not only with normative conduct, but with the negation and defiance of norms. De Certeau's description of ethics, he suggests, applies also to the possible worlds of theatre and performance: "Ethics is articulated through effective operations and it defines a distance between what is and what ought to be. This distance designates a space where we have something to do." 55

The relationships and complex interactions between performance, postmodernism, and political concerns have been the field of much of the most interesting work in both the theory and practice of performance during the past two decades. In the United States the exploration of gender concerns in general, and feminist concerns in particular, has provided the most prominent and the most varied manifestations of this work, and will be a central concern of the following chapter. Chapter 8 will examine the problems of politically and culturally resistant performance in a more general way.

Performance and identity

The previous chapters have sought to demonstrate how modern concepts of "performance" and "performance art" developed, first in association with the modernist and minimalist movements in the arts and then in relationship to postmodernism. Looking back on the development of performance from the mid-1990s, one of its most striking features is the steadily growing interest in a social or political function, this despite the tendency in both modernism and postmodernism to de-emphasize or even to reject such specific social or political activity. An earlier chapter, on modern performance art, provided a brief overview of this recent development, particularly marked in the late 1980s and early 1990s. One aspect, however, of socially engaged performance, has provided so important and so complex a part of modern performance theory and practice that it deserves independent consideration. This is performance involved with the concerns, desires, and even the visibility of those normally excluded by race, class, or gender from consideration by the traditional theatre or indeed by modern performance, at least in its formative years. The most elaborately developed area of such performance, both in theory and in practice, involves performance by women, but more recently many of the concerns explored by women performers and theorists of performance during the 1970s and 1980s have been further developed in relation to performance concerned with gay men and with various ethnic minorities.

The rapid development of feminist thought and activity in the 1970s and 1980s brought into being a great variety of different approaches both to feminist performance and to feminist theory (and eventually in the late 1980s to the interplay of theory and performance). Already by the middle of the 1980s a variety of

"feminisms" had developed, but most theorists, while utilizing slightly different terms and characteristics, tended to categorize them under three general groupings. Jill Dolan, one of the first theorists of feminist performance, adapted in her book The Feminist Spectator as Critic (1988) the categories from Alison Jaggar's Feminist Politics and Human Nature (1983)—liberal, cultural (or radical), and materialist feminism. These divisions can be roughly compared with those in Michelene Wandor's studies of British feminist performance, Carry On, Understudies (1986)-bourgeois feminism, radical feminism, and socialist feminism.2

Liberal feminism has close ties to various types of political action performance in the 1960s-performance that tended to call attention to unfairness and sexual inequality in various areas of contemporary society and sought to foster equal consideration, rights, and protection regardless of sex. Cultural or radical feminists, concerned that the so-called "universality" of liberal feminism too readily accepted the male-created standards for such "universality," sought instead to define and support the idea of a women's culture, separate and different from the culture of men. Linda Walsh Jenkins, writing in 1984 in the recently founded journal Women and Performance, for example, called for an "authentically female" performance, "replete with female signs" and based on a "biogrammar" derived from "experiences the body has known on the basis of gender."3 Similarly, Rosemary K. Curb called for a "theatrical language capable of communicating female perceptions which have been erased by the fathers and thus appear non-existent to the dominant culture."4

Although materialist feminism shares common concerns with both liberal and cultural feminism, it attempts to avoid the tendency of liberal feminism to "absorb women into the male universal," as well as that of cultural feminism, to "overturn the balance of power in favor of female supremacy." 5 Instead of liberal universalism or cultural essentialism, materialist feminism views gender as culturally constructed within a set of power relationships. In the words of Sue-Ellen Case, one of the leading theorists of feminist performance, the materialist position "underscores the role of class and history in creating the oppression of women," rather than assuming "that the experiences of women are induced by gender oppression from men or that liberation can be brought about by virtue of women's unique gender strengths."6

These various types of feminist theory, each of which could be closely related to particular feminist performance, provided much of the impetus for innovative performance work especially in the United States during the 1980s. By the end of the decade, however, many leading performance theorists felt that a kind of critical impasse had been reached—what Case characterized as a "crucial stall" resulting from the difficulty of negotiating a workable relationship between the materialist and essentialist positions, particularly in the face of an ongoing and arguably increasing conservatism and reinforcement of traditional positions in society as a whole. While distrusting the exclusionary assumptions of the essentialists, the materialists envied these assumptions as providing a grounding for effective political resistance to the power of a dominant culture. A major political and theoretical project of feminist theory and performance in recent years has been the seeking of a strategy to move forward from this "stall" a project given greater urgency by the concurrent development of modern gay and ethnic performance, which in its attempts to give voice and agency to other oppressed groups has encountered the same practical and theoretical difficulties.

In order to gain some understanding of these current negotiations, and of their implications for performance, we will look in this chapter and the next at both sides of the dialectic of recent socially oriented performance. This chapter is more oriented toward what could be called the "essentialist" position, particularly as it has been developed in cultural, mythic, and autobiographical performance, while the next is more "materialist," exploring a variety of deconstructive and postmodern strategies of politically and culturally engaged performance.

As we have seen, women artists were from the beginning of the 1960s centrally involved with modern performance. On the east coast of the United States were Yvonne Rainer, Simone Forti, Carolee Schneemann, Judson Dance participants Deborah Hay, Elaine Summers, Trisha Brown, and Lucinda Childs, Fluxus participants Alison Knowles, Yoko Ono, and Charlotte Moorman. On the west coast Ann Halprin in dance and Pauline Oliveros in music were major performance pioneers, soon followed by Barbara Smith, Bonnie Sherk, and others. Very little of this performance work, however, directly raised social or gender issues. Certain artists, among them Yvonne Rainer, Carolee Schneemann, and Yoko Ono, produced pieces that clearly moved in this

direction, but against considerable resistance. In a 1972 interview Yvonne Rainer recalled that she was criticized by her peers at the Judson Dance in the early 1960s for exploring the idea of "female projections":

I imitated women in the subway. I had screaming fits. I was sexy. I was always being someone else on stage. . . . What I was doing was taking things from life and transposing them in a dramatic form.7

In the minimalist-oriented atmosphere of the Judson Dance, this interest in the female persona seemed both too personal and too

close to the theatrical to gain much support.

Early interest in gender matters aroused much the same opposition in the world of performance art. Women artists, suggests Lucy Lippard, found little appeal in the main line of body art through the late 1960s "when Bruce Nauman was 'Thighing,' Vito Acconci was masturbating, Dennis Oppenheim was sunbathing and burning, and Barry Le Va was slamming into walls."8 Yoko Ono perhaps came closest to such work in pieces such as her Wall Piece for Orchestra (1962), in which she knelt on stage and pounded her head against the floor, but this and the subsequent Cut Piece (1964), in which she sat passively while audience members cut away her clothing, looked at personal violation and violence in a very different and distinctly more feminist way than did the male body artists. Indeed these pieces from the early 1960s could be seen as preparing the way for Ono's cinematic study of victimization, Rape, in 1969.

Carolee Schneemann describes herself and Yoko Ono as working essentially alone against a predominantly male idea of performance in the early 1960s:

In 1963, to use my body as an extension of my paintingconstructions was to challenge and threaten the psychic territorial power lines by which women were admitted to the Art Stud Club, so long as they behaved enough like the men, did work clearly in the traditions and pathways hacked out by the men. (The only artist I know of making body art before this time was Yoko Ono.)9

In the early 1970s, however, the rise of the women's movement provided a much more favorable climate for performance work created by women and concerned with their private and public experience as women. Feminist art programs in Southern Californian schools were the leaders in such work, and during the 1970s a major part of performance work in California was related to feminist concerns. "I believe absolutely that the feminist movement in Southern California has affected the rest of the Southern California art world," said Eleanor Antin in a 1978 interview. "I really think that women practically invented performance in Southern California."10

Judy Chicago began such a program at Fresno State in 1970, and she and several of her students, including Faith Wilding and Suzanne Lacy, moved to Cal Arts in Los Angeles to set up a similar program there in 1971, where Chicago, Wilding, and Lacy all made important contributions as practitioners and theorists of women's performance. Performance was seen as central to both programs. As Chicago explained: "Performance can be fueled by rage in a way painting and sculpture can't. The women at Fresno did performances with almost no skills, but they were powerful performances because they came out of authentic feelings."11 Women were also attracted to performance because it allowed them personal control. Unlike traditional actors, they created their own projects—serving as writer, producer, director, designer, cast, and often carpenter and costumer as well.12

Personal and psychological statements were often wedded in early feminist performance to specific and repeated physical actions, as in Faith Wilding's well-known Waiting (1971), in which Wilding rocked back and forth monotonously, reciting a litany of the waiting that women experience from birth to death. At "Womanhouse," a large decaying house transformed by the Cal Arts Feminist Art Program in 1972 into a center for feminist environments and performance, Sandra Orgel and Chris Rush repeatedly and obsessively carried out such conventional female activities as ironing and scrubbing, activities that according to performance artist Martha Rosler were designed to demonstrate "the preoccupations imposed on women" and to externalize "the highly negative inner response they provoke."13

Other performances sought not so much to display the burdens of imposed and unfulfilling activities imposed on women, but to give new attention to their activities as women, fulfilling or unfulfilling. Linda Montano's Home Endurance (1973) "framed" sections of her everyday life. During a week she remained at home, asked friends to visit, and carefully documented all thoughts, food eaten, visits, and phone calls. 14 Most such performance, directly or indirectly, sought an emotional identification with the experience of women spectators. During her Ordinary Life (1977), Barbara Smith would turn to question her audience "to see if their experiences might enlighten mine and break the isolation of my experience," using performance to reveal common dilemmas.15

In her study of women's performance art in the 1970s, The Amazing Decade, Moira Roth distinguished, despite a good deal of overlapping, three major orientations in such work—performance related to women's personal experience, to women's collective past, and to exploring the strategies of specific feminist activism. The first two of these clearly relate more closely to the concerns of this chapter, as, under the impetus of the women's movement, performance began to be utilized to understand better women's situation in society and in history. Cultural feminism had its greatest impact on performance during the 1970s, as performance artists drew upon a growing body of research into medieval witchcraft, prehistoric and non-Western goddesses and fertility figures, and ancient matriarchal cultures. Donna Henes has been involved since the 1970s in performance concerning Native American myths, and particularly the Southwest Spiderwoman, whom Henes sees as the Native American embodiment of the European Great Goddess. Mary Beth Edelson has drawn directly upon European Goddess worship, offering "images of my body as a stand-in for the Goddess," and traveling to a neolithic Goddess Cave in Yugoslavia in 1977 to perform a private ritual there. 16

Other performers sought to relate mythic material to personal experience, as could be seen in much of the work of Rachel Rosenthal or in Meredith Monk's Education of the Girlchild (1972). Of the latter work, Sally Banes observed: "Its strange tribe of women could be goddesses, heroines, ordinary people or different aspects of one person." 17 Powerful pieces were also created in the late 1970s by performers who placed autobiographical material in a ritualized form that suggested general or universal, almost mythic, concerns. Two of the best-known of these were Linda Montano's Mitchell's Death (1978), using performance as an exorcism of her personal grief at the loss of her ex-husband and friend Mitchell Payne, and a major piece created the following year by Barbara Smith exploring her feelings and observations upon the death of her mother.

Ritualized and myth-related performance has been less common since the 1970s, while that related to autobiography and other personal experience has remained the most common, and for many the most typical orientation of feminist performance. Moira Roth has given to such performance the title "personal clutter and the persistence of feelings," quoting from a memorable moment in modern performance art. 18 In Interior Scroll (1975) a nude Carolee Schneemann extracted a text from her vagina which she read aloud. It recounted how a male "structuralist filmmaker" explained why despite his fondness for Schneemann he could not look at her films, citing their "personal clutter," "persistence of feelings," "hand-touch sensibility," "diaristic indulgence," and "primitive techniques." 19 Concerns with self, self-image, and the social self clearly gained little sympathy from the structuralists and modernists, whose voices dominated experimental performance as well as experimental film in the early 1970s, but these were concerns central to the emerging women's movement of the same period—and this movement found in performance an important field for its expression. As Eleanor Antin described it, feminist performance "has been more a social, political and psychological thing about what it means to be a woman in this society, a particular woman, an artist ... very real political questions are often considered."20

One of the first manifestations of feminist performance, and still an important approach, utilized specifically autobiographical material, almost invariably, as Antin suggests, with a consciousness of the political and social dimensions of such material. In *The Story of My Life* (1973) Linda Montano walked uphill on a treadmill for three hours while reciting her autobiography into an amplification system.²¹ Yvonne Rainer wove together autobiographical and fiction material in her *This is the Story of a Woman Who*... (1973), later made into a major feminist film.

It is important to stress the popularity and ubiquity of performance utilizing autobiography and other "personal clutter" from the beginning of modern performance art, since it is not only structuralist film makers like Schneemann's friend, but also structuralist and modernist theorists and historians of performance who have attempted to write such work out of the historical record. One can perhaps understand that the media would focus almost exclusively on extreme examples of male body art, but even sophisticated theorists like Josette Féral have argued for a

monolithic definition of performance art based on formal and modernist principles. Looking back in a 1992 article, Féral argues that although the term "performance" "endures and is becoming institutionalized," performance as it was practiced in the 1970s was quite different, being occupied with "one and the same function: to contest the aesthetic order of the time, to explore the artist's relation to art." This primacy of formalist concerns, says Féral, characterized performance until the mid-1980s, and with its disappearance "true" performance art disappeared, to be replaced by a view of performance not as a function involved only with the art experience but as a genre that can be turned to any concerns, marking a return to "message and signification," which, Féral argues, are inimical to the original aims of performance.²²

The limitations of such a reading of modern performance can be clearly seen in Féral's specific analysis of Rachel Rosenthal's 1991 Pangea. Féral provides a lengthy, thoughtful, and sympathetic analysis of this piece, rightly noting that in it "Rosenthal affirms her position as a subject in history, a history she refuses to disclaim and which she wants to possess." This seems quite unexceptionable, but Féral goes on to argue that such an affirmation makes Rosenthal a clear example of "today's" performance

art, as opposed to that of the 1970s:

In place of the image of an essentially instinctual subject—that of performance art of the seventies-performance art of the nineties substitutes the image of a subject who refuses to eliminate tensions between the self and history and between politics and aesthetics, and who reestablishes the complexities of enunciation. Where performance art in the seventies was simply refusing the representation of a real it tried to attain in its immediacy ... performance art in the nineties has renounced the play of illusion. It has chosen to return to the real as a construction of the political, and to show the real as necessarily bound to the individual.23

Yet Féral's denial of the wide-spread and important involvement of a great deal of 1970s performance art in the self and history and in politics and aesthetics is all the more surprising in that Rosenthal herself was a central example of such activity during that period. After working as a dancer with Merce Cunningham and as a director of a Los Angeles improvisational theatre group, she became interested both in performance and in feminist issues in the 1970s. Her powerful autobiographical performance work, dealing with her childhood in Paris (*Charm*, 1977), her relationships with her half-sister, still living in Africa (*The Head of Olga K.*, 1977), and personal fears and obsessions (*The Death Show*, 1978), were by no means presentations of an abstract "instinctual" body, but very much explorations of a specific self in a historical context.

Seemingly even less compatible with formalist theory that has sought to separate "performance" from "theatre" by the absence of mimesis or role playing in the former is another sort of selfexploratory performance, also well established during the 1970s. This, sometimes called "character" or "persona" performance art, did not deal with autobiography or "real-life" experience, but with the exploration through performance of alternative, imaginary, even mythic selves. Martha Wilson's photographic Posturing: Drag (1975) explored making images as making identity, and she began to work with Jacki Apple, creating a composite fantasy self, Claudia, a self subsequently "played" by others as well. Apple, trained as a fashion designer, has concentrated on changing roles with others and the multiple roles as defined by others' perceptions. Even more detailed and elaborated was the fantasy persona "Roberta Breitmore" played between 1975 and 1978 by Lynn Hershman. Roberta, with her own driver's license, bank account, therapist, and fictional background, lived through many of the problems and personal conflicts of a woman of the mid-1970s before being ceremonially put to rest in a grave in Italy.²⁴

One of the best-known persona artists is Eleanor Antin, who has called herself a "post-conceptual artist" concerned "with the nature of human reality, specifically with the transformational nature of the self." Her work on the self in the early 1970s, though related to contemporary male body art, was also distinctly feminist in its orientation and its concerns. In 1972 she offered an exhibit that claimed to "redefine the old terms" of art history and methodology, primarily by using her own body and experience as raw material. Her first video, called *Representational Painting*, showed herself making up with the camera as a mirror, while a companion work, called *Sculpture*, displayed daily nude photographs of herself taken over a period of a month during which she lost eight pounds, changing her body to present a different "self" to the world.²⁵

After the specific transformations of her body through the

traditional women's strategies of cosmetics and weight loss, Antin became interested in the more complex question of "defining the limits of myself, meaning moving out to, in to up to and down to the frontiers of myself. The usual aids to self-definition—sex, age, talent, time, and space—are merely tyrannical limitations upon my freedom of choice." ²⁶ The exotic and imaginative alternative versions of her self that Antin explored included a King, a Ballerina, a Movie Star, and a Nurse, each developed over a number of years through a variety of performances. Each of these "personae" has developed a complex fantasy life of its own; the Nurse, for example, has appeared as Florence Nightingale and has played out a complex series of relationships with characters in her own fantasy life, represented by paper dolls. The King has developed his "character" by moving about in makeup and costume among his "subjects" in Solona Beach and asking "how things were going" in the realm.27

It is important to remember, however, that the personae performed by Antin, Apple, or Wilson are not "characters" in the traditional stage sense—roles removed from themselves and "scripted" by others. A 1976 Los Angeles exhibition featuring the work of Antin and seven other "self-transformational" artists was aptly entitled "Autobiographical Fantasies." 28 It is precisely this insistence upon the personal and specific that unites much feminist performance art but also provides it with its major claim to social and political efficacy. Catherine Elwes, herself a performance artist, has stated that "When a woman speaks within the performance tradition, she is understood to be conveying her own perceptions, her own fantasies, and her own analyses." She "combines active authorship and an elusive medium to assert her irrefutable presence (an act of feminism) within a hostile environment (patriarchy)."29

This political dimension of the relationship between performance art and identity is quite different when we consider male performers. Because the theatre has traditionally served as a podium for the expression of male concerns, the performance of personal perceptions or autobiographical fantasies by a male performance artist, such as Spalding Gray, does not by its very nature involve this socio/political dimension. Gray can and does take up social and political concerns, but the simple assertion of his "active authorship" and "irrefutable presence" cannot carry with it the challenge to a patriarchal tradition posed by any female performance artist, whether her work speaks directly of political matters or not.

Matters become more complicated when we turn to male homosexual performance, and its relationship to the expression or exploration of identity. Male homosexual identity is perhaps even more firmly excluded from the patriarchal system than female identity. (A striking recent example is the assertion of Roy Cohn in Tony Kushner's Angels in America that even though he has sex with other men he does not have a homosexual identity.) Erving Goffman's Stigma (1963) reviews current psychological and sociological work on the situation of the individual who, like the homosexual, is for one reason or another placed outside the realm of "full social acceptance." Goffman discusses the range of "management" alternatives available to those who fall within this realm of "spoiled identities," and two of these alternatives have particular relevance to identity and performance. Those attempting to divert attention from their stigma may "present the signs of their stigmatized failing as the signs of another attribute, one that is less significantly a stigma," or a stigmatized individual "can come to feel that he should be above passing, that if he accepts himself and respects himself he will feel no need to conceal his failing."30

The first strategy may be employed by shifting the performance of identity from the stigma itself (homosexuality) to what Esther Newton in a book on female impersonation calls the "halo effect," the violation of culturally standardized canons and gender-coded canons of taste, behavior, and speech that normally signal sexual orientation. For men such violations might include "effeminate" or overly "delicate" speech or behavior, an "aesthetic" orientation, an interest in fanciful or decorative costume, unseemly concern with personal appearance, and so on.³¹

Performance of this kind avoids claiming the stigma of homosexuality, but "manages" it by claiming an identity built upon these secondary signs. The late nineteenth-century dandy provided an important model for such performance, most notably in the figure of Oscar Wilde, who can be said to have used solo performance as a means of self-display and self-definition as well as a Goffmanesque "management" of the stigma of homosexuality.32 In current performance, a parallel merging of management and identity-formation can be seen in such performance as An Evening with Quentin Crisp, consisting of an autobiographical monologue

and a question-and-answer session. Crisp's blatant femininity and high style call up certain echoes of Wilde, and one can easily hear a Wildean echo in Crisp's carefully coded observation: "I am someone who had been forced by life to be self-conscious and has now tried to make that self-consciousness into a way of life."33

Closely associated with the male strategies of social management is the concept of "camp," a term that Susan Sontag brought into modern cultural discussion with her "Notes on 'Camp'" published in 1966. Among the features of camp, Sontag noted, was its close relationship to nineteenth-century dandyism as well as its view of "Being-as-Playing-a-Role, the farthest extension, in sensibility, of the metaphor of life as theatre," where "Character is understood as a state of continual incandescence—a person being one, very intense thing."34 In her 1972 book on female impersonators, Esther Newton elaborated on Sontag to suggest that camp was theatrical not only in emphasizing role playing, but in emphasizing performance and style, how something (including the self) looks and how it is done.35

The relationship between camp and the subversion of traditional gender roles has stimulated much interest among theorists and performers exploring the resistant possibilities of performance, and will therefore be considered in our next chapter, dealing with those concerns. Here, however, our concern is not with subversive performance, but enabling performance, providing a ground for identity construction or expression. For Wilde or Crisp, performance clearly provided a strategy for the social construction of an identity that permitted the integration of a normally troubling amount of "female" characteristics into a "male" persona. More commonly, however, camp performance is associated in the public mind with the actual performance of a "female" persona by a male, in the tradition of "drag."

The long and complex history of men playing women and women playing men within conventional theatre lies outside the scope of our concerns here and is in any case rather less problematic than the traditional cross-dressed performance, since the line between actor and character in the conventional theatre is historically more clearly drawn.³⁶ Within the tradition of popular performance such as vaudeville, burlesque, circus, and minstrelsy, the man dressed as a woman for comic or grotesque effect is a common phenomenon, but more "sympathetic" cross-dressings have also long been a part of this tradition, and there is no question that many cross-dressing performers have created alternate personae that have operated for them precisely as does Eleanor Antin's "King" for the exploration and expression of a differently gendered part of their identity.37 Perhaps the most elaborate and best-known contemporary creation of a cross-gendered identity is Barry Humphries' Dame Edna, a beloved cult figure in England, who has filled Drury Lane with her solo performances, hosted a popular TV talk show in prime time, sung in the Royal Albert Hall, opened the annual Harrods' Sale and turned on Regent Street's Christmas lights, appeared in cameo roles in soap operas, and become one of the four Australians represented by waxworks at Madame Tussaud's. The "reality" of Dame Edna has become so

overwhelming as to quite eclipse her male originator.38

As in much performance involved with identity and with social display, the operations of this sort of expression are always strongly conditioned by the performance circumstances. In his 1990 study of current gay performance, Mark Gevisser suggests that drag performances at downtown New York dance-clubs are often less involved with social display than with "staged representation of often misogynistic ideas of who women are."39 Although Laurence Senelick has traced the appearance of modern drag performance and female impersonation to a newly conspicuous homosexual subculture and to an interest in gender exploration in society at large in the later nineteenth century, 40 within the mass cultural context of traditional burlesque or vaudeville, drag performance often became little more than a gimmick (removing a wig after misleading the audience) or a source for crude caricatures of female types outside society's normal standards (such as the traditional comic "wench" of the minstrel show). Far from using their impersonations to suggest negotiability of gender roles or to express an alternative personality, most of the great female impersonators of the classic vaudeville and burlesque stage made a point of separating their "real selves" from these "roles" and by stressing the masculinity of the former. According to vaudeville historian Joe Laurie, Ir., Julian Eltinge, the most admired of such impersonators, emphasized his skill as a boxer, then considered a mark of a "real man," and even staged a saloon brawl in which he ejected some tough characters who made remarks about female impersonators being "nances," all of which seemingly increased his popularity. 41 The apparently more sympathetic treatment accorded camp and drag performance in such Broadway successes as La Cage aux Folles and M. Butterfly still operates, predictably, according to the demands of mainstream entertainment and cultural assumptions. "Just as black culture has been presented to mainstream white America as a minstrel show," observes Gevisser in respect to such spectacles, "gay culture is presented to mainstream heterosexual America as a drag show."42

Nevertheless, there is no question that as performance has been more and more utilized in recent years to gain political and social visibility, drag for some performers and some audiences can be seen as personally and politically enabling. The essay title "Gay Activist or Beauty Queen?" (1991) by performer David Drake expresses this tension. "Wearing a dress onstage is part of a gay aesthetic," argues Drake. "It's how one expresses oneself theatrically through a heterosexual society."43 Paul Best's appearances as "Octavia," in women's makeup and costume, in social situations are designed to make what Best has called "radical feminist" points. Best argues that Octavia's performative appearances work to reveal "the social and political implications of male vs. female clothing and how people are oppressed, confined, stereotyped and sometimes granted social approval according to what they wear."44 However, Alicia Solomon and others (particularly women) have expressed some skepticism about male drag's ability to destabilize gender assumptions: "Precisely because 'man' is the present universal, and 'woman' the gussied up other, drag changes meaning depending on who's wearing it." Since in this sense "femininity is always drag," men dressed as women almost invariably are involved in the parody of gender, women in the performance of it.45 This view of "femininity as drag" is central to masquerade theory and performance, and we will return to it in the next chapter.46

Much less easy to assimilate into the burlesque "drag show" tradition, and therefore much more disturbing to the conservative critics of contemporary performance, have been performances by gay artists that address the real-life experience of homosexuals in today's society. One of the best-known of these is Tim Miller, whose defunding by the National Endowment for the Arts in 1990 (along with Holly Hughes, Karen Finley, and John Fleck) not only demonstrated the extent of conservative resistance to the articulation of identities outside the male heterosexual mainstream, but, somewhat paradoxically, gave national prominence and publicity to the artists under attack. Autobiographical material has been utilized by all of these artists, but as is typical of more recent performance, especially that dealing with gender or sexuality, the emphasis is less upon giving voice to a silenced self than upon using autobiographical material for political ends. In such pieces as his 1986 Buddy Systems, performed with Douglas Sadownick, or his 1991 Sex/Love/Stories, Miller speaks of his experiences as a gay man in the age of AIDS, of childhood memories, of activist demonstrations, of sexual encounters, and of friends now dead, but this apparent autobiography is also continually framed or commented upon. In the former piece Sadownick regularly interrupts Miller's reminiscences, to comment, critique, or demand explanations.⁴⁷ The latter piece opens with Miller's observation: "I remember so many things, some of them even happened." As David Román has remarked, what is at stake in Miller is "not so much a recording of his life but, rather, a deliberate displacement of this life through performance."48 Such performance consciously uses identity as a ground for resistance, and in that light I will return to it again in the following chapter.

More recently, performance art has again caused problems for the National Endowment for the Arts when conservative senators protested the funding of the Walker Art Center in Minneapolis, which provided a modest grant to Ron Athey for his Four Scenes from a Harsh Life, which contained bloody mutilations. The performance of such ordeals recalls some of the extreme spectacles of body art twenty years before by such performance artists as Vito Acconci and Chris Burden, but Athey's work comes from a quite different base and reflects the current performance world as Acconci and Burden reflected theirs. Body art was calculatedly decontextualized, and physical mutilation used to emphasize the power and presentness of the moment, the experience of pain removing the body from the abstractions of representation. Athey, on the other hand, uses the performance of pain and mutilation to express and control autobiographical demons—his impoverished childhood, his severe upbringing in a Pentacostal family, his former heroin addiction, his several suicide attempts, his experiments with consensual sadomasochistic sex, his current HIV-positive status. Mark Russell, director of New York's P.S. 122, a center for performance art that presented Athey after his problems in Minneapolis, said the work showed a man dealing

"with his own suffering and mortality, without artifice. It makes an audience ask questions of themselves: about the relationship to pain, to disease, to taboos."49

An even closer connection between the suffering body, performance, and identity construction is offered by Bob Flanagan, who in his forties is one of the oldest living survivors of cystic fibrosis, a degenerative illness of the lungs and stomach that is normally fatal by early adolescence. In his Visiting Hours (1992), Flanagan welcomes audience members to a hospital room constructed in a gallery where he is hooked up to the oxygen tank now necessary for his breathing and is surrounded by various monitoring devices and pictures of his sadomasochistic experiments, still continuing as he and his collaborator Sheree Rose share with others the connections they have discovered between sexuality, sickness, and pain. Laura Trippi, curator of The New Museum in New York, has said that Flanagan's performances articulate "a self that is porous and pliant, embracing an environment in which the self is gradually but radically being redefined."50

The contemporary French performance artist Orlan's ongoing project bears an interesting relationship both to the suffering bodies of Athey and Flanagan and to the early body work of Eleanor Antin. By a series of plastic surgery operations, performed on camera and without anaesthetic, Orlan is changing her face to resemble a composite of five idealized types of feminine beauty represented by classic paintings such as the Mona Lisa. As the bloody work of the operation continues, one may notice a phrase printed on the sleeve of one of Orlan's assistants, "The body is but

a costume."

Performance that is involved with identity and autobiography has been most elaborately developed in respect to gender and sexuality, and the aura of scandal and taboo that has surrounded much of this work has also made it the most publicized. During the 1980s, however, other aspects of personal history, other tensions between self and society, began to be increasingly explored by performance. Class and race began to receive the kind of attention previously given to gender, providing a very different and much wider range of identity performance. While this is still very much a project in process, one of the most distinctive features of performance work of the late 1980s and early 1990s in the United States has been the appearance of performers and spectatorial communities dedicated to extending the sort of gender- and self-exploration that was primarily carried out in the previous decade by educated, white, middle-class women, to women of lower social class, homosexual women and men, and men and women of color.

Occasionally performance artists in the 1970s sought to use performance as a way to approach the still very difficult problem of making alliances between women of different social or ethnic background, but with only qualified success. Suzanne Lacy, for example, attempted in several of her pieces, such as Prostitution Notes or The Life and Times of Donaldina Cameron (1977), "to loosen the physical boundaries of the flesh, hence of the identity." Lacy explains:

In the pieces I consciously moved into the realm of another experience, another social setting, and became one with that. That obviously does not mean that I become black or Chinese, but that I integrate myself as closely as possible into that experience to understand the correlations of our shared experience, to expand my identity and become the other. It is a self-educating process.⁵¹

Lacy encountered much resistance, however, from Chinese radical feminists who felt that a white feminist with her own agenda could neither understand nor represent their concerns, and who saw this attempt to speak "for" them little different from male dramatists speaking for women. Feminist theory also has been attacked for being created by and addressed to the concerns of educated, upper-class white women.⁵² Between the mid-1970s and the early 1980s, especially in women's performance, the previous interest in exploring common concerns began to be challenged by a need to focus upon the experience of specific minorities. The evolution of one major performance group, Spiderwoman, during this period precisely illustrates this dynamic. Beginning in 1976 with Women and Violence, built upon autobiographical and historical material, the seven-woman company saw its strength in its bringing together the "diverse experiences as women" of Native American women, lesbians, Scorpios, women over fifty and under twenty-five, sisters, mothers, and grandmothers.53

During the 1980s, however, women and men of color began to use performance art to seek self-definition and to explore and express their more specific social, cultural, and ethnic concerns. The non-white women in Spiderwoman felt that the claimed diversity of the group was repeating the familiar social dynamic of becoming a mask for white control, and in 1981 the company separated, Spiderwoman now exploring in particular the memories and experiences of Native Americans. Women of other ethnicities also recognized the "voice" provided by performance as enabling. Cherrie Moraga dedicated her 1990 work Shadow of a Man to "las chicanas, that we may come downstage center and speak for ourselves," recognizing the need to establish a "Chicana" presence differing from the unified Chicano (male) identity in the face of a dominant white culture.54

Guillermo Gómez-Peña is a central representative of the new orientation in performance—a talented, imaginative, articulate, and much-honored artist born in Mexico who has focused on the Latino experience in the United States. An excellent illustration of the difference between identity performance of the late 1970s and that of a decade later is by comparing the "alternate" identities of a performer such as Antin and those of Gómez-Peña. Antin views her King, her Nurse, her Movie Star as alternate versions of herself, and they are created primarily to explore that self, not to comment upon social circumstances. "They help me to get out of my own skin to explore other realities," Antin commented in 1989.55 As a great deal of more recent performance art has moved in a social and cultural direction, however, performances like Antin's black ballerina have begun to be criticized, like Lacy's Chinese woman, for repeating, without sensitivity or cultural awareness, the white artist's traditional "blackface" playing of others. C. Carr of the Village Voice has accused such performance of "presumptuousness and naïveté."56

Gómez-Peña has also characterized his work as involving the expression of "multiple identities," but these arise less from internal choices than from a particular cultural matrix:

Depending on the context I am Chicano, Mexican, Latin American, or American in the wider sense of the term. The Mexican Other and the Chicano Other are constantly fighting to appropriate me or reject me. But I think my work might be useful to both sides because I'm an interpreter. An intercultural interpreter.57

Like Gómez-Peña himself, each of the characters he presents (in a variety of colorful costumes) may host several different personalities, even though each bears a single name, such as Border Brujo or Warrior for Gringostroika. These are much less imaginative extensions of Gómez-Peña's own complex personality than his sensitive projections of cultural types and stereotypes reflecting current cross-cultural politics.

The African-American theatre has a long and important performance tradition of its own, some of which has fed directly into modern performance art, even though this influence has been ignored by white performance artists and critics. As black

performance artist Keith Mason has remarked:

Blacks have always been excluded from the avant-garde, but the history of the avant-garde is based in the jazz tradition. Where did Merce Cunningham get the thematic structure of his pieces? From great urban jazz. Leroi Jones didn't call them "happenings," but he created them. In the middle of some of her famous French routines in the 1920s, Josephine Baker would stop and talk about racism in America—to me, that's performance art.58

While a student at Webster University in St. Louis in the early 1980s, Mason demonstrated a flair for politically oriented performance by such actions as wearing a noose around his neck for most of a semester. In 1985 he moved to Los Angeles and founded the Hittite Empire, devoted to utilizing performance to improve communication, self-respect, and self-understanding among black men.

The three black women who have created performances under the name "Thought Music" during the 1980s-Laurie Carlos, Jessica Hagedorn, and Robbie McCauley-also came to performance from other artistic backgrounds and only gradually realized the potential of performance to express their concerns and to relate to their ethnic heritage. During the late 1960s, McCauley experimented with "jazz theatre" at the New Lafayette Theatre, and Carlos and Hagedorn were involved with mixed-media work. Hagedorn's Gangster choir mixed music and fragments of her writing. "I didn't know about performance art," she observes, "I just called it a poet's band." By the 1980s, when Thought Music was formed, however, these artists acknowledged the relationship of their work and their concerns to current performance. "We were beginning to find our own voices," recalls Carlos, but they could not readily do so in any of the conventional venues in either black or white theatre. "Performance art was the one place where there were so few definitions." In the late 1980s Robbie McCauley developed a series of performances, Confessions of a Black Working Class Woman, using the physicality of her body (perhaps most shockingly as a nude slave on the auction block in Sally's Rape, 1989) to explore the personal and social effects of racism upon her own life history and that of her ancestors. 60

In 1989 the performance artist Tim Miller and Linda Burnham, the founding editor of *High Performance*, the United States' major chronicle of performance art, co-founded the Highways Performance Space in Los Angeles, a central venue for performance work and one of the best places for observing the contemporary performance scene. Burnham contrasts this scene with the gallery performance of the 1970s and the club performance of the 1980s:

Now the majority of people we show here are doing solo work, and they're not coming out of visual art. They're mostly writers and theater people and a few dancers who want to push the envelope. More than half of what we see at Highways is about individual identity. It's about people from so many different cultures being pushed together in L.A. and introducing themselves to each other.⁶¹

This combination of the study of individual identity and different cultures, with particular attention to disadvantaged, excluded, or oppressed groups—gays and lesbians, the handicapped, the elderly, the poor, along with racial and ethnic minorities—characterizes much of the most imaginative and provocative performance work in the United States in the early 1990s. Highways has hosted the Hittites as well as the Pomo Afro Homos, Gómez-Peña as well as Dan Kwong, whose Secrets of a Samurai Centerfielder (1989) explores the tensions of a gay son of Japanese/Chinese parentage struggling against dominant culture and sex-role expectations.

In a 1990 report on current performance in Los Angeles, Jacki Apple observed that the majority of such work was now being produced by "a coalition of women, gay men, African-American, Hispanic and young Asian-American artists whose esthetics and politics challenge both the art world's and the media's version of our socio-cultural reality." The distinguishing characteristic of the work of this coalition, claimed Apple, has been

their desire not to tear down or destroy our ailing institutions but to *heal* them. Beyond art as process is the idea of art as a means to make community rather than commodity. Imbedded in that is the need to discover and make connections between a culturally and spiritually dissociated past and our present social and political realities.

As an example of current community-oriented work, Apple cited Doug Sadownick's *Multicultural Passover Seder* (1990), offering "a convergence of performance art, spiritual practice, cultural tradition, and political consciousness."

A similar view of the potentials and concerns of current performance has been offered by Gómez-Peña, who has argued that the field of performance has significantly changed since the late 1980s when Karen Finley talked about "mainstreaming radical ideas" as the goal of performance art. That goal, says Gómez-Peña, has been attained, and now the goal should be to attack "the European myth of the artist as a marginal bohemian," still very prevalent in North America:

I aspire to speak from the center, to be active in the making of culture. The same is true for gays, women, and artists of color, who can't afford to be marginalized anymore. Performance art is the one place where this can happen—where ritual can be reinvented, and where boundaries can be crossed.⁶³

Resistant performance

Performance work based primarily upon autobiographical material and frequently dedicated to providing a voice to previously silenced individuals or groups became in the early 1970s, and still remains in the 1990s, a major part of socially and politically engaged performance; but other engaged performance has also been developed in quite different and, in general, more openly resistant ways. Here, as in identity performance, the lead has been taken, both in theory and practice, by women, although more recently gay men and ethnic minorities have continued to develop these strategies to address their own concerns.

When the modern women's movement began in the late 1960s, it existed in quite a different world from the apolitical, formalist, gallery-oriented "performance" work of the same period. Yet at the same time, many radical feminists were much attracted to the symbolic values and performance strategies of the radical guerrilla and street theatre of the period. Feminist guerrilla theatre began to appear in a number of striking and well-publicized demonstrations such as the 1968 disruption of the Miss America pageant in Atlantic City, which included the crowning of a live sheep, the auctioning off of a Miss America dummy, and the flinging of dishcloths, steno pads, girdles, and bras into a Freedom Trash Can. Later the same year, women in New York organized WITCH (Women's International Terrorist Conspiracy from Hell) and on All Hallows' Eve appeared costumed and masked as "Shamans, Faerie Queens, Matriarchal Old Sorceresses, and Guerrilla Witches" to confront and cast spells upon the denizens of the Wall Street area. WITCH covens soon appeared all over the United States to engage in similar guerrilla theatre activity, hexing Pat Nixon and the Boston Transit Authority and holding a "spell-in" at the United Fruit Company. Robin Morgan, one of the pioneers of such activity, later observed that the participants in these demonstrations "identified politically with the confrontative tactics of the male Left and stylistically with the clownish proto-anarchism of such groups as the Yippies," but that "not having raised our own consciousness very far out of our combat boots, we didn't know what we were doing, or why." 1

Later on, the raising of consciousness redirected much of this "proto-anarchic" energy into more directly political and social activity, but the tradition of the feminist guerrilla theatre lives on, for example, in the ongoing and highly visible activities of New York's Guerrilla Girls, whose posters and performance demonstrations (in gorilla masks) call attention to the continuing dominance of men in New York's art world.2 Guerrilla or street theatre has probably on the whole been less employed for consciousness-raising in women than for calling the attention of both men and women to unresolved and often ignored problems in contemporary society. This was also true when the concerns of feminist guerrilla theatre began to be explored later in the 1970s by women in the performance art scene. Suzanne Lacy and her collaborator Leslie Labowitz, for example, offered a powerful series of works in California seeking to raise community consciousness about rape (Three Weeks in May, 1977), commercial images of violence against women (Record Companies Drag Their Feet, 1977), and demeaning sexist images generally.

The years between the WITCH demonstrations of the late 1960s and the social activist performances of a decade later were of course also those of the emergence of the modern women's movement, and of a rapidly developing theoretical as well as political discourse within the women's movement. As a result, later performances tended to be more concerned not only with making a specific political statement, but with exposing the underlying social, cultural, and aesthetic practices and assumptions that supported and validated the specific phenomenon being displayed. Lacy and Labowitz' Three Weeks in May, after a series of events drawing on specific material related to recent incidences of rape, ended more abstractly or theoretically with a scene in a gallery in which four nude women, painted red, crouched mutely on a ledge. Jeanie Forte suggests that they "bore striking resemblance to the countless nude women hung on the walls of Western museums," thus providing a critique of the "cultural practice that has made of woman an object, a category, a 'sign," and suggesting "how such transposition of women into signs (or representations of femininity), endangers the lives of actual women."3

Clearly, in terms of the various subdivisions applied to modern feminism, this latter concern accords most closely with the materialist, looking beyond individual case studies to the particular social apparatus or cultural practice that has produced them and to how this apparatus favors certain social interests rather than others. By the end of the 1980s there was wide-spread interest among feminist performers and theorists internationally in the questioning, the exposing, and perhaps even the dismantling of those cultural and social constructions and assumptions that governed traditional gender roles, stagings of the body, and gender performance, both on the stage and in everyday life.

German theorists and performers Ulrike Rosenbach and Valie Export developed an approach to performance called "feminist actionism," which pursued a similar disruptive agenda, seeking "to replace the equation material=body=nature by that of body= social construction=transfigured nature." According to Export:

The representation of woman's body, as imprinted by history in the images of our phallocentric culture, demanded that these stagings of the body that had been defined by an alien ideology be brought into question and dismantled as occupations of the body by the forces of alien signs.

This questioning, in performances such as those of Rosenbach and Export, involved an emphasis on "the social construction of the body, the body as a carrier of signs, and with it the social construction of the subject in performance."4

A similar trajectory in political performance from guerrilla theatre, through a more liberal theatre of debate, to a materialist examination of the politics of representation itself also occurred in modern feminist performance in England, according to the history of that movement by Michelene Wandor, Carry On, Understudies. Wandor traces three general stages of such performance. The "vivid visual imagery of the early street theatre, with its spontaneity and its attack on stereotypical 'feminine' imagery," gave way in the mid-1970s to a "theatre of argument," attempting to "reclaim the experience of women and gays" from the "conventional priorities of male heterosexual experience,"

including its class perspective. Finally, in a third phase, some of the early spontaneity returned, but in a different context: "instead of using dressing-up and visual imagery to challenge the audience's assumptions about real-life oppression, the new spontaneity revolved around an examination of the way the theatrical forms themselves work to represent sexuality."5

This growing interest in the cultural dynamics embedded in performance and theatrical representation itself was primarily stimulated by a materialist concern for exposing the operations of power and oppression in society; but theoretical writing on the subject was at least as much influenced by recent psychoanalytical theories as by political, social, or economic ones. The model of the psychological self developed by Freud and extended by his French follower, Jacques Lacan, has exerted a particularly strong influence in modern cultural studies, and feminist theorists in particular have found in Freud and Lacan the most fully developed model for the establishment of the dominant male subject in the patriarchal cultural system.

Lacan, following Freud and indeed the traditional Western system of representation, places the male in the subject position. This subject enters self-consciousness and language with a sense of separation and incompleteness, an ongoing "desire" for an objectified "other" that both threatens and promises a lost unity. Traditional theatre and visual art are based on this system, assuming a male spectator and offering the female as "other," the object of the male's desiring gaze. As Sue-Ellen Case has observed, within the patriarchal system of signs and of representation, "women do not have the cultural mechanisms of meaning to construct themselves as the subject rather than as the object of performance." The traditional audience is assumed to be the male subject, and the woman on stage "a kind of cultural courtesan," an objectified site for the fulfillment of desire. A wedge is thus driven between this courtesan sign, "woman," and real women that "insinuates alienation into the very participation of women in the system of theatrical representation."6

Women's performance art directly challenges this system by the establishment of an actual woman as a speaking subject, a phenomenon that the system denies. Hélène Cixous has suggested that women's writing should occupy the same fluid and liminal world associated by many theorists with performance. She has

described such writing as

precisely working in the in-between, examining the process of the same and the other without which nothing lives . . . not frozen in sequences of struggle and expulsion or other forms of killing, but made infinitely dynamic by a ceaseless exchanging between one and the other different subjects, getting acquainted and beginning only from the living border of the other: a many-sided and inexhaustible course with thousands of meetings and transformations of the same in the other and in the in-between 7

Other feminist theorists and performers, especially those interested in seeking a more essentially feminist mode of expressivity, have followed the lead of such French theorists as Luce Irigaray and Julia Kristeva in regarding traditional language as itself a male construction, dominated by the operations of logic and abstraction and reflecting the interests of the patriarchy. Physical performance has been seen as offering a possibility for women to escape what Kristeva has called the "symbolic" logical and discursive language of the father for the "semiotic" poetic and physical language of the mother.8 The utilization of the body in performance may thus provide an alternative to the symbolic order of language itself, which many feminist theorists have claimed provides no opening for the representation of women within it.

Marcia Moen, working with Charles Peirce's modes of knowing, has suggested how the exploration of cognition based upon feeling and a bodily felt sense of "rightness" can "engage the body in an active role, making possible, for example, resistance to the influences of power-knowledge discourses."9 Others have argued that the body in performance provides not merely an alternative way of knowing, but a necessary subversion of the dominant symbolic order. Jeanie Forte, for example, has pointed out that this potential disruption is much greater in physical performance than in the field of writing since the female body in performance involves not only the discourse of language, but "physical presence, real time, and real women in dissonance with their representations, threatening the patriarchal structure with the revolutionary text of their actual bodies." 10 Sally Potter argues, in a 1980 catalogue devoted to women's performance in London, that live performance always possesses a subversive and threatening quality, even when that performance involves the most traditional and highly codified roles, such as the graceful ballerina or the raucous comedienne, which seem to have been designed only to "reinforce stereotypes and gratifying male desire." Real physical presence, says Potter, exerts a counter-power even here. "The ballerina's physical strength and energy is communicated despite the scenario; the burlesque queen's apposite and witty interjection transforms the meaning of what she is doing and reveals it for the 'act' it is." ¹¹

Yet even some theorists who have supported this strategy have also expressed some misgivings about it. Rachel Bowlby, for example, has warned against too ready an acceptance of bodily "discourse" as the most effective way for women to "speak." "It remains to be shown," cautions Bowlby, "that the female body is itself productive of a distinctive mode of subjectivity." It also remains to be shown whether a "distinctive mode of subjectivity" is a desirable goal for feminism, since it runs the risk of any essentialist strategy of reinforcing traditional structural relationships between dominant and subordinate positions, thus giving new support to the power relationships they involve.

The rise of poststructuralist theory demanded just this sort of questioning of essentialist strategies. Materialist feminism has generally sought to utilize the postmodern decentering of the subject, not to reverse Lacan and to create a new "subject" position for women, but to encourage both performers and spectators to think critically about the whole traditional apparatus of representation, including in particular the subject/object relationship. The "postmodern performance style," according to Jill Dolan, "breaks with realist narrative strategies, heralds the death of unified characters, decenters the subject, and foregrounds conventions of perception," its goal being to encourage critical thinking about "representation as a site for the production of cultural meanings that perpetuate conservative gender roles."13 Similarly, Elin Diamond has suggested that a feminist approach to performance might seek to move beyond "the phenomenological universals of transcendent subjects and objects" that characterized both traditional psychology and performance to place identity "in a more unstable and contingent relation to identification."14

Yet a major problem still remains—precisely how to utilize representation or performance to carry out this project, given that both have been heavily involved in the cultural assumptions that performers and theorists want to challenge. At the center of the

work of one of the most influential recent writers on gender, Judith Butler, is a view of gender not as a given social or cultural attribute but as a category constructed through performance. In Gender Trouble (1990) Butler called gender "performative," a "doing." Equally important and equally revolutionary, she characterized it also as "not a doing by a subject who might be said to preexist the deed." On the contrary, the "subject" is itself "performatively constituted" by acts, including acts that signify a particular gender. 15 These acts in turn are not singular events, but "ritualized production, a ritual reiterated under and through constraint, under and through the force of prohibition and taboo, with the threat of ostracism and even death controlling and compelling the shape of the production."16 Such a formulation would seem to leave little room for altering performed categories, since agency itself arises not from some choosing subject existing before the performance of identity, but rather from the "self" constituted by performance. Yet here and even more centrally Butler argues that the possibility of, indeed even a tendency toward, alteration and modification exist within the process of repeating the performance. Recalling that Derrida challenged Austin and Searle's concept of performative utterances by stressing their citationality17 and thus their involvement in repetition, Butler stresses that gender performance, too, is citational and, like all citation, never precisely repeats the absent original. Bakhtin, it will be remembered, made this point in relationship to the linguistic utterance, and de Certeau in relationship to the "tactics" of everyday actions. Still other theorists have described a similar "slippage" between any culturally established concept or action and specific restatements or re-enactments of it. Adorno, for example, recommended a "negative dialectic" in thinking, recognizing that no pattern or concept is ever "totally congruent and isomorphic with the experience it purports to denote."18 Human activity, he suggested, "is characterized above all by the fact that the qualitatively new appears in it . . . it is a movement which does not run its course in pure identity, the pure reproduction of such as already was there."19 An enormous social effort of constraint and prohibition, based on what Adorno calls "identity-thinking," continually works to deny or limit this slippage, to maintain a total congruity between concept and experience, pure identity and repetition, but it can never be totally successful. The possibility of innovative agency is always present, not based upon a pre-existing subject constrained by regulatory laws, but in the inevitable slippage arising from the enforced repetition and citation of social performance.²⁰

Elin Diamond has noted that even the terminology associated

with performance suggests this situation:

While a performance embeds traces of other performances, it also produces an experience whose interpretation only partially depends on previous experience. Hence the terminology of "re" in discussion of performance, as in remember, reinscribe, reconfigure, reiterate, restore. "Re" acknowledges the pre-existing discursive field, the repetition within the performative present, but "figure," "script," and "iterate" assert the possibility of something that exceeds our knowledge, that alters the shape of sites and imagines new unsuspected subject positions. ²¹

Although Butler's theories are focused not on performance art but on the performative dimension of everyday life, her approach has proven richly suggestive for the former as well. Ironically, the more aware theorists have become of the centrality of performance in the construction and maintenance of social relationships in general and gender roles in particular, the more difficult it has become to develop a theory and practice of performance that could question or challenge these constructions. Little current critical performance follows the strategy so common in the late 1960s guerrilla performance of direct opposition, but an extremely wide variety of socially and politically engaged performance of a different sort has evolved, reflecting the concerns, tensions, and assumptions of a postmodern consciousness. When the very structure of the performative situation is recognized as already involved in the operations of the dominant social systems, directly oppositional performance becomes highly suspect, since there is no "outside" from which it can operate. Unable to move outside the operations of performance (or representation), and thus inevitably involved in its codes and reception assumptions, the contemporary performer seeking to resist, challenge, or even subvert these codes and assumptions must find some way of doing this "from within." They must seek some strategy suggested by de Certeau's "tactics," which he sees as activities that "belong to the other," outside the institutionalized space of "proper" activity. A tactic, says de Certeau:

insinuates itself into the other's place, fragmentarily, without taking it over in its entirety, without being able to keep it at a distance. It has at its disposal no base where it can capitalize on its advantages, prepare its expansions, and secure independence with respect to circumstances ... because it does not have a place, a tactic depends on it—it is always on the watch for opportunities that must be seized "on the wing." Whatever it wins, it does not keep. It must constantly manipulate events in order to turn them into "opportunities."²²

Without providing specific strategies for such operations, Butler and others have nevertheless contributed significantly to grounding such strategies by providing a theoretical orientation that accepts the postmodern suspicion of an empowered subject existing outside and prior to social formations without renouncing the possibility of a position of agency to oppose the oppressions of these formations. The key to this orientation is in the operative concept of performance itself, which like all "restored behavior" simultaneously reinscribes and resists pre-existing models. As Wlad Godzich notes in summarizing de Certeau's contributions to discourse theory, de Certeau "recovers an agential dimension for us in as much as it recognises that discursive activity is a form of social activity, an activity in which we attempt to apply the roles of the discourses that we assume," thus placing us "squarely in front of our responsibility as historical actors." A typically postmodern double operation is involved in such performance; the constitution of the self through social performance is viewed as a dynamic simultaneously coercive and enabling.

The sort of double operations that Butler sees involved in social performance are closely related to the strategies of recent theorists and performers concerned with developing a resistant performance art in the cultural context of postmodern thought. The possibility, even the necessity, of critique if not subversion from within performative activity has become widely accepted, but the most effective performance strategies for such subversion remain much debated. The central concern of resistant performance arises from the dangerous game it plays as a double-agent, recognizing that in the postmodern world complicity and subversion are inextricably intertwined. Resistant theorists and performers have been very much aware of Derrida's warning that "by repeating what is implicit in the founding concepts . . . by using against the edifice the instruments or stones available in the house . . . one risks ceaselessly confirming, consolidating . . . that which one allegedly deconstructs," ²⁴ or more likely of Audre Lorde's more succinct and striking "the master's tools will never dismantle the master's house." ²⁵

Much more in line with current attitudes, however, is de Certeau's position: "The weak must continually turn to their own ends forces alien to them" ²⁶—a position much more congruent with Butler's ambivalent and postmodern view: "There is no self that is prior to the convergence or who maintains 'integrity' prior to its entrance into this conflicted cultural field. There is only a taking up of the tools where they lie, where the very 'taking up' is enabled by the tool lying there." ²⁷ Much modern resistant performance takes up whatever tools the culture offers and employs them in the manner parallel to the operations Auslander has noted in postmodern political work in general: "an elusive and fragile discourse that is always forced to walk a tightrope between complicity and critique." ²⁸

From this more recent attitude, the subversive possibilities of live performance in itself became less clear. The idea that in such performance "real women, real presence, and real time" could be separated from their "representations" could not easily be reconciled with the growing feeling that so-called "reality" was itself experienced only through representations. Materialist or postmodern feminists could no longer accept the modernist privileging of presence or such essentialist performance ideals as that of offering the nude female body as uninscribed, free from socially constructed roles. The performance space itself is already genderized, critics like Dolan pointed out, and in this space women's bodies "become accountable to male-defined standards for acceptable display."29 In the enactment of representations, one also assumes all their cultural associations—the display of gender, the frame of reference, the spectators' narrative expectations —which form part of the controlling mechanisms preventing a challenge to convention. The power of established male-oriented reception strategies over women's performance would seem to provide little opportunity for performers to gain any agency in this process, whether they attempt to exert their presence, as Potter suggests, in such highly codified performance roles as the graceful ballerina or the witty burlesque queen, or whether they seek literally to divest themselves of all such roles through nudity.

This does not mean that recent critical feminist performance has avoided nudity or highly coded traditional representations of women. On the contrary, it has frequently sought out precisely such material in order to subject it to various types of ironic quotation, a kind of political double-coding. Performers working in this direction introduce into the playing of a role a subversive and parodic self-consciousness, which is very wide-spread in contemporary engaged performance, by feminists and others, both in Europe and the United States.

Elin Diamond has suggested the use of the term "mimicry" to characterize these various forms of "ironic disturbance." ³⁰ The modern concept of mimicry, itself a mimic distortion of Plato's conventional doctrine of "mimesis," is derived from French theorist Luce Irigaray, who saw in Plato's condemnation of mimesis an attempt to control the proliferation of alternatives to a stable and monolithic patriarchal Truth. Instead of the shadowy "mere copy" of mimesis, Irigaray proposes a multiple and excessive "mimicry" that undermines rather than reinforces the unique claim of patriarchal Truth. Women, she suggests, must "play with mimesis," must "assume the feminine role deliberately. Which means already to convert a form of subordination into an affirmation, and thus to begin to thwart it."31

In an analysis of Laurie Anderson, Herman Rapaport has suggested that she is utilizing a similar process, which he calls "miming." Recalling Jencks' characterization of the postmodern as double-coded expression, Rapaport suggests that the postmodern artist may turn representation to critical or even subversive ends by stressing the disharmony of codes:

in performing the hegemony Anderson is also miming it, and in doing so she is releasing or activating resonances within the collision of vernacular and elitist cultural expressions, resonances which undermine that hegemony's efficacy as a stable equilibrium in which the power of the elite culture seems natural.

In United States, according to this view, Anderson, in "performing" the postmodern "hybridization of the elite and the vernacular," also performs

the hegemony's illusory unifications and subtly reveals its dissonances and discrepancies, but without necessarily enacting a critical stance of her own, a stance which would be recovered merely as another ideological or theoretical formation intended to dominate a field of relationships.³²

Other theorists have considered that the primary disruptive power of mimicry lies less in its conflict of codes, an emphasis that stresses its relationship to Jencks and postmodernism, than in its excess and exaggeration, an emphasis closer to Irigaray and her concern with the subversion of patriarchic unity and order. This is the direction taken by masquerade theory, which developed within the analysis of performance in film, but which has more recently become important in live performance as well. In "Film and the Masquerade" (1982), Mary Ann Doane suggested that a woman film performer could subvert traditional roles and masks if she could "flaunt her femininity, produce herself as an excess of femininity—foreground the masquerade."33 A slightly different perspective on this same performance strategy is offered by Mary Russo, who draws upon Bakhtin to postulate a carnivalesque performing body, consciously "making a spectacle of itself" in order to call attention to the spectacle as process and construction.34 When Lois Weaver in *Upwardly Mobile Home* (1985) through "subtle exaggeration . . . defuses the obvious fetishization" in the carefully choreographed artificiality of the country and western movie star, when Franca Rame in Female Parts (1977) exploits "the gender signs of heterosexual femininity" by the use of dyed blond hair and exaggerated makeup, when Rachel Rosenthal in Rachel's Brain (1987) appears as an "exaggerated parody of a salon aristocrat" whose speech on rational discourse disintegrates into whines, grunts, and stifled hysterical cries, different sorts of masquerade strategies are being employed.35

As a critical operation, masquerade performances always run the danger that Derrida cited in any deconstructive operation, which seeks to turn established structures back on themselves—that this process may also, especially for a conventional audience, simply reinscribe or reinforce those structures. This is a common problem in all postmodern political performances, which, as Auslander warns, "can turn into their own opposites by reifying the very representations they supposedly deconstruct." A striking and by no means unique example of this was encountered by the British feminist performance group Monstrous Regiment when they attempted in *Time Gentlemen Please* (1978) to foreground the degrading sexual self-representation of women in

traditional cabaret and stand-up comedy. A letter from a woman in the Communist Party newspaper Morning Star apparently understood the strategy, but nevertheless complained that "Far from creating a Dietrich image in order to subvert it, Monstrous Regiment appears to indulge itself in the creation, to revel in the fantasy." Director Susan Todd was forced to justify the performance in another letter, arguing that the women in the show "deconstruct their traditional mode of stage presence and abandon coyness, terror and self-doubt for a direct expression of sexuality." This, she insisted, "represented a victory for each woman over self-denigration."37

"Only the most cunning of female masquerades," suggests British performance artist Catherine Elwes, "can turn the spotlight on the mask and those for whom it is worn."38 Nevertheless, Elwes feels that live performance, in which the gaze of the male spectator can be returned or at least challenged or made problematic, offers possibilities for disruption of the conventional system of spectatorship impossible in representations offering permanently fixed and objectified images of women such as the cinema, painting, or sculpture. The living woman performer, she argues, can expose the (male) spectator "to the fearful proximity of the performer and the dangerous consequences of his own desires. His cloak of invisibility has been stripped away and his spectatorship becomes an issue within the work."39 The importance of at least calling attention to, if not successfully subverting, the power relationships involved in traditional spectatorship has led many performers in one way or another to "turn the spotlight" on the (male) spectator and challenge his invisibility. Some have done this literally, like Sonia Knox, who floods herself and her audience with the same uncompromising light. Valie Export, Lydia Lunch, and Rachel Rosenthal are among the many performers who have challenged the voyeurism of performance in various ways, but a particularly striking case is Karen Finley, who has combined shifting gender positions, scatology, and perverse sexuality in her monologues, mocking the visual "consumption" of her nude, or nearly nude, body by coating it with a variety of mostly edible materials. Rather than offer herself as a passive object, Finley, in Dolan's words,

forces men to be passive in the face of her rage, and she desecrates herself as the object of their desire, thereby mocking their sexuality. Her refusal to play the game leaves the male spectator nowhere to place himself in relation to her performance. He can no longer maintain the position of the sexual subject who views the performance. 40

Finley gained major public attention in 1990 as one of four performance artists denied funding by the National Endowment for the Arts, and soon became the central example of the shocking and sexually explicit performer that so outraged conservative elements during and after this controversy.

The power, anger, and imagination of Finley's work has inspired many more recent performance artists. "A lot of people seem to be drawing on work that Karen Finley's done," reports Scott Macaulay, director of programming at The Kitchen, long one of New York's leading venues for performance, "You can really see the impact of the censorship flap now: artists dealing with taboo subject matter or presenting work that is aggressively, explicitly political."41 However, even performance so disruptive and confrontational as that of Finley risks, at least with some audiences, being neutralized by the power of the reception process it seeks to challenge. As Finley's reputation grew (largely as a result of the funding denial) and she became in demand in more conventional and commercial venues. Forte reports, even her most shocking work "became re-inscribed in the fetishistic process associated with strip-tease or live sex, and not at all the feminist or subversive strategy that theory might endorse."42

Jon Erickson, in a 1990 article, "Appropriation and Transgression in Contemporary American Performance," argued that such re-inscription or re-appropriation is almost inevitable so long as minority or marginalized performance allows itself, even through ironic subversion, "to be solely defined by what we are transgressing, resisting, or deconstructing." The more sophisticated ironic strategies become and the more attention is given to the appropriation and attempted devaluation of the dominant culture, the more likely, for audiences who subscribe to that culture, that traditional meaning "will be assumed and be reinforced, not undermined." Resistance only from within the terms "given us," Erickson argues, can at best only be reformist, not revolutionary, and he urges that resistance be developed on the basis of "an alternative mode of perception or action" that can provide a clear dialectic alternative to the existing system.⁴³

Rather than attempting in performance to resist conventional reception by various types of exaggeration, any of which run this danger of reinscription, an important area of feminist theory and performance has followed the more radical strategy of placing woman in the position of the desiring subject of the performance "in contrast to the passive role traditionally granted women as the object of male desire."44 Elwes suggests that the sexual aspects of women's physical presence in performance should be constantly explored and exploited precisely because "the unknown territory of women's desire can intensify her threat."45

Lesbian performance has provided one of the most important areas for experimentation of this sort. In a 1986 article, Kate Davy argued that lesbian performance could undercut conventional reception "by implying a spectator that is not the generic, universal male, not the cultural construction 'woman,' but lesbian —a subject . . . whose desire lies outside the fundamental model or underpinnings of sexual difference."46 Similarly, in "Toward a Butch-Femme Aesthetic" (1989), Sue-Ellen Case suggests that the search for a heterosexual female subject "remains entrapped" insofar as this subject "is still perceived in terms of men." Building upon masquerade and carnival theory, but rejecting their heterosexual assumptions, Case sees in the on and off stage butch-femme performance of a couple like Peggy Shaw and Lois Weaver of Split Britches a camp fulfillment of masquerade's project against essentializing social and theatrical roles and narratives. The point of lesbian camp performance, says Case, "is not to conflict reality with another reality, but to abandon the notion of reality through roles and their seductive atmosphere and lightly manipulate appearances."47

This strategy, Case suggests, can also be found in gay camp performance, at least in its more politically conscious manifestations. In a 1968 article on the recently organized Theatre of the Ridiculous, Stefan Brecht suggested that the work there represented the attitudes of the "free person [f.p.]" as distinct from the "authoritarian phony," the normal "civilized adult." Ridiculous performers "adopt and act roles as the f.p. playfully assumes his identity—without identifying and only for the sake of playing them." Through "farcical and ironic performance" it seeks the "corrosion of make-believe identity" as it is found in the "institutionalized society" of the authoritarian phony. 48 A similar point is made by Butler, who suggests that the replication of heterosexual relationships in non-heterosexual frames "brings into relief the utterly constructed status of the so-called heterosexual original." Therefore gay is to straight "not as copy is to

original, but, rather, as copy is to copy."49

It is this corrosion of identity and foregrounding of constructedness in gay performance that Case relates to lesbian masquerade performance, but other theorists, such as Dolan and Davy, while praising Case's expansion of the sexual and performance terrain, have questioned her association of lesbian with gay camp performance. Davy approvingly cites Earl Jackson, who has written on male cross-dressing in Eastern and Western performance:

Throughout history, for various reasons, male homoerotic practices have been supportive of, rather than subversive to, hegemonic conceptions of masculinity. Even in the postmodern, late capitalist societies of the twentieth century, male homoerotic discourses are often reinscribed within the very patriarchy they would seem to countermand.50

The tools of camp performance—artifice, wit, irony, exaggeration —are of major importance to lesbian performance, Davy concedes, but she also argues that these tools are employed toward an end that is central to lesbian performance and peripheral, at best, to gay camp. The former "dismantles the construction 'woman' and challenges male sexuality as the universal norm," and thus far more radically subverts the social relations of gender and gender ideology in everyday life.51

Teresa de Lauretis in her 1988 "Sexual Indifference and Lesbian Representation" discussed other problems confronting lesbian theory and performance that she felt had so far been inadequately addressed by such theorists as Davy, Case, and Dolan. One was the difficulty of defining an autonomous form of female sexuality and desire free of the Platonic tradition and of the tendency to posit a unified viewer. The other problem was the attempt to alter the frame of visibility, of what can be seen. 52 Each of these areas of concern has in fact received increasing attention in performance and theory of the 1990s.

The process of changing what can be seen, of giving visibility as well as voice to such hitherto excluded phenomena as female desire or female subjectivity, has in fact been a central concern of much feminist performance and performance theory, and of lesbian theory and performance in particular. The playful destabilizing of sexual roles performed by Split Britches or the exposure of the passive (male) spectator and the return of his gaze by Knox or Finley provide two quite different strategies for this, and tie modern feminist performance to the familiar concerns of "visibility politics," which have often involved various forms of what might be called social or public performance.

So much attention has been given to the social importance of visibility, in fact, that Peggy Phelan, in her recent book Unmarked (1993), has cautioned that the operations of visibility itself need to be subjected to more critical inquiry. In stressing performance's ability to make visible, feminists have not considered the power of the invisible, nor the unmarked quality of live performance, which "becomes itself through disappearance." Without seeking to preserve itself through a stabilized copy, it "plunges into visibility—in a maniacally charged present—and disappears into memory, into the realm of invisibility and the unconscious where it eludes regulation and control."53 Phelan cites the performance work of Angelika Festa as work "in which she appears in order to disappear"—appearing as a motionless figure wearing a mirror as a mask (You Are Obsessive, Eat Something, 1984) or hanging for hours from a slanted pole, her eyes covered and her body wrapped in cocoon-like sheets (Untitled Dance (with fish and others), 1987).⁵⁴ Traditional representation, committed to resemblance and repetition, attempts to establish and control the "other" as "same." This is the strategy of voyeurism, fetishism, and fixity, the ideology of the visible. If performance can be conceived as representation without reproduction, it can disrupt the attempted totalizing of the gaze and thus open a more diverse and inclusive representational landscape. As Elwes has noted, women performers should "never stay the same long enough to be named, fetishized."55

Thi Minh-Ha Trinh, a feminist film maker and theorist, stresses the importance of disrupting the traditional performance/reception process. Dominant ideology, she argues, is reinforced in the activity of both the performer and spectator "everytime an interpretation of a work implicitly presents itself as a mere (obvious or objective) decoding of the producer's message." This occurs in much traditional art, whenever there is "a blind denial of the mediating subjectivity of the spectator as a reading subject and meaning maker—contributor" or whenever artists "consider their works to be transparent descriptions or immediate experiences of

Reality 'as it is." Trinh encourages a kind of Brechtian alienation strategy to "break off the habit of the spectacle by asking questions aloud; by addressing the reality of representations and entering explicitly into dialogue with the viewer/reader," the goal being to disrupt the "conventional role" of the spectators, so that they are no longer expected to discover "what the work is all about," but to "complete and co-produce" it by addressing it "in their own language and with their own representation subject-ivity."56 Performance is no longer created by someone for someone, but is the expression of a plurivocal world of communicating bodies, where difference is "conceived of not as a divisive element, but as a source of interactions; object and subject are neither in opposition nor merged with each other."57

This project relates also to de Lauretis' other challenge to feminism—that its theorists and practitioners must pay greater attention to the spectatorial diversity and the effects of this upon performance. There has in fact been a growing recognition in more recent engaged performance and theory that both, as Dolan has suggested, must recognize a range of "spectatorial communities, separated and differentiated by class, race, and ideology."58 While this is still very much a project in process, one of the most distinctive features of performance work of the late 1980s and early 1990s in the United States, as we have already noted in our survey of performance and identity, has been the appearance of performers and spectatorial communities dedicated to extending gender- and self-exploration to women of lower social class, homosexual men, and women and men of color.

Each of the performers and spectatorial communities representing positions other than the dominant ones in the culture has been forced in some way to negotiate the same tension that we have seen in feminist performance between the desire to provide a grounding for effective political action by affirming a specific identity and subject position, and the desire to undermine the essentialist assumptions of all cultural constructions. This is the dilemma at the heart of Butler's work—the problem that the acting self comes into being only through pre-existing and oppressive cultural constructions. Intervention in the operations of the dominant symbolic systems—linguistic, theatrical, political, psychological, performative—seems to require, in Elin Diamond's words, "assuming a subject position, however provisional, and making truth claims, however flexible, concerning one's own

representations."59 This operation has been appropriately termed "strategic essentialism."

The less "provisional" or "flexible" one's truth claims are, the closer one comes to pure examples of the sort of identity performance discussed in the previous chapter. The more provisional or flexible these claims, the closer one comes to the sort of resistant performance that is the subject of the present chapter, where identities and subject positions become markers in an ironic play whose goal is really to question the process of representation itself, to ask what is at stake in the performance (social and theatrical) of ethnicity, gender, or sexuality-for whom, by whom, and to what end representation is taking place. Judith Butler has tellingly articulated this position by recommending a move away from an attempt "to solve this crisis of identity politics," by concentrating on who and what wields the power to define identity; "to proliferate and intensify this crisis" and "to affirm identity categories as a site of inevitable rifting."60

It is important to bear in mind, however, particularly when speaking of recent performance, that clear-cut examples of an essentialist performance of identity, or a materialist performance dealing with the process of identity construction, are neither one so common as some sort of negotiated space between these positions. Most modern politically oriented performance is flexible very much in the manner that Diamond suggests, slipping back and forth between claiming an identity position and ironically questioning the cultural assumptions that legitimate it. The goal is not to deny identity, but on the contrary to provide through performance alternate possibilities for identity positions outside those authenticated by conventional performance and representation.

Many of the performance artists discussed in the previous chapter as operating with identity, especially those working in the late 1980s and 1990s, are in fact best understood in the terms Diamond proposes, as simultaneously engaged in the claiming of and the ironic commentary upon identity positions. This complex and ambiguous performance strategy is particularly marked in the work of performance artists exploring their identity as members of culturally, ethnically, or sexually marginalized communities. Tim Miller's gay identity is central to his work, but so is a constant attention to making the audience aware of how this "identity" is being constructed through performance—a strategy David Román calls reminiscent of Brechtian distancing.⁶¹ In a strategy very similar to Diamond's "mimicry" or to lesbian masquerade, the live performances of artists such as Miller seek to produce "a chaotic multiplicity of representations, representations that displace, by the very process of proliferation, the authority of a conservative ideology of sexual hegemony, AIDS myths, and sexual practices."⁶²

This multiplicity is particularly clear in the case of performers seeking to articulate the experience of ethnic minorities, since the pressures of otherness and of cultural stereotyping are so central to their experience and so inextricably intertwined with the exploration of an ethnic "identity." The potential performance complexity of this process has been illuminatingly explored by Rebecca Schneider in her analysis of Reverb-ber-ations (1990) by the Native American performers Spiderwoman. 63 Schneider approvingly cites Diamond's discussion of the disruptive, critical power of mimicry, noting that this power has been explored not only within feminism but by theorists interested in developing a strategy to disrupt political colonialism. Most notably, Homi Bhabha in "Of Mimicry and Man" (1984) locates a "comic turn" within colonialism's use of representation, attempting to justify the domination of a subject people by creating representations of that people as ignoble, childish, primitive. However, the representing of the "other" as an incomplete or undeveloped "same" also works against the process of domination by introducing the destabilizing carnival of mimicry, and the menace of its "double vision, which in disclosing the ambivalence of colonial discourse also disrupts its authority."64 Schneider cites Spiderwoman's restaging of "Snake Oil Sideshows" (Winnetou's Snake Oil Show from Wigwam City, 1989) and similar "exotic" material as comic, subversive mimicry that

adroitly played in the painful space between the need to claim an authentic native identity and their awareness of the historical commodification of the signs of that authenticity. Their material falls in the interstices where their autobiographies meet popular constructions of the American Indian.⁶⁵

Performance of this kind slips back and forth between "a firm declaration of identity" and parody of the social clichés that haunt that identity, insisting upon "an experience of the sacred *despite* the historical corruption and compromise of identities." 66

In an even more complex "comic turn," Schneider suggests that Spiderwoman also utilizes what she calls "countermimicry." In the "Indian Love Call" sequence of Sun, Moon, Feather (1981), for example, the native American actresses

don't act out the Indian parts-the virulent near-naked, dancing brave or the dark Indian Princess—they fight over who gets to be be-ringleted, vaseline-over-the-lens Jeanette MacDonald and who has to play stalwart, straight-backed Canadian Mounty Nelson Eddy. They are not re-playing, re-membering, or re-claiming native images but appropriating the appropriate.67

Some of the most complex and challenging recent ethnic performances have ultilized mimic or countermimic strategies to deal directly with the process of cultural stagings or representations of ethnicity. James Luna's Bessie-award winning performance/ installation, The Artifact Piece (1987), was created in San Diego's Museum of Man and provided ironic commentary on its own ethnographic surroundings and their cultural functions. Luna placed himself on display, his body laid out in one case labeled with tags identifying scars inflicted during drunken fights. Another case showed his college degree, photos of his children, arrest record, and divorce papers along with objects used in contemporary Native American ceremonies. Explanatory panels described with mock ethnographic objectivity a modern Native American life in which AA meetings have taken the place of traditional ritual ceremonies.68

A similar, but even more complex display was the well-known Two Undiscovered Amerindians Visit (1992) of Guillermo Gómez-Peña and Coco Fusco, first offered in Madrid and London, then in Australia and the United States, and finally the subject of a fascinating video documentary. 69 Drawing upon the once popular European and North American practice of exhibiting indigenous people from Africa, Asia, and the Americas in fairs, shows, and circuses, Gómez-Peña and Fusco displayed themselves for three days in a golden cage as recently discovered Amerindians from an island in the Gulf of Mexico. They performed such "traditional tasks" as sewing voodoo dolls, lifting weights, and watching TV, were fed sandwiches and fruit and taken to the bathroom on leashes by guards. As with the Luna display, explanatory panels provided mock scientific information on the "indians" and their "native culture." To the surprise of the performers, many viewers took their exhibition seriously, playing out a rich variety of accommodations or resistances to the display process itself and raising more complex questions about the cultural interpretation of this display than they had anticipated.

Current resistant performance is so varied and complex that no "typical" example of it could be cited, but the Undiscovered Amerindians show illustrates one of the central current concerns, and that is the dynamic involved when a specific performer encounters a specific culturally and historically situated audience. What began in *Undiscovered Amerindians* as an ironic commentary on appropriation, representation, and colonial imaging through the playful reconstruction of a once popular and symbolically charged intercultural performance, became a far more complicated and interesting phenomenon as the performers gradually realized that all of these concerns had to be freshly negotiated, often in surprising and unexpected ways, in every new encounter. The movement of lesbian and gay performance away from audiences identified with those subcultures into more heterogeneous reception situations has opened much more complex questions of how to negotiate appropriation, display, and representation that is politically and socially responsible. The activity of the performer is no longer the central concern of speculation on this phenomenon. It is rather the interplay of performer and public.

Conclusion: what is performance?

The term "performance" has become extremely popular in recent years in a wide range of activities in the arts, in literature, and in the social sciences. As its popularity and usage has grown, so has a complex body of writing about performance, attempting to analyze and understand just what sort of human activity it is. For the person with an interest in studying performance, this body of analysis and commentary may at first seem more of an obstacle than an aid. So much has been written by experts from such a wide range of disciplines, and such a complex web of specialized critical vocabulary has been developed in the course of this analysis, that a newcomer seeking a way into the discussion may feel confused and overwhelmed.

As the attentive reader may note, these are the words that opened the "Introduction" to this study. Between writing those words and rewriting them, I have written most of the material in this study, and I assume that between reading and re-reading them the reader has also considered much if not all of that material. This experience has caused me, as it may perhaps also cause the reader, to consider what sort of performance was involved in this process of writing about performance. Throughout this study I have felt some uneasiness with attempting to capture in descriptive or historical terms so complex, conflicted, and protean a phenomenon as performance, and I was troubled, even more than in most writing, with material from one discrete "chapter" constantly slipping away to bond with material in other chapters. By a web of stylistic pointers in the nature of "as we have seen," "as we shall see in a later chapter," "this will be later developed in more detail," and so on, the rather porous borders were maintained in the interest of presenting a series of more or

less internally coherent mappings of the fluid territory of performance. Even while carrying out this project, however, I recognized that in a fundamental way it ran contrary to the nature of the subject. Thi Minh-Ha Trinh, a Vietnamese-American who has written movingly and perceptively of the search of the modern exile and refugee to find an identity and a voice, tellingly articulates a key insight of performance and of postmodernism: "Despite our desperate, eternal attempt to separate, contain, and mend, categories always leak." ¹

As Clifford Geertz's classic 1983 essay "Blurred Genres"² suggested, traditional anthropological concerns with continuous traditions, singular and stable cultures, coherent structures, and stable identities have been largely replaced by a concept of "identity" and "culture" as constructed, relational, and in constant flux, with the porous or contested borders replacing centers as the focus of interest—because it is at these borders that meaning is continually being created and negotiated. This clearly relates to the reality of the post-colonial world, with its new patterns of global communication, multinational corporations, and the continual movement and displacement of peoples. Cultural analyst Renato Rosaldo has written: "All of us inhabit an interdependent late-twentieth-century world marked by borrowing and lending across porous national and cultural boundaries that are saturated with inequality, power, and domination."3 The "classic norms" of social analysis are inadequate to deal with the questions of "conflict, change, and inequality" characteristic of this new social world. As a result, social analysts "no longer seek out harmony and consensus to the exclusion of difference and inconsistency," and "cultural borderlands have moved from a marginal to a central place."4 The increasing fluidity and porousness of social and cultural structures is increasingly being reflected also at the personal level, giving rise to a new sense of self-what Robert Jay Lifton has called "the protean self," reflective of the flux of the postmodern world. This new sort of self may retain "corners of stability," but it is primarily engaged "in continuous exploration and personal experiment."5 Lifton in fact cites performance art as one of the tools of such experimentation.

One reader of an early draft of this study complained that I had not made it clear whether I considered performance to be a new discipline or an interdisciplinary field. I sought reactions to this question from the directors of the two leading performance

studies programs in the United States, Joseph Roach at New York University and Dwight Conquergood at Northwestern, and found their responses almost identical—that it was neither. "It is of course an antidiscipline," said Roach, "and we're about to witness its staging of the world's first antidisciplinary conference [in May 1994]." In the opening address of that conference, Conquergood spoke in almost identical terms, calling the trickster the "guru" of this new antidiscipline.

Now, coming to that part of the study where some sort of "conclusion" is normally expected, I feel a new uneasiness. Performance by its nature resists conclusions, just as it resists the sort of definitions, boundaries, and limits so useful to traditional academic writing and academic structures. It may be helpful, then, to consider these observations as a sort of anticonclusion to a study of this antidiscipline, framed in the mode of self-reflexivity, a mode that characterizes much modern (or postmodern) performative consciousness, whether one is speaking of theatrical performance, social performance, ethnographic or anthropological performance, linguistic performance, or, as in the present case, the performance of writing a scholarly study. James Clifford, in The Predicament of Culture (1988), speaks of ethnography's growing awareness that the field is "from beginning to end, enmeshed in writing," and that writing, like any form of representation, is never innocent, but always involved "in specific historical relations of dominance and dialogue."6 In his study of Julia Kristeva, John Lechte devotes an interesting section to Sho-shana Felman's analysis of John Austin's How To Do Things with Words, noting Austin's humor and conscious ambiguity and calling his writing "an instance of doing philosophy which is as much performance as it is constative." Lechte gives this analysis another turn by considering what sort of "performance" is being carried out in Felman's own writing, in her utilization of the French analytic mode with its structural/poststructural interests and emphases.7

Looking back with such a reflexive consciousness to the opening paragraph of this study and of this "conclusion," and considering what sort of performance it seems to be carrying out, I now see operating in it a clear and familiar performative strategy—the establishing of a mediating "authorial" as well as "authoritative" voice, posing itself as a useful interpreter between the "experts in such a wide range of disciplines" with their "complex web of specialized critical vocabulary" and the "confused and overwhelmed" newcomer to the field who is or is in part the implied reader who will profit by such informed interpretation to further an "interest in studying performance." Attempting to engage illocutionary and performative operations of my own writing brings home how similar the operations of this sort of scholarly discourse are to the traditional operations of other scholarly discourses, where what used to be regarded as academic objectivity and neutrality becomes something very different when it is regarded performatively by cultural critics like Clifford, Geertz, or Conquergood. From this perspective such discourse is seen as being fundamentally governed less by objective reality than by rhetorical strategies. As Geertz has observed: "The capacity to persuade readers . . . that what they are reading is an authentic account by someone personally acquainted with how life proceeds in some place, at some time, among some group, is the basis upon which anything else ethnography seeks to do . . . finally rests."8

This recognition that the performance of scholarly research and writing is by no means the innocent or transparent process it may seem has not led to ethnographers abandoning such activity, any more than it has prevented me from writing this book, but what it has done is alert them, and me, to the illocutionary and perlocutionary implications of their discourse, to consider how knowledge is created, shared, and legitimized, how fields of study are created, developed, and their boundaries protected, how social, cultural, and personal identity is involved in every sort of performative behavior. The "Introduction" to a recent collection of essays, Creativity/Anthropology (1993), notes "the acceptance of one's own role in producing ethnographic writing," as "the object of analysis also becomes an analyzing subject, and vice versa."9 Performance here becomes not only a subject for study but also an interpretive grid laid upon the process of study itself, and indeed upon almost any sort of human activity, collective or individual. As Stephen Tyler has observed in his analysis of "Postmodern Ethnography," the aim of its research is "not to foster the growth of knowledge, but to restructure experience," and its scholarly writing seeks "not to reveal purposes, but to make purposes possible,"10 that is, to demonstrate how purposes themselves are created. So the present study of performance, which I began (and which the reader may well have begun) as a project devoted to the "growth of knowledge," has perhaps better served the purposes of an introduction to modern performance if it has also restructured experience and perceptions, and increased an awareness of how performance operates "to make purposes possible."

I began this study with a discussion of how this concern with performance has changed the fields of anthropology and ethnography, and it seems appropriate that these summary remarks have also begun there, since theorists with backgrounds in these fields continue to provide some of the most stimulating and perceptive analyses of how performance operates in the activities of individuals, societies, and cultures. I know of no better general summary of the current issues and themes in this fecund area than Conquergood's 1991 survey article "Rethinking Ethnography: Towards a Critical Cultural Politics."11 Conquergood argues that a "radical rethinking" of this field of study is under way, developing from four intersecting concerns, which might be advanced also as central concerns of current performance theory. Much of what I have already said in this section about writing and performance is based on two of these concerns—an awareness of the constructedness of much human activity and of its implication in rhetoric and in social and cultural encodings, and a particular interest in liminal territory, in boundaries and borders. As Bakhtin observed: "the most intense and productive life of culture takes place on the boundaries."12

A third concern discussed by Conquergood refers even more directly to one of the fundamental concerns of modern performance, "the return of the body." Conquergood opposes ethnography, an "embodied practice," which "privileges the body as a site of knowing," to most academic disciplines, which follow a mind/body hierarchy favoring abstractions and rational thought over sensual experience. 13 After establishing itself as a "respectable" academic discipline by following the rationalist model, modern ethnography is at last returning to its proper concern with the total sensual experience of a culture. The postmodern ethnographic text, says Tyler, "will be a text of the physical, the spoken and the performed."14

In his 1989 survey of current questions in ethnography, Paths Toward a Clearing, Michael Jackson advocates a return to what William James called "radical empiricism," which rejects the boundary between observer and observed of traditional empiricism to gain a sense of the immediate, active, ambiguous

"plenum of existence," studying "the experience of objects and actions in which the self is a participant." 15 Radical empiricism, says Jackson, requires a focus on "lived experience," which is concerned not with identity and closure but with interplay and interaction, and with that peculiar doubleness that we have elsewhere noted in performance theory and performative consciousness that "encompasses both the 'rage for order' and the impulse that drives us to unsettle or confound the fixed order of things," that "accommodates our shifting sense of ourselves as subjects and as objects, as acting upon and being acted upon by the world, of living with and without certainty, of belonging and being estranged."16

Most significantly, for our purposes of this study, Conquergood's fourth concern of contemporary ethnography is "the rise of performance," involving a shift from viewing "the world as text" to "the world as performance." This shift, suggests Conquergood, opened up a number of new areas of questioning, which he groups under five headings. The first two of these have particularly engaged ethnographic researchers, and are in fact those closest to the traditional concerns of that field. First comes the question of cultural process: What are the consequences of thinking about culture as "an unfolding performative invention instead of reified system"? Second is a question of research praxis: What are the implications of viewing fieldwork as "an enabling fiction between observer and observed"?

The other three areas, less developed so far by the writers Conquergood cites, are also those areas of more general performative concern, where much work in theory and practice has been done by people not involved in and indeed not necessarily familiar with the performative emphasis of modern social science as represented by Conquergood's examples. These other three areas deal with hermeneutics ("What kinds of knowledge are privileged or displaced when performed experience becomes a way of knowing, a method of critical inquiry, a mode of understanding?"), scholarly representation ("What are the rhetorical [or institutional] problematics of performance as a complementary or alternative form of 'publishing' research?"), and politics ("How does performance reproduce, enable, sustain, challenge, subvert, critique, and naturalize ideology?").17

I know of no other summary of the orientations, concerns, and challenges of contemporary performance studies so comprehensive and sharply focused as Conquergood's essay, and this seems appropriate, since the convergence of the concerns and of the rhetoric of theatre-oriented and of culture-oriented theorists like Turner was particularly important in the development of modern performance study, and anthropological and especially ethnographic writing remains highly influential in this field.

It would be incorrect, however, to allow the usefulness or the articulateness of Conquergood's summary to give the impression that ethnographic concerns as such dominate contemporary performance studies. Even Conquergood's summary of current central questions suggests otherwise. Performance and performativity, as has often been noted, are almost ubiquitous tropes in the postmodern consciousness and owe allegiance to no particular field or discipline. Like other cultural terms, and especially essentially contested terms, "performance" must be understood by praxis, a praxis that is itself contradictory, fluid, and protean. As I write this summary, in the spring of 1995, two major attempted overviews of the field of performance provide useful insights into how this field is being currently configured and negotiated. I have already mentioned the March 1995 First Annual Performance Studies Conference on the theme of "The Future of the Field," held 23-5 March at New York University. Panels, performances, and approximately 115 papers were presented by representatives from all over the United States (though primarily from the New York area, Chicago, and California), as well as from England, Canada, France, Israel, Serbia, and Slovenia.

Only a handful of papers at this conference dealt with material that was clearly anthropological or ethnographic in nature (indeed one of the criticisms voiced at the final "wrap up" session was that such research had been under-represented). What might be considered more traditional "theatre" and/or dance subjects were distinctly more common (Brecht, Piscator, Beijing Opera, Grotowski, minstrel shows, classical opera and dance, Stanislavski, experimental theatre), although these were naturally oriented toward the performance aspect of such work, and in some cases (as in Dorothy Chansky's multi-media performance exploring the work of Mrs. Lyman Gale at the Boston Toy Theatre) presented in a highly "performative" manner.

Conquergood's three questions dealing with hermeneutics, scholarly representation, and politics were all extensively represented at this conference, with politics of gender, of class, and of culture being especially prominent. One group of eight papers was devoted specifically to "New Social Identities: Race/Nation/ Gender," and a large number of papers discussed gay and lesbian performativity, performing identities, and the relationship between performance of race and gender. Closely related to these were several papers dealing with inscribing the body (including medical performance and sadomasochist performance). Performance involved with more traditional political concerns was the subject of another large group of papers, with particular emphasis upon resistant performance in Latin America and Africa and the search for new political identities through performance in Eastern Europe. Other papers considered a political matter closer to home—the role of performance and performance studies in the university and the academic world. Finally, two sessions of papers considered the implications for performance of the emerging world of cybertechnology.

The other major mapping of this field appearing in spring 1996 is an anthology of essays edited by Elin Diamond entitled Writing Performance: Culture, Politics, Embodiment, Desire. This anthology was based upon three innovative and influential conference panels organized by Diamond at the 1992 Modern Language Association Convention under the rubric "Performance in Cultural Studies." Other papers were added to make up this anthology, which, with Diamond's perceptive introduction, presents an informed and useful representation of current work by some of the leading theorists in this field. Although certain common themes run through this collection—the production of gender, voice, identity, visibility, the discipline of bodies, the operations of spectatorship, the politics of desire—the specific subjects investigated, as is typical of current performance study, are extremely diverse. Only one essay, Susan Foster's "Pygmalion's No-Body and the Body of Dance," investigates a production from "traditional" theatre history, and it does so from a new direction—the performative function of the body. Moreover, at the conference Foster danced as well as read her paper.

Other essays cover topics from performance art (Rebecca Schneider on Annie Sprinkle or Philip Auslander on lip-synching and simulation), cultural performance (Joseph Roach developing his ongoing investigations of creole culture and the Mardi Gras, Peggy Phelan exploring the intersections of the British Parliament, the excavations of the Elizabethan Rose Theatre in London, and homophobia, Vivian Patraka on the public discourse surrounding the Holocaust Museum, Margaret Drewel on Yoruba Rituals among immigrant communities in New York City), the performance of identity and of sexual roles (Ed Cohn on Oscar Wilde as "poseur" and Linda Hart on lesbian sadomasochism), the performance of writing (Glenda Dickerson on black women's writing and Amy Robinson on "passing" narratives), and the

performative aspects of photography (Herbert Blau).

Clearly the general themes and questions associated with performance can be and are being productively applied to an almost unlimited range of human activities, as this impressive collection and conference both clearly demonstrate. Nevertheless, the anthology and even more clearly the conference gave particular attention to "theatrical" performance and to that sort of contemporary activity generally designated as "performance" or "performance art." Given the fluidity, ubiquity, and variability of the concept of performance in modern or postmodern culture, this orientation may seem somewhat surprising, and perhaps not sufficiently reflective of the operations of this new antidiscipline. I think there is an argument to be made, however, for the particular attention that is still being given to this (in itself still highly varied) particular type of performance.

There are several reasons for the great popularity of "performance" as a metaphor or analytical tool for current practitioners of so wide a range of cultural studies. One is the major shift in many cultural fields from the "what" of culture to the "how," from the accumulation of social, cultural, psychological, political, or linguistic data to a consideration of how this material is created, valorized, and changed, to how it lives and operates within the culture, by its actions. Its real meaning is now sought in its praxis, its performance. The fact that performance is associated not just with doing, but with re-doing, is also important—its embodiment of the tension between a given form or content from the past and the inevitable adjustments of an ever-changing present make it an operation of particular interest at a time of wide-spread interest in cultural negotiations—how human patterns of activity are reinforced or changed within a culture and how they are adjusted when various different cultures interact. Finally, performance implies not just doing or even re-doing, but a self-consciousness about doing and re-doing, on the part of both performers and spectators.

All of these concerns are reflected in such statements as John MacAloon's distinctly "theatricalized" model of "cultural performances" as a kind of crucible for cultural self-examination: "More than entertainment, more than didactic or persuasive formulations, and more than cathartic indulgences. They are occasions in which as a culture or society we reflect upon and define ourselves, dramatize our collective myths and histories, present ourselves with alternatives." ¹⁸ The theatrical metaphor has become so significant here that if one did not know the source of this quotation, one might likely assume that the subject was traditional theatre.

While recognizing that this formulation is quite in harmony with much recent cultural theory, I would still argue that its generalizing use of the theatrical metaphor blurs a distinction that still can and should be made between most cultural and social performance and "theatrical" performance (including traditional "theatre" but perhaps especially in the case of contemporary "performance"). The importance of praxis in the definition of selves and of societies can hardly be denied, nor the importance of such specific cultural occasions as ritual ceremonies or the celebration of cultural myths or history. What is often missing in such activity, however, is the specific blending of occasion and reflexivity that characterizes "theatrical" performance. Cultural performance may indeed function as a kind of metacommentary on its society, and may be best studied in that function by ethnographers, but neither performers nor spectators can be primarily characterized as consciously seeking out cultural performance as metacommentary on their culture. In "theatrical" performance, however, this concern is central. Performers and audience alike accept that a primary function of this activity is precisely cultural and social metacommentary, the exploration of self and other, of the world as experienced, and of alternative possibilities. Margaret Wilkerson's comments on this function of theatre are rhetorically very close to those of MacAloon on cultural performance: "Theatre provides an opportunity for a community to come together and reflect upon itself," serving not only as a "mirror through which a society can reflect upon itself," but also as an aid to shaping "the perceptions of that culture through the power of its imaging." I would argue further that this mirror and shaping function has always been more specifically associated with theatre than with most other cultural performance, and

moreover that this aspect of traditional theatre has become even more prominent in the development of modern performance art.

This makes "theatrical" performance, whether in the form of "traditional" theatre or of performance art, a special, if not unique, laboratory for cultural negotiations, a function of paramount importance in the plurivocal and rapidly changing contemporary world. Jill Dolan has perhaps most clearly articulated this mission in her 1993 survey article "Geographies of Learning: Theatre Studies, Performance, and the 'Performative'":

Theatre studies' distinct contribution across disciplines can be a place to experiment with the production of cultural meanings, on bodies willing to try a range of different significations for spectators willing to read them. Theatre studies becomes a material location, organized by technologies of design and embodiment (through artisanry and actor training), a pedagogically inflected field of play at which culture is liminal or liminoid and available for intervention.²⁰

Near the end of this article Dolan notes that even though poststructuralist theorists have raised legitimate concerns about theatre's capacity to generate an untheorized "communitas," theatre (and performance art) "remains a site to which people travel to view and/or experience something together," to "engage with the social in physically, materially embodied circumstances."21 The conscious choice of people to gather for this particular kind of embodied activity, and the expectation of what kind of experience this will be, are equally important. Dolan's use of "engage with" rather than "observe" or "contemplate" points to a key concern. Even when "theatrical" performance serves only as metacommentary on social and cultural circumstances, the particular consciousness in the framing of this activity sets it apart from much other, unreflective cultural activity. As theatre moves more in the direction of performance art, a further elaboration of this consciousness often occurs: The audience's expected "role" changes from a passive hermeneutic process of decoding the performer's articulation, embodiment, or challenge of particular cultural material, to become something much more active, entering into a praxis, a context in which meanings are not so much communicated as created, questioned, or negotiated. The "audience" is invited and expected to operate as a co-creator of whatever meanings and experience the event generates.

Many sorts of activity—political rallies, sporting events, public presentations, costume balls, religious rites—are clearly performative and are widely and rightly recognized as such. Many other activities, among them writing, everyday social interactions, and indeed almost any social or cultural activity, can surely be considered performative even if they are not normally thought of in that way. Recent studies have demonstrated the usefulness of the concept of "performance" in the analysis and understanding of all of these human operations, but I would argue that one can still also usefully distinguish "theatrical" performance from its many recently discovered close relations and find in it not only a particular orientation but also a particular utility.

A variety of attempts have been made to define the special quality of this sort of performance. Some commentators have stressed its corporality, speaking of "embodied" performance, and contrasting it, for example, with film or the plastic arts, but not, of course, with the vast array of social and cultural performance. Others have somewhat similarly stressed the importance of "presence," an emphasis that, as we have seen, has been seriously qualified by the postmodern aesthetics of absence and by postmodern performance theory's own growing attention

to citation.

Without denying the importance either of the physical body or of presence, two other related concerns seem to me even more important in defining the particular quality and power of "theatrical" performance. One is that such performance is experienced by an individual who is also part of a group, so that social relations are built into the experience itself. Alan Read lays stress upon this quality in his study of the ethics of performance. In religious experience, ritual, and therapy, Read suggests (and he might have added in the plastic arts and writing), the operations involve yourself and the performer, whereas the act of theatre is a tripartite one, involving yourself, the performer, and the rest of the audience, and bringing the experience inevitably into the realm of the political and the social.²²

Closely related to this is another concern, that of the particular way we become involved in this sort of performance. It is a specific event with its liminoid nature foregrounded, almost invariably clearly separated from the rest of life, presented by performers and attended by audiences both of whom regard the experience as made up of material to be interpreted, to be reflected upon, to be engaged in—emotionally, mentally, and perhaps even physically. This particular sense of occasion and focus as well as the overarching social envelope combine with the physicality of theatrical performance to make it one of the most powerful and efficacious procedures that human society has developed for the endlessly fascinating process of cultural and personal self-reflexion and experimentation.

Notes

INTRODUCTION

1 W. B. Gallie, Philosophy and the Historical Understanding, New York,

Schocken Books, 1964, pp. 187–8.

2 Mary S. Strine, Beverly Whitaker Long, and Mary Frances Hopkins, "Research in Interpretation and Performance Studies: Trends, Issues, Priorities," in Gerald Phillips and Julia Wood (eds.), Speech Communication: Essays to Commemorate the Seventy-Fifth Anniversary of the Speech Communication Association, Carbondale, Southern Illinois University Press, 1990, p. 183.

3 Erik MacDonald, *Theater at the Margins: Text and the Post-Structured Stage*, Ann Arbor, University of Michigan Press, 1993, p. 175.

4 Diane Spencer Pritchard, "Fort Ross: From Russia with Love," in Jan Anderson (ed.), A Living History Reader, vol. 1, Nashville, Tenn., American Association for State and Local History, 1991, p. 53.

- 5 Like most uses of "performance," this one has been challenged, particularly by the noted semiotician of circus, Paul Bouissac. Bouissac argues that what seems to be performance is actually an invariable natural response to a stimulus provided by a trainer who "frames" it as performance. In Bouissac's words, the animal does not "perform," but "negotiates social situations by relying on the repertory of ritualized behavior that characterizes its species" ("Behavior in Context: In What Sense is a Circus Animal Performing?" in Thomas Sebeok and Robert Rosenthal (eds.), The Clever Hans Phenomenon: Communication with Horses, Whales, Apes, and People, New York, New York Academy of Sciences, 1981, p. 24). This hardly settles the matter. As we shall see, many theorists of human performance could generally accept Bouissac's alternate statement, and moreover anyone who has trained horses or dogs knows that, even accounting for an anthropomorphic bias, these animals are not simply negotiating social situations, but are knowingly repeating certain actions for physical or emotional rewards, a process that, to me at least, seems to have important features in common with human performance.
- 6 Richard Schechner, Between Theater and Anthropology, Philadelphia, University of Pennsylvania Press, 1985, pp. 35–116.

7 Richard Bauman in Erik Barnouw (ed.), International Encyclopedia of Communications, New York, Oxford University Press, 1989.

1 THE PERFORMANCE OF CULTURE

1 Richard Schechner, "Performance and the Social Sciences," *The Drama Review* (hereafter *TDR*), vol. 17, 1973, p. 5.

2 Georges Gurvitch, "Sociologie du théâtre," Les Lettres nouvelles,

vols. 34-6, 1956, p. 197.

3 Dell Hymes, "Breakthrough into Performance," in Dan Ben-Amos and Kenneth S. Goldstein (eds.), Folklore: Performance and Communication, The Hague, Mouton, 1975, p. 13.

4 Schechner, Between Theater and Anthropology, Philadelphia,

University of Pennsylvania Press, 1985, p. 35.

5 John J. MacAloon, "Introduction: Cultural Performances, Culture Theory," in John J. MacAloon (ed.), *Rite, Drama, Festival, Spectacle*, Philadelphia, Institute for the Study of Human Issues, 1984, p. 9.

- 6 William H. Jansen, "Classifying Performance in the Study of Verbal Folklore," in *Studies in Folklore in Honor of Distinguished Service Professor Stith Thompson*, Bloomington, Indiana University Press, 1957, p. 110.
- 7 Milton Singer (ed.), Traditional India: Structure and Change, Philadelphia, American Folklore Society, 1959, p. xii.

8 Ibid., p. xiii.

9 Richard M. Dorson (ed.), Folklore and Folklife: An Introduction,

Chicago, University of Chicago Press, 1972, p. 45.

10 Hymes developed this idea in a number of writings in the 1960s and 1970s, but see especially his "Introduction Toward Ethnographies of Communication," in *American Anthropologist*, vol. 66, 1964, pp. 1–34.

11 Ben-Amos and Goldstein, "Introduction," to Folklore, p. 4.

- 12 Roger D. Abrahams, "Introductory Remarks to a Rhetorical Theory of Folklore," *Journal of American Folklore*, vol. 81, 1968, p. 145.
- 13 Kenneth Burke, *The Philosophy of Literary Form*, New York, Vintage Books, 1957, pp. 3, 93.
- 14 Richard Bauman, Story, Performance, and Event: Contextual Studies in Oral Narrative, New York, Cambridge University Press, 1986, p. 3.
- 15 Bauman, Verbal Art as Performance, Rowley, Mass., Newbury House, 1977, p. 11.
- 16 Later published in Gregory Bateson, Steps to an Ecology of Mind, San Francisco, Chandler, 1972.
- 17 Ibid., p. 179.

18 Ibid., p. 188.

19 Eugenio Barba, "Introduction," in Barba and Nicola Savarese (eds.), The Secret Art of the Performer, trans. Richard Fowler, London, Routledge, 1991, p. 8.

20 Jean Alter, A Sociosemiotic Theory of Theatre, Philadelphia, University

of Pennsylvania Press, 1990, p. 38.

21 Barba, "Introduction," p. 10.

22 Barba, "Pre-expressivity," in The Secret Art, p. 203.

23 Ibid., pp. 187-8.

24 Victor Turner, Schism and Continuity, Manchester, Manchester

University Press, 1957.

25 Turner, From Ritual to Theatre, Performing Arts Journal Publications, 1982; Arnold van Gennep, The Rites of Passage, trans. M. B. Vizedon and G. L. Caffee, Chicago, University of Chicago Press, 1960.

26 Dwight Conquergood, "The Institutional Future of the Field," address given at the First Annual Performance Studies Conference:

The Future of the Field, New York City, 24 March 1995.

27 Van Gennep, The Rites of Passage, p. 21.

28 Turner, *Dramas, Fields, and Metaphors,* Ithaca, N.Y., Cornell University Press, 1974, p. 33.

29 Schechner, "Approaches to Theory/Criticism," Tulane Drama Review,

vol. 10, 1966.

30 Turner, From Ritual, pp. 90-1.

31 Schechner, Essays on Performance Theory 1970–76, New York, Drama Book Specialists, 1977, p. 144.

32 Turner, From Ritual, p. 74.

33 Turner, The Ritual Process: Structure and Anti-Structure, Chicago,

Aldine Publishing Co., 1969, p. 22.

34 Brian Sutton-Smith, "Games of Order and Disorder," paper presented to the Symposium "Forms of Symbolic Inversion" at the American Anthropological Association, Toronto, 1 December 1972, pp. 17–19; quoted in Turner, From Ritual, p. 28.

35 Turner, From Ritual, pp. 20-60.

36 Ibid., p. 28.

- 37 Clifford Geertz, "Deep Play: Notes on the Balinese Cockfight," Daedalus, vol. 101, 1972, pp. 1–37.
- 38 Bruce Kapferer, "The Ritual Process and the Problem of Reflexivity in Sinhalese Demon Exorcisms," in MacAloon, Rite, Drama, p. 204.

39 MacAloon, Rite, Drama, p. l.

40 Roger Caillois, *Man, Play, and Games*, trans. Meyer Barash, New York, Free Press, 1961, p. 13.

41 Ibid., pp. 9-10.

42 Johan Huizinga, Homo Ludens, New York, Beacon Press, 1950, p. 8.

43 Caillois, Man, Play, p. 23.

- 44 Huizinga, Homo Ludens, p. 10. 45 Turner, From Ritual, pp. 55–6.
- 46 Huizinga, Homo Ludens, p. 14.

47 Ibid., pp. 12-13.

48 Mikhail Bakhtin, Rabelais and his World, trans. Helen Iswolsky, Cambridge, Mass., MIT Press, 1965.

49 Ibid., pp. 122-3.

50 Ibid., p. 131.

- 51 See, for example, Michael D. Bristol, Carnival and Theatre, New York, Methuen, 1985.
- 52 See, for example, Mary Russo, "Female Grotesques: Carnival and

Theory," in Teresa de Lauretis (ed.), Feminist Studies/Critical Studies, Milwaukee, University of Wisconsin Press, 1986, pp. 213–29.

53 Jacques Ehrmann, "Homo Ludens Revisited," trans. Cathy and Phil Lewis, in Jacques Ehrmann (ed.), Game, Play, Literature, Boston, Mass., Beacon Press, 1968, p. 33.

54 Huizinga, Homo Ludens, p. 35.

55 Ehrmann, "Homo Ludens," p. 50.

56 Marshall Sahlins, Islands of History, Chicago, University of Chicago

Press, 1985, pp. xi-xiii.

57 Colin Turnbull, "Liminality: A Synthesis of Subjective and Objective Experience," in Richard Schechner and Willa Appel (eds.), By Means of Performance, Cambridge, Cambridge University Press, 1990, p. 50.

58 Ibid., p. 76.

59 Dwight Conquergood, "Performing as a Moral Act: Ethical Dimensions of the Ethnography of Performance," *Literature in Performance*, vol. 5, 1985, p. 9.

60 James Clifford, The Predicament of Culture: Twentieth-Century Ethnography, Literature, and Art, Cambridge, Mass., Harvard University

Press, 1988, pp. 15, 230.

61 It should be noted, however, that certain theorists and practitioners have resisted the argument that all intercultural performance involves such mixing. Peter Brook has sought a theatre that transcends particular cultures in an appeal to universal human conditions beyond any divisions of race, culture, or class, a type of project Patrice Pavis calls "transcultural," while Eugenio Barba, as we have seen, attempts to achieve universality in quite the opposite way, through a "pre-expressive" appeal to some common ground of all humanity before it is individualized into specific cultural traditions. This approach Pavis calls "precultural." Patrice Pavis, Theatre at the Crossroads of Culture, trans. Loren Kruger, London, Routledge, 1992, p. 20.

2 PERFORMANCE IN SOCIETY

- 1 See the special issue of *TDR* on "Theatre and the Social Sciences," Summer 1966, and articles by and about the work of Berne in the Summer 1967 issue.
- 2 Nikolas Evreinoff, The Theatre in Life, trans. Alexander Nazaroff, New York, Brentano's, 1927, p. 24.

3 Ibid., p. 30.

4 Ibid., pp. 49, 99-100.

- 5 Kenneth Burke, A Grammar of Motives, Cleveland, Oh., Meridian, 1962, p. xvii. A Rhetoric of Motives was republished by this same press in 1962.
- 6 Barbara Kirshenblatt-Gimblett, "A Parable in Context: A Social Interactional Analysis of Storytelling Performance," in Dan Ben-Amos and Kenneth S. Goldstein (eds.), Folklore: Performance and Communication, The Hague, Mouton, 1975, pp. 105–30.

7 Erving Goffman, "On Facework: An Analysis of Ritual Elements in Social Interaction," Psychiatry, vol. 18, 1955, pp. 213-31.

8 Goffman, The Presentation of Self in Everyday Life, Garden City, N.Y.,

Doubleday, 1959, p. 22.

9 Gregory Bateson, Steps to an Ecology of Mind, San Francisco, Chandler, 1972, p. 183.

10 Goffman, Frame Analysis, Garden City, N.Y., Doubleday, 1974, p. 157.

11 Ibid., pp. 124-5.

12 Quoted in Umberto Eco, "Semiotics of Theatrical Performance," TDR, vol. 21, 1977, p. 112.

13 Bert O. States, Great Reckonings in Little Rooms: On the Phenomenology of Theater, Berkeley, University of California Press, 1985, pp. 35-6.

14 Goffman, Presentation, p. 208.

15 Ibid., p. 65.

16 Dell Hymes, "Breakthrough into Performance," in Ben-Amos and Goldstein, Folklore, p. 18.

17 Friedrich Nietzsche, Human, All Too Human, trans. Marion Faber, Lincoln, University of Nebraska Press, 1984, p. 51.

18 George Santayana, Soliloquies in England and Later Soliloquies, New York, Charles Scribner's Sons, 1922, pp. 133-4.

19 Jean-Paul Sartre, Being and Nothingness, trans. Hazel E. Barnes, New York, Philosophical Library, 1956, pp. 59-60.

20 Bruce Wilshire, Role Playing and Identity, Bloomington, Indiana University Press, 1982, pp. 280-1.

21 Wilshire, "The Concept of the Paratheatrical," TDR, vol. 34, 1990, pp. 177-8.

22 Robert Ezra Park, "Behind Our Masks," Survey Graphic, vol. 56, 1926, reprinted in Race and Culture, Glencoe, Ill., Free Press, 1950, pp. 249-50.

23 William James, The Philosophy of William James, New York, Random House, 1925, p. 128.

24 Ibid., pp. 133, 152.

25 J. L. Moreno, Psychodrama, vol. 1, New York, Beacon Press, 1946, pp. 13–15.

26 Ibid., pp. 153, 174.

27 T. Sarbin and V. Allen, "Role Theory," in G. Lindzey and E. Aronson (eds.), The Handbook of Social Psychology, vol. 1, Reading, Mass., Addison-Wesley, 1968, p. 548. For a more extended development of this parallel, see M. R. Goldfried and G. C. Davison, Clinical Behavior Therapy, New York, Holt, Rinehart & Winston, 1976.

28 See David A. Kipper, Psychotherapy through Clinical Role Playing, New

York, Brunner/Mazel, 1986, pp. 20, 22.

29 Eric Berne, Games People Play, New York, Grove Press, 1964, p. 61.

30 Berne, Transactional Analysis in Psychotherapy, New York, Grove Press, 1961, p. 116.

31 Talcott Parsons, The Structure of Social Action, New York, McGraw-Hill, 1937, p. 733.

32 P. L. Berger and T. Luckman, The Social Construction of Reality, Garden City, N.Y., Doubleday, 1967; Karl Mannheim, Ideology and Utopia, New York, Harcourt Brace, 1936.

33 Alfred Schutz, "The Problem of Rationality in the Social World," in Collected Papers, vol. 2, The Hague, Martinus Nijhoff, 1964, pp. 72–3.

34 See, for example, Harold Garfinkel, "Common Sense Knowledge of Social Structure: The Documentary Method of Interpretation," in J. Sher (ed.), Theories of the Mind, New York, Free Press, 1962, pp. 689–713.

35 Michel de Certeau, *The Practice of Everyday Life*, trans. Steven F. Rendall, Berkeley, University of California Press, 1984, p. xix.

36 Alan Read, Theatre and Everyday Life: An Ethics of Performance, London, Routledge, 1993, p. 1.

37 Goffman, Frame Analysis, p. 10.

38 Richard Bauman, Verbal Art as Performance, Rowley, Mass., Newbury House, 1977, p. 22.

39 Hymes, "Breakthrough," p. 18.

40 Richard Schechner, Between Theater and Anthropology, Philadelphia, University of Pennsylvania Press, 1985, p. 35.

41 Ibid., p. 137.

42 D. W. Winnicott, *Playing and Reality*, London, Tavistock, 1971, p. 12; quoted in Schechner, *Between Theater*, p. 110.

43 Marvin Carlson, "Invisible Presences: Performance Intertextuality," Theatre Research International, vol. 19, 1994, pp. 111–17.

44 Michael Quinn, "Celebrity and the Semiotics of Acting," New Theatre Quarterly, vol. 4, 1990, pp. 155–6.

45 States, Great Reckonings, p. 46.

46 Ibid., pp. 110-11.

- 47 Derived in turn from Mircea Eliade's "reactualization," utilized in Schechner's 1965 Rites and Symbols of Initiation (New York, Harper) as a term to characterize the operations of regularly repeated tribal ceremonies in which each repetition was seen as possessing all of the power of an originary act.
- 48 Schechner, Essays on Performance Theory, New York, Drama Book Specialists, 1977, p. 18.

3 THE PERFORMANCE OF LANGUAGE

- 1 An approach introduced in Jürgen Habermas' "On Systematically Distorted Communication," *Inquiry*, vol. 13, 1970, pp. 205–18, and much more fully developed in his two-volume *The Theory of Communicative Action*, Boston, Mass., Beacon Press, 1984 and 1987.
- 2 A critique of the transcendentalism and privileging of competence in Habermas from the point of view of ethnography of communication may be found in Michael Huspek, "Taking Aim on Habermas's Critical Theory," Communication Monographs, vol. 58, 1991, pp. 225–33.

3 Dell Hymes, Foundations in Sociolinguistics: An Ethnographic Approach, Philadelphia, University of Pennsylvania Press, 1974, p. 79.

4 John Dore and R. P. McDermott, "Linguistic Indeterminacy and Social Context in Utterance Interpretation," *Language*, vol. 58, 1982, p. 396.

5 M. M. Bakhtin, Speech Genres and Other Late Essays, trans. Vern W. McGee, Austin, University of Texas Press, 1986, pp. 88–9.

6 Ibid., p. 93.

7 Julia Kristeva in Critique, no. 239, 1967, pp. 438-65.

8 Kristeva, *Desire in Language*, Leon Roudiez (ed.), trans. T. Gora, A. Jardine, and L. Roudiez, New York, Columbia University Press, 1980, p. 79.

9 Ibid., p. 79.

10 John Austin, How To Do Things with Words, Cambridge, Mass.,

Harvard University Press, 1975, pp. 5-6.

11 Austin, "Performative Utterances," in *Philosophical Papers*, J. O. Urmson and G. L. Warnock (eds.), Oxford, Oxford University Press, 1979, p. 249.

12 Austin, How To Do Things, p. 109.

13 John R. Searle, Speech Acts: An Essay in the Philosophy of Language, Cambridge, Cambridge University Press, 1969, p. 16.

14 Ibid., p. 17.

15 Ibid., pp. 24-5.

16 Charles W. Morris, "Foundations of the Theory of Signs", in The International Encyclopedia of Unified Science, vol. 1, no. 2, Chicago, University of Chicago Press, 1938, p. 30.

17 R. C. Stalnaker, "Pragmatics," in Donald Davidson and Gilbert Harman (eds.), Semantics of Natural Language, Dordrecht, D. Reidel,

1972, p. 35.

18 Kristeva, La Révolution du langage poétique, Paris, Seuil, 1974, p. 340.

19 Emile Benveniste, "Analytical Philosophy and Language," in Problems of General Linguistics, vol. 1, trans. M. E. Meeks, Coral Gables, Fl., University of Miami Press, 1971, pp. 236–8.

20 Jerrold J. Katz, Propositional Structure and Illocutionary Force,

Hassocks, Sussex, Harvester Press, 1977, p. xii.

21 Ibid., p. 177.

22 Shoshana Felman, The Literary Speech Act: Don Juan with Austin, or Seduction in Two Languages, trans. Catherine Porter, Ithaca, N.Y., Cornell University Press, 1983, p. 35.

23 Ibid., p. 143.

24 Monique Schneider, "The Promise of Truth—The Promise of Love," Diacritics, vol. 11, 1981, p. 32.

25 John Lechte, Julia Kristeva, London, Routledge, 1990, p. 28.

26 Austin, How To Do Things, pp. 71, 104.

27 For those who wish to review the major documents in this controversy, "Signature Event Context" first appeared in English in Glyph, vol. 1, 1977, which also contained J. R. Searle's "Reiterating the Differences: A Reply to Derrida." Derrida's subsequent reply in Glyph, "Limited Inc. abc . . ." and an "Afterword" were published together with his original article as Limited Inc., Evanston, Ill., Northwestern University Press, 1988. Searle refused to give permission for his "Reply" to be printed in this collection, but he continued the debate, most notably in his review of Jonathan Culler's On Deconstruction in the New York Review of Books, 27 October 1983, pp. 74–9.

28 Derrida, "Signature Event Context," in Limited Inc., p. 18.

29 Ibid., p. 79.

- 30 Richard Ohmann, "Speech Acts and the Definition of Literature," Philosophy and Rhetoric, vol. 4, 1971, pp. 13–15.
- 31 Ohmann, "Literature as Act," in Seymour Chatman (ed.), Approaches to Poetics, New York, Columbia University Press, 1973, p. 104.
- 32 Stanley Fish, Is There a Text in This Class?, Cambridge, Mass., Harvard University Press, 1980, p. 243.
- 33 Mary Louise Pratt, Toward a Speech-Act Theory of Literary Discourse, Bloomington, Indiana University Press, 1977, p. viii.
- 34 Ibid., p. 136.
- 35 Ibid., p. 115.
- 36 Kristeva, Desire in Language, p. 75.
- 37 Ibid., p. 46.
- 38 Sandy Petrey, Speech Acts and Literary Theory, London, Routledge, 1990, p. 79.
- 39 Austin, How To Do Things, p. 9.
- 40 Teun A. van Dijk, Text and Context, London, Longmans, 1977, p. 182.
- 41 Ibid., p. 177.
- 42 Ross Chambers, "Le Masque et le miroir: Vers une théorie relationnelle du théâtre," Etudes littéraires, vol. 13, 1980, p. 104.
- 43 Umberto Eco, "Semiotics of Theatrical Performance," TDR, vol. 21, 1977, p. 115.
- 44 Chambers, "Le Masque," p. 398.
- 45 Ibid., pp. 401-402.
- 46 Joseph A. Porter, *The Drama of Speech Acts: Shakespeare's Lancastrian Tetralogy*, Berkeley, University of California Press, 1979, p. 161.
- 47 Ohmann, "Literature as Act," p. 83.
- 48 Keir Elam, The Semiotics of Theatre and Drama, London, Methuen, 1980, p. 159.
- 49 Fish, Is There a Text, p. 218.
- 50 Herbert H. Clark and Thomas B. Carlson, "Hearers and Speech Acts," Language, vol. 58, 1982, p. 332.
- 51 Elias Rivers, Quixotic Scriptures: Essays on the Textuality of Spanish Literature, Bloomington, Indiana University Press, 1983.
- 52 Rivers, Things Done with Words: Speech Acts in Hispanic Drama, Neward, Juan de la Cuesta, 1986.
- 53 Among the recent examples: Stephen H. Fleck, "Barthes on Racine: A Different Speech Act Theory," Seventeenth Century French Studies, vol. 14, 1992, pp. 143–55; Günter Graf, "Sprechakt und Dialoganalyse—Methodenansatz zur externen Dramainterpretation" [on Lessing's Emilia Galotti], Wirkendes Wort, vol. 41, 1992, pp. 315–38; Jack Halstead, "Peter Handke's Sprechstücke and Speech Act Theory," Text and Performance Quarterly, vol. 10, 1990, pp. 183–93; Kathleen O'Gorman, "The Performativity of the Utterance in Deirdre and The Player Queen," in Leonard Orr (ed.), Yeats and Postmodernism, Syracuse, N.Y., Syracuse University Press, 1991, pp. 90–104.
- 54 Eli Rozik, "Categorization of Speech Acts in Play and Performance Analysis," Journal of Dramatic Theory and Criticism, vol. 8, no. 1, 1993,

pp. 117–32; "Plot Analysis and Speech Act Theory," in Gérard Deledalle (ed.), Signs of Humanity: L'homme et ses signes, Berlin, Mouton de Gruyter, vol. 2, 1992, pp. 1183–91; and "Speech Acts and the Theory of Theatrical Communication," Kodikas/Code, vol. 12, 1989, pp. 1–2, 41–55.

55 Quoted in Rozik, "Plot Analysis," p. 1191n.

56 Geoffrey N. Leech, Principles of Pragmatics, London, Longmans, 1983; Stephen C. Levinson, Pragmatics, Cambridge, Cambridge University Press, 1983; van Dijk, Text and Context, 1977.

57 Rozik, "Speech Acts," pp. 44–5. 58 Rozik, "Plot Analysis", p. 1187.

59 Rozik, "Theatrical Conventions: A Semiotic Approach," Semiotica, vol. 89, 1992, p. 12.

60 Beverly Whitaker Long, "Editorial Statement," Literature in Perform-

ance, vol. 1, 1980, p. v.

61 James W. Chesebro, "Text, Narration and Media," Text and Performance Quarterly, vol. 9, 1989, pp. 2–4.

4 PERFORMANCE IN ITS HISTORICAL CONTEXT

1 RoseLee Goldberg, Performance: Live Art 1909 to the Present, New York, Harry N. Abrams, 1979.

2 Goldberg, Performance Art: From Futurism to the Present, New York, Harry N. Abrams, 1988.

3 Ibid., p. 9.

4 Carol Simpson Stern and Bruce Henderson, *Performance: Texts and Contexts*, White Plains, N.Y., Longmans, 1993, pp. 382–405.

5 Ibid., pp. 382–3.

6 Ibid., p. 6.

7 Goldberg, Performance Art, p. 8.

8 Jean Alter, A Sociosemiotic Theory of Theatre, Philadelphia, University

of Pennsylvania Press, 1990, p. 32.

9 Posturers, like later contortionists, could place their limbs and other parts of their bodies in unusual and grotesque positions. The famous Joseph Clark (d. 1690), according to the *Transactions of the Royal Philosophical Society*, "could disjoint almost his whole body," and specialized in the imitation of all sorts of physical deformity. A "Grimacing Spaniard" in London in 1698 worked entirely with facial changes, turning his mouth, nose, and eyes into various shapes, contracting and expanding his features, and licking his nose with his tongue. See Thomas Frost, *The Old Showmen and the London Fairs*, London, Tinsley Brothers, 1875, pp. 59, 61.

10 Ibid., p. 19.

11 Joseph Strutt, The Sports and Pastimes of the People of England, London, Thomas Tegg, 1845, pp. 180–1.

12 Ibid., p. 185.

13 M. C. Bradbrook, *The Rise of the Common Player*, Cambridge, Mass., Harvard University Press, 1962, p. 97.

- 14 John Evelyn, *The Diary of John Evelyn*, ed. William Bray, London, Dent, vol. 1, 1966, p. 325.
- 15 John Gay, *Poetry and Prose*, Vinton A. Dearing (ed.), Oxford, Oxford University Press, vol. 1, 1974, p. 121.
- 16 John S. Clarke, Circus Parade, London, B. T. Batsford, 1936, p. 7.
- 17 See, for example, Johann Goethe, *Italienische Reise*. Gedenkausgabe, vol. 11, Zurich, 1948, pp. 228ff.
- 18 Kirsten Gram Holmström, Monodrama, Attitudes, Tableaux Vivants, Uppsala, Almqvist & Wiksells, 1967, p. 143.
- 19 Flora Fraser, Emma, Lady Hamilton, New York, Alfred A. Knopf, 1987, p. 107.
- 20 Peter Jelavich, Munich and Theatrical Modernism, Cambridge, Mass., Harvard University Press, 1985, p. 160.
- 21 Richard Kostelanetz, On Innovative Performance(s): Three Decades of Recollections on Alternative Theater, Jefferson, N.C., McFarland, 1994, pp. 50, 56. Concerning performance in writing, it might be noted that Kostelanetz, unlike the author of this book, makes a point of spelling theatre with an "er," a choice that he feels marks a necessary American separation from the European tradition (p. 54).
- 22 John S. Gentile, Cast of One: One-Person Shows from the Chautauqua Platform to the Broadway Stage, Urbana, University of Illinois Press, 1989.
- 23 Laurence Senelick, Cabaret Performance 1890–1920, New York, Performing Arts Journal Publications, 1989, p. 9.
- 24 Edward Braun (ed.), Meyerhold on Theatre, New York, Hill & Wang, 1969, p. 136.
- 25 See Konstantin Rudnitsky, Russian and Soviet Theater 1905–1932, trans. Roxane Permar, New York, Harry N. Abrams, 1988, p. 57.
- 26 Ibid., p. 97.
- 27 Spencer Golub, Evreinov: The Theatre of Paradox and Transformation, Ann Arbor, University of Michigan Research Press, 1984, p. 9.
- 28 Rudnitsky, Russian and Soviet Theater, p. 17.
- 29 Braun, Meyerhold, pp. 148-9.
- 30 F. T. Marinetti, "The Pleasure of Being Booed," in Let's Murder the Moonshine: Selected Writings, R. W. Flint (ed.), trans. R. W. Flint and A. A. Coppotelli, Los Angeles, Sun and Moon, 1991, p. 122.
- 31 Marinetti, "The Variety Theater," in Let's Murder, pp. 125, 128.
- 32 Tristan Tzara, "Zurich Chronicle 1915–1919," in Hans Richter (ed.), Dada: Art and Anti-Art, New York, n.d., pp. 223–4.
- 33 Richard Huelsenbeck, En Avant Dada: Eine Geschichte des Dadaismus, trans. Robert Motherwell in The Dada Painters and Poets, New York, Wittenborn, Schultz, 1951, p. 26.
- 34 André Breton, "Manifesto of Surrealism," trans. Herbert S. Gershman in *The Surrealist Revolution in France*, Ann Arbor, University of Michigan Press, 1974, p. 35.
- 35 William A. Camfield, Francis Picabia: His Life and Times, Princeton, N.J., Princeton University Press, 1979, pp. 210–11.
- 36 Fernand Léger, "Vive Rélâche," Paris-Midi, 17 December 1924, p. 4.
- 37 Antonin Artaud, "The Theater of Cruelty (First Manifesto)," in The

Theater and Its Double, trans. Mary Caroline Richards, New York,

Grove Press, 1958, p. 93.

38 Lazlo Moholy-Nagy, "Theater, Circus, Variety," in Walter Gropius (ed.), *The Theater of the Bauhaus*, trans. Arthur S. Wensinger, Middletown, Conn., Wesleyan University Press, 1961, p. 58.

39 Karl Schwitters, "Merzbühne," 1919, p. 3, quoted in John Elderfield, Karl Schwitters, London, Thames & Hudson, 1985, pp. 109–10.

40 Natalie Crohn Schmitt, Actors and Onlookers: Theater and Twentieth Century Scientific Views of Nature, Evanston, Ill., Northwestern University Press, 1990, p. 8.

41 John Cage, "The Future of Music: Credo," in Richard Kostelanetz

(ed.), John Cage, New York, Praeger, 1970, p. 54.

42 Goldberg, Performance Art, p. 140.

43 "Woks," *Art News*, March 1959, p. 62. 44 Goldberg, *Performance Art*, pp. 130–1.

45 Quoted in Michael Kirby, *Happenings: An Illustrated Anthology*, New York, Oxford University Press, 1965, p. 47.

46 Ibid., p. 21.

47 Allan Kaprow, Assemblages, Environments, and Happenings, New York, Harry N. Abrams, 1966, p. 185.

48 Ibid., p. 188.

49 Ibid., pp. 188-96.

50 Kostelanetz, "Mixed-Means Theater," first published in Contemporary Dramatists, New York, St. James Press, 1977; reprinted in Kostelanetz, Innovative Performance(s), p. 3. Kostelanetz, The Theater of Mixed Means, New York, Dial, 1968.

51 Fluxus I: An Anthology, ed. George Maciunas, New York, ReFlux

Editions, 1963.

52 Kostelanetz, Innovative Performance(s), pp. 5-7.

53 Timothy J. Wiles, *The Theater Event: Modern Theories of Performance*, Chicago, University of Chicago Press, 1980, p. 117.

5 PERFORMANCE ART

1 Willoughby Sharp, "Body Works: A Pre-Critical, Non-Definitive Survey of Very Recent Works Using the Human Body or Parts Thereof," *Avalanche*, vol. 1, 1970, p. 17.

2 Cindy Nemser, "Subject-Object: Body Art," Arts Magazine, vol. 46,

1971, p. 42.

3 For example, see ibid., p. 38.

- 4 Christine Tamblyn, "Hybridized Art," Artweek, vol. 21, 1990, p. 19.
- 5 Robin White, Interview with Chris Burden, View, 1979; quoted in Carl E. Loeffler and Darlene Tong (eds.), Performance Anthology, San Francisco, Last Gasp Press, 1989, p. 399.

6 Willoughby Sharp and Liza Bear, Interview with Chris Burden,

Avalanche, vol. 8, 1973, p. 61.

7 Kurt Lewin, *The Principles of Topological Psychology*, New York, McGraw-Hill, 1936.

8 Quoted in RoseLee Goldberg, Performance Art: From Futurism to the Present, New York, Harry N. Abrams, 1988, p. 156.

9 Andree Hayum, "Notes on Performance and the Arts," Art Journal,

vol. 34, 1975, p. 339.

10 The first critic, I believe, to gather such artists as Robert Wilson, Richard Foreman, and the Wooster Group under the rubric "performance theatre" was Timothy Wiles in his 1980 *The Theatre*

Event (Chicago, University of Chicago Press).

11 Richard Kostelanetz, "Mixed-Means Theater," first published in Kostelanetz, Contemporary Dramatists, New York, St. James Press, 1977; reprinted in Kostelanetz, On Innovative Performance(s): Three Decades of Recollections on Alternative Theater, Jefferson, N.C., McFarland, 1994, p. 3.

12 Bonnie Marranca, The Theatre of Images, New York, Drama Book

Specialists, 1977, p. xv.

13 Sandy Craig, Dreams and Deconstructions: Alternative Theatre in Britain, Ambergate, Amber Lane Press, 1980, p. 97.

14 Toby Coult and Baz Kershaw, Engineers of the Imagination: The Welfare

State Handbook, London, Methuen, 1983, p. 217.

- 15 Anthony Howell and Fiona Templeton, *Elements of Performance Art*, The Ting, The Theatre of Mistakes, 1977, p. 17.
- 16 Bettina Knapp, "Sounding the Drum: An Interview with Jerome Savary," TDR, vol. 15, 1970, p. 94.
- 17 Quoted in Bim Mason, Street Theatre and Other Outdoor Performance, London, Routledge, 1992, p. 84.
- 18 Jacki Apple, "Art at the Barricades," Artweek, vol. 21, 3 May 1990, p. 21.
- 19 Richard Foreman, "The Life and Times of Sigmund Freud," Village Voice, 1 January 1970.
- 20 Quoted in Laurence Shyer, Robert Wilson and his Collaborators, New York, Theatre Communications Group, 1989, p. xv.

21 Published by Theatre Communications Group, New York.

22 Linda Frye Burnham, "Performance Art in Southern California: An Overview," in Carl E. Loeffler and Darlene Tong (eds.), Performance Anthology, San Francisco, Last Gasp Press, 1989, p. 416.

23 Eleanor Munro, Originals: American Women Artists, New York,

Simon, 1979, p. 427.

- 24 These walkabout examples are drawn from Mason, *Street Theatre*, especially the section "Walkabout," pp. 166–77.
- 25 Samuel G. Freedman, "Echoes of Lenny Bruce, via Bogosian and Reddin," *New York Times*, 19 January 1986, sec. 2, p. 5.
- 26 Janice Arkatoy, "Bogosian's One-Man Bunch: Bouncing Ideas off Funhouse Walls," Los Angeles Times, 5 April 1985, sec. 6, p. 2.
- 27 M. Walsh, "Post-Punk Apocalypse," *Time*, 21 February 1983, vol. 121, p. 68.
- 28 M. Small, "Laurie Anderson's Whizzbang Techno-Vaudeville Mirrors Life in These United States," *People Weekly*, 21 March 1983, vol. 19, p. 107.
- 29 Quoted in John Howell, Laurie Anderson, New York, Thunder's Mouth Press, 1992, p. 75.

30 Barbara Smith, "Ordinary Life," High Performance, vol. 1, 1978, p. 13.

31 Apple, "Art at the Barricades," p. 21.

32 Henry Louis Gates, Jr., "Sudden Def," The New Yorker, 19 June 1995, p. 42.

33 R. G. Davis, "Guerrilla Theatre," Tulane Drama Review, vol. 10, 1966, pp. 130-6.

34 Richard Schechner, "Guerrilla Theatre: May 1970," The Drama Review, vol. 14, 1970, p. 163.

35 Coult and Kershaw, Engineers, p. 219.

36 The 1981 version of this work is described in Mason, Street Theatre, pp. 134-5.

37 Steven Durland, "Witness, the Guerrilla Theater of Greenpeace," High Performance, vol. 10, 1987, pp. 30-5.

38 Jorge-Uwe Albig, "Heiliger Krieg um Bäume und Steine," Art, vol. 6, 1987, pp. 64-9.

39 Regina Vater, "Ecology Art is Alive and Well in Latin America," High Performance, vol. 10, 1987, p. 35.

40 Lance Carlson, "Performance Art as Political Activism," Artweek, 3 May 1990, p. 24.

6 PERFORMANCE AND THE POSTMODERN

- 1 Anne Kisselgoff, "Not Quite/New York," New York Times, 27 September 1981.
- 2 Frank Rich, "The Regard of Flight," New York Times, 10 May 1985.

3 Nick Kave, Postmodernism and Performance, New York, St. Martin's Press, 1994, pp. 22-3.

4 Michel Benamou, "Presence as Play," in Michel Benamou and Charles Caramello, Performance in Postmodern Culture, Milwaukee, Wisc., Center for Twentieth Century Studies, 1977, p. 3.*

5 Ihab Hassan, The Dismemberment of Orpheus: Towards a Postmodern Literature, Madison, University of Wisconsin Press, 1971.

6 Hassan, "The Question of Postmodernism," in Harry R. Garvin (ed.), Romanticism, Modernism, Postmodernism (Bucknell Review special issue), vol. 25, 1980, pp. 123, 125.

7 Clement Greenberg, "After Abstract Expressionism," Art International, vol. 6, 1962, p. 30.

8 Greenberg, "Recentness of Sculpture," Arts, vol. 39, June 1965, pp. 22-5.

9 Michael Fried, "Art and Objecthood," in Gregory Battcock (ed.), Minimal Art, New York, Dutton, 1968, p. 127.

10 Ibid., pp. 139, 145.

11 Michael Kirby, "Nonsemiotic Performance," Modern Drama, vol. 25, 1982, p. 110.

12 Bonnie Marranca, The Theatre of Images, New York, Drama Book Specialists, 1977, p. 3.

13 Richard Foreman, Plays and Manifestos, Kate Davy (ed.), New York, New York University Press, 1976, p. 145.

- 14 Xerxes Mehta, "Some Versions of Performance Art," Theatre Journal, vol. 36, 1984, p. 165.
- 15 Louis Horst and Carroll Russell, *Modern Dance Forms*, San Francisco, Dance Horizons, 1961, pp. 16, 24.
- 16 Sally Banes, *Democracy's Body: Judson Dance Theater*, 1962–1964, Ann Arbor, University of Michigan Press, 1983, p. 3.
- 17 Banes, Terpsichore in Sneakers: Post-Modern Dance, 2nd edn., Middletown, Conn., Wesleyan University Press, 1987, p. xv.
- 18 Kaye, Postmodernism, pp. 76-7.
- 19 Banes, Terpsichore, p. xiv.
- 20 Susan Manning, "Modernist Dogma and Post-Modern Rhetoric," TDR, vol. 32, 1988, p. 34.
- 21 Michael Kirby, "Post-Modern Dance," TDR, vol. 19, 1975, pp. 3-4.
- 22 Kisselgoff, "Not Quite/New York."
- 23 Banes, "Is It All Postmodern?," TDR, vol. 36, 1992, pp. 59-62.
- 24 Charles Jencks, The Language of Postmodern Architecture, New York, Rizzoli, 1977.
- 25 Linda Hutcheon, A Poetics of Postmodernism, London, Routledge, 1988, p. 92.
- 26 John Barth, "The Literature of Replenishment: Postmodernist Fiction," *Atlantic Monthly*, vol. 245, 1980, pp. 68, 70.
- 27 Banes, "Is It All Postmodern?," pp. 59-62.
- 28 Roger Copeland, "Postmodern Dance/Postmodern Architecture/ Postmodernism," Performing Arts Journal, vol. 7, 1983, p. 39.
- 29 A title such as Jon Whitmore's Directing Postmodern Theater, Ann Arbor, University of Michigan Press, 1994, might suggest a clear body of material being addressed, but this is not really so. Whitmore lists a group of artists including Richard Foreman, Peter Brook, Robert Wilson, Martha Clarke, and JoAnne Akalaitis who "have contributed to the development of the postmodern theater" but not all of whom are "hard-core postmodernists." These "hard-core postmodernists" are not identified, though postmodern performance Whitmore generally defines as "primarily nonlinear, nonliterary, nonrealistic, nondiscursive and nonclosure oriented" (pp. 3-4). In fact Whitmore's approach is heavily semiotic, as is indicated by his opening assertion: "The reason for creating and presenting theater is to communicate meanings" (p. 1). The rest of the book is devoted to the analysis, with much insight and intelligence, of the various semiotic systems in theatre and how they communicate, but those theorists and practitioners who relate postmodernism with poststructuralism would surely reject this orientation toward so structuralist an approach as semiotics, and the communication of meanings would equally surely be specifically rejected as a goal by many if not most "hard-core postmodernists." This is not to condemn Whitmore's book, which is useful and thorough in its project, but only to suggest how far theatre studies is from a consensus as to what postmodern theatre might be.
- 30 Hal Foster, "(Post)Modern Polemics," New German Critique, vol. 33, 1984; reprinted in Recodings: Art, Spectacle, Cultural Politics, Seattle, Bay Press, 1985, p. 121.

- 31 Ibid., p. 125.
- 32 Ibid., p. 128.
- 33 Ibid., p. 129.
- 34 Fredric Jameson, Fables of Aggression, Berkeley, University of California Press, 1979, p. 20.
- 35 Henry M. Sayre, "The Object of Performance: Aesthetics in the Seventies," *The Georgia Review*, vol. 37, 1983, p. 174.
- 36 Ibid., p. 182.
- 37 Josette Féral, "Performance and Theatricality: The Subject Demystified," Modern Drama, vol. 25, 1982, p. 175.
- 38 Jacques Derrida, Writing and Difference, trans. Alan Bass, Chicago, University of Chicago Press, 1978, pp. 249–50.
- 39 Herbert Blau, "Universals of Performance: Or, Amortizing Play," Sub-Stance, vols. 37–8, 1983, pp. 143, 148.
- 40 Chantal Pontbriand, "The Eye Finds No Fixed Point on Which to Rest...," trans. C. R. Parsons, *Modern Drama*, vol. 25, 1982, p. 157.
- 41 Ibid., pp. 155, 158.
- 42 Kaye, Postmodernism, pp. 22-3.
- 43 Féral, "Performance and Theatricality," p. 179.
- 44 Jameson, "Foreword" to Jean-François Lyotard, The Postmodern Condition: A Report on Knowledge, Minneapolis, University of Minnesota Press, 1984, p. vii.
- 45 Ibid., pp. xxiv, xxvii.
- 46 Bill Readings, Introducing Lyotard: Art and Politics, London, Routledge, 1991, p. 69.
- 47 David George, "On Ambiguity: Towards a Post-Modern Performance Theory," Theatre Research International, vol. 14, 1989, p. 83.
- 48 Joel C. Weinsheimer, Gadamer's Hermeneutics: A Reading of "Truth and Method," New Haven, Conn., Yale University Press, 1985, pp. 109–10.
- 49 "Situation Esthetics: Impermanent Art and the Seventies Audience," *Artforum*, vol. 18, 1980, pp. 22–9.
- 50 Barbara Freedman, *Staging the Gaze*, Ithaca, N.Y., Cornell University Press, 1991, p. 74.
- 51 Jon Erickson, "Appropriation and Transgression in Contemporary American Performance," *Theatre Journal*, vol. 42, 1990, p. 235.
- 52 Randy Martin, Performance as Political Act: The Embodied Self, New York, Bergin & Garvey, 1990, pp. 175–6.
- 53 Lyotard, "Notes on the Critical Function of the Work of Art," trans. Susan Hanson, *Driftworks*, New York, Semiotext(e), 1984, p. 78.
- 54 Philip Auslander, Presence and Resistance: Postmodernism and Cultural Politics in Contemporary American Performance, Ann Arbor, University of Michigan Press, 1994, p. 31.
- 55 Alan Read, Theatre and Everyday Life: An Ethics of Performance, London, Routledge, 1993, p. 90.

7 PERFORMANCE AND IDENTITY

- 1 Jill Dolan, The Feminist Spectator as Critic, Ann Arbor, University of Michigan Research Press, 1988, p. 3; Alison Jaggar, Feminist Politics and Human Nature, Totowa, N.J., Rowan & Allanheld, 1983.
- 2 Michelene Wandor, Carry On, Understudies: Theatre and Sexual Politics, New York, Routledge & Kegan Paul, 1986, p. 131.
- 3 Linda Walsh Jenkins, "Locating the Language of Gender Experience," Women and Performance Journal, vol. 2, 1984, pp. 6–8.
- 4 Rosemary K. Curb, "Re/cognition, Re/presentation, Re/creation in Woman-Conscious Drama: The Seer, The Seen, The Scene, The Obscene," *Theatre Journal*, vol. 37, 1985, p. 304.
- 5 Dolan, Feminist Spectator, p. 10.
- 6 Sue-Ellen Case, Feminism and Theatre, New York, Methuen, 1988, p. 82.
- 7 Yvonne Rainer, "The Performer as a Persona," *Avalanche*, Summer 1972, p. 50.
- 8 Quoted in Moira Roth, *The Amazing Decade*, Los Angeles, Astro Artz, 1983, p. 125.
- 9 Carolee Schneemann, More Than Meat Joy, New Paltz, Domentext, 1979, p. 52.
- 10 Quoted in Leo Rubinflen, "Through Western Eyes," Art in America, vol. 66, 1978, p. 76.
- 11 Quoted in Moira Roth, "Autobiography, Theater, Mysticism and Politics: Women's Performance Art in Southern California," in Carl Loeffler and Darlene Tong (eds.), *Performance Anthology*, San Francisco, Last Gasp Press, 1989, p. 466.
- 12 A point stressed by Elizabeth Zimmer in "Has Performance Art Lost Its Edge?" Ms., vol. 5, no. 5, 1995, p. 78.
- 13 Martha Rosler, "The Private and the Public: Feminist Art in California," *Artforum*, vol. 16, 1977, p. 69.
- 14 Linda Frye Burnham, "High Performance, Performance Art, and Me," TDR, vol. 30, 1986, p. 40.
- 15 Barbara Smith, "Ordinary Life," High Performance, vol. 1, 1978, pp. 45-7.
- 16 Mary Beth Edelson, "Pilgrimage/See for Yourself," Heresies, Spring 1978, pp. 96–9.
- 17 Sally Banes, Terpsichore in Sneakers: Post-Modern Dance, 1st edn., Boston, Mass., Houghton Mifflin, 1980, p. 156.
- 18 Roth, The Amazing Decade, p. 20.
- 19 Schneemann, Meat Joy, p. 238.
- 20 Quoted in Rubinflen, "Through Western Eyes," p. 76.
- 21 See Linda Montano, Art in Everyday Life, Los Angeles, Astro Artz, 1981, unpaginated.
- 22 Josette Féral, "What is Left of Performance Art? Autopsy of a Function, Birth of a Genre," *Discourse*, vol. 14, 1992, pp. 148–9.
- 23 Ibid., p. 154.
- 24 Roth, The Amazing Decade, pp. 17, 20, 102.
- 25 Marilyn Nix, "Eleanor Antin's Traditional Art," Artweek, vol. 3, 1972, p. 3.

26 Quoted in Linda Frye Burnham, "Performance Art in Southern California: An Overview," in Loeffler and Tong, Performance Anthology, p. 406.

27 Eleanor Munro, Originals: American Women Artists, New York,

Simon, 1979, p. 427.

28 Marcia Traylor, "Catalog: Autobiographical Fantasies," Laica Journal, vol. 10, 1976.

29 Catherine Elwes, "Floating Femininity: A Look at Performance Art by Women," in Sarah Kent and Jacqueline Morreau (eds.), Women's Images of Men, London, Writers and Readers Publishing, 1985, p. 162.

30 Erving Goffman, Stigma: Notes on the Management of Spoiled Identity, Englewood Cliffs, N.J., Prentice-Hall, 1963, pp. 94, 101.

31 Esther Newton, Mother Camp: Female Impersonators in America, Chicago, University of Chicago Press, 1972, p. 108.

32 Wilde's life "performance" is analyzed in Ed Cohen's "Posing the Question: Wilde, Wit, and the Ways of Men," in Elin Diamond (ed.), Writing Performances, London, Routledge, 1995.

33 Quoted in John S. Gentile, Cast of One: One-Person Shows from the Chataugua Platform to the Broadway Stage, Urbana, University of

Illinois Press, 1989, p. 153.

34 Susan Sontag, "Notes on 'Camp," in Against Interpretation, New York, Farrar Straus & Giroux, 1966, pp. 280, 286.

35 Newton, Mother Camp, p. 107.

36 This of course does not mean that cross-dressing cannot provide a site of social and cultural tension and identity exploration in traditional theatre as well, as many recent theorists of English Renaissance culture have argued. See, for example, Jonathan Dollimore, Sexual Dissidence, Oxford, Oxford University Press, 1991, esp. chap. 18; Rudolf Dekker and Lotte van De Pol, The Tradition of Female Transvestism in Early Modern Europe, New York, St. Martin's Press, 1989; Stephan Orgel, "Nobody's Perfect," South Atlantic Quarterly, vol. 88, 1989, pp. 7-29.

37 Occasionally performance artists such as Split Britches have utilized performance to explore different gender possibilities within themselves in the same piece. In his I Got the He-Be-She-Be's (1986), John Fleck, stripped naked, played his own female and male halves,

caressing, cajoling, battering, and having sex with himself.

38 See John Lahr, "Playing Possum," The New Yorker, 1 July 1991, pp. 38-66.

39 Mark Gevisser, "Gay Theater Today," Theater, vol. 21, 1990, p. 46.

40 Laurence Senelick, "Boys and Girls Together," in Lesley Ferris (ed.), Crossing the Stage, London, Routledge, 1993, pp. 82, 93.

41 Joe Laurie, Jr., Vaudeville, New York, n.d., p. 92.

42 Gevisser, "Gay Theater," p. 48.

43 David Drake, "Gay Activist or Beauty Queen?," Theater Week, 5 August 1991, p. 19.

44 Quoted in Burnham, "Performance Art," p. 416.

45 Alicia Solomon, "It's Never Too Late To Switch," in Ferris, Crossing the Stage, p. 145.

46 It is important also to note that although recent theory, much interested in the implications of performance in identity formation and political placement, has traced these implications in earlier performance work, such work (drag in particular) rarely aroused any speculation in performers or audiences at the time of its creation. A clear example of the shift was Ron Vawter's re-creation of a 1981 Jack Smith performance in 1992. The original production, like all of Smith's work, was concerned primarily with flamboyant and excessive display, akin to the Aristophanic exuberance of the early Theatre of the Ridiculous. Ten years later, in a more reflexive performative context, Vawter saw this piece (and a companion enactment of Roy Cohn) in a quite different light, as statements "about repression and how the homosexual deals with repression" ("Two Strangers Meet Through an Actor," interview with Stephen Holden, New York Times, 3 May 1992, sec. 2, p. 8). Even New York Times reviewer Frank Rich was sufficiently aware of the theoretical placement of Vawter's re-enactment to characterize it as "an heroic act of minority cultural anthropology" ("Diversities of America in One-Person Shows," New York Times, 15 May 1992, sec. C, p. 1).

47 See Linda Burnham, "Making Family," High Performance, vol. 9, 1986, pp. 48–53.

48 David Román, "Performing All Our Lives: AIDS, Performance, Community," in Janelle Reinelt and Joseph Roach (eds.), Critical Theory and Performance, Ann Arbor, University of Michigan Press, 1992, p. 215.

49 Quoted in William Harris, "Demonized and Struggling with his Demons," New York Times, 23 October 1994, sec. H, p. 31.

50 Laura Trippi, "Visiting Hours," Program of the New Museum, New York, September 1994.

51 Moira Roth, "Vision and Re-Visions: A Conversation with Suzanne Lacy," *Artforum*, vol. 19, no. 3, 1980, pp. 39–40.

52 For example, by Barbara Christian, in "The Race for Theory," Feminist Studies, vol. 14, 1988.

53 From a company press flyer quoted by Rebecca Schneider, in "See the Big Show: Spiderwoman Theater Doubling Back," in Lynda Hart and Peggy Phelan (eds.), *Acting Out: Feminist Performances*, Ann Arbor, University of Michigan Press, 1993, p. 241.

54 Yvonne Yarbro-Bejarano, "Cherríe Moraga's 'Shadow of a Man,'" in Hart and Phelan, Acting Out, p. 85.

55 Grace Glueck, "In a Roguish Gallery," New York Times, 12 May 1989, sec. C, p. 3.

56 C. Carr, "Revisions of Excess," Village Voice, May 1989; reprinted in Carr, On Edge: Performance at the End of the Twentieth Century, Middletown, Conn., Wesleyan University Press, 1994, p. 179.

57 Quoted in Carr, "Rediscovering America," Village Voice, October 1991; reprinted in Carr, On Edge, p. 196.

58 Quoted in Margot Mifflin, "Performance Art: What Is It And Where Is It Going?" Art News, vol. 91, no. 4, 1992, p. 87.

59 Both quoted in Lenora Champagne (ed.), Out from Under: Texts by

Women Performance Artists, New York, Theatre Communications Group, 1990, pp. 92-3.

60 See Raewyn Whyte, "Robbie McCauley: Speaking History Other-Wise," in Hart and Phelan, Acting Out, pp. 277-93.

61 Quoted in Mifflin, "Performance Art," p. 87.

62 Jacki Apple, "Art at the Barricades," Artweek, vol. 21, 1990, p. 21.

63 Ouoted in Mifflin, "Performance Art," p. 89.

8 RESISTANT PERFORMANCE

1 Robin Morgan, Going Too Far, New York, Random House, 1977, pp. 65, 72, 75.

2 See Suzi Gablik, "A Conversation with the Guerrilla Girls," Art in

America, January 1994, pp. 43-7.

"Women's Performance Art: Feminism and 3 Jeanie Forte, Postmodernism," in Sue-Ellen Case (ed.), Performing Feminisms: Feminist Critical Theory and Theatre, Baltimore, Md., Johns Hopkins University Press, 1990, p. 253.

4 Valie Export, "Persona, Proto-Performance, Politics: A Preface," trans. Jamie Daniel, Discourse, vol. 14, 1992, p. 33. See also Export's essay, "Feminist Actionism," in Nabakowski, Gislind, et al. (eds.),

Frauen in der Kunst, Frankfurt, Suhrkamp, 1980.

5 Michelene Wandor, Carry On, Understudies: Theatre and Sexual Politics, London, Routledge & Kegan Paul, 1986, p. 87.

6 Sue-Ellen Case, Feminism and Theatre, New York, Methuen, 1988, p. 120.

7 Hélène Cixous, "Le Rire de la Méduse," L'Arc, vol. 61, n.d., p. 46.

8 Jeannette Laillou Savona, "French Feminism and Theatre: An Introduction," Modern Drama, vol. 27, 1984, p. 540.

9 Marcia K. Moen, "Peirce's Pragmatism as a Resource for Feminism," Transactions of the Charles S. Peirce Society, Amherst, University of Massachusetts Press, 1991, p. 439.

10 Forte, "Women's Performance Art," p. 260.

11 Sally Potter, About Time Catalogue, London, Institute for the Contemporary Arts, September 1980; quoted in Catherine Elwes, "Floating Femininity: A Look at Performance Art by Women," in Sarah Kent and Jacqueline Morreau (eds.), Women's Images of Men, London, Writers and Readers Publishing, 1985, p. 170.

12 Rachel Bowlby, "The Feminine Female," Social Text, vol. 42, 1983,

p. 62; quoted in Forte, "Women's Performance Art," p. 261.

13 Jill Dolan, "In Defense of the Discourse: Materialist Feminism, Postmodernism, Poststructuralism ... and Theory," TDR, vol. 33, 1989, pp. 59-60.

14 Elin Diamond, "The Violence of 'We': Politicizing Identification," in Janelle Reinelt and Joseph Roach (eds.), Critical Theory and Performance, Ann Arbor, University of Michigan Press, 1992, p. 397.

15 Judith Butler, Gender Trouble, New York, Routledge, 1990, p. 25.

16 Butler, Bodies That Matter, New York, Routledge, 1993, p. 95.

17 The earlier chapter on linguistic performance summarizes this argument.

18 Theodor W. Adorno, Negative Dialectics, trans. E. B. Ashton, New

York, Seabury Press, 1973, p. 5.

19 S. Buck-Morss, The Origin of Negative Dialectics: Theodor W. Adorno, Walter Benjamin, and the Frankfurt Institute, Hassocks, Sussex, Harvester Press, 1977, p. 54.

20 Butler, Bodies, p. 94.

- 21 Diamond, "Introduction," Writing Performances, London, Routledge, 1995.
- 22 Michel de Certeau, The Practice of Everyday Life, trans. Steven F. Rendall, Berkeley, University of California Press, 1984, p. xix.
- 23 Wlad Godzich, "The Further Possibility of Knowledge," in de Certeau, Heterologies, Minneapolis, University of Minnesota Press, 1988, p. viii.
- 24 Jacques Derrida, "The Ends of Man," Margins of Philosophy, trans. Alan Bass, Chicago, University of Chicago Press, 1982, p. 135.
- 25 Audre Lorde, Sister/Outsider: Essays and Speeches, Freedom, Calif., Cross Press, 1984, p. 223.
- 26 De Certeau, The Practice, p. xix.

27 Butler, Gender Trouble, p. 145.

28 Philip Auslander, Presence and Resistance: Postmodernism and Cultural Politics in Contemporary American Performance, Ann Arbor, University of Michigan Press, 1994, p. 31.

29 Dolan, "The Dynamics of Desire: Sexuality and Gender in Pornography and Performance," Theatre Journal, vol. 39, 1987, p. 159.

30 Diamond, "Mimesis, Mimicry, and the 'True-Real," Modern Drama,

vol. 32, 1989, pp. 59-60.

31 Luce Irigaray, "The Power of Discourse," in This Sex Which Is Not One, trans. Catherine Porter with Carolyn Burke, Ithaca, N.Y., Cornell University Press, 1985, p. 76.

32 Herman Rapaport, "'Can You Say Hello?' Laurie Anderson's United States," Theatre Journal, vol. 38, 1986, p. 348.

33 Mary Ann Doane, "Film and the Masquerade: Theorizing the Female Spectator," Screen, vol. 23, 1982, p. 81.

34 Mary Russo, "Female Grotesques: Carnival and Theory," in Teresa de Lauretis (ed.), Feminist Studies/Critical Studies, Bloomington, Indiana University Press, 1986, p. 85.

- 35 Diamond, "Mimesis, Mimicry," pp. 66-7.
- 36 Auslander, Presence and Resistance, p. 23.
- 37 Quoted in Wandor, Carry On, p. 72.
- 38 Elwes, "Floating Femininity," p. 172.

39 Ibid., p. 37.

40 Dolan, "Dynamics of Desire," pp. 162-3.

41 Quoted in Margot Mifflin, "Performance Art: What Is It And Where Is It Going?" Art News, vol. 91, 1992, p. 86.

42 Forte, "Women's Performance Art," p. 268.

43 Jon Erickson, "Appropriation and Transgression in Contemporary American Performance," Theatre Journal, vol. 42, 1990, p. 235.

44 Sue-Ellen Case and Jeanie K. Forte, "From Formalism to Feminism," Theater, vol. 16, 1985, p. 65.

45 Elwes, "Floating Femininity," p. 154.

46 Kate Davy, "Constructing the Spectator: Reception, Context, and Address in Lesbian Performance," Performing Arts Journal, vol. 10, 1986, p. 47.

47 Case, "Toward a Butch-Femme Aesthetic," in Lynda Hart (ed.), Making a Spectacle: Feminist Essays on Contemporary Women's Theatre, Ann Arbor, University of Michigan Press, 1989, pp. 283, 296.

48 Later published in Stefan Brecht, Queer Theatre, London, Methuen, 1986, pp. 31-2.

49 Butler, Gender Trouble, p. 31.

- 50 Earl Jackson, Jr., "Kabuki Narratives of Male Homoerotic Desire in Saikuku and Mishima," Theatre Journal, vol. 41, 1989, p. 459.
- 51 Kate Davy, "Fe/male Impersonation: The Discourse of Camp," in Reinelt and Roach, Critical Theory, p. 244.
- 52 Teresa de Lauretis, "Sexual Indifference and Lesbian Representation," Theatre Journal, vol. 40, 1988, pp. 169-71.
- 53 Peggy Phelan, Unmarked, London, Routledge, 1993, p. 148.

54 Ibid., pp. 152-3.

55 Elwes, "Floating Femininity," p. 173.

56 Thi Minh-Ha Trinh, When the Moon Waxes Red: Representation, Gender and Cultural Politics, London, Routledge, 1991, pp. 93-4.

57 Ibid., p. 136.

58 Dolan, "Epilogue" to "Desire Cloaked in a Trenchcoat," in Lynda Hart and Peggy Phelan (eds.), Acting Out: Feminist Performances, Ann Arbor, University of Michigan Press, 1993, p. 113.

59 Diamond, "Mimesis, Mimicry," p. 59.

- 60 Butler, "The Force of Fantasy: Feminism, Mapplethorpe, and Discursive Excess," differences, vol. 2, 1990, p. 121.
- 61 David Román, "Performing All Our Lives: AIDS, Performance, Community," in Reinelt and Roach, Critical Theory, p. 215.

62 Ibid., p. 218.

- 63 Rebecca Schneider, "See the Big Show: Spiderwoman Theater Doubling Back," in Hart and Phelan, Acting Out, pp. 227–56.
- 64 Homi Bhabha, "Of Mimicry and Man: The Ambivalence of Colonial Discourse," October, vol. 28, 1984, p. 126. 65 Schneider, "See the Big Show," p. 237.
- 66 Ibid., p. 251.

67 Ibid., p. 246.

68 Mifflin, "Performance Art," p. 88.

69 See Coco Fusco, "The Other History of Intercultural Performance," TDR, vol. 38, 1994, pp. 143-67.

CONCLUSION

1 Thi Minh-Ha Trinh, Women, Native, Other: Writing Postcoloniality and Feminism, Bloomington, Indiana University Press, 1989, p. 94.

2 Clifford Geertz, "Blurred Genres," Local Knowledge: Further Essays in Interpretive Anthropology, Stanford, Stanford University Press, 1983, pp. 19–35.

3 Renato Rosaldo, Culture and Truth: The Remaking of Social Analysis,

Boston, Mass., Beacon Press, 1989, p. 45.

4 Ibid., p. 28.

5 Robert Jay Lifton, The Protean Self, New York, Basic Books, 1993,

p. 1.

6 James Clifford, The Predicament of Culture: Twentieth-Century Ethnography, Literature, and Art, Cambridge, Mass., Harvard University Press, 1988, pp. 23, 25.

7 John Lechte, Julia Kristeva, London, Routledge, 1990, p. 27.

8 Geertz, Works and Lives: The Anthropologist as Author, Stanford, Calif.,

Stanford University Press, 1988, p. 143.

9 "Introduction," to Smadar Lavie, Kirin Narayan, and Renato Rosaldo (eds.), Creativity/Anthropology, Ithaca, N.Y., Cornell University Press, 1993, p. 6. This collection is dedicated to Victor Turner, whose work is the focus of the Introduction. The close relationship between creativity, play, carnival is also stressed, with references to Johan Huizinga and Mikhail Bakhtin.

10 Stephen Tyler, The Unspeakable: Discourse, Dialogue, and Rhetoric in the Postmodern World, Madison, University of Wisconsin Press, 1987,

pp. 212, 218.

11 Dwight Conquergood, "Rethinking Ethnography: Towards a Critical Cultural Politics," Communication Monographs, vol. 58, 1991, pp. 179–94.

12 Mikhail Bakhtin, Speech Genres and Other Late Essays, trans. Vern W.

McGee, Austin, University of Texas Press, 1986, p. 2. 13 Conquergood, "Rethinking Ethnography," p. 180.

14 Tyler, *The Unspeakable*, p. 225.

15 James M. Edie, "Notes on the Philosophical Anthropology of William James," in J. M. Edie (ed.), An Invitation to Phenomenology: Studies in the Philosophy of Experience, Chicago, Quadrangle Books, 1965, p. 119.

16 Michael Jackson, Paths Toward a Clearing: Radical Empiricism and Ethnographic Inquiry, Bloomington, Indiana University Press, 1989,

p. 2

17 Conquergood, "Rethinking Ethnography," p. 190.

18 John J. MacAloon (ed.), *Rite, Drama, Festival, Spectacle: Rehearsals Toward a Theory of Cultural Performance,* Philadelphia, Institute for the Study of Human Issues, 1984, p. 1.

19 Margaret Wilkerson, "Demographics and the Academy," in Sue-Ellen Case and Janelle Reinelt (eds.), The Performance of Power, Iowa

City, University of Iowa Press, 1991, p. 239.

20 Jill Dolan, "Geographics of Learning: Theatre Studies, Performance, and the 'Performative,'" *Theatre Journal*, vol. 45, 1993, p. 432.

21 Ibid., p. 441.

22 Alan Read, Theatre and Everyday Life: An Ethics of Performance, London, Routledge, 1993, p. 90.

Selected bibliography

Abrahams, Roger D. (1968) "Introductory Remarks to a Rhetorical Theory of Folklore," Journal of American Folklore, vol. 81, pp. 143-58. Adorno, Theodor W. (1973) Negative Dialectics, trans. E. B. Ashton, New

York: Seabury Press.

Albig, Jorge-Uwe (1987) "Heiliger Krieg um Bäume und Steine," Art, vol. 6, pp. 64-9.

Alter, Jean (1990) A Sociosemiotic Theory of Theatre, Philadelphia:

University of Pennsylvania Press.

Anderson, Jay (ed.) (1991) A Living History Reader, vol. 1, Nashville: American Association for State and Local History.

Apple, Jacki (1990) "Art at the Barricades," Artweek, vol. 21.

Arkatoy, Janice (1985) "Bogosian's One-Man Bunch: Bouncing Ideas off Funhouse Walls," Los Angeles Times, 5 April, sec. 6, p. 2.

Artaud, Antonin (1958) The Theater and Its Double, trans. Mary Caroline

Richards, New York: Grove Press.

Auslander, Philip (1994) Presence and Resistance: Postmodernism and Cultural Politics in Contemporary American Performance, Ann Arbor: University of Michigan Press.

Austin, J. L. (1975) How To Do Things with Words, Cambridge, Mass.:

Harvard University Press.

- (1979) Philosophical Papers, J. O. Urmson and G. L. Warnock (eds.), Oxford: Oxford University Press.

Bakhtin, Mikhail (1965) Rabelais and his World, trans. Helen Iswolsky,

Cambridge, Mass.: MIT Press.

- (1986) Speech Genres and Other Late Essays, trans. Vern W. McGee, Austin: University of Texas Press.

Banes, Sally (1983) Democracy's Body: Judson Dance Theater, 1962-1964, Ann Arbor: University of Michigan Press.

(1987) Terpsichore in Sneakers: Post-Modern Dance, 2nd edn., Middletown, Conn.: Wesleyan University Press.

– (1992) "Is It All Postmodern?" TDR, vol. 36, pp. 59–62.

Barba, Eugenio (1991) "Introduction," in Barba and Nicola Savarese (eds.), The Secret Art of the Performer, trans. Richard Fowler, London: Routledge. Barnouw, Erik (ed.) (1989) International Encyclopedia of Communications,

New York: Oxford University Press.

Barth, John (1980) "The Literature of Replenishment: Postmodernist Fiction," Atlantic Monthly, vol. 245, pp. 65–71.

Bateson, Gregory (1972) Steps to an Ecology of Mind, San Francisco: Chandler.

Battcock, Gregory (ed.) (1968) Minimal Art, New York: Dutton.

Bauman, Richard (1977) Verbal Art as Performance, Rowley, Mass.: Newbury House.

- (1986) Story, Performance, and Event: Contextual Studies in Oral Narrative, New York: Cambridge University Press.

- (1989) "Performance," in Barnouw, International Encyclopedia of Communications.

Ben-Amos, Dan and Kenneth S. Goldstein (eds.) (1975) Folklore: Performance and Communication, The Hague: Mouton.

Benamou, Michel and Charles Caramello (1977) Performance in Postmodern Culture, Milwaukee, Wisc.: Center for Twentieth Century Studies.

Benveniste, Emile (1971) "Analytical Philosophy and Language," in Problems of General Linguistics, vol. 1, trans. M. E. Meeks, Coral Gables, Fl.: University of Miami Press.

Berger, P. L. and Luckman, T. (1967) The Social Construction of Reality,

Garden City, N.Y.: Doubleday.

Berne, Eric (1961) Transactional Analysis in Psychotherapy, New York: Grove Press.

- (1964) Games People Play, New York: Grove Press.

— (1967) "Notes on Games and Theatre," TDR, vol. 11, no. 4, pp. 89-91.

Bhabha, Homi (1984) "Of Mimicry and Man: The Ambivalence of Colonial Discourse," October, vol. 28, pp. 125–33.

Bharucha, Rustom (1993) Theatre and the World: Performance and the Politics of Culture, London: Routledge.

Blau, Herbert (1982) Blooded Thought: Occasions of Theatre, New York: Performing Arts Journal Publications.

- (1983) "Universals of Performance: Or, Amortizing Play," Sub-

Stance, vols. 37–8, pp. 140–61.

— (1987) The Eye of Prey, Bloomington: Indiana University Press.

—— (1990) The Audience, Baltimore, Md.: Johns Hopkins University Press. (1992) To All Appearances: Ideology and Performance, London: Routledge.

Bouissac, Paul (1981) "Behavior in Context: In What Sense is a Circus Animal Performing?" pp. 18–25 in Sebeok and Rosenthal, Clever Hans.

Bradbrook, M. C. (1962) The Rise of the Common Player, Cambridge, Mass.: Harvard University Press.

Braun, Edward (ed.) (1969) Meyerhold on Theatre, New York: Hill & Wang.

Brecht, Stefan (1986) Queer Theatre, London: Methuen.

Breton, André (1974) "First Manifesto," trans. Herbert S. Gershman in Gershman, The Surrealist Revolution.

Brewer, Mária Minich (1985) "Performing Theory," Theatre Journal, vol. 37, pp. 13-30.

Bristol, Michael D. (1985) Carnival and Theatre, New York: Methuen. Buck-Morss, S. (1977) The Origin of Negative Dialectics: Theodor W. Adorno, Walter Benjamin, and the Frankfurt Institute, Hassocks, Sussex: Harvester Press.

Burke, Kenneth (1957) *The Philosophy of Literary Form*, New York: Vintage Books.

—— (1962) A Grammar of Motives, Cleveland, Oh.: Meridian.

Burnham, Linda Frye (1986) "High Performance, Performance Art, and Me," TDR, vol. 30, pp. 15–51.

— (1989) "Performance Art in Southern California: An Overview,"

pp. 390–438 in Loeffler and Tong, Performance Anthology.

Butler, Judith (1988) "Performative Acts and Gender Constitution: An Essay in Phenomenology and Feminist Theory," *Theatre Journal*, vol. 40, pp. 519–31.

— (1990) Gender Trouble, New York: Routledge.

— (1990) "The Force of Fantasy: Feminism, Mapplethorpe, and Discursive Excess," differences, vol. 2, p. 121.

—— (1993) Bodies That Matter, New York: Routledge.

Cage, John (1970) "The Future of Music: Credo," in John Cage, Richard Kostelanetz (ed.), New York: Praeger, p. 54.

Caillois, Roger (1961) Man, Play, and Games, trans. Meyer Barash, New York: Free Press.

Camfield, William A. (1979) Francis Picabia: His Life and Times, Princeton, N.J.: Princeton University Press.

Carlson, Lance (1990) "Performance Art as Political Activism," Artweek, vol. 22, pp. 23–4.

Carlson, Marvin (1994) "Invisible Presences: Performance Intertextuality," Theatre Research International, vol. 19, pp. 111–17.

Carr, C. (1994) On Edge: Performance at the End of the Twentieth Century, Middletown, Conn.: Wesleyan University Press.

Case, Sue-Ellen and Jeanie K. Forte (1985) "From Formalism to Feminism," *Theater*, vol. 16, pp. 62–5.

— (1988) Feminism and Theatre, New York: Methuen.

—— (1989) "Toward a Butch-Femme Aesthetic," pp. 282–9 in Hart, Making a Spectacle.

—— (ed.) (1990) Performing Feminisms: Feminist Critical Theory and Theatre, Baltimore, Md.: Johns Hopkins University Press.

— and Janelle Reinelt (1991) The Performance of Power, Iowa City: University of Iowa Press.

Chambers, Ross (1980) "Le Masque et le miroir: Vers une théorie relationnelle du théâtre," Etudes littéraires, vol. 13.

Champagne, Lenora (ed.) (1990) Out from Under: Texts by Women Performance Artists, New York, Theatre Communications Group.

Chatman, Seymour (ed.) (1973) Approaches to Poetics, New York: Columbia University Press.

Chesebro, James W. (1989) "Text, Narration and Media," Text and Performance Quarterly, vol. 9, pp. 2–4.

Chomsky, Noam (1965) Aspects of the Theory of Syntax, Cambridge, Mass.: MIT Press.

Christian, Barbara (1988) "The Race for Theory," Feminist Studies, vol. 14, pp. 67–79. Cixous, Hélène (n.d.) "Le Rire de la Méduse," L'Arc, vol. 61, pp. 45-7. Clark, Herbert H. and Thomas B. Carlson (1982) "Hearers and Speech Acts," Language, vol. 58, pp. 332-73.

Clarke, John S. (1936) Circus Parade, London: B. T. Batsford.

Clifford, James (1988) The Predicament of Culture: Twentieth-Century Ethnography, Literature, and Art, Cambridge, Mass.: Harvard University Press.

Cohen, Ed (1995) "Posing the Question: Wilde, Wit, and the Ways of

Men," in Diamond, Writing Performances.

Conquergood, Dwight (1985) "Performing as a Moral Act: Ethical Dimensions of the Ethnography of Performance," Literature in Performance, vol. 5, pp. 1-13.

- (1991) "Rethinking Ethnography: Towards a Critical Cultural

Politics," Communication Monographs, vol. 58, pp. 179-94.

- (1992) "Ethnography, Rhetoric, and Performance," Quarterly Journal of Speech, vol. 78, pp. 80-97.

Copeland, Roger (1983) "Postmodern Dance/Postmodern Architecture/ Postmodernism," Performing Arts Journal, vol. 7, pp. 27-43.

Coult, Toby and Baz Kershaw (1983) Engineers of the Imagination: The Welfare State Handbook, London: Methuen.

Craig, Sandy (1980) Dreams and Deconstructions: Alternative Theatre in Britain, Ambergate: Amber Lane Press.

Curb, Rosemary K. (1985) "Re/cognition, Re/presentation, Re/creation in Woman-Conscious Drama: The Seer, The Seen, The Scene, The Obscene," Theatre Journal, vol. 37, pp. 302–16.

Davidson, Donald and Gilbert Harman (eds.) (1972) Semantics of Natural

Language, Dordrecht: D. Reidel.

Davis, R. G. (1966) "Guerrilla Theatre," Tulane Drama Review, vol. 10, pp. 130-6.

Davy, Kate (1986) "Constructing the Spectator: Reception, Context, and Address in Lesbian Performance," Performing Arts Journal, vol. 10, pp. 43-54.

- (1992) "Fe/male Impersonation: The Discourse of Camp," p. 244 in

Reinelt and Roach, Critical Theory.

de Certeau, Michel (1984) The Practice of Everyday Life, trans. Steven F. Rendall, Berkeley: University of California Press.

— (1988) Heterologies, Minneapolis: University of Minnesota Press. de Lauretis, Teresa (ed.) (1986) Feminist Studies/Critical Studies,

Bloomington: Indiana University Press.

- (1988) "Sexual Indifference and Lesbian Representation," Theatre Journal, vol. 40, no. 2, pp. 155-77.

Dekker, Rudolf and Lotte van De Pol (1989) The Tradition of Female Transvestism in Early Modern Europe, New York: St. Martin's Press.

Deledalle, Gérard (ed.) (1992) Signs of Humanity: L'Homme et ses signes, Berlin: Mouton de Gruyter, vol. 2, pp. 1183-91.

Derrida, Jacques (1978) Writing and Difference, trans. Alan Bass, Chicago: University of Chicago Press.

- (1982) Margins of Philosophy, trans. Alan Bass, Chicago: University of Chicago Press.

—— (1988) Limited Inc., Evanston, Ill.: Northwestern University Press. Diamond, Elin (1989) "Mimesis, Mimicry, and the 'True-Real,'" Modern Drama, vol. 32, pp. 58–72.

— (1992) "The Violence of 'We': Politicizing Identification," pp. 390-8

in Reinelt and Roach, Critical Theory.

—— (ed.) (1995) Writing Performances, London: Routledge.

Doane, Mary Ann (1982) "Film and the Masquerade: Theorizing the Female Spectator," Screen, vol. 23.

Michigan Research Press.

— (1989) "In Defense of the Discourse: Materialist Feminism, Postmodernism, Poststructuralism...and Theory," *TDR*, vol. 33, no. 3, pp. 58–71.

— (1993) "Geographics of Learning: Theatre Studies, Performance, and the 'Performative,'" *Theatre Journal*, vol. 45, no. 4, pp. 417–42.

Dollimore, Jonathan (1991) Sexual Dissidence, Oxford: Oxford University Press.

Dore, John and R. P. McDermott (1982) "Linguistic Indeterminacy and Social Context in Utterance Interpretation," *Language*, vol. 58, pp. 374–98.

Dorson, Richard M. (ed.) (1972) Folklore and Folklife: An Introduction,

Chicago: University of Chicago Press.

Drake, David (1991) "Gay Activist or Beauty Queen?" Theater Week, 5 August, p. 19.

Durland, Steven (1987) "Witness, the Guerrilla Theater of Greenpeace," High Performance, vol. 10, pp. 30–5.

Eco, Umberto (1977) "Semiotics of Theatrical Performance," *TDR*, vol. 21, pp. 107–17.

Edelson, Mary Beth (1978) "Pilgrimage/See for Yourself," Heresies, Spring, pp. 96–9.

Edie, James M. (1965) An Invitation to Phenomenology: Studies in the Philosophy of Experience, Chicago: Quadrangle Books.

Ehrmann, Jacques (ed.) (1968) Game, Play, Literature, trans. Cathy and Phil Lewis, Boston, Mass.: Beacon Press.

Elam, Keir (1980) *The Semiotics of Theatre and Drama*, London: Methuen. Elderfield, John (1985) *Karl Schwitters*, London: Thames & Hudson.

Elwes, Catherine (1985) "Floating Femininity: A Look at Performance Art by Women," pp. 64–93 in Kent and Morreau, Women's Images.

Enslin, Elizabeth (1994) "Beyond Writing: Feminist Practice and the Limitations of Ethnography," *Cultural Anthropology*, vol. 9, no. 4, pp. 537–58.

Erickson, Jon (1990) "Appropriation and Transgression in Contemporary American Performance," *Theatre Journal*, vol. 42, no. 2, pp. 225–36.

Evelyn, John (1966) The Diary of John Evelyn, ed. William Bray, vol. 1, London: Dent.

Evreinoff, Nikolas (1927) The Theatre in Life, trans. Alexander Nazaroff, New York: Brentano's.

Export, Valie (1992) "Persona, Proto-Performance, Politics: A Preface," trans. Jamie Daniel, Discourse, vol. 14.

Fabian, Johannes (1990) Power and Performance, Madison: University of Wisconsin Press.

Felman, Shoshana (1983) The Literary Speech Act: Don Juan with Austin, or Seduction in Two Languages, trans. Catherine Porter, Ithaca, N.Y.: Cornell University Press.

Féral, Josette (1982) "Performance and Theatricality: The Subject

Demystified," Modern Drama, vol. 25, pp. 170-81.

— (1992) "What is Left of Performance Art? Autopsy of a Function, Birth of a Genre," Discourse, vol. 14, pp. 142-62.

Fernandez, J. (1986) Persuasions and Performances: The Play of Tropes in Culture, Bloomington: Indiana University Press.

Ferris, Lesley (1993) Crossing the Stage, London: Routledge.

Fine, Elizabeth (1984) The Folklore Text: From Performance to Print, Bloomington: Indiana University Press.

Fish, Stanley (1980) Is There a Text in This Class?, Cambridge, Mass.: Harvard University Press.

Fleck, Stephen H. (1992) "Barthes on Racine: A Different Speech Act Theory," Seventeenth Century French Studies, vol. 14, pp. 143-55.

Fluxus (1963) Fluxus I: An Anthology, ed. George Maciunas, New York: ReFlux Editions.

Foreman, Richard (1970) "The Life and Times of Sigmund Freud," Village Voice, 1 January.

- (1976) Plays and Manifestos, ed. Kate Davy, New York: New York University Press.

Forte, Jeanie (1990) "Women's Performance Art: Feminism and Postmodernism," pp. 251-69 in Case, Performing Feminisms.

Foster, Hal (1985) Recodings: Art, Spectacle, Cultural Politics, Seattle: Bay

Fraser, Flora (1987) Emma, Lady Hamilton, New York: Alfred A. Knopf. Freedman, Barbara (1991) Staging the Gaze, Ithaca, N.Y.: Cornell University Press. Freedman, Samuel G. (1986) "Echoes of Lenny Bruce, via Bogosian and

Reddin," New York Times, 19 January, sec. 2, p. 5.

Fried, Michael (1968) "Art and Objecthood," in Battcock, Minimal Art. Frost, Thomas (1875) The Old Showmen and the London Fairs, London: Tinsley Brothers.

Fusco, Coco (1994) "The Other History of Intercultural Performance," TDR, vol. 38, pp. 143-67.

Gablik, Suzi (1994) "A Conversation with the Guerrilla Girls," Art in America, January, pp. 43-7.

Gallie, W. B. (1964) Philosophy and the Historical Understanding, New York: Schocken Books.

Garfinkel, Harold (1962) "Common Sense Knowledge of Social Structure: The Documentary Method of Interpretation," in J. Sher (ed.), Theories of the Mind, vol. 1, pp. 689-712.

Garner, Stanton B., Jr. (1994) Bodied Spaces: Phenomenology and Performance in Contemporary Drama, Ithaca, N.Y.: Cornell University Press.

Garvin, Harry R. (ed.) (1980) Romanticism, Modernism, Postmodernism, Bucknell Review special issue, vol. 25.

Gates, Henry Louis, Jr. (1995) "Sudden Def," The New Yorker, 19 June,

pp. 34-42.

Gay, John (1974) Poetry and Prose, Vinton A. Dearing (ed.), Oxford: Oxford University Press.

Geertz, Clifford (1972) "Deep Play: Notes on the Balinese Cockfight," Daedalus, vol. 101, pp. 1–37.

- (1983) Local Knowledge: Further Essays in Interpretive Anthropology, Stanford, Calif.: Stanford University Press.

(1988) Works and Lives: The Anthropologist as Author, Stanford, Calif.: Stanford University Press. Gentile, John S. (1989) Cast of One: One-Person Shows from the Chautauqua

Platform to the Broadway Stage, Urbana: University of Illinois Press. George, David (1989) "On Ambiguity: Towards a Post-Modern Performance Theory," Theatre Research International, vol. 14.

Gershman, Herbert S. (1974) The Surrealist Revolution in France, Ann

Arbor: University of Michigan Press.

Gevisser, Mark (1990) "Gay Theater Today," Theater, vol. 21, pp. 46-51. Glueck, Grace (1989) "In a Roguish Gallery," New York Times, 12 May, sec. C, p. 3.

Goethe, Johann (1948) Italienische Reise. Gedenkausgabe, vol. 11, Zurich. Goffman, Erving (1955) "On Facework: An Analysis of Ritual Elements in Social Interaction," Psychiatry, vol. 18, pp. 213-31.

- (1959) The Presentation of Self in Everyday Life, Garden City, N.Y.:

Doubleday.

(1963) Stigma: Notes on the Management of Spoiled Identity, Englewood Cliffs, N.J.: Prentice-Hall.

— (1974) Frame Analysis, Garden City, N.Y.: Doubleday.

Goldberg, RoseLee (1979) Performance: Live Art 1909 to the Present, New York: Harry N. Abrams.

(1988) Performance Art: From Futurism to the Present, New York:

Harry N. Abrams.

Goldfried, M. R. and G. C. Davison (1976) Clinical Behavior Therapy, New York: Holt, Rinehart & Winston.

Golub, Spencer (1984) Evreinov: The Theatre of Paradox and Transformation, Ann Arbor: University of Michigan Research Press.

Graf, Günter (1992) "Sprechakt und Dialoganalyse-Methodenansatz zur externen Dramainterpretation," Wirkendes Wort, vol. 41, pp. 315-38.

Graver, David (1995) "Violent Theatricality: Displayed Enactments of Aggression and Pain," Theatre Journal, vol. 47, pp. 43-64.

Greenberg, Clement (1962) "After Abstract Expressionism," Art International, vol. 6.

- (1965) "Recentness of Sculpture," Arts, vol. 39, pp. 22–5.

Grindal, Bruce T. and William H. Shephard (1987/88) "Redneck Girl: From Performance to Experience," Journal of the Steward Anthropology Society, vol. 17, pp. 193-218.

Gropius, Walter (ed.) (1961) The Theater of the Bauhaus, trans. Arthur S. Wensinger, Middletown, Conn.: Wesleyan University Press.

Gurvitch, Georges (1956) "Sociologie du théâtre," Les Lettres nouvelles, vols. 34-6.

Habermas, Jürgen (1970) "On Systematically Distorted Communication," Inquiry, vol. 13, pp. 205-18.

- (1984, 1987) The Theory of Communicative Action, Boston, Mass.: Beacon Press.

Halstead, Jack (1990) "Peter Handke's Sprechstücke and Speech Act Theory," Text and Performance Quarterly, vol. 10, pp. 183–93.

Harris, William (1994) "Demonized and Struggling with his Demons,"

New York Times, 23 October, sec. H, p. 31.

Hart, Lynda (ed.) (1989) Making a Spectacle: Feminist Essays on Contemporary Women's Theatre, Ann Arbor: University of Michigan Press. - and Peggy Phelan (eds.) (1993) Acting Out: Feminist Performances,

Ann Arbor: University of Michigan Press.

Hassan, Ihab (1971) The Dismemberment of Orpheus: Towards a Postmodern Literature, Madison: University of Wisconsin Press.

- (1980) "The Question of Postmodernism," in Garvin, Romanticism. Hayum, Andree (1975) "Notes on Performance and the Arts," Art Journal, vol. 34, pp. 337-40.

Holden, Stephen (1992) "Two Strangers Meet Through an Actor," New York Times, 3 May, sec. 2, p. 8.

Holmström, Kirsten Gram (1967) Monodrama, Attitudes, Tableaux Vivants, Uppsala: Almqvist & Wiksells.

Horst, Louis and Carroll Russell (1961) Modern Dance Forms, San Francisco: Dance Horizons.

Howell, Anthony and Fiona Templeton (1977) Elements of Performance Art, The Ting: The Theatre of Mistakes.

Howell, John (1992) Laurie Anderson, New York: Thunder's Mouth Press. Huelsenbeck, Richard (1951) En Avant Dada: Eine Geschichte des Dadaismus, trans. in Motherwell, The Dada Painters.

Huizinga, Johan (1950) Homo Ludens, New York: Beacon Press.

Huspek, Michael (1991) "Taking Aim on Habermas's Critical Theory," Communication Monographs, vol. 58, pp. 225-33.

Hutcheon, Linda (1988) A Poetics of Postmodernism, London: Routledge. Hymes, Dell (1964) "Introduction Toward Ethnographies of Communication," in American Anthropologist, vol. 66, pp. 1-34.

— (1974) Foundations in Sociolinguistics: An Ethnographic Approach,

Philadelphia: University of Pennsylvania Press.

- (1975) "Breakthrough into Performance," in Ben-Amos and Goldstein, Folklore.

Irigaray, Luce (1985) This Sex Which Is Not One, trans. Catherine Porter with Carolyn Burke, Ithaca, N.Y.: Cornell University Press.

Issacharoff, Michael and Robin F. Jones (1988) Performing Texts, Philadelphia: University of Pennsylvania Press.

— (1989) Discourse as Performance, Stanford, Calif.: Stanford University

Jackson, Earl, Jr. (1989) "Kabuki Narratives of Male Homoerotic Desire in Saikuku and Mishima," Theatre Journal, vol. 41, no. 4, pp. 459-77.

Jackson, Michael (1989) Paths Toward a Clearing: Radical Empiricism and Ethnographic Inquiry, Bloomington: Indiana University Press.

Jackson, Shannon (1993) "Ethnography and the Audition: Performance as Ideological Critique," Text and Performance Quarterly, vol. 13, pp. 21–43.

Jaggar, Alison (1983) Feminist Politics and Human Nature, Totowa, N.J.: Rowan & Allanheld.

James, William (1925) The Philosophy of William James, New York: Random House.

Jameson, Fredric (1979) Fables of Aggression, Berkeley: University of California Press.

—— (1984) "Foreword," to Lyotard, The Postmodern Condition.

Jansen, William H. (1957) "Classifying Performance in the Study of Verbal Folklore," in Studies in Folklore in Honor of Distinguished Service Professor Stith Thompson, Bloomington: Indiana University Press.

Jelavich, Peter (1985) Munich and Theatrical Modernism, Cambridge, Mass.: Harvard University Press.

Jencks, Charles (1977) The Language of Postmodern Architecture, New York: Rizzoli.

Jenkins, Linda Walsh (1984) "Locating the Language of Gender Experience," Women and Performance Journal, vol. 2, pp. 6–8.

Kapferer, Bruce (1984) "The Ritual Process and the Problem of Reflexivity in Sinhalese Demon Exorcisms," pp. 179–207 in MacAloon, *Rite, Drama*.

Kaprow, Allan (1966) Assemblages, Environments, and Happenings, New York: Harry N. Abrams.

Katz, Jerrold J. (1977) Propositional Structure and Illocutionary Force, Hassocks, Sussex: Harvester Press.

Kaye, Nick (1994) Postmodernism and Performance, New York: St. Martin's Press.

Kent, Sarah and Jacqueline Morreau (eds.) (1985) Women's Images of Men, London: Writers and Readers Publishing.

Kipper, David A. (1986) Psychotherapy through Clinical Role Playing, New York: Brunner/Mazel.

Kirby, Michael (1965) Happenings: An Illustrated Anthology, New York: Oxford University Press.

—— (1975) "Post-Modern Dance," TDR, vol. 19, pp. 3–4.

— (1982) "Nonsemiotic Performance," Modern Drama, vol. 25, pp. 105–11.

Kirshenblatt-Gimblett, Barbara (1975) "A Parable in Context: A Social Interactional Analysis of Storytelling Performance," in Ben-Amos and Goldstein, Folklore, pp. 105–30.

Kisselgoff, Anne (1981) "Not Quite/New York," New York Times, 27 September.

Knapp, Bettina (1970) "Sounding the Drum: An Interview with Jerome Savary," TDR, vol. 15, pp. 92–9.

Kostelanetz, Richard (1968) The Theater of Mixed Means, New York: Dial.
 —— (1994) On Innovative Performance(s): Three Decades of Recollections on Alternative Theater, Jefferson, N.C.: McFarland.

Kristeva, Julia (1967) "Le Mot, le dialogue, et le roman," Critique, no. 239, pp. 438-65.

– (1974) La Révolution du langage poétique, Paris: Seuil.

(1980) Desire in Language, ed. Leon Roudiez, trans. T. Gora, A. Jardine, and L. Roudiez, New York: Columbia University Press.

Lahr, John (1991) "Playing Possum," The New Yorker, 1 July, pp. 38-66.

Laurie, Joe, Jr. (n.d.) Vaudeville, New York.

Lavie, Smadar, Kirin Narayan, and Renato Rosaldo (eds.) (1993) Creativity/Anthropology, Ithaca, N.Y.: Cornell University Press.

Lechte, John (1990) Julia Kristeva, London: Routledge.

Leech, Geoffrey N. (1983) Principles of Pragmatics, London: Longmans.

Léger, Fernand (1924) "Vive Rélâche," Paris-Midi, 17 December.

Levinson, Stephen C. (1983) Pragmatics, Cambridge: Cambridge University Press.

Lewin, Kurt (1936) The Principles of Topological Psychology, New York: McGraw-Hill.

Lifton, Robert Jay (1993) The Protean Self, New York: Basic Books.

Lindzey, G. and E. Aronson (eds.) (1968) The Handbook of Social Psychology, Reading, Mass.: Addison-Wesley.

Loeffler, Carl E. and Darlene Tong (eds.) (1989) Performance Anthology, San Francisco: Last Gasp Press.

Long, Beverly Whitaker (1980) "Editorial Statement," Literature in Performance, vol. 1, pp. i-v.

Lorde, Audre (1984) Sister/Outsider: Essays and Speeches, Freedom, Calif.: Cross Press.

Lyotard, Jean-François (1984) The Postmodern Condition: A Report on Knowledge, Minneapolis: University of Minnesota Press.

- (1984) "Notes on the Critical Function of the Work of Art," trans.

Susan Hanson, Driftworks, New York: Semiotext(e).

MacAloon, John J. (ed.) (1984) Rite, Drama, Festival, Spectacle: Rehearsals Toward a Theory of Cultural Performance, Philadelphia: Institute for the Study of Human Issues.

MacDonald, Erik (1993) Theater at the Margins: Text and the Post-Structured Stage, Ann Arbor: University of Michigan Press.

Mannheim, Karl (1936) Ideology and Utopia, New York: Harcourt Brace.

Manning, Susan (1988) "Modernist Dogma and Post-Modern Rhetoric," TDR, vol. 32, pp. 32-9.

Marinetti, F. T. (1991) Let's Murder the Moonshine: Selected Writings, ed. R. W. Flint, trans. R. W. Flint and A. A. Coppotelli, Los Angeles: Sun and Moon.

Marranca, Bonnie (1977) The Theatre of Images, New York: Drama Book Specialists.

Martin, Randy (1990) Performance as Political Act: The Embodied Self, New York: Bergin & Garvey.

Mason, Bim (1992) Street Theatre and Other Outdoor Performance, London: Routledge.

McCall, M. M. and Howard Becker (1990) "Performance Science," Social Problems, vol. 37, pp. 117-32.

Mehta, Xerxes (1984) "Some Versions of Performance Art," Theatre Journal, vol. 36, pp. 164–98.

Mifflin, Margot (1992) "Performance Art: What Is It And Where Is It

Going?" Art News, vol. 91, no. 4, pp. 84-9.

Moen, Marcia K. (1991) "Peirce's Pragmatism as a Resource for Feminism," *Transactions of the Charles S. Peirce Society*, Amherst: University of Massachusetts Press.

Moholy-Nagy, Lazlo (1961) "Theater, Circus, Variety," in Gropius, The

Theater of the Bauhaus.

Montano, Linda (1981) Art in Everyday Life, Los Angeles: Astro Artz.

Moreno, J. L. (1946) Psychodrama, vol. 1, New York: Beacon Press.

Morgan, Robin (1977) Going Too Far, New York: Random House.

Morris, Charles W. (1938) "Foundations of the Theory of Signs," in *The International Encyclopedia of Unified Science*, vol. 1, no. 2, Chicago: University of Chicago Press.

Motherwell, Robert (1951) The Dada Painters and Poets, Wittenborn, N.Y:

Schultz.

Munro, Eleanor (1979) Originals: American Women Artists, New York: Simon.

Nemser, Cindy (1971) "Subject-Object: Body Art," Arts Magazine, vol. 46, pp. 38–42.

Newton, Esther (1972) Mother Camp: Female Impersonators in America, Chicago: University of Chicago Press.

Nietzsche, Friedrich (1984) Human, All Too Human, trans. Marion Faber, Lincoln: University of Nebraska Press.

Nix, Marilyn (1972) "Eleanor Antin's Traditional Art," Artweek, vol. 3, p. 3.

O'Gorman, Kathleen (1991) "The Performativity of the Utterance in Deirdre and The Player Queen," pp. 90–104 in Orr, Yeats.

Ohmann, Richard (1971) "Speech Acts and the Definition of Literature," Philosophy and Rhetoric, vol. 4, pp. 10–15.

—— (1973) "Literature as Act," in Chatman, Approaches to Poetics.

Orgel, Stephan (1989) "Nobody's Perfect," South Atlantic Quarterly, vol. 88, pp. 7–29.

Orr, Leonard (ed.) (1991) Yeats and Postmodernism, Syracuse, N.Y.: Syracuse University Press.

Paget, Marianne (1990) "Performing the Text," Journal of Contemporary Ethnography, vol. 19, pp. 136–55.

Park, Robert Ezra (1950) Race and Culture, Glencoe, Ill.: Free Press.

Parsons, Talcott (1937) The Structure of Social Action, New York: McGraw-Hill.

Pavis, Patrice (1992) *Theatre at the Crossroads of Culture,* trans. Loren Kruger, London: Routledge.

Petrey, Sandy (1990) Speech Acts and Literary Theory, London: Routledge.

Phelan, Peggy (1993) Unmarked, London: Routledge.

Phillips, Gerald and Julia Woods (eds.) (1990) Speech Communication: Essays to Commemorate the Seventy-Fifth Anniversary of the Speech Communication Association, Carbondale: Southern Illinois University Press.

Porter, Joseph A. (1979) The Drama of Speech Acts: Shakespeare's Lancastrian Tetralogy, Berkeley: University of California Press.

Pratt, Mary Louise (1977) Toward a Speech-Act Theory of Literary Discourse, Bloomington: Indiana University Press.

Pritchard, Diane Spencer (1991) "Fort Ross: From Russia with Love," p. 53 in Anderson, A Living History Reader.

Quinn, Michael (1990) "Celebrity and the Semiotics of Acting," New Theatre Quarterly, vol. 4, pp. 154–61.

Rainer, Yvonne (1972) "The Performer as a Persona," Avalanche, Summer, pp. 50–2.

Rapaport, Herman (1986) "'Can You Say Hello?' Laurie Anderson's United States," Theatre Journal, vol. 38, no. 3, pp. 339–54.

Read, Alan (1993) Theatre and Everyday Life: Ān Ethics of Performance, London: Routledge.

Readings, Bill (1991) Introducing Lyotard: Art and Politics, London: Routledge.

Reinelt, Janelle and Joseph Roach (eds.) (1992) Critical Theory and Performance, Ann Arbor: University of Michigan Press.

Rich, Frank (1985) "The Regard of Flight," New York Times, 10 May.
—— (1992) "Diversities of America in One-Person Shows," New York
Times, 15 May, sec. C, p. 1.

Richter, Hans (n.d.) Dada: Art and Anti-Art, New York.

Rivers, Elias (1983) Quixotic Scriptures: Essays on the Textuality of Spanish Literature, Bloomington: Indiana University Press.

—— (1986) Things Done with Words: Speech Acts in Hispanic Drama, Neward: Juan de la Cuesta.

Román, David (1992) "Performing All Our Lives: AIDS, Performance, Community," pp. 208–22 in Reinelt and Roach, *Critical Theory*.

Rosaldo, Renato (1989) Culture and Truth: The Remaking of Social Analysis, Boston, Mass.: Beacon Press.

Rosler, Martha (1977) "The Private and the Public: Feminist Art in California," *Artforum*, vol. 16, pp. 66–77.

Roth, Moira (1980) "Vision and Re-Visions: A Conversation with Suzanne Lacy," *Artforum*, vol. 19, no. 3, pp. 39–45.

— (1983) The Amazing Decade, Los Angeles: Astro Artz.

—— (1989) "Autobiography, Theater, Mysticism and Politics: Women's Performance Art in Southern California," in Loeffler and Tong, Performance Anthology, p. 466.

Rozik, Eli (1989) "Speech Acts and the Theory of Theatrical Communication," Kodikas/Code, vol. 12, pp. 41–55.

—— (1992) "Plot Analysis and Speech Act Theory," in Deledalle, Signs of Humanity, pp. 1183–91.

—— (1992) "Theatrical Conventions: A Semiotic Approach," Semiotica, vol. 89, p. 12.

—— (1993) "Categorization of Speech Acts in Play and Performance Analysis," *Journal of Dramatic Theory and Criticism*, vol. 8, pp. 117–32.

Rubinflen, Leo (1978) "Through Western Eyes," Art in America, vol. 66, pp. 75-83.

Rudnitsky, Konstantin (1988) Russian and Soviet Theater 1905–1932, trans. Roxane Permar, New York: Harry N. Abrams.

Russo, Mary (1986) "Female Grotesques: Carnival and Theory," pp. 213–29 in de Lauretis, Feminist Studies.

Sahlins, Marshall (1985) Islands of History, Chicago: University of Chicago Press.

Santayana, George (1922) Soliloquies in England and Later Soliloquies, New York: Charles Scribner's Sons.

Sarbin, T. and V. Allen (1968) "Role Theory," pp. 488-567 in Lindzey and Aronson, The Handbook of Social Psychology, vol. 1.

Sartre, Jean-Paul (1956) Being and Nothingness, trans. Hazel E. Barnes, New York: Philosophical Library.

Savona, Jeannette Laillou (1984) "French Feminism and Theatre: An Introduction," Modern Drama, vol. 27, pp. 540-3.

Sayre, Henry M. (1983) "The Object of Performance: Aesthetics in the Seventies," The Georgia Review, vol. 37.

Schechner, Richard (1965) Rites and Symbols of Initiation, New York: Harper.

- (1966) "Approaches to Theory/Criticism," TDR, vol. 10, pp. 20–53. — (1970) "Guerrilla Theatre: May 1970," TDR, vol. 14, pp. 163–8.

— (1973) "Performance and the Social Sciences," TDR, vol. 17, pp. 5–36. — (1977) Essays on Performance Theory 1970-76, New York: Drama Book Specialists.

- (1985) Between Theater and Anthropology, Philadelphia: University of

Pennsylvania Press.

- and Willa Appel (eds.) (1990) By Means of Performance, Cambridge:

Cambridge University Press.

Schmitt, Natalie Crohn (1990) Actors and Onlookers: Theater and Twentieth Century Scientific Views of Nature, Evanston, Ill.: Northwestern University Press.

Schneemann, Carolee (1979) More Than Meat Joy, New Paltz: Domentext. Schneider, Monique (1981) "The Promise of Truth—The Promise of Love," Diacritics, vol. 11.

Schneider, Rebecca (1993) "See the Big Show: Spiderwoman Theater Doubling Back," pp. 227-56 in Hart and Phelan, Acting Out.

Schutz, Alfred (1964) Collected Papers, vol. 2, The Hague: Martinus Nijhoff.

Searle, John R. (1969) Speech Acts: An Essay in the Philosophy of Language, Cambridge: Cambridge University Press.

-(1977) "Reiterating the Differences: A Reply to Derrida," Glyph, vol. 1. (1983) On Deconstruction (review), New York Review of Books,

27 October, pp. 74-9.

Sebeok, Thomas and Robert Rosenthal (eds.) (1981) The Clever Hans Phenomenon: Communication with Horses, Whales, Apes, and People, New York: New York Academy of Sciences.

Senelick, Laurence (1989) Cabaret Performance 1890-1920, New York: Performing Arts Journal Publications.

—— (1993) "Boys and Girls Together," pp. 80–95 in Ferris, Crossing the

Stage.

Sharp, Willowby (1970) "Body Works: A Pre-Critical, Non-Definitive Survey of Very Recent Works Using the Human Body or Parts Thereof," Avalanche, vol. 1, pp. 14–17.

— and Liza Bear (1973) "Chris Burden: The Church of Human

Energy," Avalanche, vol. 8, pp. 54-61.

Sher, J. (ed.) (1962) Theories of the Mind, New York: Free Press.

Shyer, Laurence (1989) Robert Wilson and his Collaborators, New York: Theatre Communications Group.

Singer, Milton (ed.) (1959) Traditional India: Structure and Change,

Philadelphia: American Folklore Society.

Small, M. (1983) "Laurie Anderson's Whizzbang Techno-Vaudeville Mirrors Life in These United States," People Weekly, vol. 19, p. 107.

Smith, Barbara (1978) "Ordinary Life," High Performance, vol. 1, pp. 45-7.

Solomon, Alicia (1993) "It's Never Too Late To Switch," pp. 144-54 in Ferris, Crossing the Stage.

Sonneman, Eve (1980) "Situation Esthetics: Impermanent Art and the Seventies Audience," Artforum, vol. 18, pp. 22-9.

Sontag, Susan (1966) Against Interpretation, New York: Farrar, Straus &

Stalnaker, R. C. (1972) "Pragmatics," in Davidson and Harman (eds.), Semantics of Natural Language.

States, Bert O. (1985) Great Reckonings in Little Rooms: On the Phenomenology of Theater, Berkeley: University of California Press. Stern, Carol Simpson and Bruce Henderson (1993) Performance: Texts and

Contexts, White Plains, N.Y.: Longmans.

Strine, Mary S., Beverly Whitaker Long, and Mary Frances Hopkins (1990) "Research in Interpretation and Performance Studies: Trends, Issues, Priorities," pp. 181–93 in Phillips and Woods, Speech Communication.

Strutt, Joseph (1845) The Sports and Pastimes of the People of England,

London: Thomas Tegg. Tamblyn, Christine (1990) "Hybridized Art," Artweek, vol. 21, pp. 18–19. Traylor, Marcia (1976) "Catalog: Autobiographical Fantasies," Laica Journal, vol. 10. Trinh, Thi Minh-Ha (1989) Women, Native, Other: Writing Postcoloniality

and Feminism, Bloomington: Indiana University Press.

– (1991) When the Moon Waxes Red: Representation, Gender and Cultural

Politics, London: Routledge. Trippi, Laura (1994) "Visiting Hours," New York, Program of the New Museum.,

Turnbull, Colin (1990) "Liminality: A Synthesis of Subjective and Objective Experience," pp. 50-81 in Schechner and Appel, By Means of Performance.

Turner, Victor (1957) Schism and Continuity, Manchester: Manchester

University Press.

(1969) The Ritual Process: Structure and Anti-Structure, Chicago: Aldine Publishing Co.

- (1974) Dramas, Fields, and Metaphors, Ithaca, N.Y.: Cornell University Press.

and Edith Turner (1982) "Performing Ethnography," TDR, vol. 26,

pp. 33-50.

(1982) From Ritual to Theatre, New York: Performing Arts Journal Publications.

(1984) "Liminality and the Performative Genres," pp. 19-41 in MacAloon, Rite, Drama.

Tyler, Stephen (1987) The Unspeakable: Discourse, Dialogue, and Rhetoric in the Postmodern World, Madison: University of Wisconsin Press.

Tzara, Tristan (n.d.) "Zurich Chronicle 1915–1919," in Richter, Dada.

van Dijk, Teun A. (1977) Text and Context, London: Longmans.

van Gennep, Arnold (1960) The Rites of Passage, trans. M. B. Vizedon and G. L. Caffee, Chicago: Chicago University Press.

vanden Heuvel, Michael (1991) Performing Drama/Dramatizing Performance: Alternative Theater and the Dramatic Text, Ann Arbor: University of Michigan Press.

Vater, Regina (1987) "Ecology Art is Alive and Well in Latin America,"

High Performance, vol. 10, pp. 30-5.

Wagner, Arthur (1967) "Transactional Analysis and Acting," TDR, vol. 11, no. 4, pp. 81-8.

Walsh, M. (1983) "Post-Punk Apocalypse," Time, 21 February, vol. 121, p. 68.

Wandor, Michelene (1986) Carry On, Understudies: Theatre and Sexual

Politics, London: Routledge & Kegan Paul. Weinsheimer, Joel C. (1985) Gadamer's Hermeneutics: A Reading of "Truth

and Method," New Haven, Conn.: Yale University Press. Whitmore, Jon (1994) Directing Postmodern Theater, Ann Arbor:

University of Michigan Press.

Whyte, Raewyn (1993) "Robbie McCauley: Speaking History Other-Wise," pp. 277–94 in Hart and Phelan, Acting Out.

Wiles, Timothy (1980) The Theater Event: Modern Theories of Performance, Chicago: University of Chicago Press.

Wilkerson, Margaret (1991) "Demographics and the Academy," pp. 238–41 in Case and Reinelt, The Performance of Power.

Wilshire, Bruce (1982) Role Playing and Identity, Bloomington: Indiana University Press.

- (1990) "The Concept of the Paratheatrical," TDR, vol. 34, pp. 177-8. Winnicott, D. W. (1971) Playing and Reality, London: Tavistock.

Worthen, William (1995) "Disciplines of the Text, Sites of Performance," TDR, vol. 39, pp. 13-28.

Yarbro-Bejarano, Yvonne (1993) "Cherríe Moraga's 'Shadow of a Man,'" pp. 85–104 in Hart and Phelan, Acting Out.

Zimmer, Elizabeth (1995) "Has Performance Art Lost Its Edge?," Ms., vol. 5, no. 5, pp. 78-83.

Name index

Abdoh, Reza 108 Abrahams, Roger 17 Acconci, Vito 103-4, 115, 140, 158 Adorno, Theodor 171 Akalaitis, JoAnne 213 Allen, V. 47 Alter, Jean 19, 27, 81-2, 87, 97 Anderson, Laurie 104-5, 115-16, 119, 141, 175 Antin, Eleanor 113-15, 150, 152-3, 156, 159, 161 Appia, Adolphe 125 Apple, Jacki 108, 116, 152–3, 163 - 4Aristotle 71, 82, 94 Arp, Hans 91 Artaud, Antonin 91-2, 106, 124, 126, 135 Artforum 140 Arts Magazine 101 Artweek 108, 116 Astley, Phillip 85 Athey, Ron 158-9 Auslander, Philip 141-2, 174, 176, 194 Austin, John 59-75, 171, 189 Avalanche 101 Avner the Eccentric 112, 116

Baker, Josephine 162 Bakhtin, Mikhail 28, 50, 57–9, 62, 66, 68, 75, 138, 171, 176, 221 Banes, Sally 127–32, 149 Barba, Eugenio 18–20, 35, 203 Barth, John 131 Bateson, Gregory 18, 38, 51-2 Bauman, Richard 5, 17-20, 51 Bausch, Pina 99, 111 Beckett, Samuel 111 Ben-Amos, Dan 17 Benamou, Michel 123 Benveniste, Emile 29, 62-4 Berger, P. L. 48 Bergson, Henri 43 Berne, Eric 21, 35, 48, 51 Bernini, Giovanni 81 Best, Paul 113, 157 Beuys, Joseph 79, 98, 101, 103, 119 Bhabha, Homi 184 Blau, Herbert 4, 112, 135, 195 Boal, Augusto 120 Bogosian, Eric 86, 114 Bouissac, Paul 200 Bowlby, Rachel 170 Bradbrook, M. C. 83-4 Brecht, Bertolt 71, 87, 182, 184, 193 Brecht, Stefan 179 Breuer, Lee 109, 117 Breton, André 91 Brisley, Stuart 119 Brook, Peter 203, 213 Brown, Trisha 146 Browne, Robert 84 Brun, Ida 85 Büchner, Georg 117 Burden, Chris 103, 158 Burke, Kenneth 17, 36-8, 57 Burnham, Linda 163 Butler, Judith 171–3, 182–3

Caffee, G. L. 21 Cage, John 26, 79, 91, 94-5, 98, 105, 128 Caillois, Roger 25-6, 28, 71, 80 Camillieri, Camille 32 Caramello, Charles 123 Carlos, Laurie 162 Carlson, Thomas 72–3 Case, Sue-Ellen 145-6, 168, 179-80 Chambers, Ross 70-1, 74 Chansky, Dorothy 193 Chekhov, Anton 117, 132 Chesebro, James W. 75 Chicago, Judy 148 Childs, Lucinda 111, 146 Chomsky, Noam 56, 63 Christo 101, 119 Cixous, Hélène 168–9 Clark, Herbert 72–3 Clarke, John 85 Clarke, Martha 111, 213 Cleopatra 40 Clifford, James 32, 189-90 Cohn, Ed 195 Cohn, Roy 154, 217 Coleridge, S. T. 52 Conquergood, Dwight 13, 20, 31, 190-4 Copeland, Roger 131 Coriolanus 72 Craig, Edward Gordon 125 Craig, Sandy 106 Cranach, Lucas 91 Crisp, Quentin 86, 154-5 Csikszentmihalyi, Mihaly 27 Cunningham, Merce 75, 94-5, 98, 120, 127–8, 151, 162 Curb, Rosemary K. 145

Dame Edna 156
da Vinci, Leonardo 81
Davis, R. G. 118
Davy, Kate 179–80
Dean, Laura 132
de Certeau, Michel 49–50, 138, 142, 171–4
deGroat, Andrew 111
de Lauretis, Teresa 180, 182

Derrida, Jacques 8, 29, 58, 65-6, 134-7, 171, 173, 176 de Saussure, Ferdinand 56 Diamond, Elin 170, 172, 175, 182-4, 194 Dickens, Charles 86 Dickerson, Glenda 195 Dine, Jim 95-6 Doane, Mary Ann 176 Dolan, Jill 145, 170, 174, 177, 180, 182, 197 Don Juan 64 Dore, John 57 Dorson, Richard M. 16 Dostoevsky, Fyodor 108 Drake, David 157 Drama Review, The (TDR) 13, 35, 107, 129-30 Draper, Ruth 80-1, 86, 114 Drewel, Margaret 195 Duchamp, Marcel 101-2, 124 Duncan, Isadora 86, 88-9, 93-4 Dunn, Robert 128

Eco, Umberto 39-41, 54-5, 68, 70, 74, 131 Edelson, Mary Beth 149 Ehrmann, Jacques 29-30 Eisenstein, Sergei 88 Elam, Keir 71–2 Eliade, Mircea 205 Eliot, T. S. 132 Elizabeth I 83 Elwes, Catherine 153, 177, 179, Erikson, Jon 140-1, 178 Eltinge, Julian 156 Euripides 117 Evelyn, John 84 Evreinoff, Nikolas 35-6, 46, 88 Export, Valie 167, 177

Fabre, Jan 110
Felman, Shoshana 63–5, 189
Féral, Josette 136–7, 140, 150–1
Finley, Karen 115, 157, 164, 177–8, 181
Fischer-Lichte, Erika 32
Fish, Stanley 67, 72–3, 75

Flanagan, Bob 159 Flaubert, Gustave 132 Fleck, John 157, 216 Flying Karamazov Brothers 112, 116 - 17Fokine, Mikhail 88 Fonteles, Bené 119 Foregger, Nikolai 88 Foreman, Richard 99, 109, 111, 127, 213 Forte, Jeanie 166–7, 169 Forti, Simone 98, 101, 146 Foster, Hal 133-4, 141 Foster, Susan 194 Freedman, Barbara 140 Freud, Sigmund 168 Fried, Howard 102 Fried, Michael 125-7, 129, 134-5, 137, 140 Fuller, Loie 89, 93-4 Fusco, Coco 185-6

Gadamer, Hans Georg 139-40 Gale, Mrs. Lyman 193 Gallie, W.B. 1 Garfinkel, Harold 49 Garth, Midi 93 Gates, Henry Louis, Jr. 117 Gatti, Armand 120 Gay, John 84-5 Geertz, Clifford 24, 188, 190 Gentile, John 86 George, David 139 Gevisser, Mark 156–7 Gilbert and George 101, 111 Glass, Philip 115 Godzich, Wlad 173 Goethe, Johann 82 Goffman, Erving 13-14, 18, 21, 30, 34-47, 50-2, 57, 59, 75, 154 Goldberg, RoseLee 79–82, 87 Goldberg, Whoopi 80-1, 86, 114 Goldstein, Kenneth S. 17 Gómez-Peña, Guillermo 161-4, 185-6Graham, Martha 93-4 Gray, Spalding 86, 112, 116, 153 Greenberg, Clement 125 Grice, H. P. 68

Grooms, Red 95 Grotowski, Jerzy 193 Gurvitch, Georges 14

Habermas, Jürgen 56 Hagedorn, Jessica 162 Halprin, Ann 79, 94-5, 97-8, 101, 127, 146 Hamburger, Anne 108 Hamilton, Lady Emma 85–6 Hamlet 4-5, 117 Hart, Lynda 195 Hassan, Ihab 124 Hawkins, Erick 93 Hay, Deborah 146 Hendel-Schütz, Henriette 85 Henderson, Bruce 80 Henes, Donna 149 Herford, Beatrice 81, 114 Hershman, Lynn 152 High Performance 119, 163 Hixon, Lin 108 Hockney, David 101 Hoffman, Abbie 118 Holbrook, Hal 86 Hopkins, Mary 1 Horst, Louis 128 Howell, Anthony 106 Huelsenbeck, Richard 90 Hughes, Holly 115, 157 Huizinga, Johan 21, 25–9, 80 Humphries, Barry 156 Humphrey, Doris 93, 128 Hutcheon, Linda 131 Hymes, Dell 14–20, 42, 51, 57

Ibsen, Henrik 85, 117 Irigaray, Luce 169, 175–6 Irwin, Bill 112, 116, 123, 129–30, 132

Jackson, Earl 180 Jackson, Michael 191–2 Jaques-Dalcrose, Emile 88–9 Jaggar, Alison 145 James, William 45, 59, 68, 191 Jameson, Fredric 133–4, 141 Jansen, William H. 15 Jencks, Charles 130-4, 175–6 Jenkins, Linda Walsh 145 Jenkins, Ron 112 Jones, Leroi 162 Johns, Jasper 101 Jonas, Joan 104

Kapferer, Bruce 24 Kaprow, Allan 93, 95-9, 101-2, 104 Katz, Jerrold 63–4 Kaye, Nick 123, 128-30, 136 Kienholz, Edward 101 Kirby, Michael 96, 126, 129 Kierkegaard, Søren 64 Kirshenblatt-Gimblett, Barbara 37 Kirstein, Lincoln 129 Kisselgoff, Anne 129 Klein, Yves 79, 96 Knowles, Alison 146 Knowles, Christopher 110 Knox, Sonia 177, 181 Kostelanetz, Richard 86, 98-9, 105 Kristeva, Julia 59, 62, 64, 68–70, 137, 169, 189 Kushner, Tony 154 Kwong, Dan 163

Labov, William 67 Labowitz, Leslie 166 Lacan, Jacques 64, 137, 168, 170 Lacy, Suzanne 148, 160, 166 Lamb, Charles 82 Laurie, Joe, Jr. 156 Lazarus, A. A. 35 Lechte, John 64, 189 Leech, Geoffrey 73 Léger, Fernand 91–2 Lepage, Robert 110 Le Va, Barry 147 Levinson, Stephen 73 Lewin, Kurt 103 Lifton, Robert Jay 188 Lippard, Lucy 147 Literature in Performance 75 Littlewood, Joan 120 Litz, Katherine 93–4 Lorde, Audre 174 Long, Beverly 1 Luckman, T. 48

Luna, James 185 Lunch, Lydia 177 Lyotard, Jean-François 137–8, 142

MacAloon, John 15, 24–5, 27, 196 Macaulay, Scott 178 McCauley, Robbie 162–3 McDermott, R. P. 57 MacDonald, Erik 1 Malpede, John 120 Mannheim, Karl 49 Manning, Susan 129–30 Manzoni, Piero 79, 96 Marin, Maguy 99, 111 Marinetti, Filippo 89–90 Marioni, Tom 102 Marranca, Bonnie 105, 108, 126 Martin, John 129 Martin, Randy 141 Mason, Keith 162 Mehta, Xerxes 127, 130 Meyerhold, Vsevolod 88-9 Miller, Arthur 132 Miller, Tim 115, 157–8, 163, 183–4 Modern Drama 136 Moen, Marcia 169 Moffett, Marjorie 81 Moholy-Nagy, Lazlo 92 Molière 64 Monk, Meredith 98–9, 149 Montano, Linda 102, 148-50 Moore, Jack 93 Moorman, Charlotte 146 Morenga, Cherríe 161 Moreno, J. L. 34, 45–7, 54 Morgan, Robin 166 Morris, Charles 40–1, 54, 61

Naumann, Bruce 101, 147 New York Times 3, 123, 129 Newton, Esther 154–5 Nietzsche, Friedrich 42, 64 Nightingale, Florence 153 Nuttall, Jeff 106

Ohmann, Richard 66–8, 71, 74 Oldenburg, Claes 96 Oliveros, Pauline 146 O'Neill, Eugene 132 Ono, Yoko 146–7 Oppenheim, Dennis 147 Orgel, Sandra 148 Orlan 159 Osolsobe, Ivo 40 Ostrovsky, Alexander 88 Othello 72

Park, Robert 44-5 Parsons, Talcott 48 Patraka, Vivian 195 Pavis, Patrice 32, 203 Pavlova, Anna 88 Payne, Mitchell 149 Peirce, Charles 39-40, 73, 169 Penn and Teller 112 People Weekly 115-16 Petrey, Sandy 69 Pfaff, Judy 101 Phelan, Peggy 181, 194 Picabia, Francis 92 Piscator, Erwin 193 Plato 42, 175, 180 Pontbriand, Chantal 136, 140 Porter, Joseph A. 71 Potter, Sally 169-70, 174 Pratt, Mary Louise 67-8 Pritchard, Diane Spencer 3-4, 6

Quinn, Michael 53

Radlov, Sergei 88 Rainer, Yvonne 98, 101, 104, 146, 150 Rame, Franca 176 Rapaport, Herman 175 Read, Alan 50, 142, 198 Reagan, Ronald 119 Rich, Frank 217 Rivers, Elias 73 Roach, Joseph 189, 194 Robinson, Amy 195 Román, David 158, 184 Rosaldo, Renato 188 Rose, Sheree 159 Rosenbach, Ulrike 167 Rosenthal, Rachel 149, 151-2, 176 - 7Rosler, Martha 148

Roth, Moira 149–50 Rozik, Eli 73–4 Rubin, Jerry 118 Rush, Chris 148 Russo, Mary 176 Russell, Mark 158

Saar, Bettye 101 Sahlins, Marshall 29-30 St. Denis, Ruth 93 Sandownick, Douglas 158, 164 Santayana, George 43 Sarbin, Theodore 47 Sartre, Jean-Paul 43 Savarese, Nicola 19 Savary, Jérôme 107 Sayre, Henry 134-5 Schechner, Richard 4, 13–15, 21–2, 34, 36, 47, 51–2, 54, 118 Schlemmer, Oskar 92 Schmitt, Natalie Crohn 94 Schneemann, Carolee 98, 146–7, 150 Schneider, Monique 64 Schneider, Rebecca 184-5, 194 Schutz, Alfred 49 Schwitters, Kurt 93 Searle, John 8, 59, 61-2, 66, 72, 75, 171 Senelick, Laurence 87, 156 Shakespeare, William 40, 71-3, 86, 117, 140 Shaw, Peggy 179 Shawn, Ted 93 Sherk, Bonnie 102, 146 Singer, Milton 16, 20, 23 Skinner, Cornelia Otis 86 Smith, Anna Deveare 114 Smith, Barbara 116, 146, 149 Smith, Jack 217 Smithson, Robert 101, 119 Solomon, Alicia 157 Sonneman, Eve 140 Sontag, Susan 155 Sprinkle, Annie 123, 194 Stalin, Josef 87 Stalnaker, R. C. 62 Stanislavsky, Constantin 46, 74, 193

States, Bert O. 27, 40–1, 53–4 Stern, Carol Simpson 80 Strine, Mary 1 Sutton-Smith, Brian 23, 27

Tairov, Alexander 88 Tyler, Stephen 190-1 Terence 83 Text and Performance Quarterly Thatcher, Margaret 113, 119 Time 115 Tomlin, Lily 86 Trinh, Thi Minh-Ha 181-2, 188 Trippi, Laura 159 Tudor, David 95 Turnbull, Colin 30-1 Turner, Victor 13-14, 19-25, 27-30, 34, 36-7, 46-7, 52, 54, 59, 117, 221 Twain, Mark 86 Tzara, Tristan 90-1

van Dijk, Teun A. 69, 73–4 van Gennep, Arnold 20–3, 29, 52 Vawter, Ron 217 Village Voice 3 Vizedon, M. B. 21 von Wely, Warner 107 von Wolzogen, Ernst 88

Wade, Stephen 112 Wandor, Michelene 145, 167 Waring, James 127 Weaver, Lois 176, 179 Wedekind, Frank 87 Weidman, Charles 93 Weinsheimer, Joel 139 Whitman, Walt 65 Wilde, Oscar 154-5, 195 Wilder, Thornton 132 Wilding, Faith 148 Wiles, Timothy 99 Wilkerson, Margaret 196 Williams, Willym 86 Wilshire, Bruce 44 Wilson, Martha 152–3 Wilson, Robert 99, 105, 109-11, 115, 117, 213 Winnicott, D.W. 52 Wittgenstein, Ludwig 40 Wolpe, Joseph 35

Zaloom, Paul 112, 116

Subject index

academic performance 189-90, 194 acrobats see juggling, tumbling, clown acts, new vaudevillians African-American performance see black performance animal performance 200 anthropology and performance 13-33, 57, 190; see also ethnogra-Asian-American performance 160, 163 attitudes 85 audience 5, 15, 32, 41-2, 53, 55, 71-4, 89, 91, 94, 96-7, 120, 127, 139-40, 149, 177, 181-2, 186, 194, 197-9; see also gaze, reception author function 68-9 autobiographical performance 6, 104, 113-16, 147, 149-55 avant-garde theatre 79-81, 87-99,

Bauhaus 79, 92–3, 96 behavior rehearsal 35, 47 behavior therapy 47–8, 51 Beijing Opera 193 Beryl and the Perils 107 Big Apple Circus 112 black performance 114, 161–3, 195; see also ethnicity and performance, Whoopi Goldberg Black Mountain College 95, 128 body art 79, 101–3, 152, 158

100-1

liminoid activity Bread and Puppet Theatre 118 bricolage 49 Brooklyn Academy of Music 109 bruitism 90-1, 93 cabaret performance 84, 86-7, 89, 91 - 2Cal Arts 148 camp performance 155, 179-80 carnival 28-9, 58-9, 68, 179, 221 Cartoon Archetypical Slogan Theatre (CAST) 118 chance 26-7, 91, 128 character performance art 113, 152–3, 156, 160–2 Chautauqua 86 Chicano, Chicana performance circus 82, 85, 88-9, 93, 155, 200 Cirque du Soleil 112 citation 66, 171 clown acts 85–6, 89, 106, 111–13, 118, 123; see also new vaudevillians Commedia dell'arte 46 Compagnie Extrêmement Prétentieuse 113 conceptual art 98, 101-2 conflict 26 contested concepts 1-2, 15, 18 costume 36, 41, 82, 111–13, 129, 198

borders and margins 20, 188,

190–1; see also liminal and

Crazy Idiots 113
creole culture *see* interculturalism cross-dressing *see* drag performance
Cubism 97, 127
cultural performance 16, 194–7; *see also* ethnography
Cunning Stunts 107
cybertechnology and performance 194

dada 26, 80–1, 87, 89–91, 93, 95, 97, 100, 102, 105–6, 115, 124 dance and dance theory 79, 88–9, 93–5, 98–9, 101, 111–12, 120, 123, 127–31, 193–4 dance-theatre (*Tanztheater*) 111 dialogism 59 Dogtroep 107 double-coding 130–2 drag performance 155–7, 217

earth art 101

ecological performance 118–19 Elizabethan drama and performance 29, 73, 83-4, 86, 194; see also Shakespeare En Garde Arts 108 ethnography and performance 13, 31-2, 189-95; see also anthropology and performance, cultural performance, folklore ethnomethodology 49, 53 engaged performance see political performance environments 97-8; see also sitespecific theatre ethnicity and performance 104, 114, 146, 149, 160-4, 194; see also Asian-American performance, black performance, Native American performance expressionism 111

feminist theatre and performance 118–19, 141, 144–54, 160, 165–70, 181–3; see also lesbian performance Fez 117 formalism 67 flow 24, 27 Fluxus 96, 103 folklore studies 14–18, 57 framing 4, 18–19, 25, 38–41, 53, 70 front 41 Fura dels Baus 110 futurism 79–81, 87, 89–90, 92–3, 97, 100

gay performance 146, 154–9, 163–4, 167, 180, 183, 186, 194–5; see also gender and performance gaze 168, 177, 180–1 gender and performance 143, 171–4, 194–5; see also feminist theatre and performance, gay performance, lesbian performance ghosting 53 Greenpeace 119 Guerrilla Girls 166 guerrilla theatre 118, 165–6, 172

halo effect 154
happenings 79–81, 93, 95–9
Highways Performance Space 163
Hittite Empire 162
homosexual performance see gay performance, lesbian performance

identity and performance 8, 113–14, 144–64, 171–4, 181, 183–6, 188, 194–5; see also autobiographical performance, character performance art, feminist theatre and performance, gay performance, lesbian performance illocution 60, 65–74, 190 Incubus and Kaboodle 107 interculturalism 32, 117, 163–4, 186, 188, 194–5, 203 International Outlaw University (IOU) 108 irony 74, 132, 175, 178–9, 183–6

jesters 83 Judson Dance Group 98, 127–8, 146–7 jugglers 84, 86, 89, 111–12

keying 39, 50–1 Kitchen, The 178 KRAKEN 112

lesbian performance 163, 179–80, 186, 194–5; see also feminist theatre and performance lip-synching 194 liminal and liminoid activity 21–3, 25, 28–31, 47, 52, 117, 168, 198
Lincoln Center 117 linguistic performance 8, 17, 56–75 living history 3
Living Newspaper 46
Living Theatre 99
Los Angeles Poverty Dept. (LAPD) 120

Mabou Mines 109 magicians 111-12 Mardi Gras 194 masquerade 141, 157, 176-7, 179 Media Theatre 110 medical performance 194 metacommunication 18, 51 Metropolitan Transit Authority (MTA) 5 mimesis 26–7, 66–7, 152, 175 mimicry 175-6, 184-5 minstrel performance 155, 193 mixed-means see multimedia performance modern dance see dance and dance theory Modern Language Association monologuists 80-1, 83, 86, 112, 114-17, 217 Monstrous Regiment 176–7 multicultural performance see interculturalism multimedia performance 80, 98-9, 101, 105–11, 115, 117, 162, 193 music hall *see* cabaret

National Endowment for the Arts 157, 178 Native American performance 104, 149, 160-1, 184-5; see also ethnicity and performance Natural Theatre 113-14 New Museum 159 New Vaudevillians 6, 107, 112-13, New York University 189, 193 Noh drama 106 Northwestern University 189 "not-me . . . not not me" 54 nudity 6, 150, 152, 163, 166, 174-5, 177 Nuyorican Café 117 Nuova Spettacolarità 110

Ontological-Hysteric Theatre 109, 111 ostentation 39–41, 53, 68; see also framing

parody and pastiche 132 People Show 106 performance art 2-3, 6-8, 53, 55, 79–81, 100–20, 123, 141, 144, 146-64, 195 performance studies 20, 189, 193 performative utterances 60, 62-5, 171, 189 persona performance art see character performance art phenomenology 27, 53-4, 126-7, 134, 170 photography 195 Pickle Family Circus 112 play 13, 18, 20, 23–30, 38, 46, 48, 52-3, 139 Plimouth Plantation 52 poem-paintings 80 political performance 133-4, 140–3, 151–4, 165–99, 192–3; see also ecological performance, feminist theatre and performance, guerrilla theatre

Pomo Afro Homos 123, 163
pose band 106
postmodern architecture 130–4
postmodern dance see dance and
dance theory
postmodernism 8, 112, 123–43,
173–8, 188–90, 198, 213
poststructuralism 2
pragmatics 61–2, 68, 74
pre-expressivity 19, 35, 203
presence 125–6, 134–7, 198
Provos 118
P.S. 122 158
psychodrama 45–7, 51–2, 54
psychotherapy 13, 35

race and performance 44-5, 101, 114; see also ethnicity and performance rap 117 reactualization 205 referentiality 19, 81–2 resistant performance 15, 165-86, 194; see also engaged performance, political performance restored behavior 4, 15, 47, 51-2, 66, 173 rhetoric 17, 36-7 ritual 13, 20-1, 27, 52, 195, 198 rope-dancing 84-6 role playing 4, 34-6, 38, 43-7, 52; see also character performance, drag performance

sadomasochistic performance 158–9, 194–5
San Francisco Mime Troop 118 scenery 6, 41
Scharlatan Theater 113
self and performance 46, 113–15; see also autobiographical performance, identity and performance, race and performance, role playing semiotics 13, 19, 27, 39–41, 53, 71, 73, 81, 139, 200
simulations 6; see also lip-synching, living history

site-specific theatre 108, 111; see also environments Spiderwoman 160-1, 184-5 Split Britches 179, 181 social drama 19, 21-2, 52, 54 social constructionism 48-9, 53 sociolinguistics 16, 57, 67, 73 sociology and performance 13–14, 17–18, 34–45 solo performance see monologuists Spanish Golden Age drama 73, 88 speech-act theory 61–75 stand-up comedy 141; see also monologuists stigma 154 strip of behavior/experience 50–2 structuralism 67 surrealism 26, 79, 81, 89, 91-3, 97

symbolism 82

tactics of everyday actions 171-3 tableaux vivants 85, 91, 106, 109, Teatro Campesino 118 Tender 114 Théâtre Décale 113 Theatre of Images 105, 115, 117, 126 Theatre of Mistakes 106 Theatre of the Ridiculous 179, 217 theatrical performance 196–9; see also dance and dance theory, feminist theatre and performance, gay performance, lesbian performance, multimedia performance, performance art, total theatre, variety theatre, vaudeville Thought Music 162 total theatre 92; see also multimedia performance transactional analysis 35, 52 transformation 35 Trapu Zaharra Teatro Trapero tumbling 83-5, 89-90, 111

utterance 57–8, 138

variety theatre 88, 90, 93; see also cabaret vaudeville 84, 86, 90, 93, 106, 118, 155 visibility 180–1

walkabouts 113–14 Walker Art Center 158 Welfare State 106–7, 118–20 Womanhouse 148
Women's International Terrorist
Conspiracy from Hell (WITCH)
118, 165–6
Wooster Group 99, 131, 141
writing and performance 187–91,
195, 198; see also poem-painting

Yoruba ritual 195